LEONARDO ART AND SCIENCE

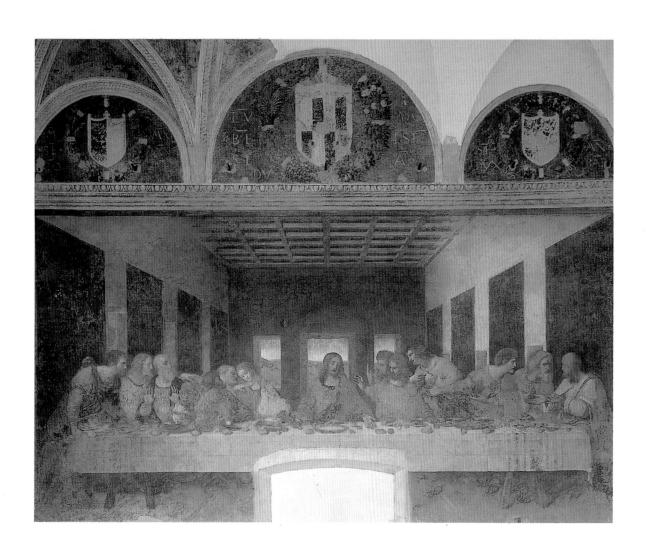

LEONARDO ART AND SCIENCE

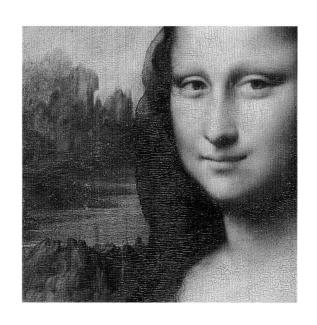

Note

Leonardo's manuscripts and drawings, all available in the Vincian National Edition (Giunti), are found in the following locations: the Codex Atlanticus in the Biblioteca Ambrosiana, Milan;

the Anatomical manuscripts and other drawings in the Royal Library, Windsor Castle;

the Codex Arundel 263 in the British Library, London (the former Library of the British Museum);

Forster Manuscripts I-II in the Library of the Victoria and Albert Museum, London;

Madrid Manuscripts I and II in the Biblioteca Nacional, Madrid;

Manuscripts A-M in the Library of the Institut de France, Paris;

the Codex Hammer (former Codex Leicester) owned by Bill Gates, Seattle, Washington (U.S.A);

the Codex Trivulziano in the Biblioteca Trivulziana, Castello Sforzesco, Milan;

the Codex on the Flight of Birds in the Biblioteca Reale, Turin.

The chronology of Leonardo's notes and drawings frequently varies even within the context of a single manuscript. Accordingly, for each image reproduced, the approximate or certain date is given. Unless otherwise indicated, all of the works reproduced here are by Leonardo da Vinci. Where the location is not indicated, the work is in a private collection.

Editorial Note

This book has gone through several reprints and editions in various languages and in the process it has undergone careful revisions and improvements so as to have it updated for every new printing. In its original format, which goes back to the first Italian and English edition of 1999 and 2000, it consisted of two separate items: Leonardo. Art e e Scienza (Leonardo. Art and Science) and Leonardo. Le machine (Leonardo. The Machines). Only the latter was entirely written and designed by Carlo Pedretti, while the first was an editorial compilation made up mainly by texts on the life and work of Leonardo da Vinci previously published by the same author but supplemented by brief texts or sentences contributed by other authors, who, as friends and colleagues of the main author or as his pupils, have agreed to be mentioned only in the back flap of that first edition, while Carlo Pedretti was to appear only as the author of the introductury essay, "A Close-up of the Genius" ("II Genio in diretta"). These authors are: Luca Andoccia, André Chastel, Paolo Galluzzi, Domenico Laurenza and Rodolfo Papa. The two original works have now come together to form a single volume under the name of a single author, Carlo Pedretti, whose publications in the course of half a century have contributed to the foundation of modern Leonardo scholarship.

Published by TAJ Books 2004 Reprinted 2005, 2006. 27 Ferndown Gardens Cobham Surrey KT11 2BH UK www.tajbooks.com

All rights reserved. No part of this publication may be reproduced, stored in a retrieval system, or transmitted in any form or by any means, electronic, mechanical, photocopying, recording, or otherwise, without the prior written permission of the Publisher and copyright holders.

All notations of errors or omissions (author inquiries, permissions) concerning the content of this book should be addressed to info@tajbooks.com.

ISBN 1-84406-035-7 (hardcover) ISBN 1-84406-036-5 (paperback)

Printed in China. 2 3 4 5 07 06 05

© 2000 Giunti Gruppo Editoriale - Florence

Opposite page: detail of Leonardo's Annunciation, variously dated from 1475 to 1480, Florence, Uffizi Gallery.

CONTENTS

Art and Science

7

A close-up of genius

10

Life of the artist 29 Leonardo on film

30

Leonardo's painting 89 School of Leonardo

90

The notebooks
109 Studying Leonardo

110

 $\begin{tabular}{ll} Anatomy \\ 125 \ \mbox{The body in art and in science} \end{tabular}$

126

Science and technology 137 And I can square the circle

The Machines

141

True science
163 Helicopter and the hang glider

165

The tools of knowledge 183 The perspectograph and the ellipsograph

185

The artist-scientist 203 The steam cannon

205

From theatre to industry
215 The automobile and
the life preserver

217

Leonardo and printing 225 Relief etching

 $\begin{array}{c} \textbf{226} \\ \textbf{Chronology} \end{array}$

 $\frac{228}{Index}$

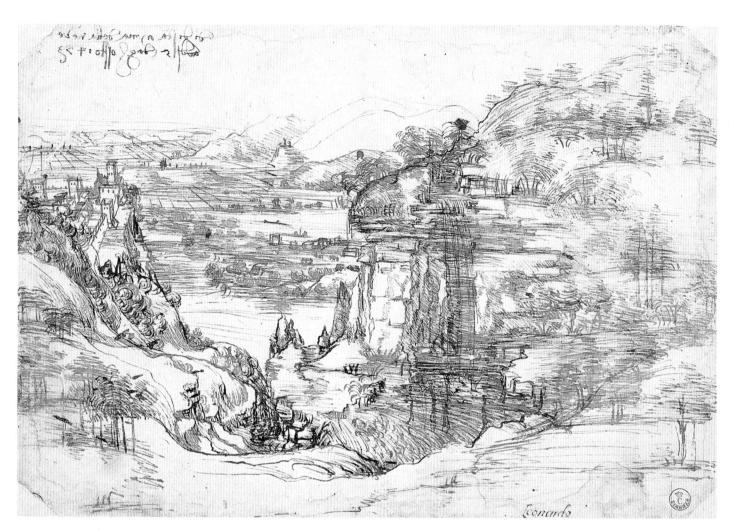

Landscape (1473), Florence, Uffizi Gallery.

A CLOSE-UP OF GENIUS

by Carlo Pedretti

n April 15, 1452 Leonardo was born in Vinci, a little village lying in the shelter of a Medieval castle on the slopes of Montalbano. All around the village are gently sloping hills covered with vineyards and olive groves. In the background the broad valley of the Arno opens out, framed on one side by steep heights crowned with the spas of Monsummano and Montecatini, and on the other, beyond the Fucecchio plain, by San Miniato al Tedesco, site of an imperial court at the time of Matilde di Canossa, and the ancient thoroughfare travelled by pilgrims, merchants and prostitutes: the Via Francigena that linked Northern Europe to Rome.

Vinci is halfway between Florence and Pisa. Leonardo was born, then, in a little village apparently far removed from the world but in reality lying at the crossroads of great highways of communication. At the age of sixteen or seventeen he moved to Florence, where his father, notary by profession, apprenticed him to work in Verrocchio's workshop. The road he covered, on foot or on horseback – forty miles or so – is the one that still today runs along the Arno. This same road had very probably already taken him to Pisa, attracted by a strange landscape where the rocky outcrops in the surrounding mountains often take on the primordial features appearing in the background of the Louvre *Virgin of the Rocks*, the first Milanese painting commissioned of him in 1483 when he was thirty-one. Of similar nature is his first known drawing, the landscape dated August 5, 1473, perhaps painted from nature when he was twenty-one. It is a picture of the Arno valley seen from a high viewpoint, above Vinci, perhaps from Porciano, on the road that leads to Pistoia looking toward Pisa and Livorno. And it is perhaps no coincidence that it was precisely in 1473 that the Florentine Studio with its Faculties of medicine and philosophy moved to Pisa.

In Florence Leonardo spent twelve years of systematic study and intense experimentation, soon entering under the protection of Lorenzo de' Medici, almost his own age (1449-1492), a refined humanist, crafty merchant, wise statesman and skillful politician, but above all an incomparably able diplomat: in short, a master of communication.

For the young Leonardo, Lorenzo was an intriguing example of the technique of communication, where the persuasive power of words was based on eloquence and psychology. Inspired by this example Leonardo began to refine his own visual language, adopting a kind of "speaking" painting which, with the *Adoration of the Magi* painted in 1481 at the age of twenty-nine, arrived at the intensely animated gestures and iconic impact of a silent film. This explains Leonardo's precocious ability to capture his listeners' attention with charming eloquence, an innate gift perhaps inherited from his father the notary. It is the same gift that was soon to serve him well in the systematic program of entrusting his thought to written records, as is done today through magnetic recording.

Following the example of Lorenzo de' Medici, Leonardo became a master of communication. A contemporary referred to him as «another Cato» and Giorgio Vasari, a generation later, presents an image of him still vividly alive, but already wrapped in the proverbial veil of legend expressed in anecdote. «And he was again the first», states Vasari, «who, as a young man, spoke of channeling the Arno River between Florence and Pisa». He then adds: «And every day he made models and drawings to enable him to dig out mountains easily, and to tunnel into them to pass from one level to another [...]. And among these models and drawings there was one which he showed several times to many ingenious citizens who then governed Florence, demonstrating how he wanted to raise the temple of San Giovanni in Florence and put steps under it without ruining it». «And so forceful were the reasons with which he persuaded them», Vasari concludes, «that it seemed possible, although each one after leaving, recognized for himself that such a feat was impossible».

All of Leonardo's work as painter and theoretician of painting is imbued with the concept that art should

be considered a form of creative knowledge, on the same level as science and philosophy. And still today the lesson taught by Leonardo has the immediate impact of a live broadcast, whether it involves traditional media – still unsurpassed in historical research – or the new electronic technologies, now beginning to show their true worth as indispensable aid to historical research, having developed beyond the initial stage of games used in play.

On the other hand, Leonardo played too, as noted by Sigmund Freud already in 1910: «The great Leonardo, it seems, remained infantile in some aspects his whole life long. He continued to play even as an adult and for this reason too he was at times incomprehensible and disturbing to the eyes of his contemporaries». And as such – disturbing and incomprehensible – he appears even today, five centuries later, since he has been more studied than understood. The genius has been rediscovered, but the man has been lost.

During a visit to Pavia in January 1490 accompanied by the Sienese architect Francesco di Giorgio Martini for a consultation on work then being done on the cathedral, Leonardo, then thirty-eight, was attracted by the ingenious arrangement of the rooms in a famous bordello in that city, and drew the floor-plan as a model "lupanare".

The drawing appears on a page in a manuscript from that time. Only now has another floor-plan for a bordello been identified, sketched by Leonardo in about 1505 on a folio in the British Library's Codex Arundel at London, and put in evidence by the new facsimile in the publication edited by myself for the National Edition of manuscripts and drawings by Leonardo da Vinci (Giunti). Beside one of the rooms sketched Leonardo notes: «Le putte», an abbreviation for "puttane" (whores). Below this he drew a young man seen in profile, standing and with an erection. The little drawing is still visible in spite of attempts made to delete it at some time in the past by rubbing it with a finger dampened in water or saliva.

On another folio in the same manuscript Leonardo recorded a surprising comment on women which seems to allude to his heterosexual experience at that time, when he was a little over fifty: «The man wants to know if the woman will consent to his lust, and believing that she will, and that she feels desire for the man, he asks her for it and puts his desire in practice, and being unable to do so without confessing, confessing he copulates».

On the same folio, at the same time, Leonardo notes: «catena aurea», which is the title of the grandiose Thomist compendium on the Gospels. These are small but sure indicators of how the real Leonardo, viewed in close-up, could finally re-emerge in the new millennium. After dying the first time in France on May 2, 1519, he has died many times over in the writings of posterity – those very writings that proclaimed his immortality.

LEONARDO ART AND SCIENCE

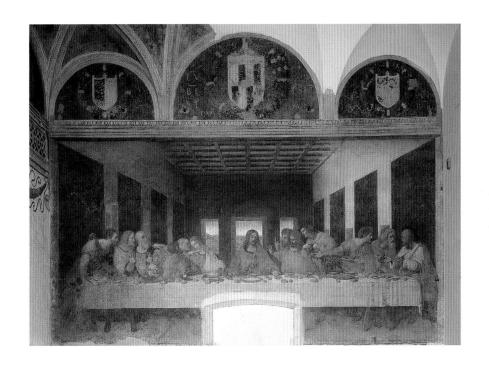

Almost nothing is known of Leonardo's early education and training. Before his entry into Verrocchio's workshop in Florence in 1469 there is no trace of his talent or of any apprenticeship served in his native Vinci, a little village far from the industrious activity of the artists' workshops in centres such as Florence and Pistoia. Nor do we know of any work of Leonardo completed prior to 1473, the date of the drawing now in the Uffizi.

After this time his career took up off, and he was called upon by powerful States: Milan and Venice, Florence, Rome and the France of King François I. And it was here, on foreign soil, that the life of this extraordinary, complex personality, almost a symbol of the Italian Renaissance, was to come to an end.

- Overleaf, on the two preceding pages: Anonymous, Doria Panel (1503-1504).
- 1.View of Vinci (Province of Florence), Leonardo's birthplace.
- Seal of the Town of Vinci, 14th century, Florence, Bargello National Museum.
- 3. The Vincian
 Museum at Vinci,
 in Castello Guidi,
 with models
 of Leonardo's
- machines.
 4. Florentia
 (map known as
 "della Catena"),
 Florence,
 c. 1472,
 Museo
 di Firenze
 com'era.
- 5. Map of Florence by Pietro del Massaio Fiorentino with the most important monuments (1469), Rome, Biblioteca Apostolica.

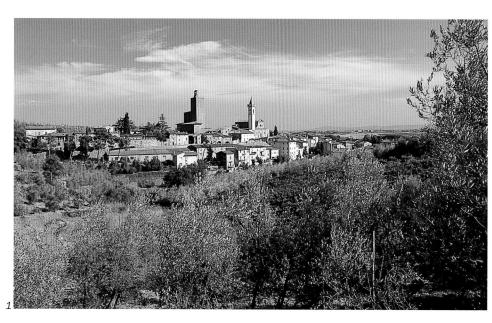

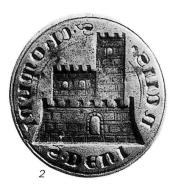

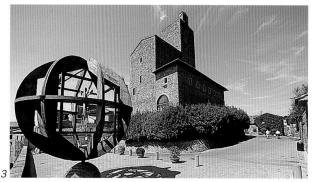

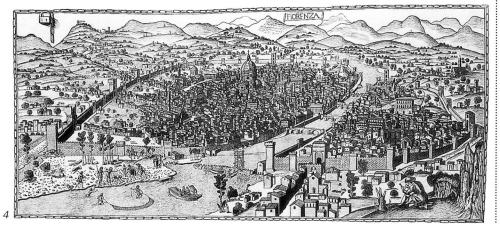

1452 a grandson was born to me, the son of Ser Piero my son, on April 15, on Saturday, at 3 o'clock in the night. He was named Lionardo. He was baptised by the priest Piero di Bartolomeo da Vinci». This record of Leonardo's birth in the village that his name was to make famous was noted by his grandfather Antonio, a notary. In Vinci, situated about thirty kilometres from Florence, the artist's family, which belonged to the upper middle class of landowners, had been living since the 13th century. The house of Leonardo's father, where he spent his childhood (and may have been born) still exists today, on the outskirts of the modern town.

Leonardo was the illegitimate son (not a particularly problematical situation, in those days) of Ser Piero and a woman of lower social standing named Caterina. In his writings Leonardo mentions his family and his boyhood only very rarely. At the age of five he was living in the home of his father, who had married in the meantime. As for his education, he himself was later to lament the lack of good schooling, exerting great efforts to learn Latin and geometry. At the death of his grandfather in 1468, Leonardo followed his father to Florence where Ser Piero, who was to have twelve children, moved with the whole family. In the Cronica rimata by Giovanni Santi, Raphael's father, - a document published only in the 19th century and then unaccountably forgotten - the exceptional chronicler narrates the stages of a journey to Florence undertaken by Federigo da Montefeltro, duke of Urbino, in that same 1468. In describing the stop in Florence he pauses to list the successful artists of the day, among whom were two rising stars: «Two young men the equals in rank and in loves / Leonardo da Vinci and Perusino / Pier della Pieve who is

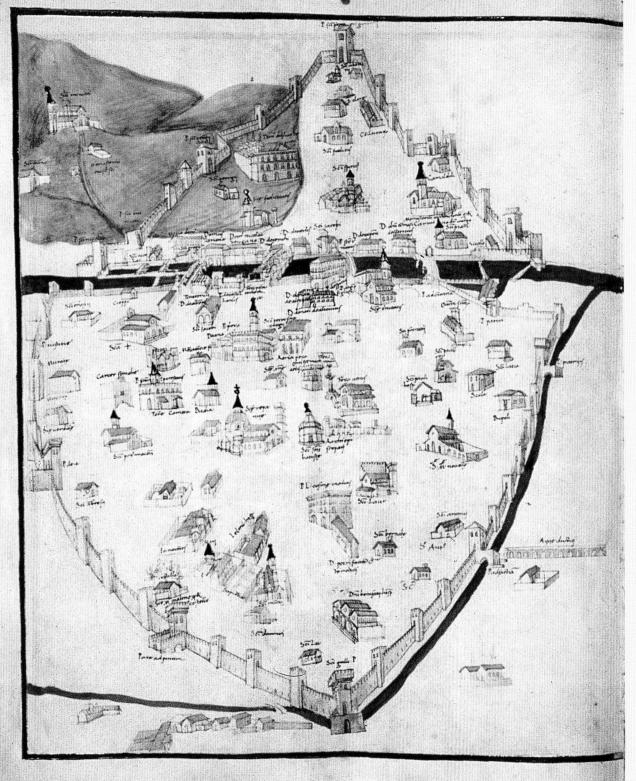

- 1. Domenico
 Ghirlandaio,
 Approval of
 the Franciscan Rule
 by Honorius III,
 (detail with,
 from right to left,
 Poliziano and
 the three sons of
 Lorenzo de' Medici:
- Giovanni, Piero and Giuliano) (1485), Florence, Church of Santa Trinita, Sassetti Chapel.
- Sassetti Chapel.

 2. Sandro Botticelli,
 Madonna with
 Child, the Infant St.
 John and two Angels
 (c. 1468).
- Florence,
 Accademia Gallery.
 3. Workshop of Andrea
 del Verrocchio,
 Virgin with Child
 standing
 on a Parapet
 (1471),
 Monastery

of Camaldoli.

4. The Virgin with the Flowers (1478-1481), Munich, Alte Pinakothek

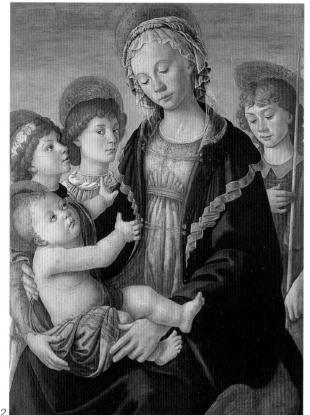

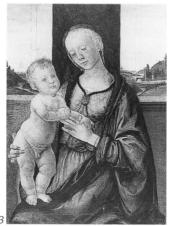

a divine painter». In 1468 Leonardo was sixteen years old. A document dated 1469 informs us that he was still living with his father, thus hinting that he may have approached the art of painting even earlier than has been thought, since his entry into the workshop of Andrea del Verrocchio, one of the most famous and popular Florentine artists of the times, is customarily considered to have taken place in 1469. His companions in this precocious apprenticeship were other voung painters named Botticelli, Perugino, Lorenzo di Credi and Francesco di Simone Ferrucci.

APPRENTICED TO VERROCCHIO

Why Leonardo turned to the artist's career rather than the notary's profession, in keeping with his family tradition, is unknown. His apprenticeship with Verrocchio, in the city rightly considered the cradle of the Italian Renaissance, gave him an almost complete education in art, with experience ranging from sculpture to painting and architecture, and from the diligent study of figures to the theory of optics and perspective and thus of geometry, natural sciences – botany in particular - and music. Moreover, he had a chance to become acquainted with the great clients, the Medici in particular, who not only preferred Verrocchio's workshop but also used the services of Leonardo's father as the family notary. However, we have no knowledge of any work by Leonardo prior to 1473, the date of his earliest known drawing, now in the Uffizi. It is true that in 1472, at the age of twenty, Leonardo was already enrolled in the Guild of Florentine Painters, the corporation of San Luca, entitled to receive commissions independent of his master, but it is equally true that in 1476 he was still apprenticed to Verrocchio. Perhaps the episode related

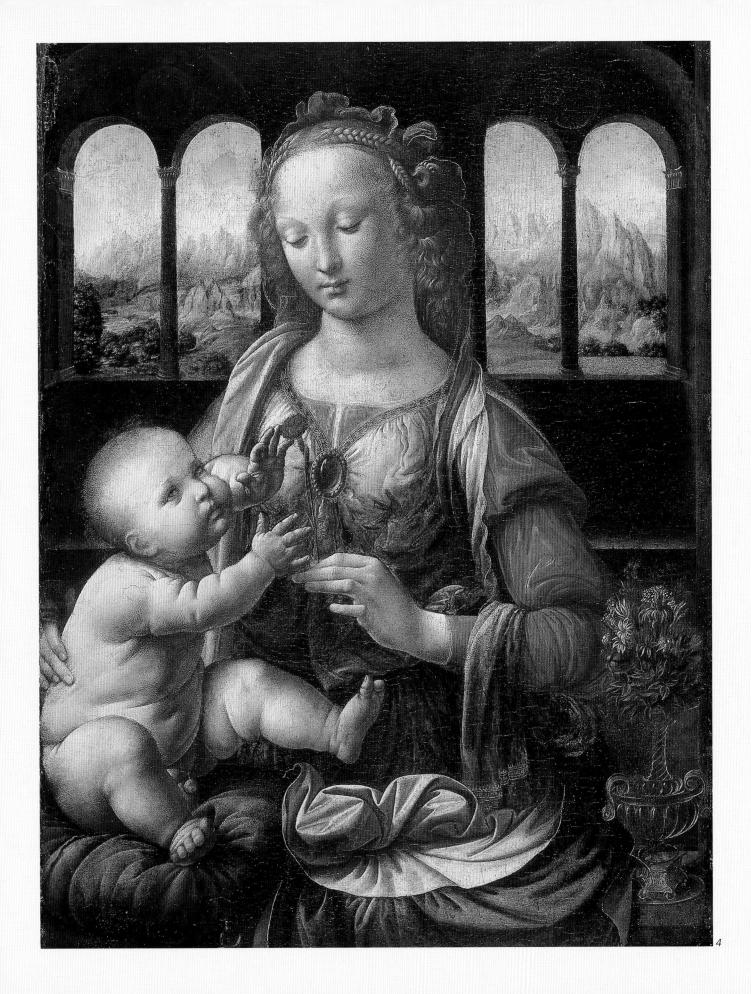

- 1. Angel's head, study for the Baptism of Christ by Verrocchio and Leonardo (1473), Turin, Biblioteca Reale.
- 2. Verrocchio and Leonardo, Baptism of Christ, (1473-1478) detail of the angel painted by Leonardo, Florence, Uffizi Gallery.
- 3. Study of hands, Windsor, Royal Library.
- 4. Verrocchio and Leonardo, Baptism of Christ (1473-1478), Florence, Uffizi Gallery.
- 5. St. Jerome (1480-1482), Rome, Pinacoteca Vaticana.

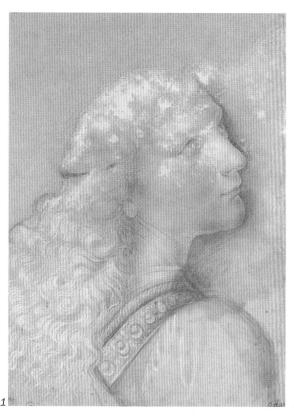

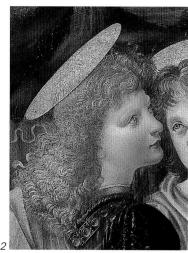

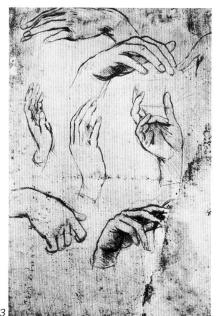

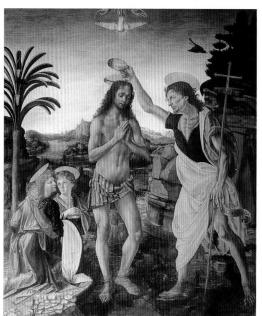

by Vasari in regard to the angel painted by Leonardo in his master's Baptism of Christ (now in the Uffizi Gallery) took place at that time. It even seems that as late as 1478 Verrocchio (often absent from Florence since he had been commissioned to sculpt the equestrian monument to Bartolomeo Colleoni in Venice) entrusted Leonardo and Lorenzo di Credi with the task of completing an important altar-piece for the Pistoia Cathedral. This is the famous Madonna di Piazza, from which comes a part of the predella attributable to Leonardo, the Annunciation now in the Louvre. Also dating from that time, although not from the same occasion, are the stupendous studies of drapery drawn by Leonardo with brush tip on very fine linen, or with metal tip on red paper.

Perhaps this gave Leonardo the idea of an Annunciation adapted to the format of an altarpiece. This is the painting now in the Uffizi. Its style seems to point to the time of his collaboration on Verrocchio's Madonna di Piazza, starting in 1478. And in fact a study for the Virgin's raised hand appears on a folio of various studies of hands in the Windsor collection, all of which can be linked to the gesticulating figures in the Adoration of the Magi, the painting which first engaged Leonardo on a monumental scale. For this work, commissioned of him in 1481 by the monks in the monastery of San Donato a Scopeto near Florence, the last payment, made on September 28 of the same year, is documented. Upon his departure for Milan the following year Leonardo left the painting unfinished with the father of Ginevra Benci, whose portrait he had painted some years before (now in the National Gallery at Washington). Coeval with the Adoration of the Magi is the St. Jerome of the Pinacoteca Vaticana, which shows spatial effects similar, in

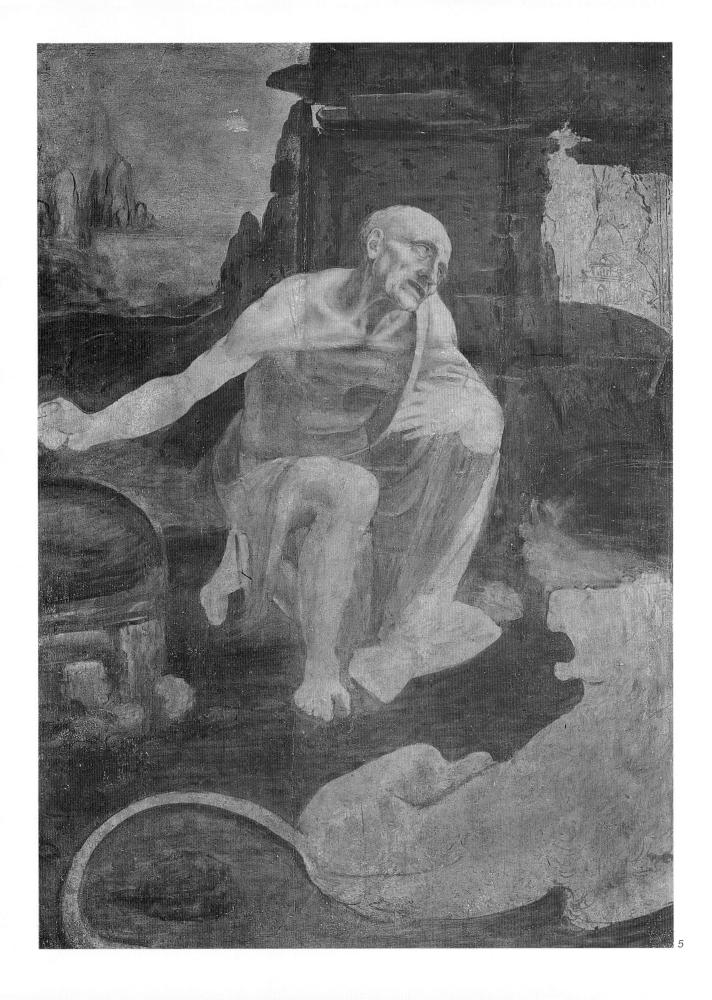

- 1. Study for a
 Madonna of the Cat
 (1478-1480),
 London,
 British Museum.
- 2. Study from life for a Madonna of the Cat (1480-1483), Florence, Uffizi Gallery, Gabinetto dei disegni e delle stampe.
- 3. Study for young woman with a child in her arms (1478-1480), London, British Museum.
- 4. Study for a cherub (c. 1480), Florence, Uffizi Gallery.
- 5. The Benois
 Madonna
 (1478 -1480),
 St. Petersburg,
 Hermitage.

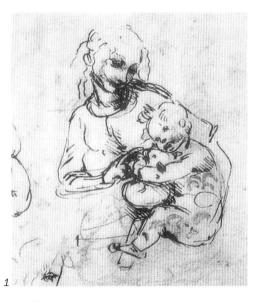

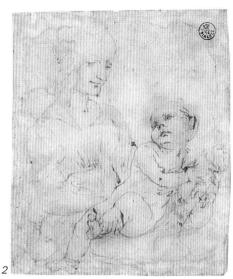

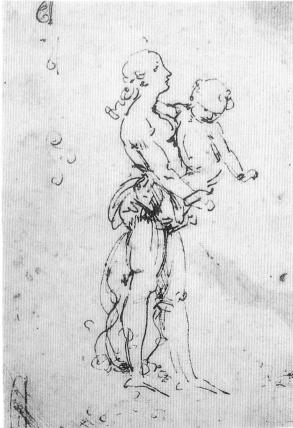

the representation of the human body, to other early works such as the *Benois Madonna* at the Hermitage in St. Petersburg and studies for the lost *Madonna of the Cat*.

FROM THE MAGNIFICENT TO IL MORO

Lorenzo the Magnificent had given Leonardo access to the sculpture garden of San Marco with its precious Medicean collection of antique statues - a collection of decisive importance for the new generations of Florentine artists including the already successful Leonardo and, a few years later, Michelangelo. The protection of Lorenzo the Magnificent was determinant for what was to be the great changing point in Leonardo's career: the move to Milan, another political and cultural capital of Italy at the time, in 1482. This is confirmed by the oldest source on Leonardo, the so-called Anonimo Gaddiano (writing in about 1540), utilised later by Vasari. From this source we learn that it was Lorenzo who sent Leonardo to Ludovico Sforza, known as Il Moro, as his emissary for art (a gesture obviously to be viewed within the broader context of political and diplomatic relations). «He was thirty years old when from the said magnificent Lorenzo he was sent to the Duke of Milan [...] to give him a lyre, which instrument he played to perfection». Leonardo presented himself to Ludovico il Moro with a letter in which he described his skills, including those as civil engineer and constructor of war machines. In the field of art he mentioned an ambitious project which he was never able to carry out: «constructing a bronze horse which will be to the immortal glory and eternal honour of the felicitous memory of your father [Francesco I] and of the illustrious House of Sforza».

In the Lombard capital the artist

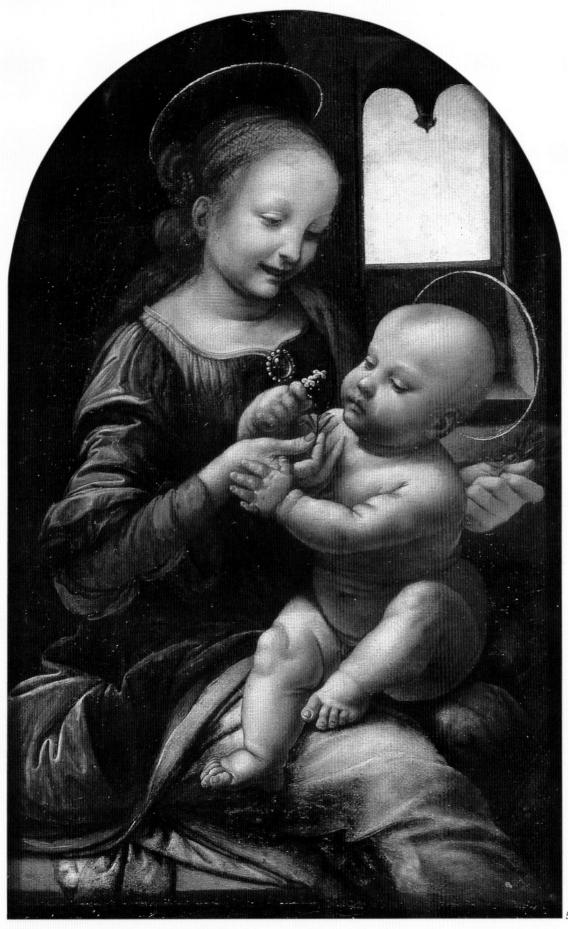

- 1. Study of animals, detail of St. George and the dragon (1507-1508), Windsor, Royal Library.
- 2. Caricature (c. 1507).
- 3. Study of rearing horse and horseman trampling on a fallen enemy (c. 1490), Windsor, Royal Library.
- Caricature study for head of a man with curly hair (c. 1515), Oxford, Christ Church College.
- 5. Painted decoration of the Sala delle Asse (c. 1498), Milan, Castello Sforzesco.

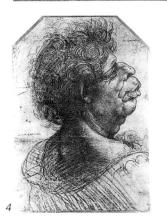

lived with the De Predis brothers, also painters, in the Porta Ticinese quarter. To the Milanese period belong the *Virgin of the Rocks* in the Louvre, for which there is a contract dated 1483, and the *Lady of the Ermine* now in Crakow, a portrait of Cecilia Gallerani, the mistress of Ludovico Sforza.

In Milan Leonardo continued his assiduous study of the human figure, under every aspect: anatomy, motion, expression (and thus physiognomy), in pictures ranging from portraits to caricature. His folios are crowded with profiles and grotesque figures, in an impetuous succession of types and characters – personages who throng the streets, squares, markets, churches and bordellos.

The years between 1495 and 1497 saw the birth of one of his most famous works, the Last Supper in the church of Santa Maria delle Grazie. While working on this fresco Leonardo received a commission to decorate a great hall on the ground floor of the tower on the north-eastern side of the Castello Sforzesco, the Sala delle Asse. This work seems inspired by the festivities held at Milan in 1494 for the wedding of Ludovico Sforza's niece, Bianca Maria, and the Emperor Maximilian. Leonardo had the idea of transforming the hall into an "outdoor" ambience, with a pergola of trees whose branches intertwine along the lines of the vaulted ceiling. The trees (perhaps the black mulberry of the Sforza emblems) are rooted in rocky soil, sectioned in depth as if to reveal the very foundations of the Castello Sforzesco.

The project took on a political meaning. The visual metaphor suggests how good government can be compared to the geometric precision and complexity of Nature's works. In the intricate system of intertwining branches and ropes can be seen, as in good govern-

- 1. Study of horses for the Battle of Anghiari, detail, Windsor, Royal Library (no. 12326r).
- 2. Map of Imola (1502), Windsor, Royal Library.
- 3. Preparatory drawing for the Battle of Anghiari, Venice, Gallerie dell'Accademia.
- 4. Aristotele
 da Sangallo (attr.),
 copy of
 Michelangelo's
 cartoon for the
 Battle of Cascina,
 Norfolk,
 Holkam Hall.
- 5. Anonymous, Doria Panel (1503-1504).

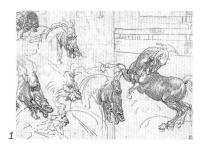

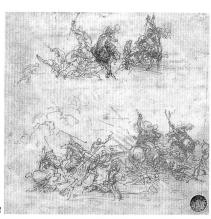

ment, the strength that radiates from a point located at the upper centre: the Sforza coat-of-arms. This was the last work accomplished by Leonardo in Milan. In 1499 the King of France Louis XII invaded the Duchy of Milan: «The Duke lost the state, his property and his freedom, and no work was finished for him», wrote Leonardo in 1500. As events precipitated the artist left Milan and returned to Florence after eighteen years of absence.

In the trip back to Florence, between late 1499 and early 1500, Leonardo stopped at Venice where he was consulted for works of military engineering on the eastern boundary of the Venetian Republic. The painter did not pass unobserved, and admiring comments acclaimed the charcoal portrait of Isabella d'Este drawn by him a little earlier in Mantua. Although it is not known whether he had other works of art with him, it is certain that he brought abundant manuscripts and drawings.

BACK IN FLORENCE

«The life of Leonardo is extremely varied and undetermined, so that it seems he lives only for the day», wrote Piero da Novellara to Isabella d'Este. On the date of April 3, 1501, Leonardo received Isabella's correspondent in Florence. In 1502 he was in Romagna as military architect in the service of Cesare Borgia. The next year he was back in Florence, where he was commissioned to decorate the new Great Council Hall constructed at the back of Palazzo Vecchio from 1495 to 1498. The subject chosen for the painting was a historical one, the battle of Anghiari. The enormous composition (three times bigger than the Last Supper) was to commemorate the victory of the Florentines over the Milaneses in 1440. A year later, the central part of the composition had already been

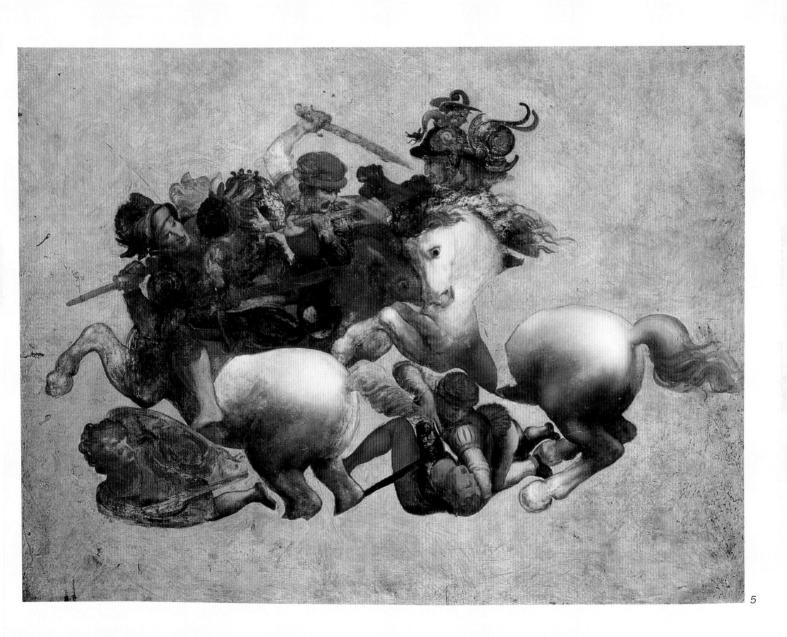

- 1. Hall of the Five Hundred, Florence, Palazzo Vecchio.
- 2. Drawing of
 Michelangelo's
 David
 (1504) detail,
 Windsor,
 Royal Library
 (no. 12591r).
- 3. Study of the course of the Arno (1503), Madrid Codex II (fo. 149r).
- 4. Study of proportions (c. 1490) and study of horsemen for the Battle of Anghiari (additions around 1503-1504), Venice, Gallerie dell'Accademia.

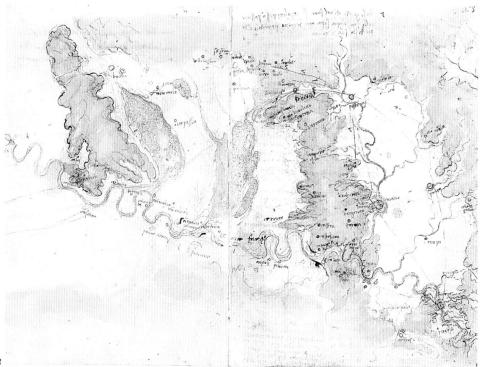

transferred to the wall. In the meantime Michelangelo, already renowned as the sculptor of the colossal David, had been commissioned to decorate the other side of the wall. This painting was to have a similar subject, the Battle of Cascina, but Michelangelo completed only the cartoon, returning to the Pope's service in 1506. Leonardo too abandoned the work in about 1506, when he departed for Milan at the request of the French governor Charles d'Amboise. And so they disappeared, the two works which for Cellini «while they existed were a school for the whole world». Michelangelo's cartoon was dismembered in 1512 upon the return of the Medici to Florence. Leonardo's painting disappeared in 1563 when the hall was restructured by Vasari. Only copies, prints and drawings remain.

THE SECOND STAY IN MILAN

During his second stay in Milan Leonardo worked mainly on architectural and river channelling projects. In particular, some sketches and notes for a palace and garden designed for D'Amboise near the church of San Babila are known. It was probably after 1508 that the Marshall of France Gian Giacomo Trivulzio requested him to design an equestrian monument to be erected in his funeral chapel built by Bramantino after 1512 in the Milanese church of San Nazaro. The second version of the Virgin of the Rocks, in which the figures are more sculptural and the setting more architectural, also belongs to Leonardo's second stay in Milan.

Then came the mythological subjects. *Leda*, symbol of the fecund forces of Nature, appeared already at the time of the studies for the *Battle of Anghiari*, in about 1504, as did another mythological theme, that of *Neptune with his seahorses*. Lastly, the

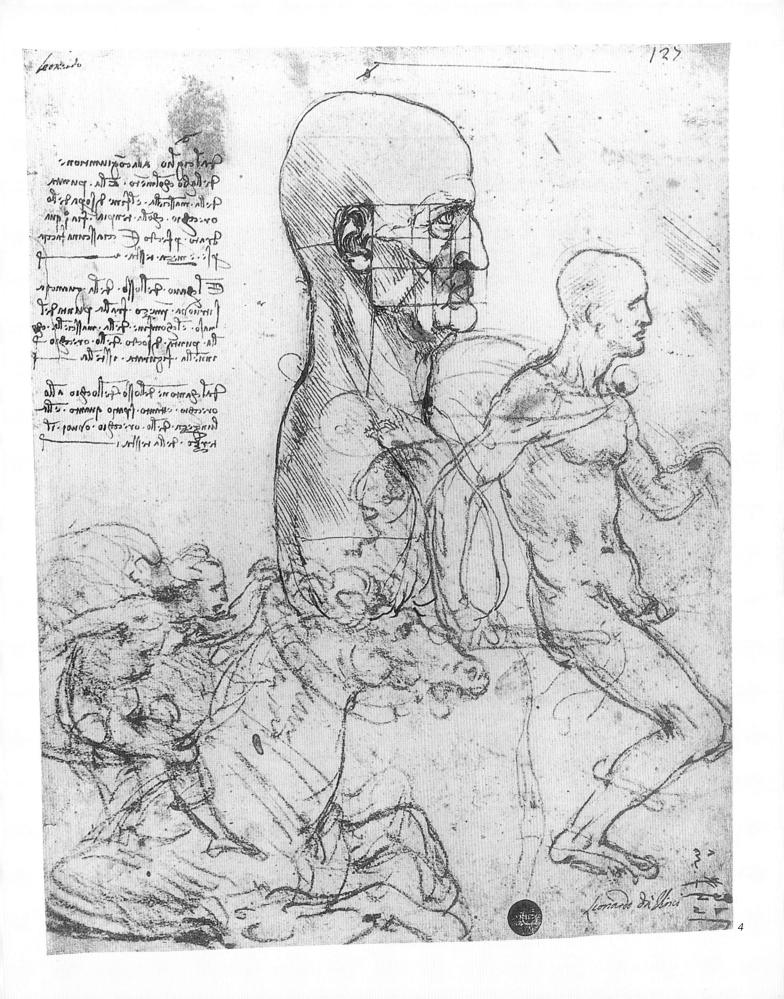

- 1. Raphael,
 Portrait of Leo X
 (1518),
 Florence,
 Uffizi Gallery.
- 2. Portrait of Lorenzo de' Medici (1483-1485), from the Codex Atlanticus (fo. 902 ii r), Windsor, Royal Library (12442r).
- 3. Anonymous
 Lombard painter
 (late 14th century),
 Sforzesca
 Altarpiece,
 detail with
 Ludovico il Moro,
 Milan,
 Brera.
- 4. Jean Clouet, François I (c. 1525), Paris, Louvre.
- 5. Neptune with his seahorses, Windsor, Royal Library.

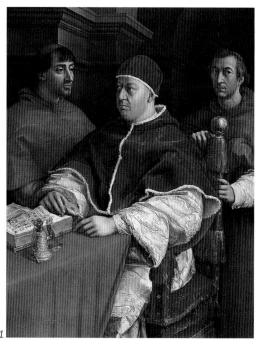

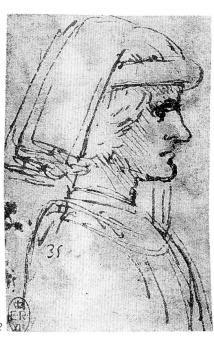

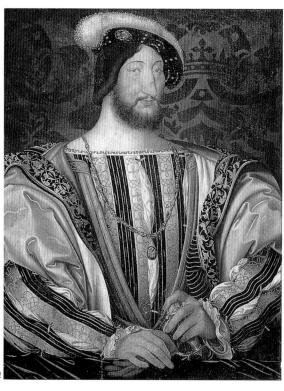

FROM ROME TO FRANCE

around 1509.

idea of an angel of the Annunciation,

known from a pupil's sketch corrected

by Leonardo on a folio from the same

period, also dates from the time of the

Battle of Anghiari. Its characteristic

features appear again in the St. John

the Baptist now in the Louvre, datable

In 1513, the year when Giovanni de' Medici became Pope under the name of Leo X, Leonardo moved from Milan to Rome, with good hopes of receiving commissions through his protector Cardinal Giuliano de' Medici, the Pope's brother. But in Rome Leonardo was to live a rather solitary life in the Belvedere, travelling occasionally to various places. Then in 1517 he accepted the invitation of the King of France who called him to Amboise, honouring him with the highest praise and appointing him «premier peintre, architecte et méchanicien du roi». In the castle of Cloux Leonardo was free to dedicate himself to his research, and here he accomplished the extraordinary drawings of the Deluge (now at Windsor). It is probable that his most famous work, the Mona Lisa, was also painted during his stay in France.

We know that in France Leonardo was still working on his Saint Anne. The studies for the unfinished part of the Virgin's drapery, that which would have revealed through the fabric the mechanics of the positioning of the legs, also date from this period, after 1517. No studies for the Mona Lisa exist, but the veils she is draped in show the same characteristics as the studies of drapery done in France for Saint Anne. They are veils that model, and thus enhance, the splendid forms they cover, as in the left arm, which can be clearly seen in a a good photograph, up to the elbow and above. Not one of the over forty known copies repro-

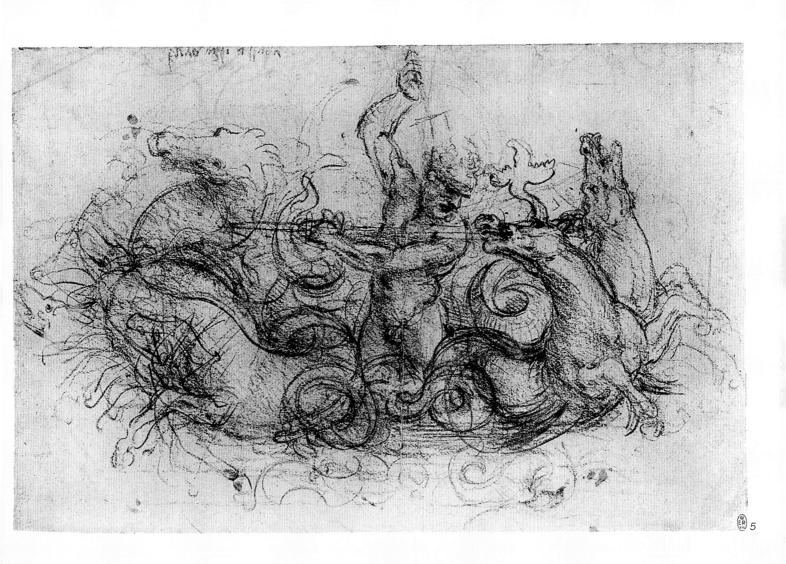

- 1. Woman standing near a stream (Pointing Lady) (c. 1518), Windsor, Royal Library.
- 2. Eye beside a cascade of wavy hair (1515-1516) detail, Codex Atlanticus (fo. 315r-a).
- 3. Telemaco Signorini, Church of San Fiorentino, Library of Castel Vitoni (c. 1885).
- 4. Photograph of the church of San Fiorentino.

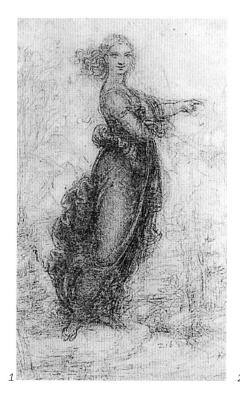

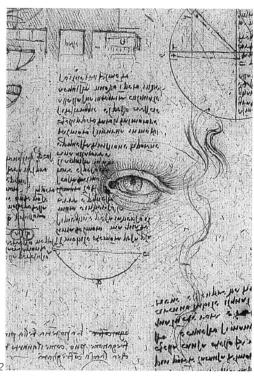

duces this detail. Although dressed, *Mona Lisa* is revealed in the fullness of her anatomical forms.

The same can be said of a charcoal drawing at Windsor from the artist's last years, representing a young woman standing against a landscape of rocks, water and vegetation. Her face, lit by an ineffable smile, is that of the Mona Lisa, her hair floats in the breeze, her light garments swirl about her like the clouds in the last drawings of the *Deluge*. One arm is lifted to her breast to grasp the edge of her gown, the other stretches out to indicate a distant point deep in space. If Walter Pater had known of this drawing when he wrote his famous description of the *Mona Lisa*, he would undoubtedly have recognised the same personage as that of the Louvre portrait, whom he had already seen in symbolic relationship with Leda, the mother of Helen of Troy, and Saint Anne, the mother of Mary, almost to suggest that in Leonardo's work – conceptually as well as stylistically – the *Leda* and the Saint Anne must necessarily have preceded the Mona Lisa. It seems instead that in about 1515 Leonardo was still working on the *Leda*, a small sketch of which appears on a folio of geometric studies from that time in the Codex Atlanticus (fo. 156 r-b).

And on a folio from the same series of geometrical studies, also in the Codex Atlanticus (fo. 315 r-a), datable with precision between 1515 and 1516, appears a pen-and-ink drawing of an eye beside a cascade of wavy hair, just as in the *Mona Lisa*. It is like a graphic reflection, half unconscious, of a hypnotic detail in the painting just completed.

Leonardo died at Amboise on May 2, 1519. His remains, buried in the church of San Fiorentino, were dispersed when his tomb was violated during the religious wars of the 16th century.

mong all of the films on Leonardo, *The Life of* Leonardo da Vinci (1971) by Renato Castellani is perhaps the one that achieves the best

compromise between entertainment and education.

The story opens with Leonardo dying in the arms of François I. Immediately afterward the narrator, a device employed by the director to provide historical/technical explanations without hindering the free flow of

LEONARDO ON FILM

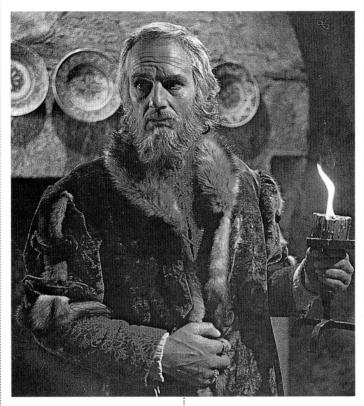

Upper left, The Hanged Man (Portrait of Bernardo di Bandino Baroncelli) (1479), Bayonne, Musée Bonnat. Above and below: frames taken from the television serial Leonardo

the story, interrupts the sequence to announce that this is the somewhat legendary verby Renato Castellani: Philippe Leroy in the part of Leonardo; Leonardo with Ludovico il Moro and Cecilia Gallerani; the friars of Santa Maria delle Grazie standing before the Last Supper.

sion taken from Vasari's *Lives*.

Starting from the very prologue, Castellani thus raises

the question of the mystery surrounding a figure overwhelmingly rich in many-sided aspects ("But of the life of such a well-known man what is really known in the end? Very little").

Crucial moments in Castellani's biographical film are the scene where Leonardo sketches a man hanged for the Pazzi conspiracy in 1478, shocking his friend Lorenzo di Credi, and the one where Leonardo, in the hospital of Santa Maria Nuova, dissects a cadaver to search for "the cause of such gentle dying" — both episodes are metaphors for the thirst for knowledge devoid of any moral scruples even in the face of death.

Leonardo's first years in Milan, marked by the projects for the Navigli and by increasingly fervent studies for the never-tobe-written treatise on anatomy. as well as by a few works of art including the magnificent Lady of the Ermine, are convincingly portrayed. In the Leonardo who organised the Paradiso pageant, in frivolous glorification of Ludovico il Moro. Renato Castellani seems to hint at the artist's destiny - yesterday as today - of being forced to produce "pot-boilers" or the works of a courtier to finance his own artistic research.

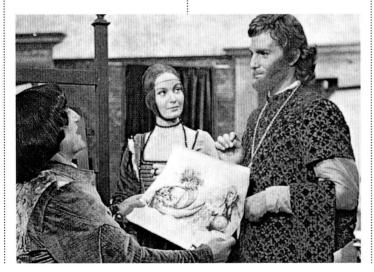

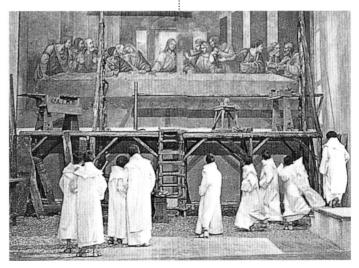

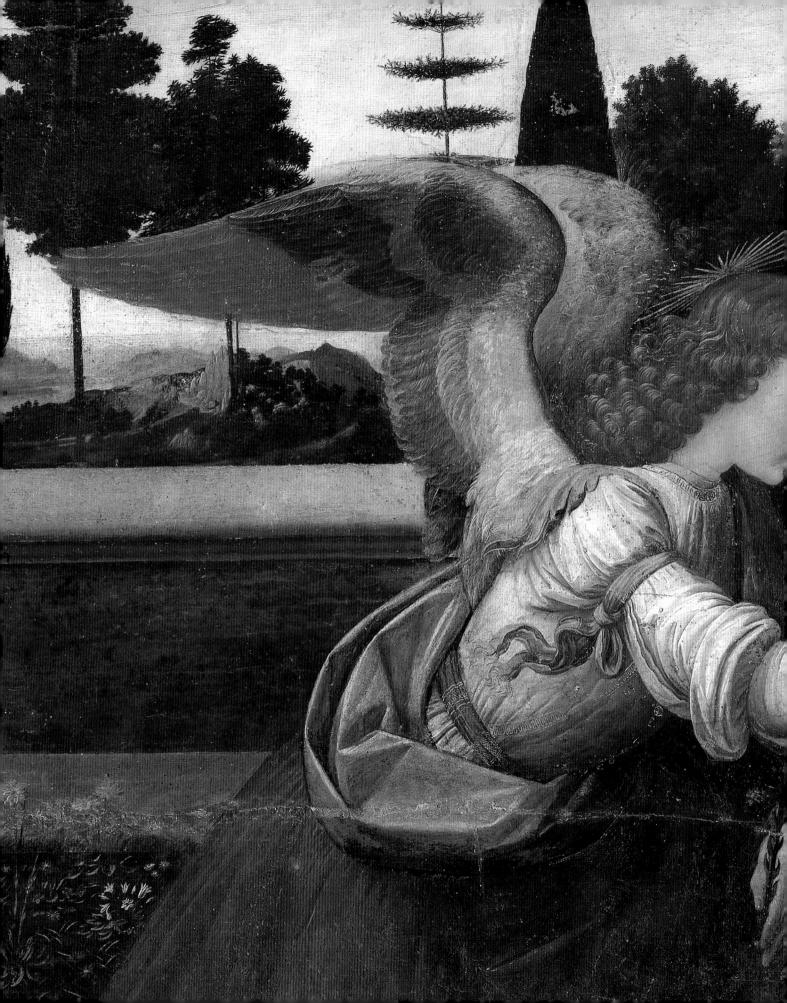

Even a quick glance at Leonardo's artistic production is sufficient to reveal the essence of his work, in the sense of a continuous recurrence to research and experimentation. For Leonardo painting was philosophy, that is, science: the most appropriate language through which to transmit knowledge of the perceivable world. For this reason he could state: «And in effect that which exists in the universe by essence, presence or imagination, the painter has it first in his mind, and then in his hands, and those are of such excellence, that at the same time they generate a proportioned harmony in a single glance, as things do». Art was thus for Leonardo a "second" creation. From his first steps in the Florentine workshop of Verrocchio, the artist matured his research in painting to rise to the supreme heights of the Last Supper and the Mona Lisa.

- Overleaf, on the two preceding pages: Annunciation (1475-1480) detail, Florence, Uffizi Gallery.
- Study from a male model for the head of the Virgin in the Uffizi Annunciation
- (c. 1475), New York, Pierpont Morgan Library.
- 2. Annunciation (1475-1480) detail, Florence, Uffizi Gallery.
- 3. Verrocchio, Madonna di Piazza (1478), Pistoia Cathedral.
- 4. Study of drapery (c. 1478), Paris, Louvre.
- 5. Annunciation (1478),
 Paris,
 Louvre.
- 6. Annunciation (1475-1480), Florence, Uffizi Gallery.

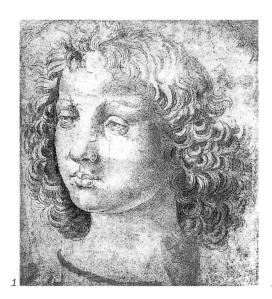

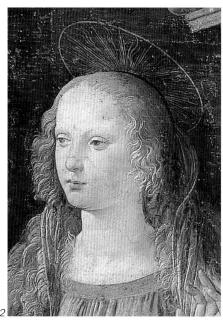

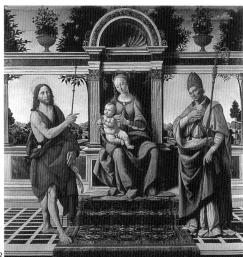

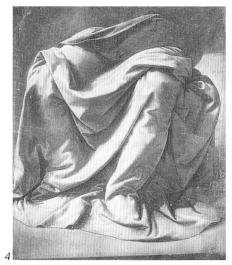

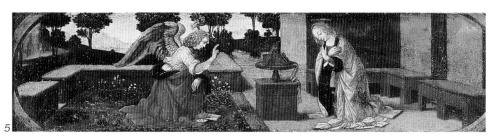

mong Leonardo's youthful masterpieces with religious subjects is the *Annunciation* in the Uffizi. This theme had illustrious precedents, from Simone Martini to Fra Angelico, to the contemporary Antonio Pollaiolo. But in his spatial arrangement Leonardo was still constrained by the scheme of the predella or the bass-relief. He was fascinated by perspective, but committed errors, as in the arm of the Virgin, which cannot reach the book placed on a lectern standing closer to the spectator than the Virgin herself: an error that the splendour of the forms and colours does much to conceal. On the basis of this mistake it has been thought that the painting is a very early one, even from the beginning of the 1470s, but it may be that Leonardo worked on it for years, as if to form a compendium of all of the lessons he had learned. Stylistic similarities between this work and the Annunciation in the Louvre, painted by Leonardo for the predella of Verrocchio's Madonna di Piazza in Pistoia Cathedral, seem to date it instead after 1478.

Also in the Uffizi is the Adoration of the Magi, begun by Leonardo in 1481 and left unfinished when he moved to Milan in 1482. In this case too, the theme is a traditional one. Here Leonardo's spatial arrangement echoes the format of the Ghiberti plaques for the Porta del Paradiso of the Florentine Baptistery, while turning toward the characterisation and animation of the figures in Donatello's bass-reliefs. The painting is little more than a sketch, revealing a creative process emerging as conclusion to lengthy preparatory studies, some of them developed from those for a Nativity on which Leonardo was working in 1478, of which nothing more is known. And it is expressly

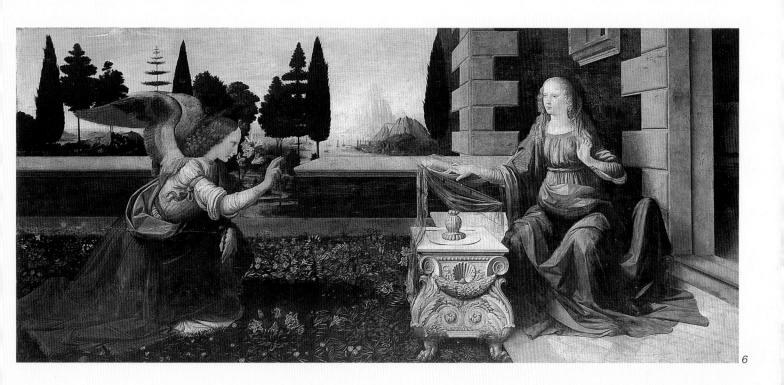

- 1. Raphael (attr.), copy of detail on the left in Leonardo's Adoration of the Magi, Paris, Louvre.
- 2. Study of horses and horsemen for the Adoration of the Magi (c. 1480), Cambridge, Fitzwilliam Museum.
- 3. Filippo Lippi, Adoration of the Magi (1496), Florence, Uffizi Gallery.
- 4. Perspective study for the Adoration of the Magi
- (c. 1481), Florence, Uffizi Gallery, Gabinetto dei disegni e delle stampe.
- 5. Adoration of the Magi (1481), Florence, Uffizi Gallery.

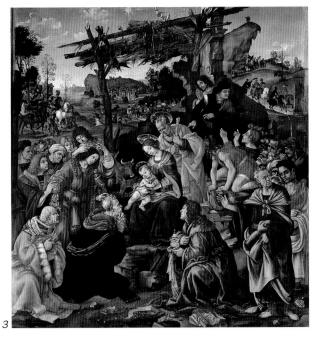

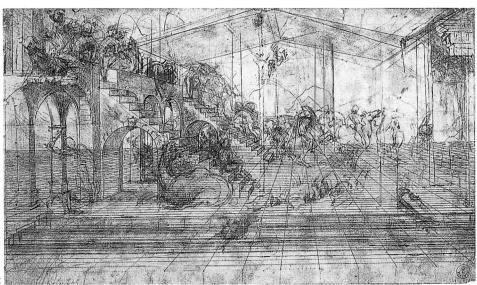

the event of the Nativity to be incorporated in the Adoration of the Magi in a solution that is highly cinematic. Leonardo employs perspective, which is his movie camera. The composition is centred according to a system of diagonal lines crossing over the Virgin's head. But the perspective of the scene has its vanishing point shifted to the right, between two trees. This means that everything to the right is being left out of the running shot: the hut of the Nativity, where only the ox and the ass remain, partially visible. And this is a way of alluding, with the Adoration of the Magi, to the event that had taken place two weeks before, the Nativity. Introducing the narration and commenting on it is the young man standing in the right foreground, gazing out of the picture. Even without this proof, he must inevitably be recognised as a self-portrait of the "director", the young Leonardo.

THE SACRED AND THE CORPOREAL

In the figures of the *Adoration of the Magi*, the need for a thorough knowledge of the mechanics of the human body can already be felt. The *St. Jerome* in the Pinacoteca Vaticana, painted in those same years, seems almost an anatomical model, similar to those that Leonardo was to adopt almost thirty years later, in about 1510. But with *St. Jerome* the anatomical model is alive, the form is human, possessing compactness and sculptural shape. It is like a clay model on a circular rotating platform.

Leonardo's first painting in Milan was the *Virgin of the Rocks*, commissioned of him on April 25, 1483 by the Brotherhood of the Immaculate Conception. It seems that the De Predis brothers and some of Leonardo's pupils collaborated on this work.

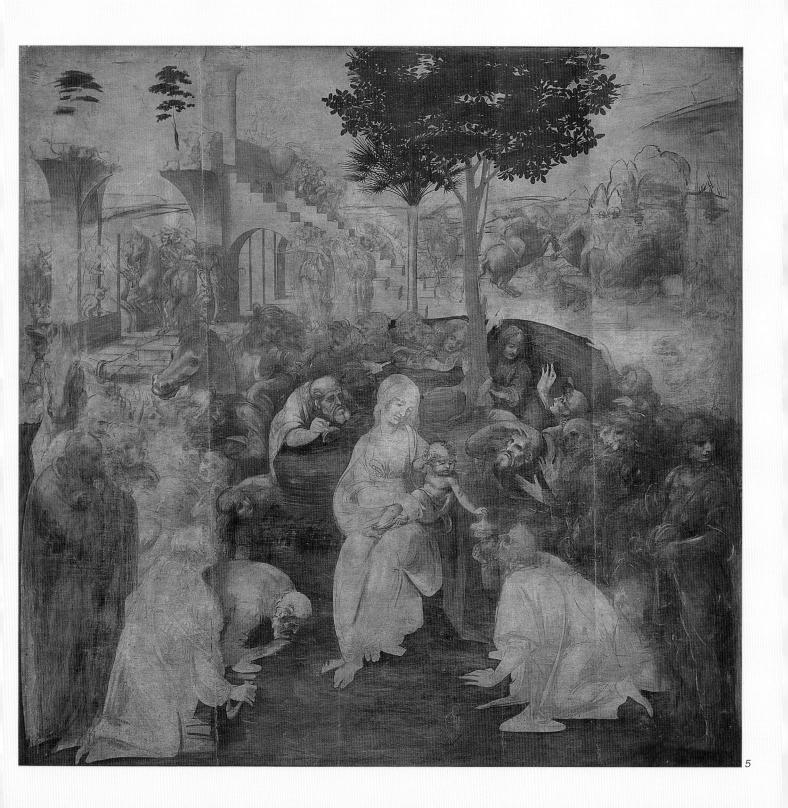

- 1. Virgin of the Rocks (1508), London, National Gallery.
- 2. Marco d'Oggiono or Giovan Antonio Boltraffio, Portrait of a woman (c. 1490), Milan, Biblioteca Ambrosiana.
- 3. Study for the
 Virgin of the Rocks,
 Turin,
 Biblioteca Reale.
- 4. Virgin of the Rocks (c. 1483) detail, Paris, Louvre.
- 5. Virgin of the Rocks (1483-1486), Paris, Louvre.

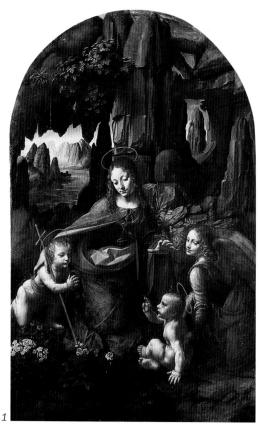

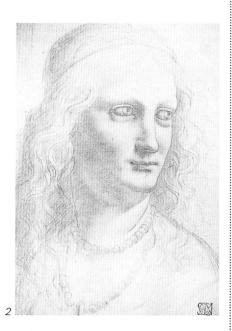

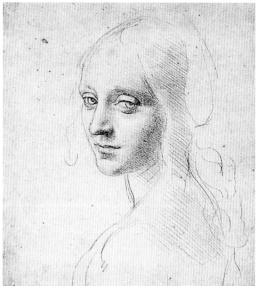

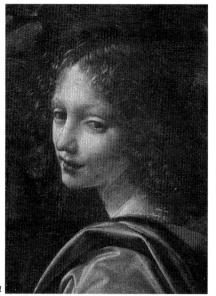

The very iconography of the group is enigmatic, with the Virgin and Child, the infant St. John and the angel appearing within the enchanted half-light of an incomparable scenario of rocks, water and vegetation. We know only that the theme is the one, hotly debated at the time, of the Immaculate Conception. The angel kneeling to the right, gazing out of the painting, has a function similar to that of the youth standing on the far right in the Adoration of the Magi, although it is certainly not a selfportrait of Leonardo, as shown by the study for this figure, now in Turin, portraying a young woman.

On returning to Florence from Milan in late 1499 or early 1500, Leonardo showed a total rejection of painting («He devotes himself to geometry, most impatient with his brush» wrote Pietro da Novellara to Isabella d'Este in 1501). And yet, just at this time, he was creating two works of art weighted with significance for his future development: the first cartoon of Saint Anne, lost, and the Madonna of the Yarn Winders, known from two versions painted by pupils with the aid of the master. Novellara's letter reports an explanation of the religious symbolism furnished by Leonardo himself. The cartoon of Saint Anne is small, but the figures are full size, portrayed seated or leaning. The Virgin in her mother's lap leans toward her son with maternal solicitude, attempting to draw him away from the lamb (symbol of the Passion) which he is joyfully embracing. But Saint Anne tries to dissuade her, and «perhaps indicates the Church which does not wish Christ's passion to be prevented». Preparatory drawings show us how Leonardo proceeded toward the focal point of the iconography, employing effects of scanning and

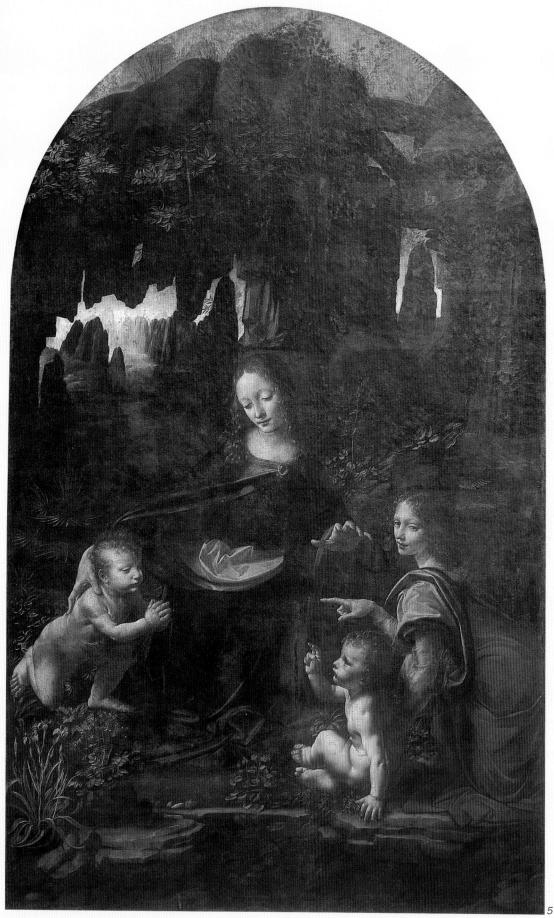

- 1. Madonna of the Yarn Winders (1501).
- 2. Copy from
 Leonardo,
 The Virgin,
 Saint Anne and the
 Infant St. John.
- 3. Study of woman's bust for the Madonna of the Yarn Winders (c. 1501), Windsor, Royal Library.
- 4. The Virgin,
 Saint Anne,
 the Child and
 the Infant St. John,
 Burlington House
 cartoon
 (c. 1497),
 London,
 National Gallery.
- 5. The Virgin, Saint Anne and the Child with a Lamb (1510), Paris, Louvre.

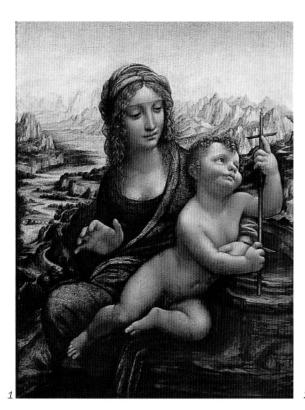

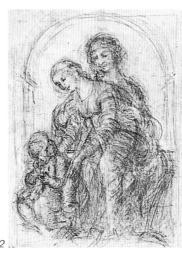

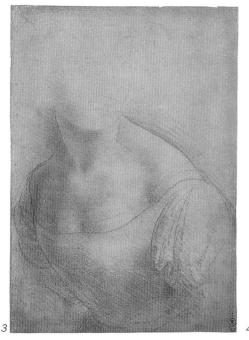

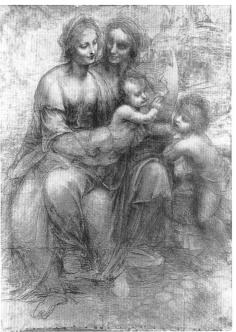

balancing of the forms in relation to the landscape and the architecture. The narration is clear and open; perhaps too open for an iconography which cannot legitimately be presented on a human, almost domestic level. With a sense of classical idealisation of form which is found again in a late cartoon, the one in London, dating from 1508 (as has recently been demonstrated), the iconography is transposed from statement to allusion. It is true that the Virgin is seated in her mother's lap without any apparent tension. But the position of the legs in relation to the twisting of the torso shows that the Virgin could rise effortlessly to her feet and depart, removing her Son from a less obvious symbol of the Passion, his playmate the Infant St. John. But this she does not do. Her mother convinces her by her expression and by the gesture of her hand raised heavenward.

Then came the painting. It is the one begun in about 1510 and now in the Louvre. Leonardo returns to the motif of the lamb, but avoids brusque movements and emphatic gestures. The head of Saint Anne now rises above the group. The Virgin leans forward to support her Son, who has embraced the lamb and turns to gaze at her with an air of glorious triumph. His mother, with her gently melancholy smile, knows that she could take him away merely by raising her head. It is her head, in fact, which keeps her body in equilibrium. The foot of the bent leg, which is not visible, presses against the same rock on which Saint Anne is seated. It is thus the fulcrum of a human balance; but a balance that Saint Anne can control with her concealed hand. The painter has put his science at the service of religious symbolism. At first glance the picture reveals no more than a

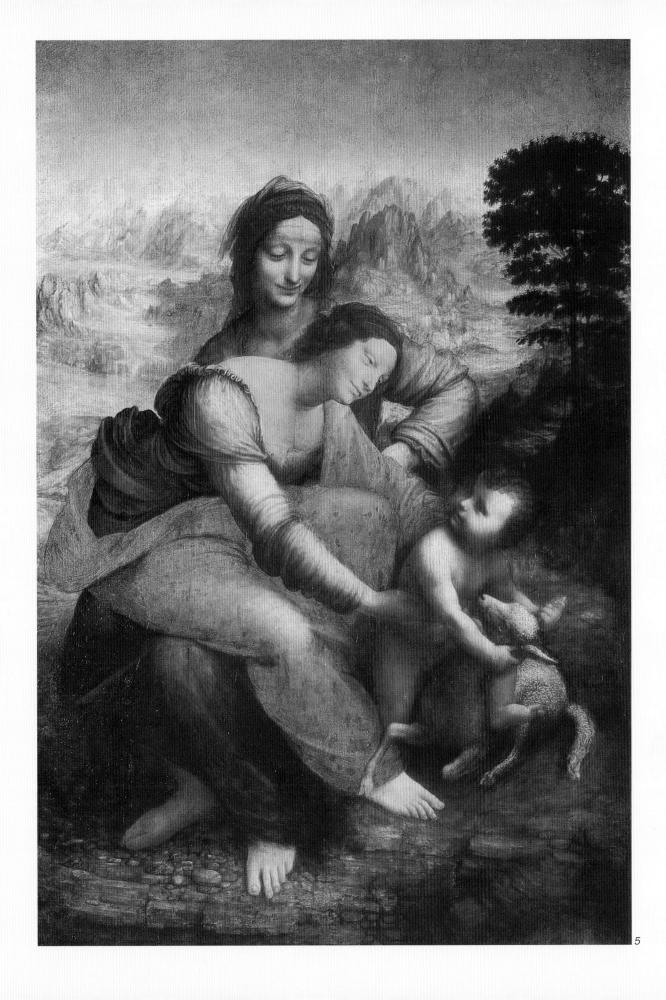

- 1. Study for a Bacchus.
- 2. Caravaggio, Bacchus (c. 1596-1600), Florence, Uffizi Gallery.
- 3. Drawing by a pupil with the angel of the Annunciation on a folio of studies by Leonardo for the Battle of Anghiari (1503-1505), Windsor, Royal Library.
- 4. St. John the Baptist (1513-1516), Paris, Louvre.

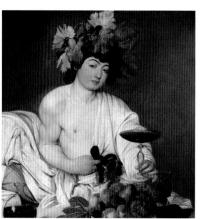

complex, harmonious flow of forms placed before a majestic scenario of mountain chains, an even too obvious allegory of the passage of time.

Painted one year earlier is the St. John the Baptist now in the Louvre, datable around 1509. Leonardo's figure, no longer the emaciated one of Tuscan tradition, is florid like a Bacchus, although not openly equivocal as in Caravaggio, of palpitating corporeality, dazzling and at the same time repugnant, his face lit up by a smile that extends to involve the hypnotic fixity of the large eyes encircled in shadow. Already with the Angel of the Annunciation, known from a pupil's sketch retouched by Leonardo on a folio from about 1504, Leonardo had arrived at representing the fusion of the sexes: the ambiguity, not merely physical but also mental, of the hermaphrodite. Some school versions exist, the best of which, now in Basil, is attributed to Leonardo.

THE LAST SUPPER

Among the paintings of religious subject the *Last Supper* in the refectory of the monastery of Santa Maria delle Grazie in Milan, Leonardo's most famous painting along the *Mona* Lisa, merits a separate discussion. This fresco was probably painted between 1495 and 1497 - certainly by 1498 as can be assumed from Luca Pacioli's dedicatory letter to Ludovico il Moro, in his De divina proportione. For the Last Supper the documents of the commission are missing, and thus any indication of planning in relation to the setting and the historical moment. Accordingly, any hypothesis on the creative process can be formulated only on the basis of the hints given by Leonardo himself in his manuscripts and drawings. Very little has remained of the preparatory studies for this monumental work. In

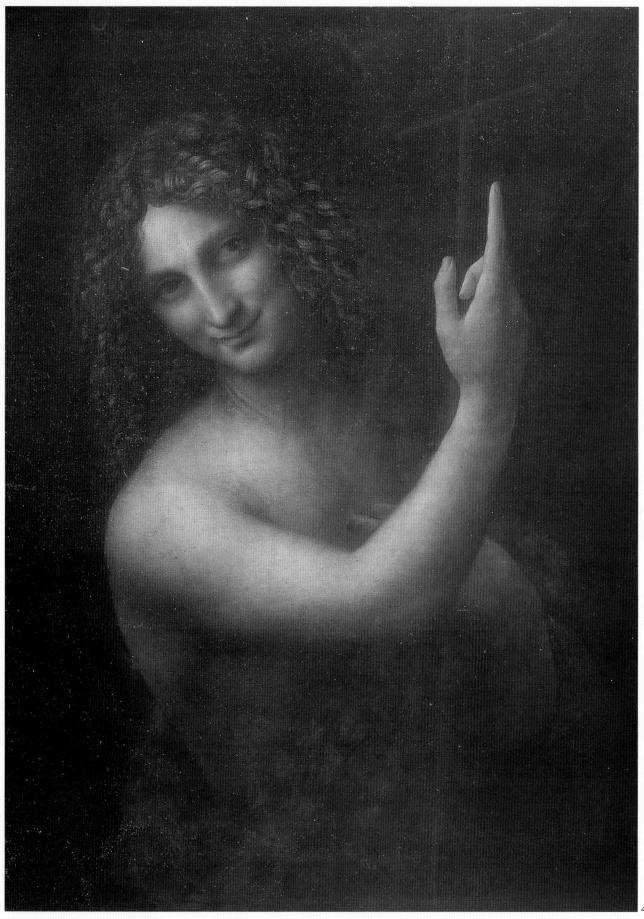

- 1. Pages from Codex Forster II (ff. 62v and 63r).
- 2. Floor plan of the Santa Maria delle Grazie Church.
- 3. First proposal for interpretation of the architecture in the Last Supper as theatrical stage setting (Pedretti, 1973).
- 4. The Last Supper (1495-1498), Milan, Santa Maria delle Grazie.

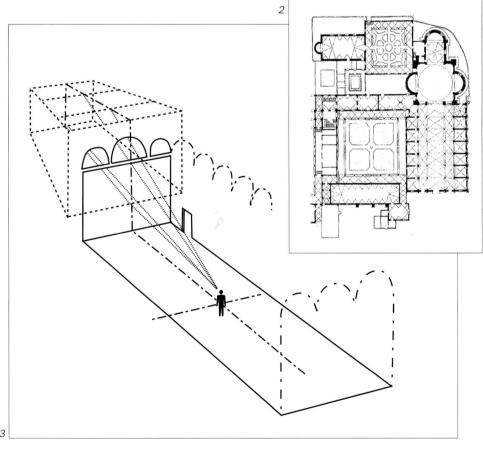

one of his pocket-size notebooks Leonardo described the gestures of the apostles, but was still far from any final co-ordination of their actions.

This description/written plan (unique in Leonardo's production) seems almost a kind of screenplay, an action to be used by Leonardo as "painter-director".

It is the proof of a Last Supper conceived as a theatrical performance, where the temporal component implied in the gestures of the personages is expressed through spatial arrangement controlled by sources of light - frontal, lateral and background - fusing together in the dynamics of the narration. From this derives the rhythmic scanning of groups of three apostles at the sides of the central figure, isolated, of Christ. If the tracking shot shows how the scene is broken down into episodic sequences, from centre to periphery and vice versa, the close-up is striking for its characterisation removed from context and thus endowed with universal values to clearly reveal the temperament of the personage represented. As for the execution of the work, in this case too Leonardo could have played the role of "director" in the sense that painters from the Milanese academy he founded, such as Marco da Oggiono and Boltraffio, probably collaborated on it.

An indirect confirmation of this is furnished by Giovan Paolo Lomazzo (1538-1600) who mentioned the *Last Supper* in one of his works that remained unpublished up to our own day, the *Libro de' sogni* now in the British Library at London. In an imaginary conversation between the Greek sculptor Phydias and Leonardo, the latter states: «Thus I may hope to say that in drawing and motion I was so perfect in regard to religious matters

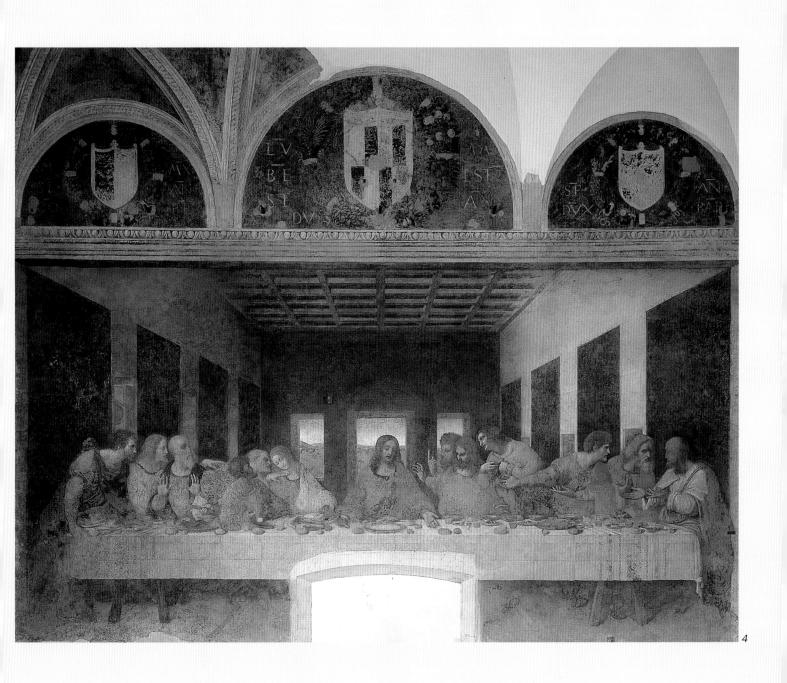

- 1. Andy Warhol, The Last Supper (1986).
- 2. Giacomo Raffaelli, The Last Supper (c. 1806-1814) mosaic, Vienna, Church of the Italians.
- 3. Romeno Gazzera, The Passion Flower (1930).
- 4. Study of composition for the Last Supper (1493-1494), Venice, Gallerie dell'Accademia.

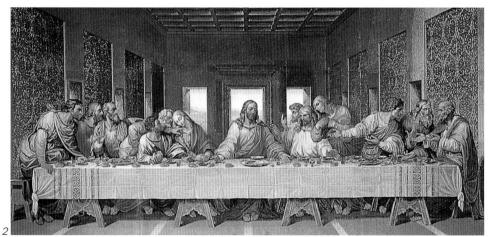

that many people were inspired by the figures that I had drawn, even before they had been painted by my pupils. Among these figures were those of that Supper in the refectory of the monks of Santa Maria delle Grazie in Milan». It is true that on the scaffolding erected for the *Last Supper*, according to an eye-witness such as Matteo Bandello – we are in 1497 –, Leonardo always appeared alone, but a writer may ignore the presence of assistants in order to heighten the dramatic intensity of his personage.

Leonardo's reconstruction of the episode related in the Gospels is precisely based on the Scriptures. The perspective of the Last Supper has in fact a point of view located at a height of six meters – today no longer perceivable, since the flooring has been raised by over a meter - corresponding to the gaze of a man standing on the second floor of a building. Now according to the Gospel writers (Mark, XIV, 15; Luke, XXII, 12), the Last Supper took place in a "coenaculum stratum" (in Greek "anagaion"), that is, a room which in the Mediterranean architecture of the 1st century was located on the second floor of a building.

In representing this scene Leonardo shows that he takes due account of preceding pictorial tradition, while interpreting it freely. In the customary decoration of refectories the Last Supper was almost always part of a broader program that included the other episodes of the Passion. For example, Andrea del Castagno in the refectory of Sant'Apollonia in Florence represented the Supper in a building open like a stage, inserted in a birds-eye view of a landscape where the Crucifixion, the Deposition and the Resurrection are taking place.

Now the Milan Last Supper has a

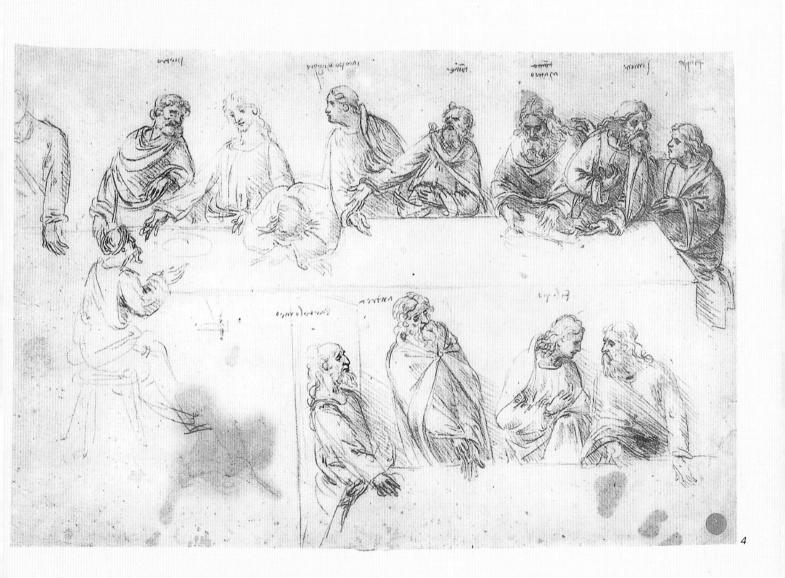

- 1. André Dutertre, The Last Supper (1789-1794), Oxford, The Visitors of the Ashmolean Museum.
- 2. Giovanni Donato da Montorfano, Crucifixion (1495), Milan, Santa Maria delle Grazie.
- 3. The Last Supper (1495-1498) detail of Christ, Milan, Santa Maria delle Grazie.

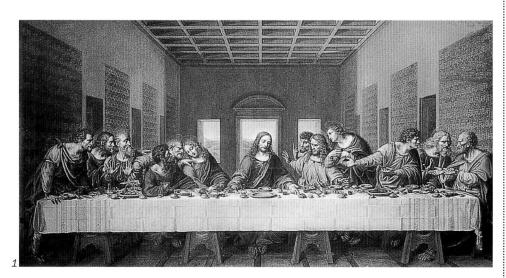

clear iconographic relationship with the *Crucifixion* painted in 1495 by Giovanni Donato da Montorfano on the opposite wall of the refectory.

It even seems that Leonardo had taken account of the other fresco in the gesture he gave Christ: one hand raised heavenward in the direction of the crucified good thief, the other pointing downward toward the cross of the unrepentant thief.

But there is even more. Before describing the extraordinary animation of the apostles, Luca Pacioli, in 1498, refers to the figure of Christ as «simulacrum of the ardent desire for our salvation». This is a hint at the temporal sequence with which Leonardo was to replace the traditional repertoire of the episodes of the Passion. He incorporates by allusion the theme of the institution of the Eucharist, which in the Gospel of Luke is preceded expressly by the announcement of the sacrifice and is followed by the words that provoke physical and emotional distress among the apostles: «The hand of he who will betray me is here with me on the table». It is no longer important to isolate Judas as had been customary in other representations of this scene. Now he is an actor among the other actors, portrayed with the intense gesture of one who draws back in guilt.

The decision not to isolate the figure of the betrayer may have been influenced by the fact that Santa Maria delle Grazie was a Dominican monastery, and the monks had undoubtedly been consulted as to the iconography of the work. Comparison with other paintings of the Last Supper, in fact, immediately reveals the Dominican nature of Leonardo's biblical exegesis. The Last Supper on the Silverware Cupboard painted by Fra Angelico for another Dominican

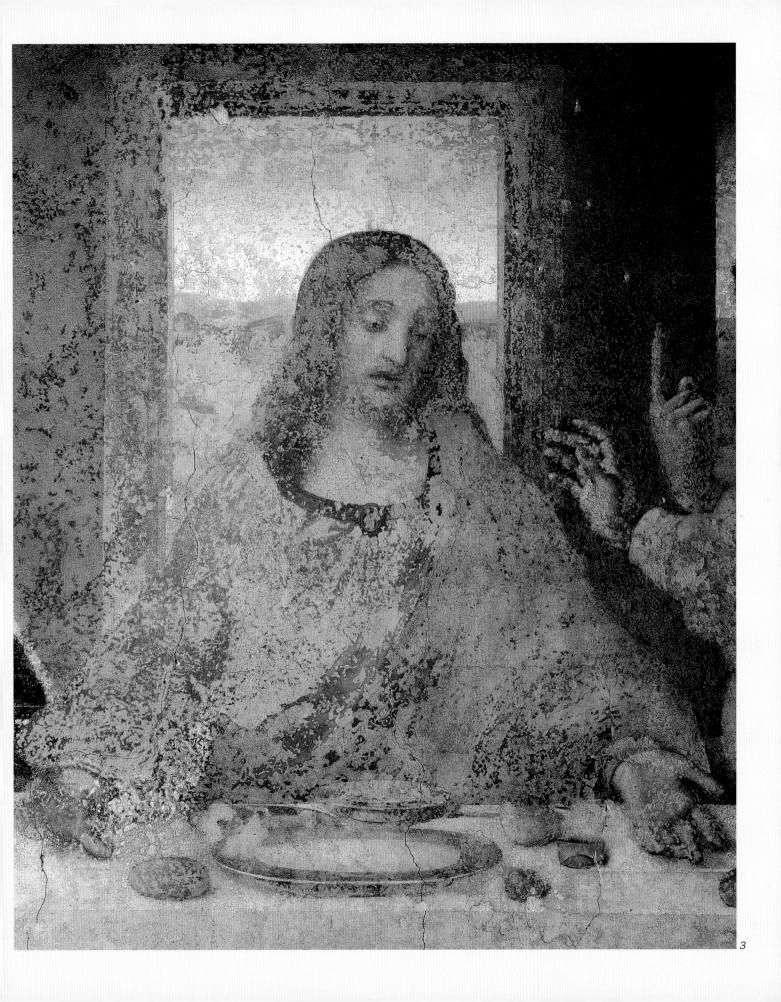

- 1-2. Taddeo Gaddi, Last Supper (1350) whole and detail of Judas, Florence, Santa Croce Basilica.
- 3-4. Domenico
 Ghirlandaio,
 Last Supper
 (1480)
 whole and detail
 of Judas,
 Florence,
 former Monastery
 of Ognissanti.
- 5. Andrea del Castagno, Last Supper (1450), Florence, Refectory of Sant'Apollonia.
- 6. The Last Supper (1495-1498) detail of Judas, Peter and John (in the middle), Milan, Santa Maria delle Grazie.

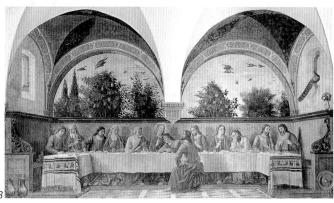

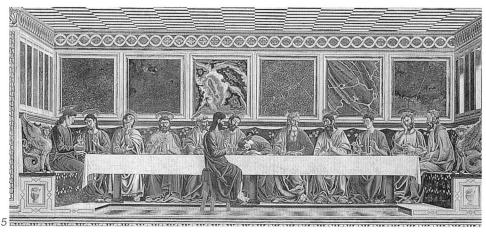

monastery, that of San Marco in Florence, has in common with Leonardo's the theological context within which the figure of Judas is interpreted, represented as participating in the Paschal banquet in the same way as the other apostles, he too wearing a halo and recognizable only by the gesture of dipping his bread, as narrated by Mark (XIV, 20).

Conversely, in the Last Suppers painted by Taddeo Gaddi (1350, Florence, Santa Croce), Andrea del Castagno (1450, Florence, Santa Apollonia) and Domenico Ghirlandaio (1480, Florence, Ognissanti), Judas is placed on the opposite side of the table from the other apostles, already isolated and condemned, portrayed as the only one without a halo and with the bag of thirty pieces of silver.

Now a cardinal point in Dominican preaching was the question of free will. In Leonardo's Last Supper Judas is shown with the bag of coins, an attribute which distinguishes him, but not isolated nor marked by the absence of a halo, since none of the other apostles have one either. On the contrary John, Jesus' favourite apostle, is placed almost at the same point as Judas. Leonardo depicts Judas as a man torn by indecision, according to the Thomist teaching of the voluntary nature of sin. Judas is condemned for having voluntarily betrayed and above all for having voluntarily despaired in God's pardon.

Accordingly, emphasis is placed on the theme of man's freedom, implicitly replying to the many paintings where, isolated on the other side of the table set for the Easter banquet, could seem the helpless victim of a condemnation "ab aeterno".

As previously mentioned, in the *Last Supper* the apostles are placed in groups of three, six to the right and six to the left of Jesus. In a highly

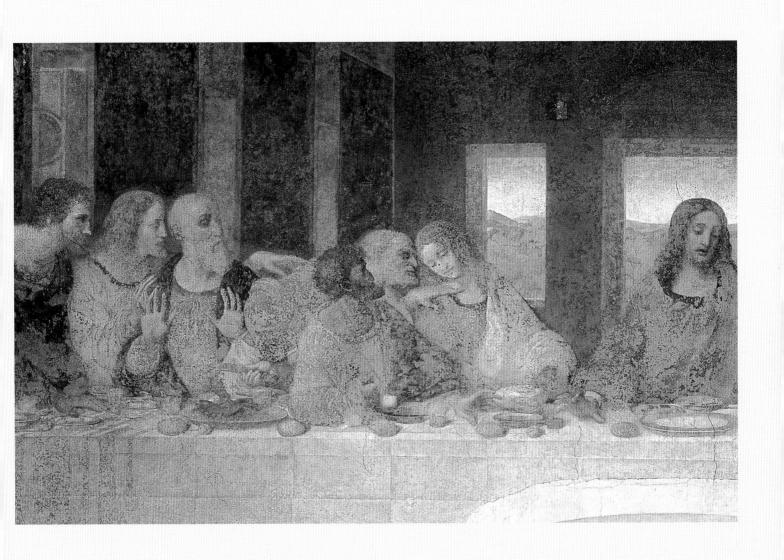

- 1. Study for the head of Bartholomew for the Last Supper (c. 1495), Windsor, Royal Library.
- 2. Study for an apostle (c. 1495), Windsor, Royal Library.
- 3. Study for the head of Judas for the Last Supper (c. 1495), Windsor, Royal Library.
- 4. Study for the heads of Judas and St. Peter for the Last Supper (c. 1495), Milan, Biblioteca Ambrosiana.
- 5. The Last Supper (1495-1498) detail with Thomas, James the Elder and Philip, Milan, Santa Maria delle Grazie.

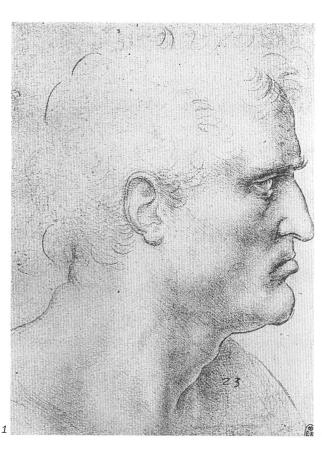

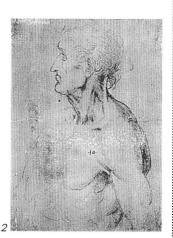

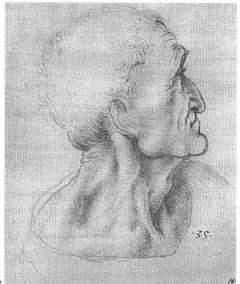

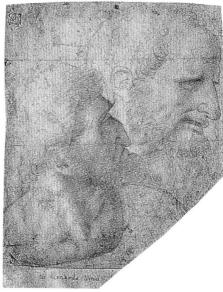

dynamic scene each apostle is represented in his own individual nature, surprised in an attitude that characterises him psychologically in the role he plays in the sacred performance, as related in the Gospels. Examination of the components involved in the iconography of the personages is sufficient alone to reveal the enormous work and complex elaboration faced by Leonardo in creating the Last Supper. At least three components form the basis for Leonardo's iconography: tradition, verisimilitude, and the most original aspect, research in anatomy and physiognomy.

As regards the first component, the essential source for the iconography of these personages is primarily the hagiographic tradition, from the Gospels to a work such as the Vita de' santi by the Camaldolensian Niccolò Malermi, published in the vulgar tongue in 1472. In the second place Leonardo undoubtedly drew inspiration from persons encountered in the streets and in places such as markets, ghettos and synagogues, frequented by Semitic types. There exist notes by Leonardo himself, schematic reminders that reveal his sources, as when he notes: «Christ. Giovan Conte, the man of Cardinal del Mortaro», or «Alessandro Carissimi da Parma, for Christ's hand». And still further: «Giovannina, fantastic face, lives at Santa Caterina, at the hospital». This is in a notebook datable just from the time of the preparatory studies for the Last Supper, around 1493-1494. But an even more determinant contemporary testimonial exists, that of Antonio De Beatis who visited the Last Supper in 1517, after having met Leonardo at Amboise. It may even be that what he states in his Diario was confirmed by Leonardo himself: «The personages in the painting are the natural portraits of several persons in

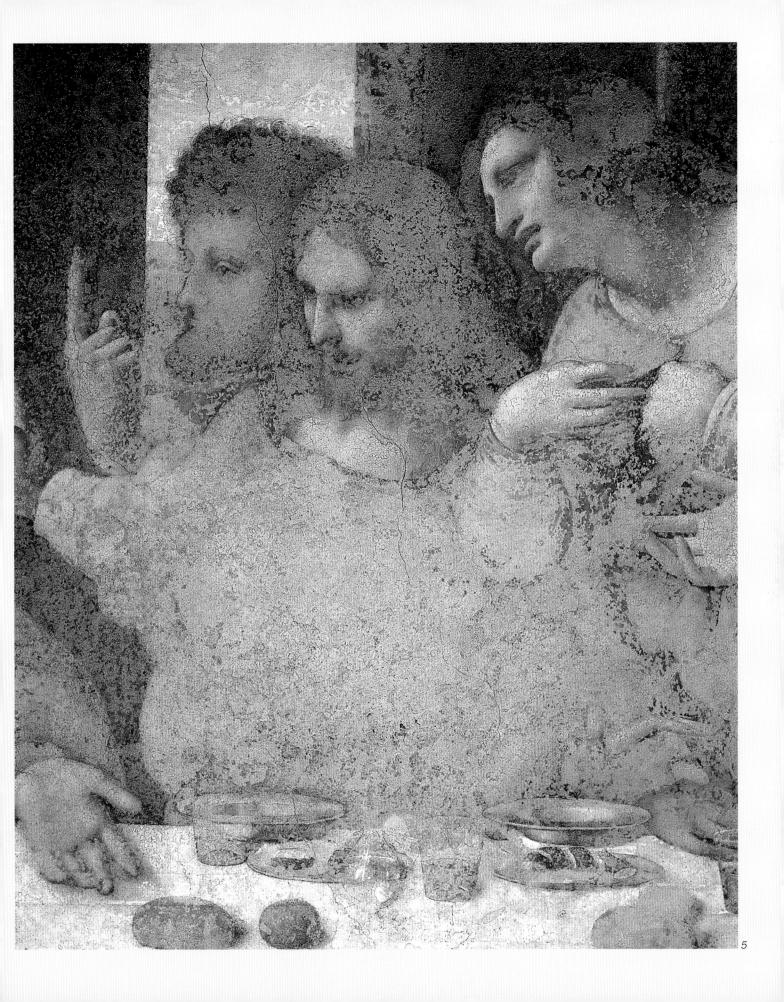

- 1. The shadow of Leonardo projected on the floor (1492) detail, Manuscript A (fo. 1r).
- 2. Scheme of interpretation for the manuscript (Pedretti).
- 3. Andrea del Verrocchio and Leonardo, Bust of Christ (c. 1475).
- Study for the Apostle Philip, Windsor, Royal Library.
- 5. The Last Supper (1495-1498) detail with Philip, Milan, Santa Maria delle Grazie.

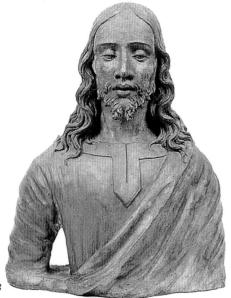

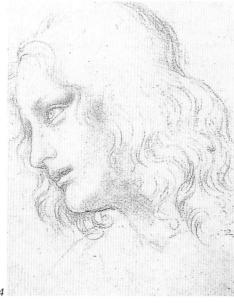

the Court and of Milanese of that time of the same rank», that is, that the figures appearing in the *Last Supper* are portraits of members of the Sforza court. This testimony should not be disregarded, considering also that the figures, of more than life-size, seem drawn from projected shadows, a procedure well known to Leonardo according to Sabba da Castiglione, who in his *Ricordi*, published only in 1546, wrote that Leonardo was reputed to be the «first inventor of the large figures taken from the shadows of lanterns».

As for the third component, Leonardo fused the hagiographic tradition and the search for verisimilitude with his studies of anatomy and physiognomy

Pliny in his *Naturalis Historia* describes the artist Aristides in these terms: «Aristides was the first among all painters to paint the soul, both the sentiments, which the Greeks call "ethos", and the emotional turmoil». The distinction is clear. It is one thing to represent the permanent character of an individual (which may tend more toward anger or toward timidity, and so on), and it is another to portray the fleeting emotion felt on occasion. Even before Pliny, Aristotle in his *Poetics* referred to the former as "ethos" (permanent characteristic), to the latter as "pathos" (temporary emotion). This distinction is a fundamental key to understanding Leonardo's Last Supper, in which he has depicted the instantaneous emotional reaction ("pathos") of the apostles to Christ's announcement that a traitor is among them.

The momentary passion in question is basically the same, a mixture of astonishment, incredulity and fear, but the way in which it is expressed varies from one apostle to another, according to the character ("ethos")

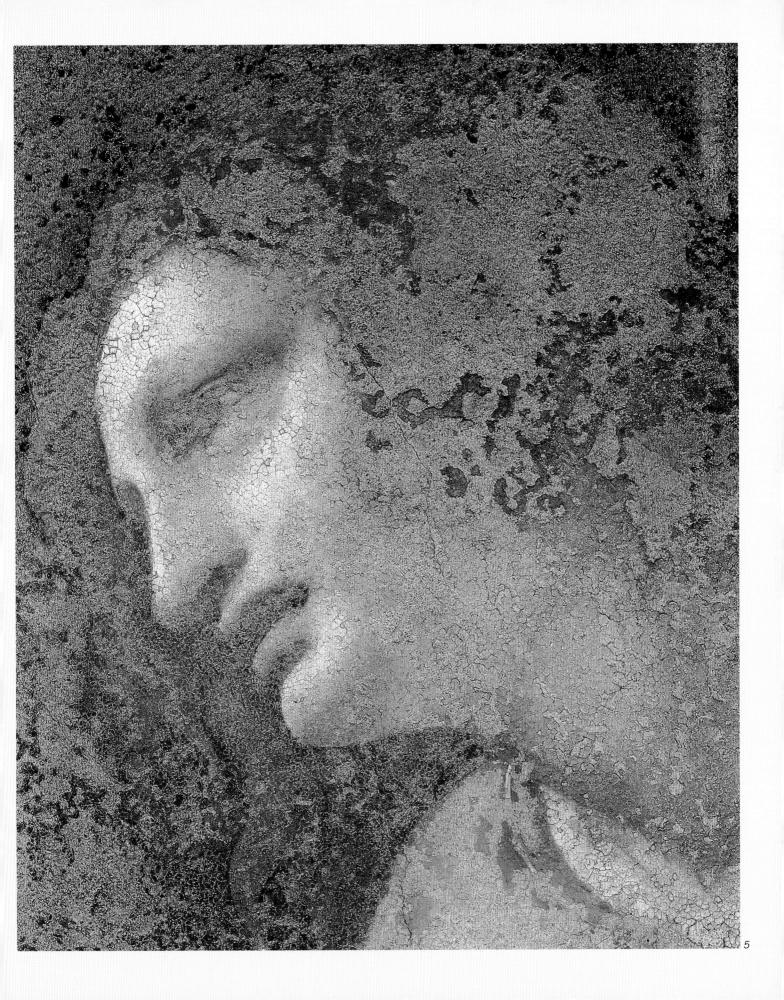

- 1. Caricature study of an old man (1490-1495) recto, Rome, Gabinetto nazionale delle stampe e dei disegni.
- 2. Caricature study of an old man (1490-1495) verso, Rome, Gabinetto nazionale delle stampe e dei disegni.
- 3. Study of physiognomy of two profiles, Windsor, Royal Library.
- 4. Two busts of men facing each other (1495), Florence, Uffizi Gallery,
- Gabinetto dei disegni e delle stampe.
- 5. Study for the
 Last Supper
 (1493-1494),
 Venice,
 Gallerie
 dell'Accademia.

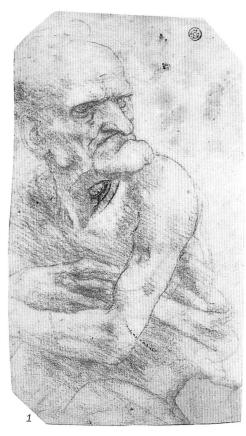

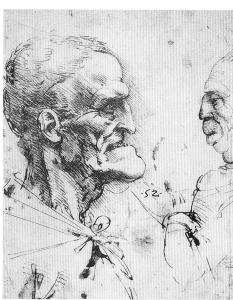

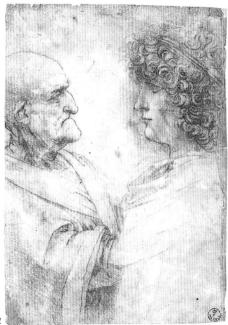

of each. 15th century artistic theory had been deeply concerned with temporary emotions, «movements of the soul» as Alberti called them; less so with permanent character (and not from the viewpoint of physiognomy), and still less with the complex relationship between them. Leonardo carried on this tradition, went deeper into it, and revolutionised it in two ways. First, by basing portrayal of permanent character on scientific considerations of anatomy and physiognomy having to do with the relationship between body and soul. Second, by considering, after having distinguished between them, the complex relationship between "ethos" and "pathos", between physiognomy and momentary passions, «mental motions» as he called them.

Under one of the preparatory drawings for the *Last Supper* (Windsor 12555r), perhaps representing Judas, the artist wrote: «When you draw a figure, consider well who it is and what you want it to do». «Who it is», that is its character, its psychological and somatic nature, its physiognomy; «what you want it to do», that is the momentary emotional participation in the event experienced on the occasion.

Leonardo conceived of physiognomy and momentary passions as part of his anatomical research. The years in which the Last Supper was painted as well as the preceding ones (around 1495-1498, but perhaps even earlier) were marked by intense anatomical studies. Dating from 1489 are a group of studies dedicated to the structure of the skull. Leonardo had dissected a cranium, had traced a series of lines relating to precise protuberances and cavities in the bone, and at their meeting point had placed "common sense". This as not only a psychological faculty of sensorial perception

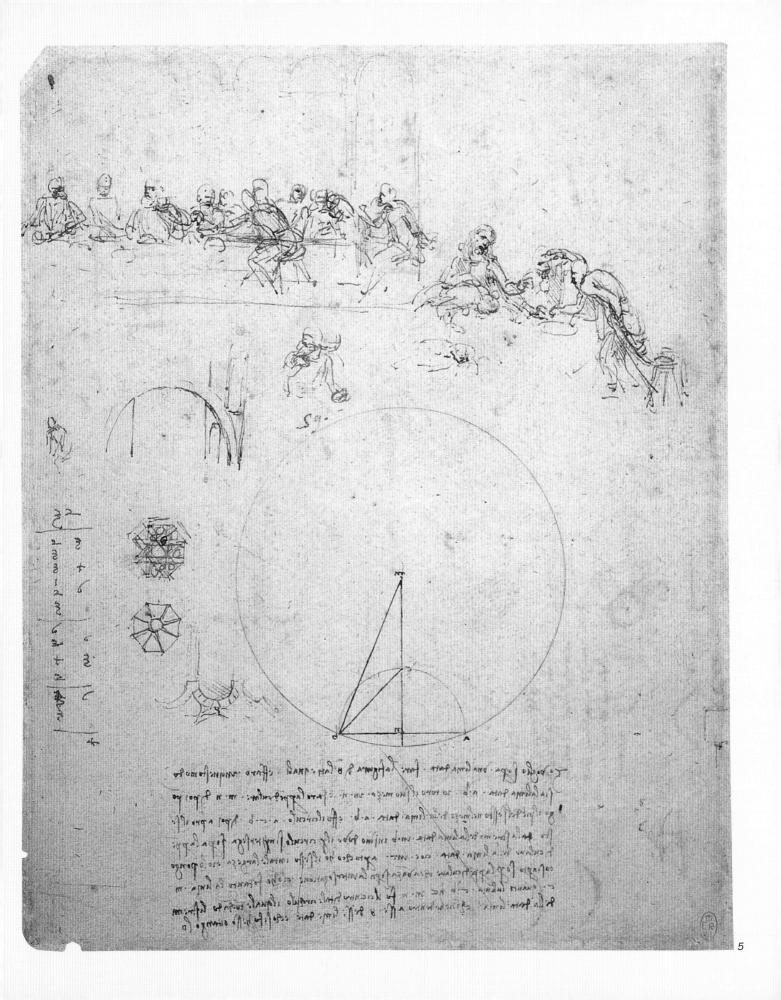

- 1. Series of drawings on the ventricles of the heart (1513) detail, Windsor, Royal Library (RL 19118-19119v; K/P 116v).
- 2. Study for the head of the Apostle Simon for the Last Supper (c. 1505), Windsor, Royal Library.
- 3-4. Studies of a skull (1489), Windsor, Royal Library.
- 5. The Last Supper (1495-1498), detail of Matthew, Milan, Santa Maria delle Grazie.

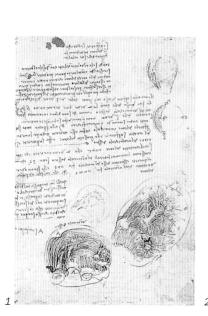

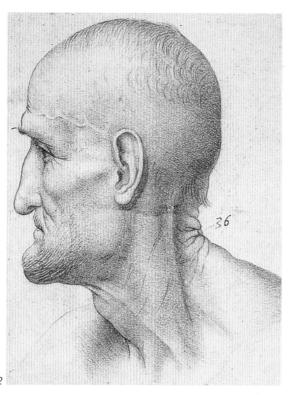

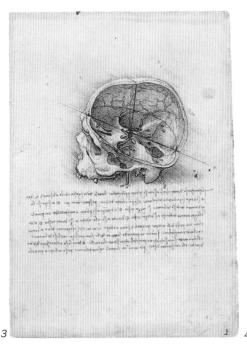

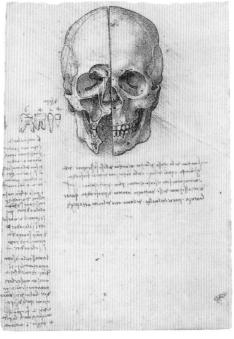

and the origin of voluntary neuromuscular movement, but in Leonardo's view it coincided with the very "soul".

The position of the soul is thus closely related to the shape of the body, that of the cranium and its cavities in particular. Apart from this solid, morphological aspect, the relationship between body and soul also had, according to Leonardo, a more fluid substratum: the complexion, the blood, and the heart. While widelyaccepted traditional medical theory attributed importance to four different humours - blood, yellow and black bile, phlegm - Leonardo believed that the psychosomatic makeup of an individual depended essentially on one of the humours alone, blood. The connection between body and soul, of physiognomic or emotional type, thus had for Leonardo a dual anatomical basis: morphological (the cranium) and fluid (the heart and blood).

One of his first and most intense studies for the Last Supper is a drawing now in Vienna (c. 1490). The firm lines of the cranium, its height, its shape, and even the particular threequarter foreshortening, are very closely reminiscent of his studies of the skull. But as we know, along with this aspect of studies of the cranium, of morphology and physiognomy, there exists a more fluid one, based on the complexion, which could be more or less sanguine and «spirited». In a preparatory study for the Apostle Simon, known through copies, a vein stands out across his forehead.

Within the context of the fluid and the complexion, the main physiognomic and artistic sign was however colour. And considering the vicissitudes undergone by the *Last Supper* it would be useless to search for traces of it in the work.

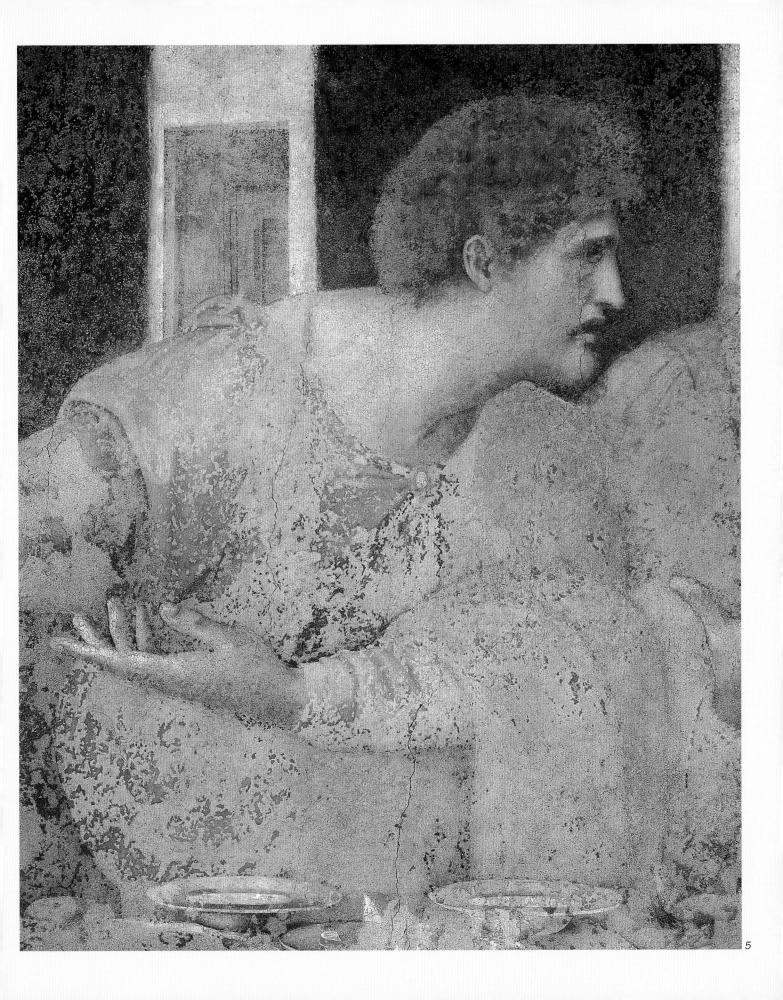

1-2. The Last Supper (1495-1498), detail before and after restoration, Milan, Santa Maria delle Grazie.

3. First idea for the figure of the Apostle Peter (c. 1490), Vienna, Graphische Sammlung Albertina.

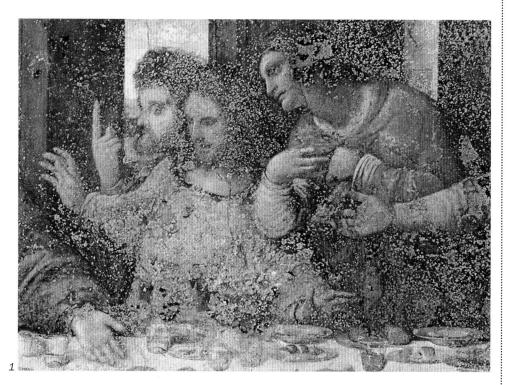

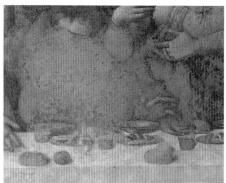

All of this concerns the physiognomic features of each individual apostle, his character and permanent somatic aspect. On this depends the specific "pathos" of each figure, the emotional reaction to the announcement of betrayal, expressed through gestures and actions, facial expressions, changes in flesh tones.

While the latter are now illegible, as regards facial expressions we can start from the two apostles immediately to the right of Christ: John and Peter. These two personages represent a typical case of convergence between personal research in anatomy and physiognomy and hagiographic tradition, where John's gentle nature (symbolic, according to St. Thomas, of the contemplative life) was frequently opposed to Peter's irascible character (symbolic of active life).

Leonardo, by placing the two disciples one beside another, accentuates the difference through the contrasting features of the two, with an outraged profile appearing beside a melancholy one. John, who according the Gospels was almost resting on Christ's breast when Peter questioned him as to the words pronounced by their Master, is portrayed in gestures consistent with his character: his head gently leaning to one side, his hands clasped in abandonment. Peter, on the contrary, shakes John with his left hand to question him, while with an awkward gesture of the other arm he grasps – almost concealed – a knife. The Last Supper, famous and widely copied since the time it was painted, has greatly deteriorated over the years, becoming at last almost illegible. The first attempt at conserving it dates from the early 18th century; the most recent, an endeavour lasting twenty years, was concluded in June 1999.

- 1. Giovanni Bazzi known as "Sodoma", Leda (1477-1549), Rome, Galleria Borghese.
- 2. Study for a kneeling Leda (1503-1504), Chatsworth, Duke of Devonshire collection.
- 3. Kneeling lady, (c. 1483) detail, Bayonne, Musée Bonnat.
- 4. Master of the Sforzesca Altarpiece, Sforzesca Altarpiece, detail with portrait of Beatrice d'Este (1494), Milan, Pinacoteca di Brera.
- 5. Copy from
 Leonardo,
 Leda and the Swan
 ("The Vinci Leda")
 (1506-1508),
 Vinci,
 Museo Leonardiano.

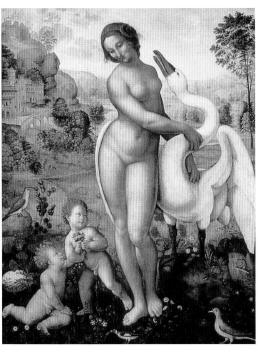

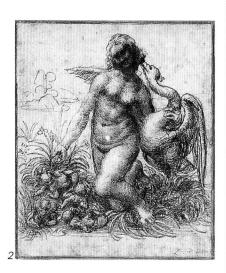

THE MYTHOLOGICAL SUBJECTS

Leda, symbol of the fecund forces of Nature, appeared already at the time of the studies for the Battle of Anghiari, around 1504. At first Leonardo imagined her in the kneeling position of the young St. Jerome, surrounded by flourishing vegetation which emphasised her exuberant sensuality.

Later, perhaps in Milan, he was to elaborate the standing version. In around 1515, it seems, Leonardo was still working on the *Leda*, of which a small sketch exists on a folio of geometric studies from that time in the Codex Atlanticus (fo. 156 r-b).

Another mythological subject was that of *Neptune with his sea-horses*, where spiral shapes are used to embody the concept of the whirling, twisting forces of nature.

The original motif, inspired by the oval of an ancient gemstone, dates back to 1504, to the time of the *Battle of Anghiari*. Later, the motif of the erect position was to predominate: a figure no longer concentrated in action, but powerful in its Herculean proportions as a warrior in the lost Battle. It is perhaps an idea for a fountain.

THE PORTRAITS

During his stay in Milan, from 1483 to 1499, Leonardo painted at least four portraits, all half-bust views as may have been the sculptures he executed during his apprenticeship with Verrocchio, when he probably acquired experience in the technique of bassrelief as well. It may also be that in the works of Verrocchio himself his pupils or assistants participated, raising a complex problem destined to remain unresolved in the absence of documentary proof. It has thus been hypothesised that Leonardo partici-

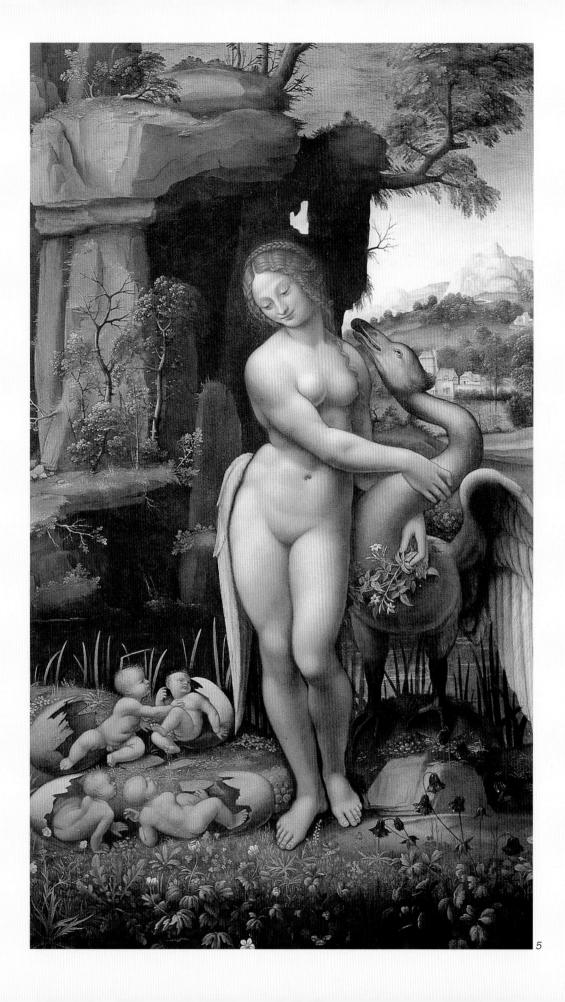

- 1. Andrea
 del Verrocchio,
 Noblewoman
 with Bouquet
 (c. 1475),
 Florence,
 Bargello
 National Museum.
- Study of hands (1475-1480), Windsor, Royal Library.
 Integration
- 3. Integration of the emblem of Ginevra Benci (from Thiis, 1909).
- 4. Emblem on back of the Portrait of Ginevra Benci (c. 1475), Washington, National Gallery.
- 5. Mutilated Portrait of Ginevra Benci (c. 1475), Washington, National Gallery.

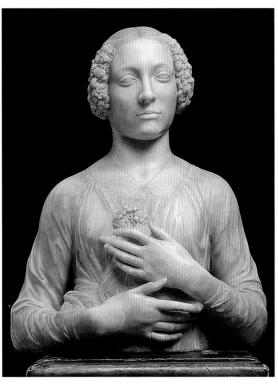

pated in the extraordinary marble bust of the so-called *Lady of the Beautiful Hands*, or *Noblewoman with Bouquet* now in the Bargello.

This masterpiece by Verrocchio presents the motif of the hands raised to the breast in an attitude entirely similar to what must have been that of Leonardo's Portrait of Ginevra Benci, a work datable around 1475, or even later, and thus still influenced by Verrocchio. The painting is evocative of a sculpture, although the human figure is delicately fused with the symbolic landscape surrounding it (the juniper bush in the background of the diaphanous image alludes to the girl's name). Proof that all of the lower part of Ginevra's portrait that contained the hands is missing is provided by the mutilated emblem on the back of the panel, since it has been possible to establish exactly how much space it would take if complete.

Still of Tuscan imprint, still sculptural is the portrait of the *Musician* in the Ambrosiana, which dates from the first decade of Leonardo's stay in Milan, around 1490. The three-quarter bust viewed slightly from above, the hand holding the sheet of music which emerges from below, the brilliant red of the robe and head-dress, the rosy complexion and the uniformly dark background evoke a Nordic model imported by Antonello.

The bony face is dominated by large glassy eyes, on which the painter's attention was focused. The *Musician*'s eyes have, it can be said, been a school to artists. And they were to return, regularly, in the paintings and drawings of Leonardo's Lombard pupils, Marco da Oggiono and Boltraffio in particular.

In the *Lady of the Ermine*, identified as Cecilia Gallerani, the mistress of Ludovico Sforza, it is impossible to

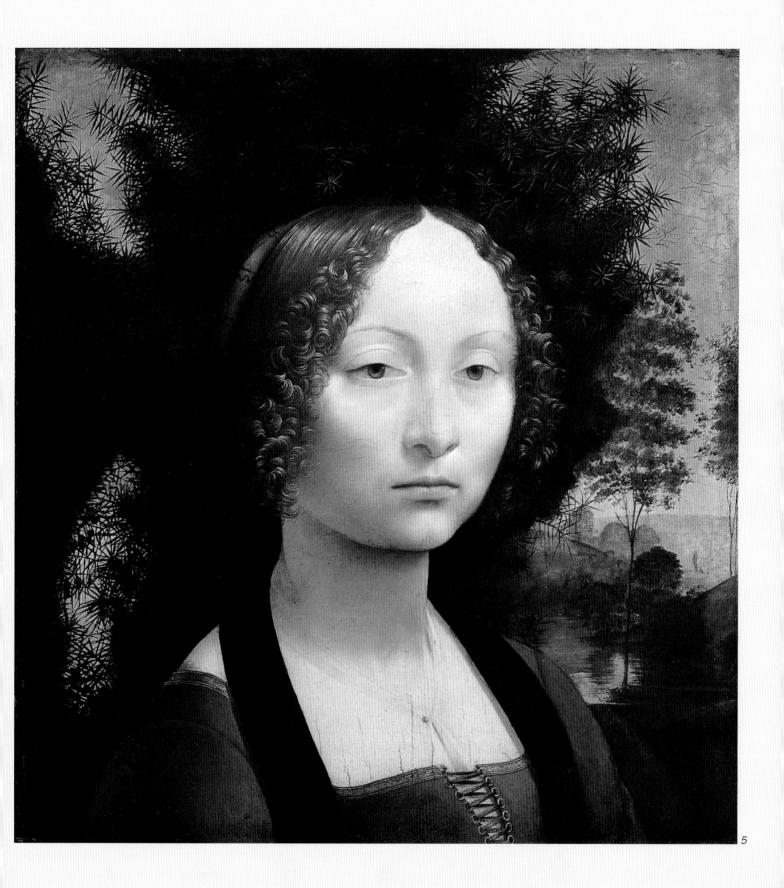

- 1. Allegory
 of the Ermine
 (c. 1490),
 Cambridge,
 Fitzwilliam Museum.
- 2. Portrait of a young woman (c. 1490), Windsor, Royal Library.
- 3. Profile of a youth (c. 1490), Windsor, Royal Library.
- 4. Eighteen positions of a woman's bust (1475-1480), Windsor, Royal Library.
- 5. The Lady of the Ermine (Portrait of Cecilia Gallerani) (1488-1490), Cracow, Czartoryski Muzeum.

determine the extent to which the model has been idealised, so that the extraordinary effect of the physiognomic relationship between woman and animal could be entirely real, and could at the same time be symbolically appropriate. In fact the ermine, in Greek "gale", alludes firstly to the family name of the sophisticated courtesan, and is also a traditional symbol of moderation and candour of sentiments. Moreover, this animal was a Sforza symbol, alluding to Ludovico il Moro himself, who in the poetic metaphor of Bellincioni appears in fact as «the Italian Moore, with ermine». And it has recently been discovered that Ludovico greatly desired to be invested with the Order of the Armellino by the King of Naples, the highest honour granted to personages such as the King of England and the Duke of Urbino, an honour of which the Duke could finally boast in 1488, only to renounce it forever in about 1490, when the first conflicts with the Aragonese broke out.

Leonardo's portrait can thus be dated during that period. The date is confirmed by the Spanish costume which came into fashion just at that time, and which dates at the same time the style of an allegorical drawing by Leonardo representing the fable of the ermine, probably designed for a medal.

The Lady of the Ermine is a typical example of the so-called "shoulder portrait", a type developed through Leonardo's studies on the dynamics of the human body, as exemplified by the bust of a woman portrayed in eighteen different positions on a folio in the Windsor collection. Cecilia Gallerani, the beautiful, highly educated favourite of Ludovico Sforza, appears in half-bust. Viewed in three-quarter profile looking to the left, she turns to gaze out of the picture to the

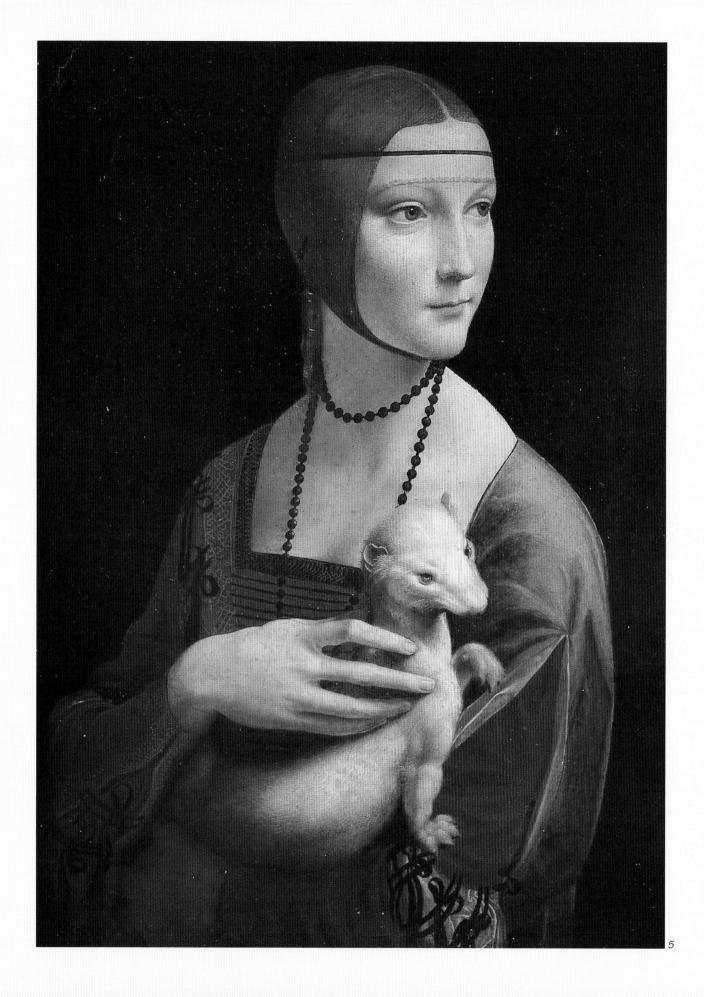

- 1. Raphael, Maddalena Doni (c. 1506), Florence, Galleria Palatina.
- 2. Raphael, Lady with a Unicorn (c. 1506), Rome, Galleria Borghese.
- 3. Portrait of Isabella d'Este (1500),
 Paris,
 Louvre.
- 4. Anonymous,
 copy of cartoon
 for the Portrait
 of Isabella d'Este
 (xvi century),
 Oxford,
 Christ Church
 College Collection.
- 5. La Belle Ferronière (1495-1498), Paris, Louvre.

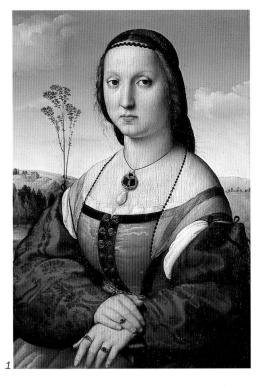

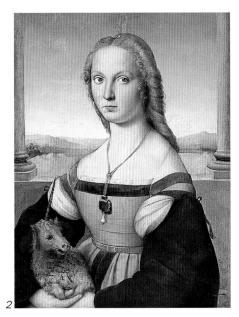

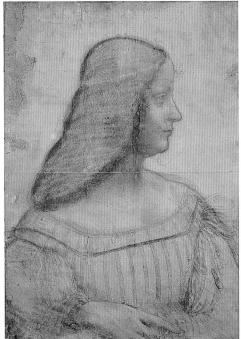

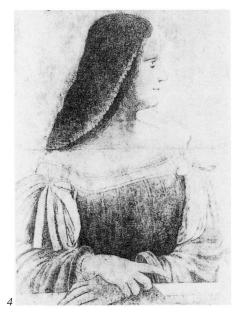

right, her face exposed to the light that falls on her shoulders and on the white mantle of the ermine she holds in her arms like a cat. Her gaze is intense and slightly detached, her lips barely touched by a smile.

Another extraordinary and still unjustly underrated portrait of a woman is the picture in the Louvre known as La Belle Ferronière, whose style indicates dating at the time of the Last Supper or immediately afterward.

The figure appears in a three-quarter view behind a parapet against a dark background. Contrary to what might be expected from Leonardo, her arms are not raised to her breast, where the hands could be shown, even if only to display their beauty. The position of the figure is disconcerting, like that of a person standing for a moment at a window or seated in a box at the theatre and watching those around her. The fascination of this portrait lies in the magnetic fixity of the eyes. «The eye is the window of the soul», stated Leonardo in his Libro di pittura where he confronted all theoretical aspects of portrait painting in texts dated mainly from the Sforza period, the time when these portraits were painted. If this is, as seems probable, the portrait of Lucrezia Crivelli, the lady who was to succeed Cecilia Gallerani in the favour of il Moro, and thus in about 1497, this would be an extraordinary experiment in poetic function, which sees in the eyes a source of light, the manifestation of the soul as simulacrum of divinity.

In 1500 Leonardo was back in Florence. From Milan he journeyed to Venice, stopping in Mantua where Isabella d'Este asked him to paint her portrait, which he immediately drew in charcoal, promising her to transfer it to a panel as soon as possible, a promise he was never to fulfill.

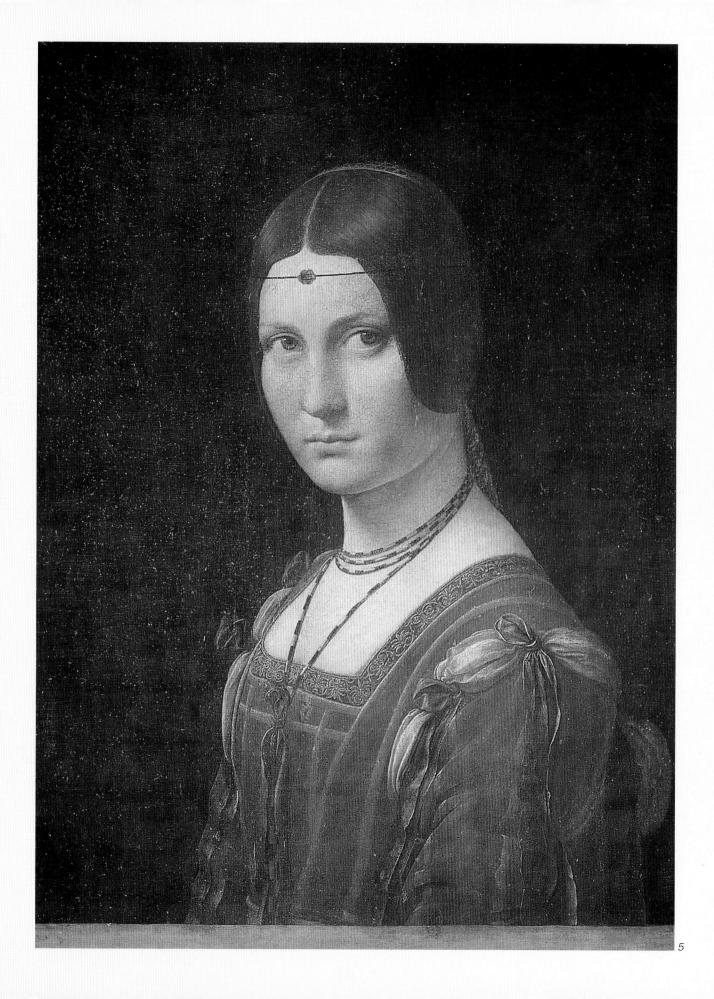

- 1. School of Leonardo, Nude Gioconda (c. 1515), St. Petersburg, The Hermitage.
- 2. Salai and Leonardo, Nude Gioconda (c. 1515).
- 3. Lorenzo di Credi, Portrait of a Young Woman (or Lady of the Jasmine), Forlì, Pinacoteca Civica.
- 4. Flemish Master,
 Portrait of a Lady
 from a cartoon
 of the Leonardesque
 school (c. 1515),
 Rome,
 Galleria Doria
 Pamphili.
- 5. Mona Lisa (1506-1510; 1513-1516), Paris, Louvre.

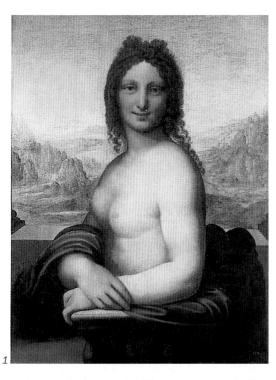

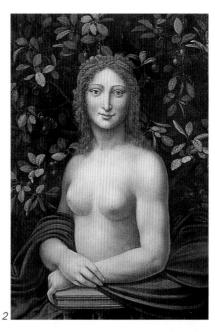

Isabella, the sister of Beatrice, the Duchess of Milan who died in childbirth in 1497, appears in a three-quarter view behind a parapet like La Belle Ferronière, but with her face shown in full profile as if on a medal. A hand too can be seen, emerging from below like that of the Musician, and laid on the other which can barely be seen and which may have been pointing to a book. This circumstance is confirmed by a poor copy now at Oxford. In 1497 Isabella had had the portrait of Cecilia Gallerani sent to her so that she could compare it with one by Costa.

Although she must have been well aware of Leonardo's subtle innovative quality as portrait painter, she approved a representation of herself that is traditional, tranquil, almost archaic. But if she did so it is because the image, splendidly majestic, already shows the imprint of the new century which was opening with the imperial visions of popes and monarchs and which saw the lesson of antiquity reappearing in republican ideals.

Leonardo's most celebrated portrait, however, and one of the most famous of all times, is the *Mona Lisa*. In all probability this was the painting that Leonardo showed Cardinal Louis of Aragon in France in 1517 as the portrait of «a certain Florentine woman, done from life, at the instance of the late Magnificent, Giuliano de Medici», as reported in that same year by Antonio De Beatis. It is known that Leonardo was in the service of Giuliano from 1513 to 1516, although there may have been earlier contacts, not in Florence, where Giuliano returned from exile only in 1512, but almost certainly in Venice in 1500 where Giuliano was living at he time of Leonardo's brief stay. But any conjectures in this regard would be

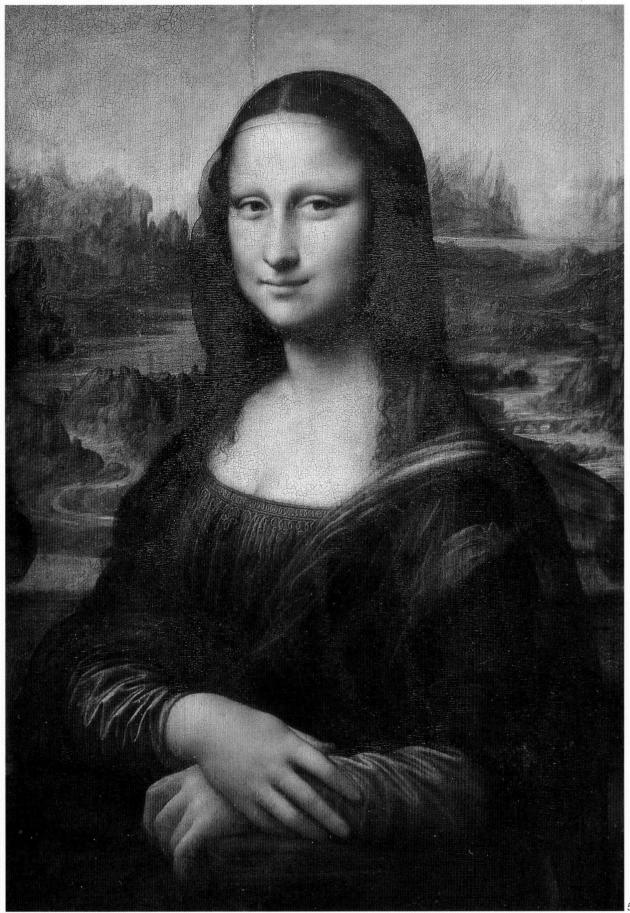

- 1. Study for a landscape (c. 1500) detail, Windsor, Royal Library.
- 2-3. Two studies of drapery for the Louvre Saint Anne (c. 1518), Windsor, Royal Library.
- 4. First reproduction of the Mona Lisa as illustration for a chapter in the French edition of Leonardo's Trattato della pittura (1651).
- 5. Portrait of a maiden (La Scapiliata) (c. 1508), Parma, Galleria Nazionale.

hazardous; and it is no longer necessary to anchor the *Mona Lisa* to a time, around 1505, when Raphael could have drawn inspiration from it. At that time in fact the "external" formula of the *Mona Lisa* had already been diffused through Leonardo's other works, as can be seen for example in the portrait of a woman by Lorenzo di Credi at Forlì. The "internal" formula instead was unique and unrepeatable.

In realty the style, elements such as the nature of the landscape and the skilful play of veils seem those of Leonardo's last works, after 1510 – as suggested by Kenneth Clark – and it is probable that the artist continued to work on the painting up to his last days in France.

The French studies - black on black – for the drapery of the Virgin in the painting of Saint Anne and the related drawings at Windsor, which date from 1510 and 1511, spring to mind; or the landscapes of the Adda from 1513 and others sketched on folios of geometric studies from 1514 and 1515. On a folio of geometric studies in the Codex Atlanticus (fo. 315r-a), datable with certainty between 1515 and 1516, appears a penand-ink drawing of an eye beside a cascade of wavy hair, just as in the Mona Lisa, sketched as if inspired by a remembered detail in the just finished painting.

But the most compelling reference is to the character, if not the spirit, of a drawing at Windsor – a very late one – of a woman standing in a land-scape that is barely visible in the mist. She has the body, the clothing and even the smile of the *Mona Lisa*; her pointing hand indicates a symbolic distance in space and in time.

Over the *Mona Lisa*, the proverbial rivers of ink have flowed. The painting is a victim of too much erudition,

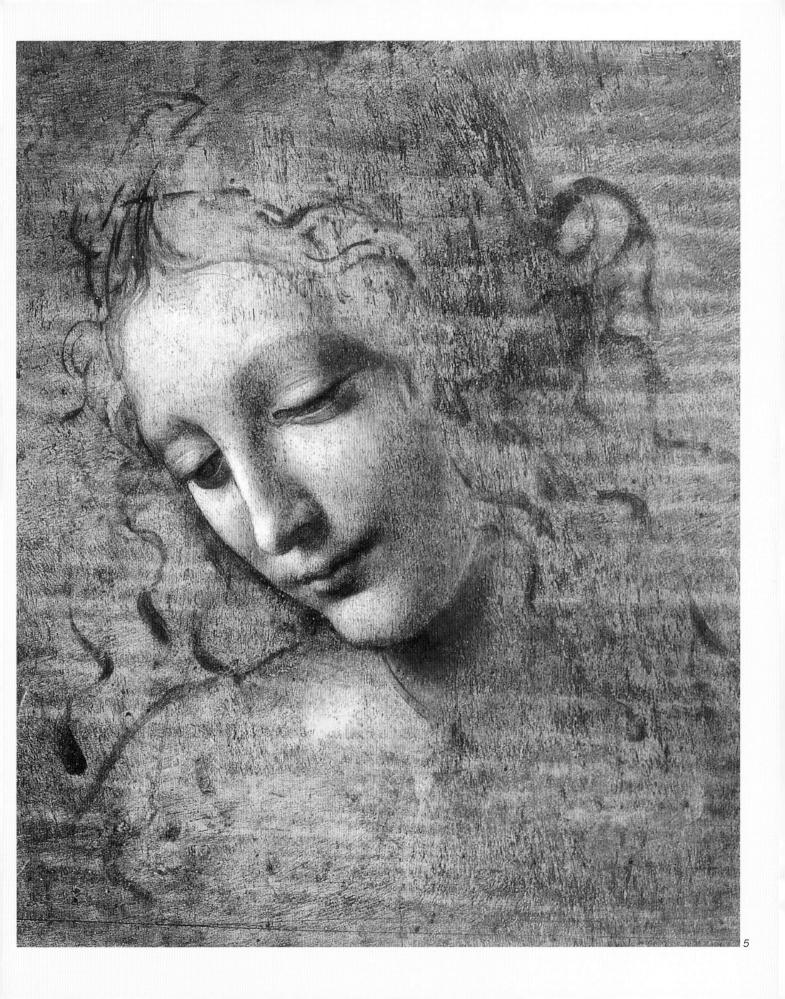

- 1. Antonie van Dyck, Multiple Portrait of Charles I (1635-1636), Windsor, Royal Collections.
- 2. Giorgione, The three Ages of Man
- (1477-1510), Florence, Galleria Palatina.
- 3. Three views of the same head (c. 1500), Turin, Biblioteca Reale.
- 4-5. Repertoire of
- noses, illustration for a text in the Libro di pittura (copied from the lost Libro A, 1508-1510), from the Codex Vaticano Urbinate 1270
- (fo. 108 v), Rome, Biblioteca apostolica vaticana.
- 6. Portrait of a Musician (c. 1490), Milan, Pinacoteca Ambrosiana.

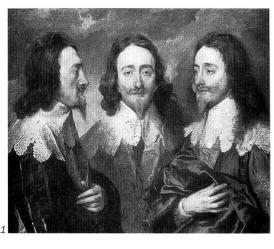

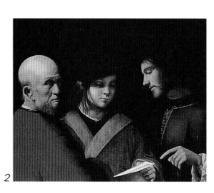

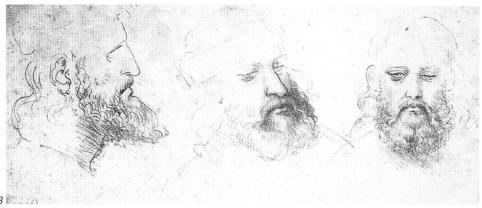

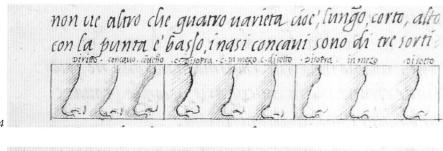

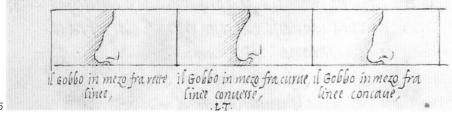

too much philology, too much philosophy, too much psychology, too much arrogance and, on the whole, too much misunderstanding.

Many hypotheses have been formulated as to the identity of the woman portrayed. In 1625 Cassiano dal Pozzo saw the painting at Fontainebleau and christened it "La Gioconda" on the basis of a description by Vasari, who wrote of it with great eloquence, but without ever having seen it. Today it is certain that this is not the Mona Lisa described by Vasari, also in consideration of the previously mentioned testimony of De Beatis.

Perhaps the day may come when the Mona Lisa will be wisely restored (but perhaps it would be even wiser to leave her untouched) to bring back the luminosity of Leonardo's colours, intense and vaporous in the distance, brilliant and effulgent in the monumental presence in the foreground. And it can then be confirmed that the key to reading the painting consists expressly of the play of veiled forms: that miraculous «veil of colours» insistently mentioned in the Trattato della pittura which modern critics have misunderstood, interpreting it as «relationships between colours». And in the meanwhile the most famous painting in the world will continue to arouse hypotheses and arbitrary inferences. The expression of the face and certain characteristics of the hands have even led to the suggestion that the woman portrayed is pregnant. And of all the interpretations that have been made, from the morbid enthusiasm of 19th century decadence down to the most recent computerised studies, this is perhaps the one most consonant with what is known of Leonardo in his last years. It falls within the context of his embryological studies of 1510-1513 and geological ones of the same period, where the

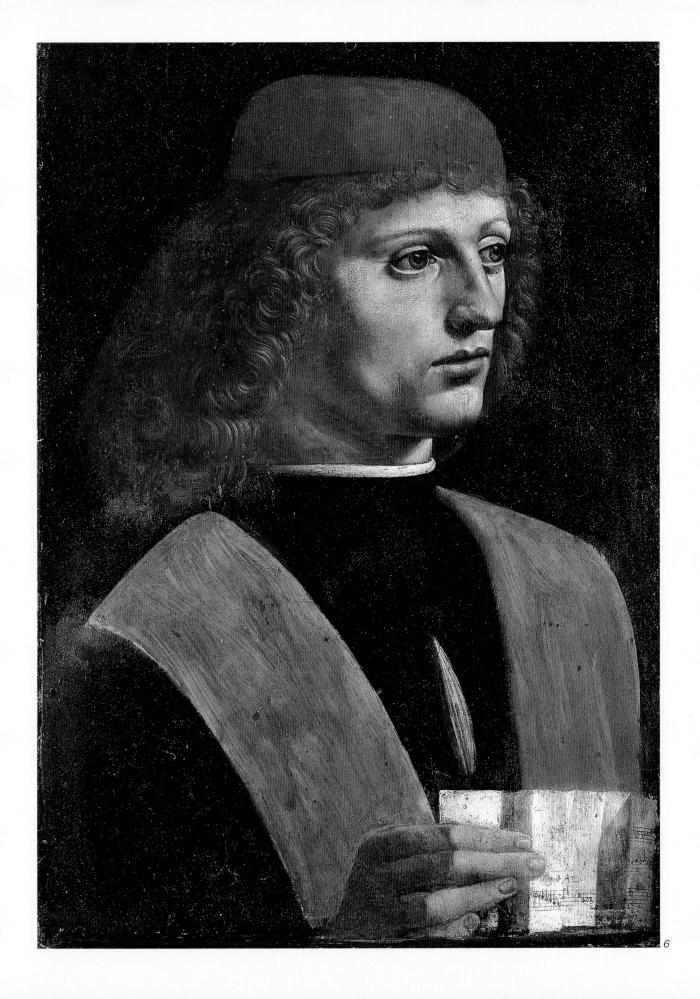

- 1. Side by side profiles (1508-1510), Codex Atlanticus (fo. 635r).
- 2. Alexandrine artist, Gonzaga Cameo, (3th century BC), St. Petersburg, the Hermitage.
- 3. Francesco di Simone Ferrucci, Scipion (c. 1475), Paris, Louvre. 4. Profile of
- 4. Profile of an ancient captain (1475-1480), London, British Museum.
- 5. Herculean profile of a warrior (c. 1508), Turin, Biblioteca Reale.

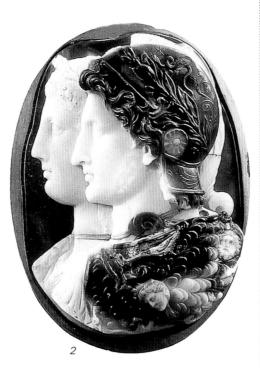

concept of human life is seen in relation to that of the earth. But Leonardo was not merely a natural philosopher, in the Aristotelian sense. He was also a poet, in the sense of being able to evoke the dreams and images of infancy. And so it may be that Freud was right in recognising in the *Mona Lisa* an idealised portrait of Leonardo's mother.

DRAWING

In the Uffizi Adoration of the Magi Leonardo followed a new procedure, later to be emulated by the Venetians. It consisted of drawing the composition directly on the surface to be painted, without the aid of a cartoon but developing an idea tried out in preliminary drawings of relatively small size.

In all of the paintings brought by Leonardo to a high degree of completion the drawing is always impeccable. When Vasari reported the episode of Leonardo's father presenting his son to Andrea del Verrocchio he wrote: «One day [Ser Piero] took some of his drawings [and so it was drawing that first opened the way to Leonardo] and brought them to Andrea del Verrocchio, who was a very good friend of his, and urgently begged him to say whether Leonardo would profit from studying design. Andrea was amazed when he saw Leonardo's extraordinary beginnings».

Leonardo's talent in drawing thus seems to date back to a period preceding his apprenticeship with Verrocchio, but of this time no trace has remained, no documentary evidence.

Leonardo's first known drawing is the famous landscape in the Uffizi Gallery, dated «the day of Saint Mary of the Snow, 5 August 1473». The valley of the Arno is seen in a bird's eye view from a point on Montalbano

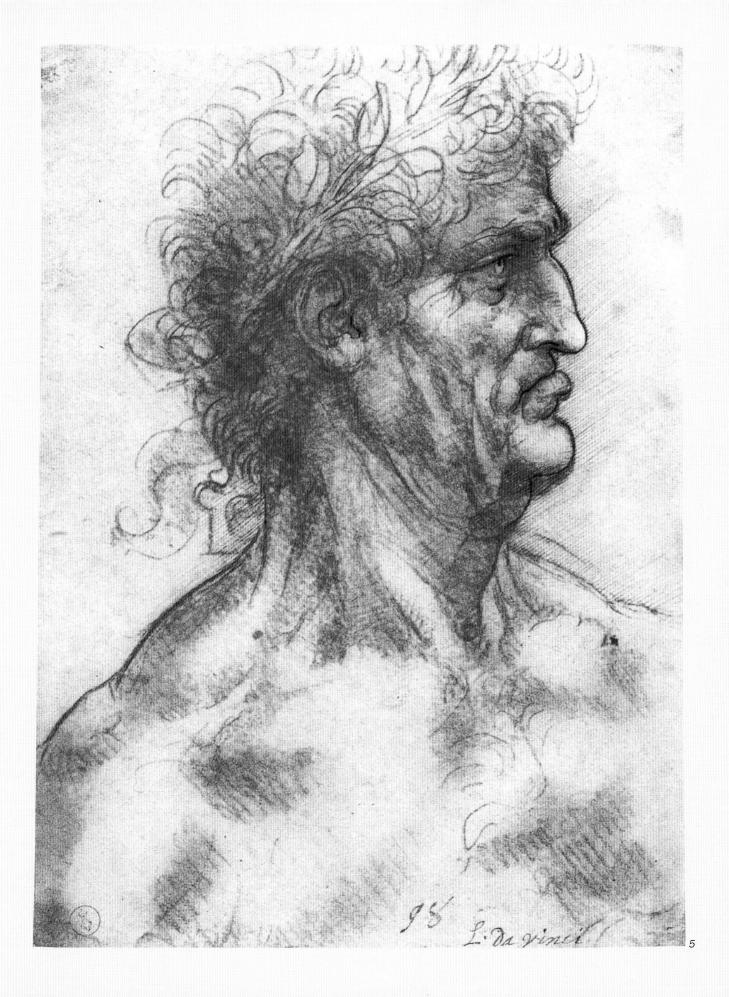

- 1. Study for a standing cherub (1506-1508) detail, Windsor, Royal Library.
- 2. Studies of crabs (c. 1480) detail, Cologne, Wallarf-Richartz Museum.
- 3. Albrecht Dürer, engraving of the Accademia Vinciana panels.
- 4. Engraving of the Accademia Vinciana (c. 1495), Milan, Biblioteca Ambrosiana.
- 5. Decorative motifs inspired by antiquity on a folio of studies for the Adoration of the Magi and other sketches from life (c. 1480), Bayonne, Musée Bonnat.

near Vinci. The drawing was done with the left hand, like all of Leonardo's known drawings. Since the artist was then twenty years old, it was not drawn before he moved to Florence. And in fact all of the drawings from Leonardo's so-called youthful period published up to now are later than 1473, including the one in the Morgan Library at New York recently acknowledged to be his.

The youthful drawings, especially the studies for the personages in the *Adoration of the Magi* (now dispersed among Florence, Venice, Hamburg, Cologne, Paris, Bayonne, London and Windsor) are distinguished by a melodic quality in the line which flows to embody a new sense of grace, still of Neo-platonic influence, as noted already by Leon Battista Alberti in the beauty of the women's faces; a grace fully expressed in the motion and postures of Leonardo's figures, which would be emulated by Raphael over thirty years later.

But the folios with the studies for the Adoration contain other things as well: curiosities, fantasies, whimsy. On the back of the folio with the Cologne drawing, for instance, are two crabs. On another folio, now at Bayonne, Leonardo drew two standing cherubs, one of whom has loaded an enormous crab on his shoulders. Leonardo's playfulness had begun to emerge, that special taste of his for the surprise effect, for new themes and motifs, often destined to go no further than the drawing, the first idea or conception, like a sudden joke. Playing on words taken from a vast repertoire of objects and figures, turning them into ideograms and rebus: this was the exuberant whimsicality that would cause Vasari to reproach him for his "divertissement", classifying among such even those masterpieces which are the

- 1. Albrecht Dürer, Perspectograph (1525).
- 2. Portrait painted with the perspectograph (c. 1490), Windsor, Royal Library.
- 3. Portrait painted with the perspectograph (c. 1495), attributed by Adolfo Venturi (1930) to Leonardo.
- 4. Studies for a Nativity (c. 1483), New York, Metropolitan Museum.
- 5. Albrecht Dürer, Perspectograph (1525).
- 6. Bellows machine for drawing up water and man portraying an armillary sphere with a perspectograph (c. 1480), Codex Atlanticus (fo. 5r).

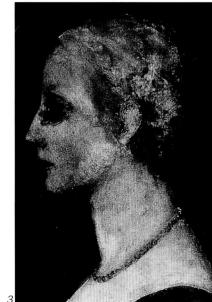

pages of the so-called Accademia Vinciana: six copper prints with variations on the theme of interwoven emblems.

Here Leonardo's drawing becomes a synthesis of the concept of creative, and thus cosmic, knowledge, manifested in the abstract language of geometry, appearing as symbol of law and order in nature and as inexhaustible stimulus to the imagination.

A node of this kind, albeit in the embryonic state and barely perceptible in a faint charcoal drawing, is already present on the back of Leonardo's first known drawing, the landscape from 1473. Clearer and more varied, the same nodes reappear on another youthful folio with studies of hydraulic technology in the Codex Atlanticus.

Alongside these nodes is the drawing of a perspectograph for the mechanical reproduction of objects (in this case an armillary sphere) or persons, a device based on the Albertian principle of the square or "graticule" as intersecting plane of the visual cone, which Leonardo codified in texts from about 1490 destined to the Trattato della pittura. There he described the two types of perspectograph which were to be made famous by Dürer's illustrations thirty-five years later. One of them has a graticule or glass on which the observed image is delineated, then to be transferred by tracing to a sheet of paper. In the other the graticule is replaced by a reticle, the same used to prepare the sheet of paper on which the painter draws the features of the figure observed through the sight: borderlines or profiles defined in the space divided into squares.

In the sheet of studies for a *Nativity* now in the Metropolitan Museum, where the infant St. John appears in the role of playmate to the Christ

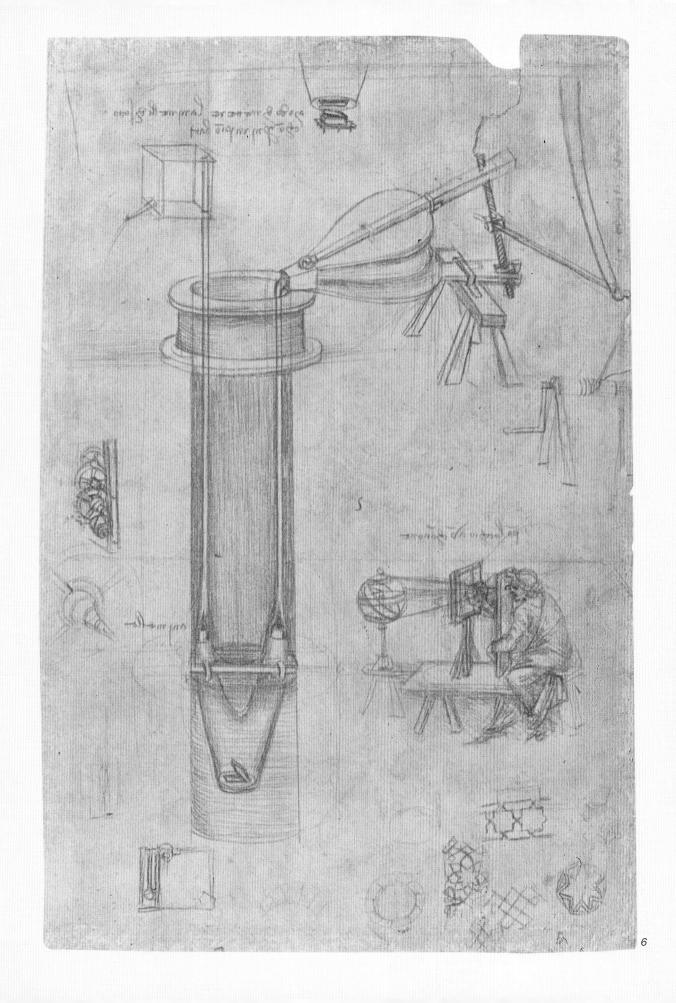

- 1. Homo Vitruvianus, from Cesare Cesariano's edition of Vitruvius (Como 1521).
- 2. Homo Vitruvianus as a Robot from the dust jacket of the book by Mark E. Rosheim, Robot Wrist Actuators (New York 1989).
- 3. Geometric proportions applied to the human figure, Windsor, Royal Library (RL 19132r).
- 4. Homo Vitruvianus, study of proportions with the human figure inscribed in a circle and a square (c. 1490), Venice, Gallerie dell'Accademia.

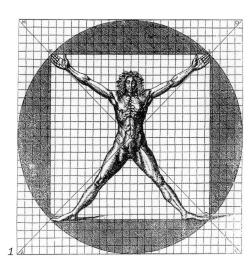

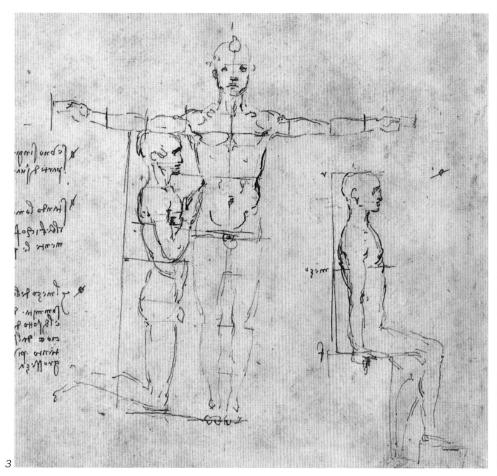

Child, the development of Leonardo's iconography and composition which was to lead to the Louvre *Virgin of the Rocks* can be observed. The head of the kneeling angel at the right can instead be studied in a famous drawing in Turin, in which a young woman is viewed from the shoulders, her bust seen in profile.

In this drawing many have recognised Cecilia Gallerani, the splendid Lady of the Ermine, a painting also conceived as a "shoulder" portrait, but from a different angle of perspective. In fact, starting from the early drawings of a woman's bust observed from various points of view Leonardo arrived, in the Turin study, at formulating a basic principle of "action motion", the motion that a figures makes "in itself", without changing position and with the implicit suggestion of a spiral process; motion which is the very germ of the "serpentine" characteristic of Michelangelo and the Mannerists, but which was in effect introduced by Leonardo with his studies for the kneeling Leda and the standing one (Rotterdam, Chatsworth and Windsor).

These developments emerged from 1503 to 1510 and beyond, when Leonardo's drawing became more emphatic, especially in the anatomical studies, with hatching that curves to follow the form, accentuating its sense of volume.

The final result shows marked characteristics of classic monumentality, attained through a process involving the studies for the apostles in the Last Supper and above all the figure of the Virgin in the Madonna of the Yarn Winders, studied in a powerful drawing now at Windsor, and that of Saint Anne in the London cartoon, and so on to the Louvre's enigmatic St. John the Baptist.

One of Leonardo's most famous

Virump . most of on mich in la proper trader them . of hi million to them for to the nature Hangale . wdn Ho wo of . the west of . the wood of . the wood of . the wood of whom the ale porto Be firmado us Juntag איוונים חף: לבחם חול בלתמות יקעוני כ לחי (עו . הלבבת Internationano trodapego atten of one Atmento . . theremo dellation tout pocho of meno alla Com A & Espos 1: Lecture & there & flowe And Joseph & Jacto ale Jampa factores of the trip of the month of the form of the form of the flower of the trip of the flower of the Ante forto fitamochio atna francisto francisto for taquaria francis francis is prompi of fine bome and this chale stuffermino fregulaced chart freed on a para ple familiationed or the server Studies

- 1. Angel of the
 Annunciation,
 copy from Leonardo,
 Basle,
 Kunstmuseum.
- 2. Drawing of whirlpools, detail, Windsor, Royal Library (no. 12579r).
- 3. Study of dancers (c. 1515), drawing recomposed of two fragments, Venice, Gallerie dell'Accademia.
- 4. Bacchus (1511-1515), Paris, Louvre.

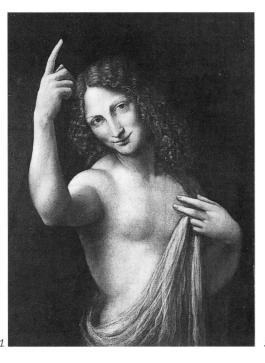

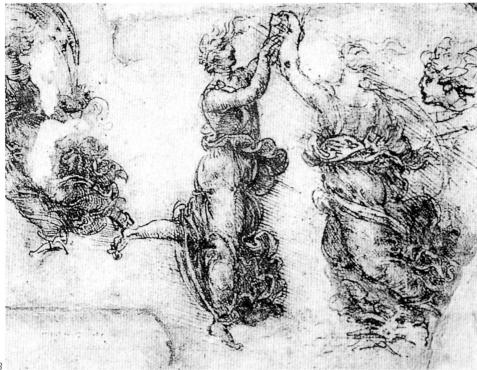

drawings, the so-called *Homo Vitruvianus* in Venice, illustrates the canon of human proportions that Vitruvius, the Roman architect of the 1st century BC, had postulated as basis for his architectural theory. In Vitruvius' text, transcribed by Leonardo in an Italian version, the human figure is inserted first in a circle and then in a square, a procedure always followed in the illustrations to Vitruvius' treatise, starting from the one edited by Fra Giocondo in 1511.

Twenty years earlier then, in 1490, the date of the Venice drawing, Leonardo had already thought of using it as illustration, producing a visual synthesis of Vitruvius' demonstration through the simultaneous perception of two different superimposed transparent images, to suggest the possibility of motion from one position to another. Yet one of Leonardo's figures is surprising. The nude man inscribed in the square is distinguished by an erect member and by long curly hair adorned with vine leaves. Now there is nothing in Vitruvius' text to justify the presence of the erection. Leonardo's figure seems a young Bacchus with features resembling those of the angel of the Annunciation. It is only natural then to link this figure to a drawing recently found in Germany in which the angel of the Annunciation is transformed into the demoniacal image of a young Bacchus with an erection, viewed foreshortened, like his raised arm. This may be an indirect confirmation of the suspected metamorphosis of the Louvre St. John the Baptist into a Bacchus. It is in fact a drawing that for technique and style can be dated at the same time as that painting, around 1513-1515.

Moreover, on the back of the refound folio Leonardo has noted three words in Greek — "astrapen", "bronten", "ceraunobolian" – taken from a

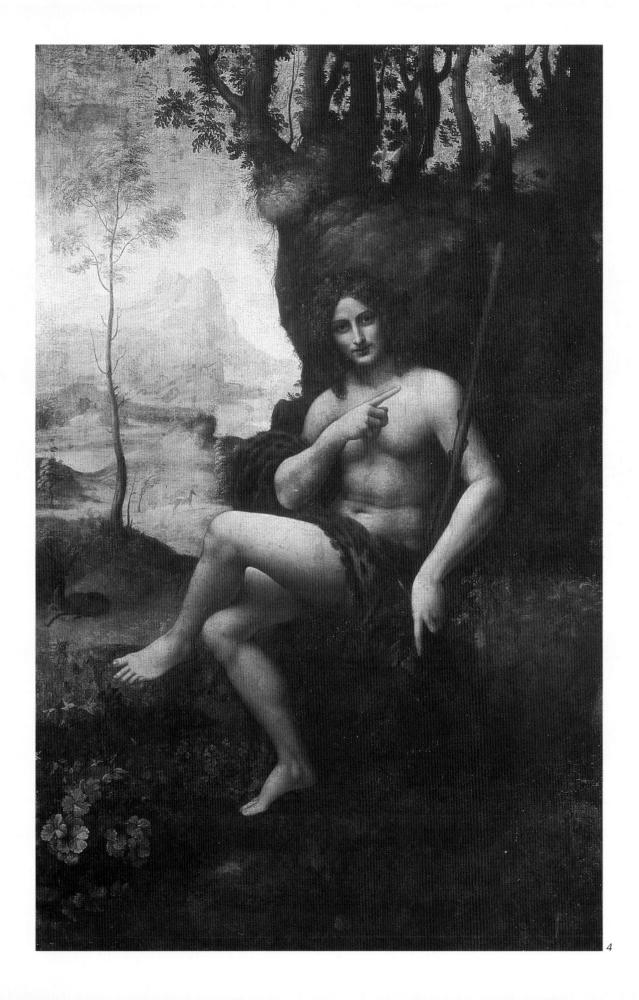

- Studies of lines
 of force in currents
 of «acqua
 panniculata»
 (1508) detail,
 Manuscript F.
- 2. Studies of fabric, probably military tents, uprooted by the wind (c. 1515), Codex Atlanticus.
- 3. Study for a Deluge (c. 1515), Windsor, Royal Library.
- 4. Study for a Deluge, Windsor, Royal Library (no. 12380).

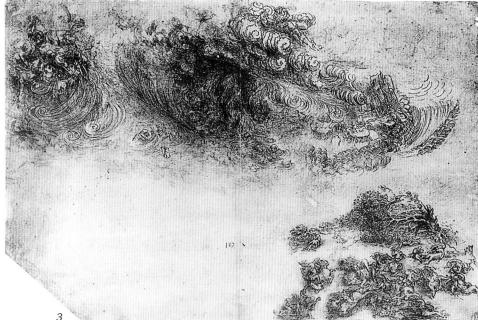

text by Pliny extolling Apelles' ability to paint what cannot be painted, atmospheric phenomena such as the flashes of lightening and thunderbolts indicated by the three words in Greek.

Leonardo himself, in a spirit of emulation, finally managed to portray such phenomena in about 1515 with the stupendous series of drawings of the *Deluge* in the Windsor collection and the Codex Atlanticus.

Dating from the same period are drawings on the theme of drapery, already confronted by Leonardo at the very beginning. Fabric too could be caught in the wind, and the complexity of its motion had to be analysed, recorded and then codified like that of the elements themselves. From this come the enigmatic drawings on a folio in the Codex Atlanticus where only recently has it been possible to recognise the same objects depicted in the stormy sky of one of the Windsor drawings of the Deluge: military tents uprooted by the fury of the wind. Within this same context are the stupendous figures of dancers now in Venice and the socalled Pointing Lady of Windsor, where the theme is that of clothing whirled about by the wind.

THE PROBLEM OF THE SELF-PORTRAIT

Other important considerations are introduced by the theme of the self-portrait. The famous drawing in Turin, the best-known *Self-portrait* of Leonardo, remains stubbornly anchored to a date, 1512, consistent with the authority and wisdom emanating from an artist who has reached the age of sixty.

And yet dating at 1515, if not even later, cannot be excluded. Stylistic similarities to the so-called *Allegory* of Fluvial Navigation at Windsor, the

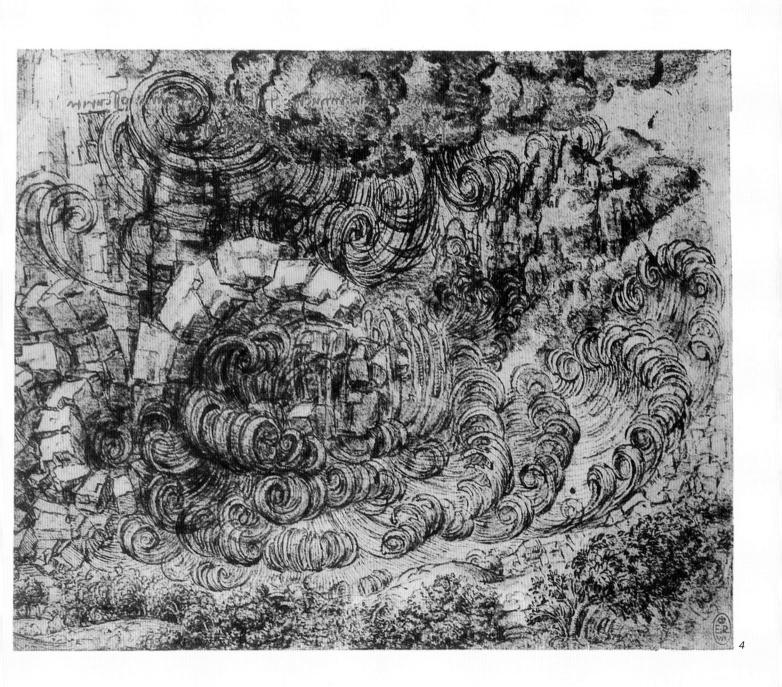

- Study of an old man seated (c. 1513) detail, Windsor, Royal Library.
- 2. Raphael,
 The School of Athens
 (1510)
 detail of Plato,
 Vatican City,
 Palazzi Vaticani,
 Stanza
 della Segnatura.
- 3. Allegory of navigation (c. 1516), Windsor, Royal Library.
- 4. Self-portrait (after 1515), Turin, Biblioteca Reale.

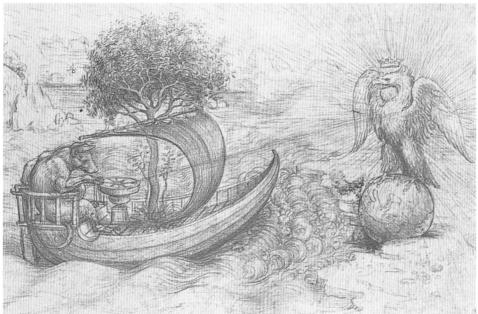

one with the dog in the boat, also a red-chalk drawing and datable at that time, are obvious.

Turning then from style to iconography, the suspicion arises that the age represented could suggest dating during the French period, after 1517, when the sixty-five-year-old Leonardo appeared, to those who met him in October 1517, already «an old man over seventy».

For this reason it would be useful to ascertain whether the Turin folio is still as it was when Leonardo drew on it his self-portrait. The ratio between base and height suggests the elongated format of the folios he used in France. But the measurements are not the same, suggesting that the folio may have been trimmed at the sides enough to make the presence of the shoulders less conspicuous and to confer on the personage an erect position which in effect it did not have.

The venerable aspect would in fact be lacking if Leonardo appeared seated with his shoulders bowed like Raphael's *Julius II*.

In the well-known Windsor drawing (c. 1513) depicting an old man seated beside whirlpools of water, which has been thought to be a profile of Leonardo, the neck is in fact sunk between the shoulders.

The format used for the Turin drawing is larger than that of any other portrait drawn by Leonardo, except for the portrait of *Isabella d'Este* in the Louvre, which is however a cartoon perforated for transferral to a painting.

The large Oxford drawing of the socalled *Scaramaccia Captain of the Gypsies* belongs to the category of grotesques, and might also be a study for a painting (it is in fact perforated for transferral) or perhaps a drawing from 1515, when Leonardo was resid-

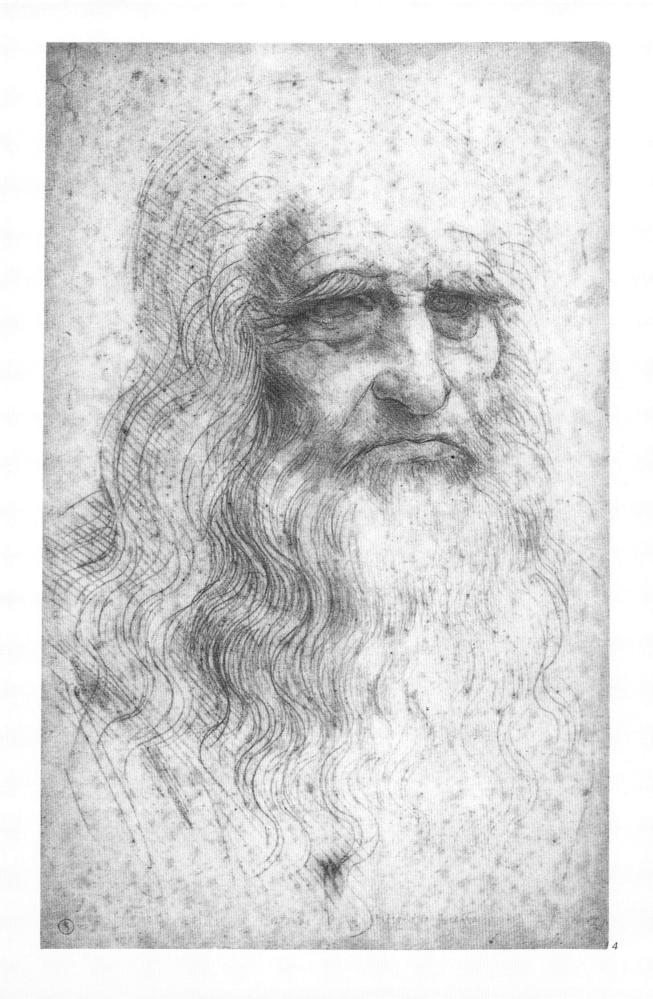

- 1. Adoration of the Magi (c. 1481) detail, Florence, Uffizi Gallery.
- 2. James the Elder (c. 1495), Windsor, Royal Library.
- 3. Giorgio Vasari, Portrait of Leonardo, from The Lives, 1568 edition.

ing in the Vatican, of a court jester or juggler.

Some have seen a self-portrait in the Windsor study for the apostle James the Elder, in which the age represented seems that of a man about forty-five. The marked arch of the eyebrows, the prominent nose and cheekbones, the wide mouth with the well-modelled lips, could be viewed within a process of transformation that in twenty years would have led to the Turin self-portrait.

But in this process it is difficult if not impossible to insert the Windsor profile, of which the Ambrosiana possesses a copy, drawn by a pupil as a portrait of Leonardo, where the age is certainly not over fifty and the features seem more appropriate to the figure of a Saviour. All this has given rise to the perplexity, still unresolved, as to whether or not the Turin red-chalk drawing can be identified as a self-portrait of Leonardo.

Still another hypothesis has been advanced, that of the stereotype, in which the Turin drawing might be an idealised image, rather than a true self-portrait. Apart from the singular proposal by Hans Ost that the Turin drawing is a fake done by Giuseppe Bossi in the early 19th century, it has also been suggested, by Robert Payne for instance, that it should be recognised as a portrait of Leonardo's father drawn in about 1503.

Payne has remarked that the Turin drawing actually represents an old man over seventy, as was in fact Ser Piero da Vinci in the early 16th century, but the suggestion fails to take account of the fact that Leonardo himself appeared to have this same age to those who met him at Amboise in 1517.

n Milan Leonardo gathered around him pupils and follows who assimilated his style, interpreting it in their own works. A long-debated question is whether or not the Leonardo school should be considered a real academy modelled on the Neoplatonic one sponsored by Lorenzo de' Medici in Florence for the humanists and philosophers who gathered around Marsilio Ficino. Undoubtedly, welcomed not only apprentices, as was still customary in the workshops of the time, but also affirmed masters who were

offered the chance to practice their profession within the framework of an important institution.

The school seems to have been most successful producing portraits, where the intervention of Leonardo might even be limited to the concept or the initial idea alone. Among the painters in Accademia Vinciana were the brothers Evangelista and Ambrogio De Predis, d'Oggiono, Marco Antonio Boltraffio and Francesco Napolitano.

Worthy of special mention are Oggiono and Boltraffio, both of whom may have collaborated on the *Last Supper*, and considered up until recently the painters of one of Leonardo's most admired portraits, the

SCHOOL OF LEONARDO

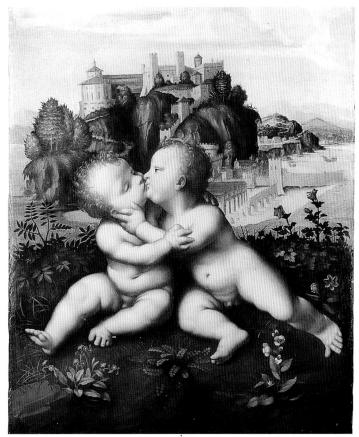

Above, from left: Giovan Antonio Boltraffio, Symbolic Portrait (c. 1500), Florence, Uffizi Gallery; Marco d'Oggiono, The Holy Children; Giovan Antonio Boltraffio, Portrait of Gerolamo Casio (c. 1500), Milano, Pinacoteca di Brera. Below, from left: Giovan Antonio Boltraffio.

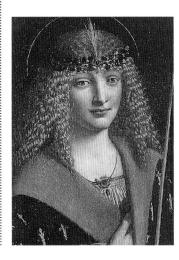

Symbolic Portrait on the Theme of St. Sebastian (c. 1500), Moscow, Puškin Fine Arts Museum; Giovan Antonio Boltraffio, Portrait of a Woman (c. 1500), Milan, Biblioteca Ambrosiana; Emblem of the Achademia Leonardi Vinci (1495), engraving, London, British Museum.

Lady of the Ermine, attributed first to one, then to the other. In Oggiono's production (c. 1475 - c. 1530), abundant but poorly documented, the obvious influence of Leonardo is reinforced by reference to coeval Lombard sculpture.

Among his certain works are the signed polyptych in the museum at Blois, the altarpieces at Brera (*The three archangels*) and the *Madonna and Saints* of the Besate parish house near Abbiategrasso.

Of Antonio Boltraffio (Milan 1466/ 1467-1516) portraits in

particular are known, of clear Leonardesque imprint (even the Ambrosiana *Musician* was attributed to him for years), as well as the Portrait of *Gerolamo Casio* at Brera and innumerable portraits of women. His Madonnas reflecting, with elegant variations, the models of the master are highly popular.

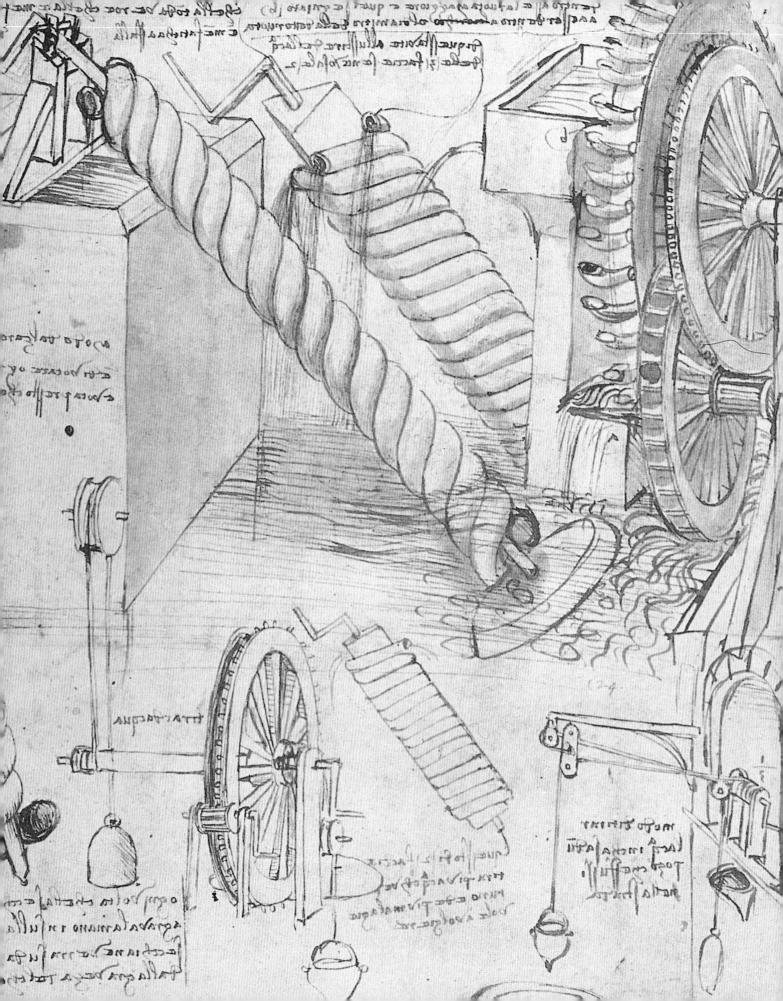

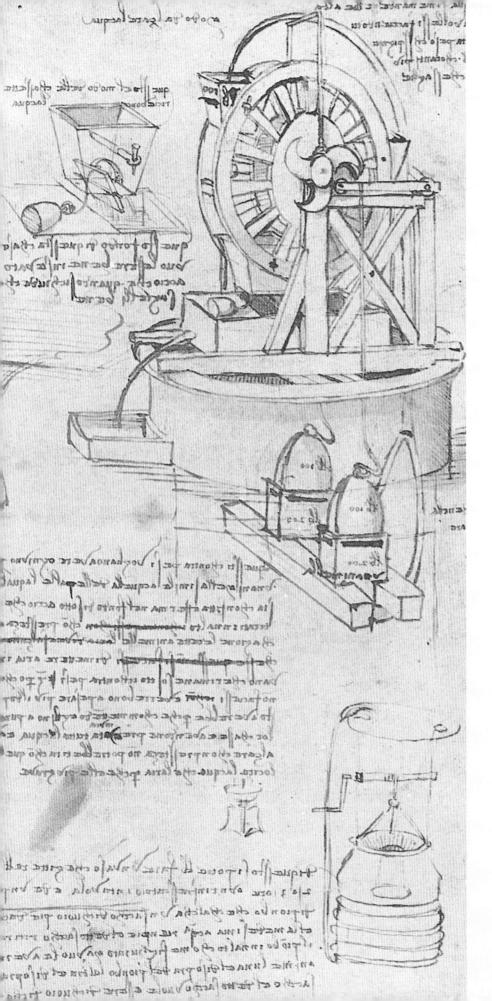

For almost all his life Leonardo filled notebooks and notebooks with drawings and writings, recording not only his most complex, profound thoughts but also curiosities, personal facts, and idiosyncrasies. The vicissitudes of Leonardo's notebooks are as intricate and complicated as the plot of a spy story, with personages contending the precious treasure in Europe and recently in America as well, and with scholars as committed to reconstructing their history as detectives hot on the trail of a geographically scattered terrain, possessing only a handful of documents to be compared and integrated with the innumeable folios already hard to decipher and jumbled in wild confusion by generations of different owners.

- 1. Two types of adjustable-opening compass, mortar-piece and mechanical parts (1493-1494), Manuscript H (ff. 108v and 109r).
- 2. Study of plants (c. 1506), Windsor, Royal Library.
- 3. Original binding of Manuscript C (17th century).
- 4. Studies of decorative motifs and of proportions of the head of a dog (1497-1498), Manuscript I (ff. 47v and 48r).

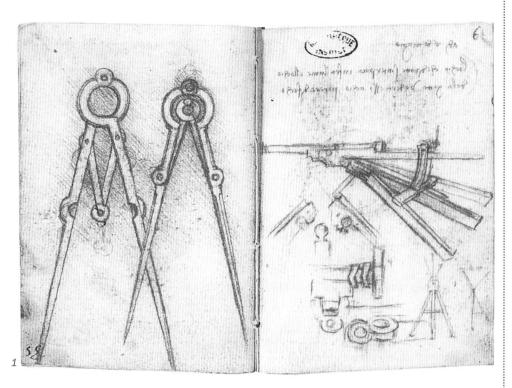

pon the death of Leonardo in 1519 at Amboise, Francesco Melzi, the faithful disciple and friend of his last years, inherited all of the manuscripts written by his master. He brought them back to Italy where they were conserved and utilised (for example in extending the *Trattato della pittura*) until he too died in 1570 at his villa in Vaprio d'Adda near Milan.

After the death of Melzi there was a first dispersion of Leonardo's manuscripts in which Madrid became, at the turn of the 16th century, the place where most of the notebooks were concentrated. Here Pompeo Leoni, sculptor to the Spanish court, had managed to collect, it seems, up to fifty manuscripts and about two thousand scattered folios: an impressive collection to which were to be added the 283 folios (Codex Arundel) probably acquired in Spain by the Englishman Lord Arundel and the two notebooks recently (1966) rediscovered in the Biblioteca Nacional of Madrid.

At the death of Leoni, his heirs decided to sell his collection, and Leonardo's notebooks came back to Italy, again to Milan, purchased first in 1632 by Count Galeazzo Arconati, who in 1637 donated to the Biblioteca Ambrosiana the Codex Atlanticus and almost all of the Leonardo manuscripts now in Paris, at the Institut de France (Manuscripts A-M).

In about 1630 other manuscripts left for England, again from Madrid, and again from the Leoni inheritance: the above-mentioned Codex Arundel (now at the British Museum in London) as well as the book of 234 folios (Windsor collection) with extraordinary drawings of anatomy, figures, animals, and landscapes which then passed from the hands of the English lord to those of the royal family, which kept it in the library of Windsor Castle. Only

- 1. Study of mechanisms and for a hygrometer (c. 1480), Codex Atlanticus.
- 2. Drawing of a machine for draining canals (1513-1514), Manuscript E (fo. 75v).
- 3. Study of a centrifugal pump for draining swamps (c. 1508), Manuscript F (fo. 15r).
- 4. Volcanic explosion (c. 1517), Windsor, Royal Library.

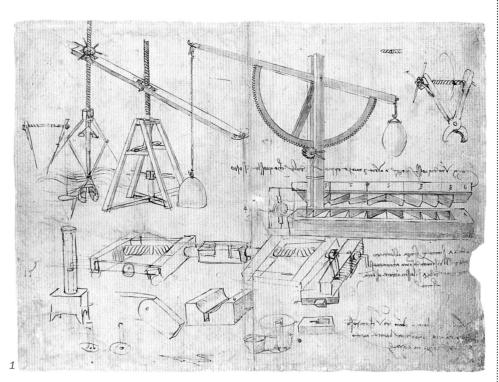

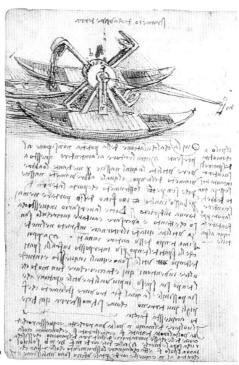

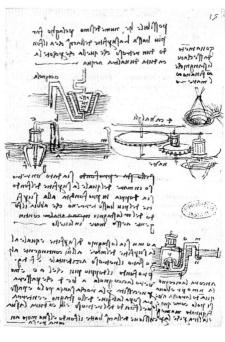

since 1873 has information been available on the three notebooks that reached England, in what way is not known, to be purchased by John Forster who then donated them to the Victoria and Albert Museum in London.

The geographical location of the notebooks, thus distributed in the mid-17th century between Milan, Madrid and London, was abruptly disarranged in 1795 when General Napoleon Bonaparte, in a gesture that was already "imperial", ordered all of Leonardo's notebooks to be transferred from the Biblioteca Ambrosiana in Milan to Paris.

At the end of the 18th century the French capital thus suddenly became one of the outstanding sites in the geography of the notebooks, although the Codex Atlanticus (and it alone) was returned to Milan after the Congress of Vienna in 1815.

In the mid-19th century the so-called "Guglielmo Libri case" occurred. This naturalised Frenchman, professor of mathematics and illustrious historian of science who had risen fast in his career as director of French libraries, during an official inspection at the Institut de France removed a number of sheets from Leonardo's manuscripts, including even the small Codex on the Flight of Birds.

Libri then fled to England where he rearranged the folios he had removed in "notebooks" which he managed to sell to Lord Ashburnham, from whom they were later purchased again by France.

More straightforward is the path of the Leonardo codex which arrived in the hands of the 16th century sculptor Guglielmo della Porta by other ways than those of the Melzi heredity, and was then bought by the painter Giuseppe Ghezzi. The latter sold it in 1717 to the future Count of Leicester, who was travelling in Italy at the time.

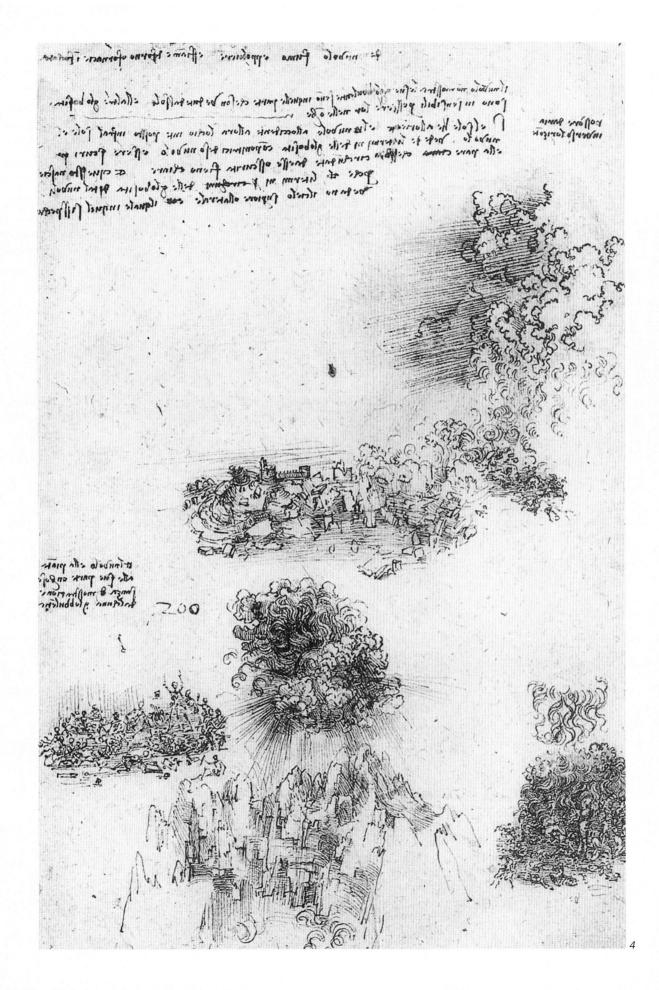

- 1. Anonymous
 16" century, drawings
 of machines copied
 from folios
 by Leonardo,
 in part lost
 (c. 1530),
 Florence,
 Uffizi Gallery,
- Gabinetto dei disegni e delle stampe.
- 2. Drawing of a mortar (c. 1485), Codex Atlanticus (fo. 59v).
- 3. Archimedes screws and pumps to draw up water (c. 1480), Codex Atlanticus (fo. 26v).
- 4. System of defence and studies of horses for the Battle of Anghiari (c. 1504), Codex Atlanticus (fo. 72r).

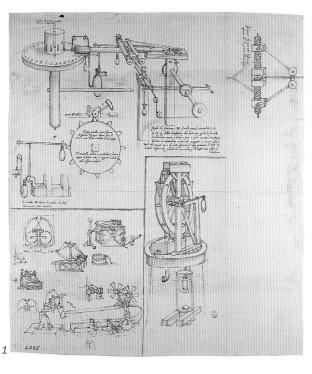

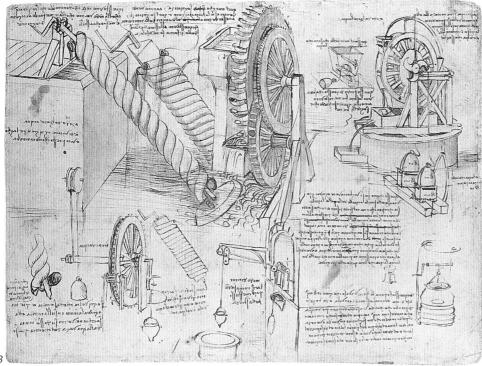

Known as the Codex Leicester for the next two hundred and sixty years, this manuscript has made the headlines in recent years for the sensational auctions in which it has changed hands twice, bringing it to the United States. Purchased in 1980 by the oil millionaire Armand Hammer (who gave it the name by which it is now known), and then bought in 1994 by Bill Gates, the computer magnate, it is the only codex that has remained private property.

THE CODEX ATLANTICUS

The Codex Atlanticus (Milan, Biblioteca Ambrosiana), with its original 16th century binding, is, with its 401 pages, the largest and most extraordinary collection of Leonardian folios in existence. The name derives from the large format (65x44 cm), of the Atlas type, of its pages. Although it may appear to be a real codex, a book arranged by its author to be filled with drawings and notes, it is in reality a miscellaneous collection of folios and fragments collected in single volume by the sculptor Pompeo Leoni. A debatable attempt at restoration was made in the 1960s-70s.

The material in the Codex Atlanticus encompasses Leonardo's entire career, for a period of over 40 years, from 1478 when he was twenty-six to his death in 1519. It contains the richest documentation on his contributions to the sciences of mechanics and mathematics, to astronomy, physical geography, botany, chemistry and anatomy; but also a record of his thoughts expressed in fables, apologies, and philosophical meditation.

Furthermore, there are notes on the theoretical and practical aspects of painting and sculpture, on optics, perspective, the theory of light and shadow, down to the materials used by the artist, as well as numerous studies

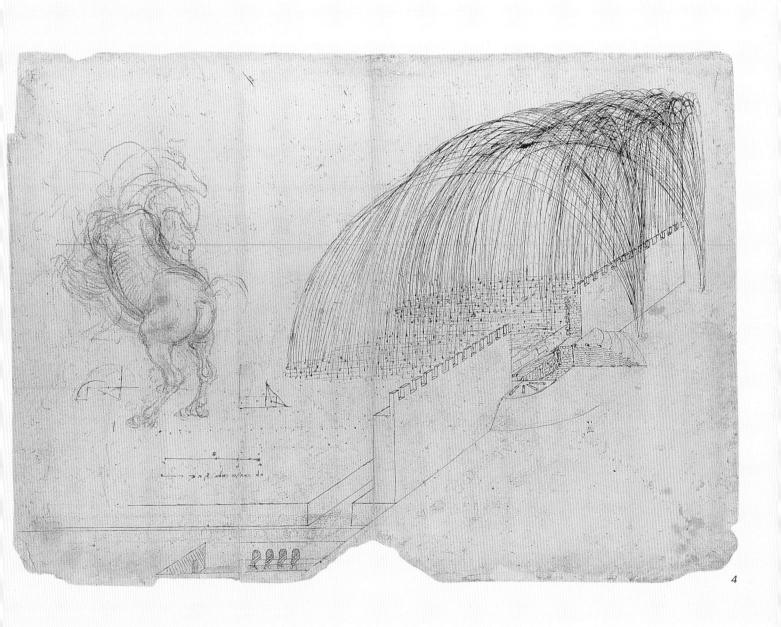

- Original binding of the Windsor collection (16th century) in red leather with decorations in gold, 48x35 cm, Windsor, Royal Library.
- 2. Draped torso of an old man (c. 1489) detail, "Landscapes", Windsor, Royal Library (fo. 1r).
- 3. Study of two plants for the Leda (c. 1508-1510), "Landscapes", Windsor, Royal Library (fo. 23r).
- 4. Study of muscles of the trunk and of the thigh (1510), Windsor, Royal Library.

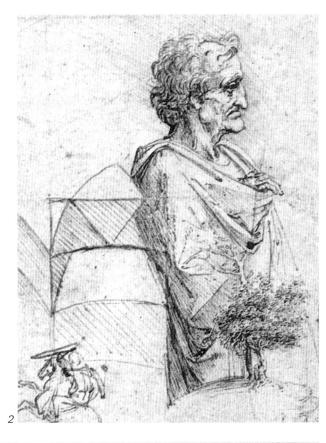

such as those for the Adoration of the Magi, the Leda, the Battle of Anghiari, and projects for the monuments to Francesco Sforza and Gian Giacomo Trivulzio, and even for the construction of automatons.

WINDSOR COLLECTION

Everything indicates that this volume – owned by the British royal family since 1690 – is the book of 234 folios listed in the inventory of the property of Leoni compiled in 1609 (with addenda in 1613), a book that up to 1630 was in the possession of Lord Arundel who had bought it in Spain from Leoni's heirs.

It is a miscellaneous collection with the original binding. On its pages Leoni mounted about six hundred drawings executed by Leonardo between 1478 and 1518, of varying format and subject matter.

In the late 19th century the work of disassembly was begun, concluding in 1994 with the individual folios placed between two sheets of perspex, an operation which ensures better viewing and conservation, as well as the arrangement of the folios by subject and chronology according to the cataloguing scheme adopted by Carlo Pedretti in publishing them in facsimile.

The codex opens with the section "Anatomy", the most conspicuous nucleus (about two hundred drawings), fruit of thirty years of studies conducted by Leonardo directly on the human body through the dissection of over thirty cadavers.

This is followed by "Landscapes", among them the extraordinary *Deluges*, then by "Horses and Other Animals" in which appear studies for the youthful Adorations, for the monuments to Sforza and to Trivulzio and for the *Battle of Anghiari*.

The section "Figures, Profiles, Caricatures" includes studies for the *Vir*-

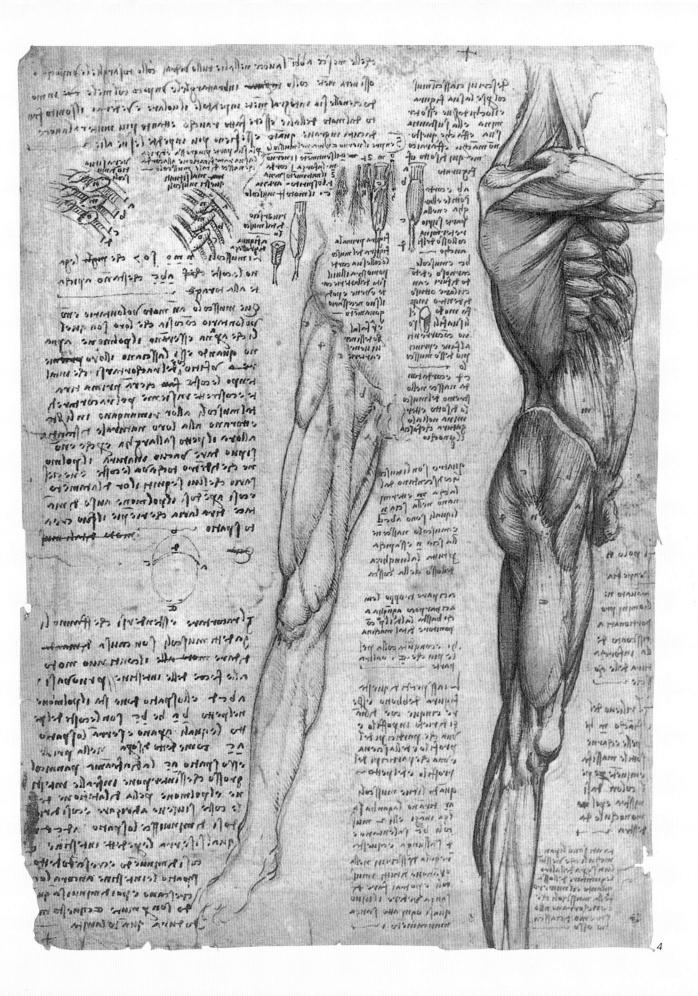

- Study of stage sets for Poliziano's Orpheus (c. 1506-1508), Codex Arundel (ff. 231v and 224r).
- 2. Studies of shadows (1510-1515), Codex Arundel (ff. 246v and 243r).
- 3. Study of floater with breathing tubes for a diver (1508), Codex Arundel (fo. 24v).

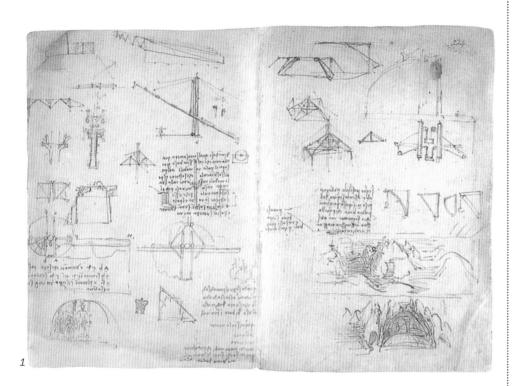

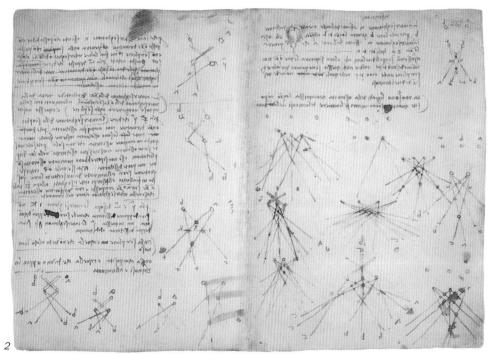

gin of the Rocks and the beautiful nucleus of fifteen folios for the Last Supper.

Lastly, the "Miscellaneous Papers" contain various material including rebus, emblems and allegories.

CODEX ARUNDEL

This codex too (London, British Museum) is in reality a miscellaneous collection, not of scattered sheets or fragments, but of booklets, with a total of 283 folios of various format, mainly 21x15 cm. The history of this manuscript is obscure, especially in the early stages. It is not, in fact, listed among the volumes possessed by Leoni, although it is highly probable that Lord Arundel had purchased it in Spain in the 1630s. Certainly in his possession in 1642, the codex was donated by Lord Arundel's heirs to the Royal Society of London in 1666; then in 1831-1832, it was transferred to the British Museum.

Mathematics is the dominant theme of this manuscript. From some notes on expenses and reminders, often dated, the chronology of the folios can be determined: the first 30 are from 1508 (in realty, 1509), while the others date from 1478 to 1518.

On some of the individual folios there are drawings of ingenious objects, such as the device with mask and tubes for breathing underwater.

FRENCH MANUSCRIPTS

Now in Paris, at the Institut de France, are twelve notebooks which differ in format, number of pages, binding, chronology and content. In 1795 Napoleon Bonaparte had them brought here from the Biblioteca Ambrosiana in Milan. The indications A-M, from the end of the 18th century, were assigned by the Abbot Giovan Battista Venturi. Of small, even pocket-book, size, these little books with their

sand some de l'une per molphure annonnes.

due acutus uou jegenhum numa di dunduno in de allen es chale de come de come de come de come per de la societa per de come de come per de come per de come de come de come per de come per de come de come per de come de come per de come de come de come de come de come de come per de come per de come de come per de come per de come de come per de come de come

expone alle lighter of the front delle sulles of chome alle lighter of the front delle sulles of the front delle sulles of the front delle sulles of the front of the front of the front of the contract of the front of the front of the contract of the front of the contract of the

- Manuscript K, Paris, Institut de France.
- 2. Rays of light through an angular opening (1490-1491), Manuscript C (fo. 10v).
- 3. Manuscript I, Paris, Institut de France.
- 4. Machinery
 for manufacturing
 concave mirrors;
 study on shearing
 power with
 mathematical
 calculations
 (c. 1515),
- Manuscript G (ff. 83v and 84r).
- 5. Clockwork for planetary clocks (c. 1498), Manuscript L (fo. 92v).
- 6. Balanced scales and notes; studies of comparative
- anatomy (1506-1507), Manuscript K (ff. 110r and 109v).
- 7. Coloured fruits and vegetables on a large ink-spot (1487-1489), Manuscript B (fo. 2r).

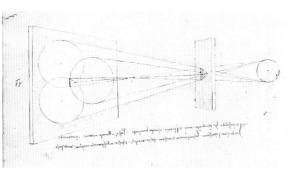

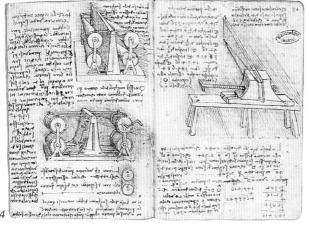

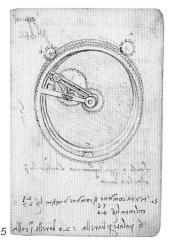

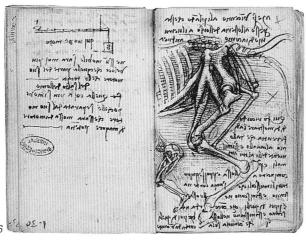

drawings and notes conserve the form and the original characteristics of Leonardo's compiling, including the habit of beginning from the back of the book and proceeding toward the front (here it should be recalled that Leonardo was left-handed and that he wrote from right to left) and the frequent upside-down sheets. Of the twelve notebooks, Manuscript A (1490-1492) and Manuscript B (the oldest known of Leonardo's notebooks, dating from 1487-1489) were involved in the theft by Guglielmo Libri. Integral parts of them were the so-called Ashburnham notebooks 2038 and 2037 (put together by Libri of the sheets he had stolen, sold by him to Lord Ashburnham and then returned to the Institut de France in 1891).

In Manuscript B appears a series of futuristic drawings of flying machines, the submarine, and even an "aerial screw", a forerunner of the modern helicopter. Manuscript E is important (a late codex, containing notes from 1513-1514), from which Libri also robbed the last booklet, which was to be lost. The main section deals with mechanical physics, to which Leonardo made a determinant contribution. Manuscript F (1508), where the theme of water plays a major role, is one of the notebooks which has come down to us practically intact from the time of Leonardo. In Manuscript L (1497-1504) are notes on the Last Supper. Manuscript M (1499-1500) testifies to an important moment in the life of Leonardo, when he began to study some of the great classical authors, such as Euclid, whose lesson was to decidedly influence his observations on geometry, a significant subject in this codex.

NOTEBOOKS FORSTER

These are three small notebooks

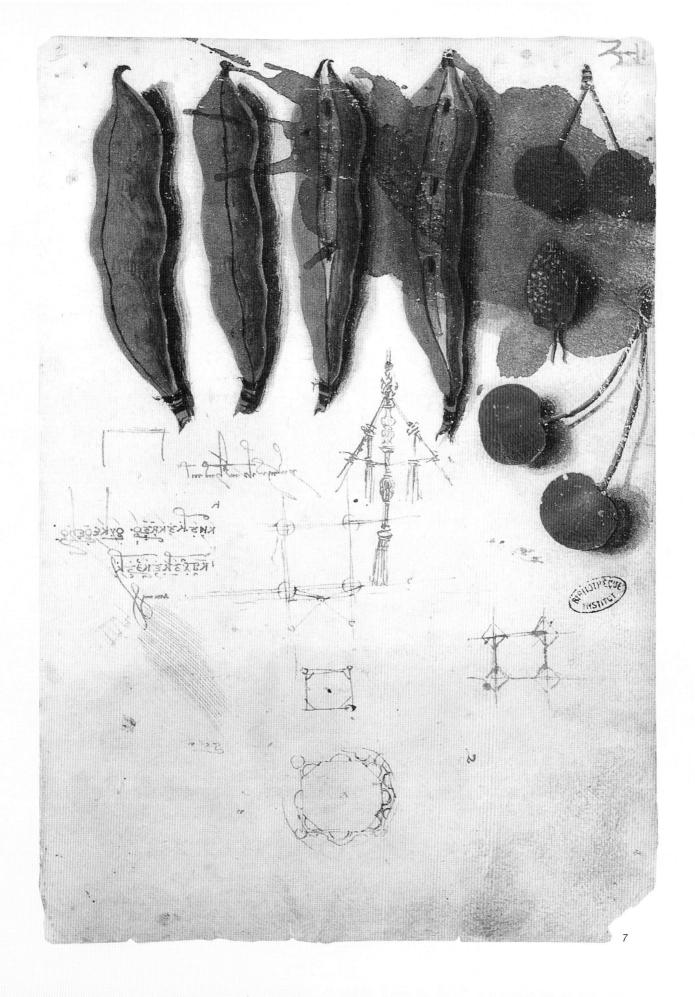

- 1. Geometrical figure; proportional compass and its nutscrew (1505), Codex Forster I (fo. 4r).
- 2. Geometrical figures: dodecahedron and pyramid with pentagonal base (1505), Codex Forster I (fo. 7r).
- 3. Drawings of device for rotating wing (c. 1505), Codex on the Flight of Birds (ff. 16v and 17r).
- 4. Birds exploiting currents of air for their spiralling flight (c. 1505), Codex on the Flight of Birds (fo. 8r).

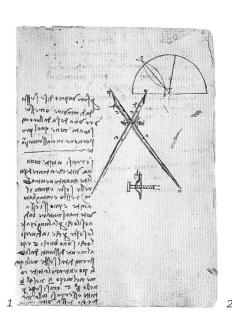

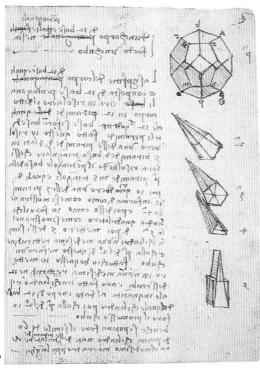

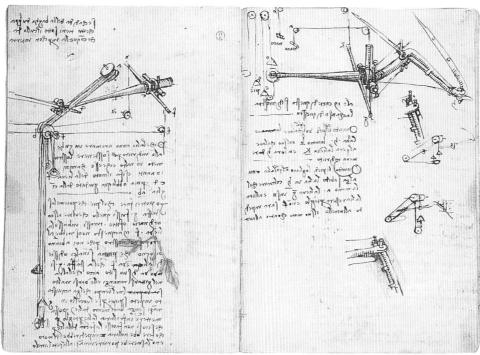

(London, Victoria and Albert Museum), of the pocket notebook type, which differ greatly in the subjects dealt with (geometry, hydraulic engineering, physics, but also literary questions, notes on the *Last Supper*, architectural projects, and practical notes of various kinds) as well as in dating (a span of time ranging from 1487 to 1505).

The three manuscripts met the common fate of passing from the ownership of Leoni to that of Lytton, then to be inherited by John Forster who bequeathed them to the London museum at his death in 1876.

CODEX ON THE FLIGHT OF BIRDS

Of small size (Turin, Biblioteca Reale; 21x15 cm), this codex formed part of Manuscript B from which, as previously mentioned, it was removed by Guglielmo Libri, who then dismembered it, selling five folios in England. The rest of the codex, now only thirteen folios, was purchased in 1867 by Count Giacomo Manzoni di Lugo. His heirs then sold it to the Russian Prince Theodore Sabachnikoff, who published the first printed edition after having acquired one of the five missing folios.

In 1893 Sabachnikoff donated the manuscript to the Savoia family. Placed in the Biblioteca Reale at Turin, it was completed with the four missing pages in the years between 1903 and 1920 and bound in 1967. As indicated by the name of the manuscript it consists mainly of studies on the flight of birds linked to attempts at building a flying machine.

The date 1505 appearing in the codex specifies its chronology, also in relation to the design of the flying machine. First conceived with beating winds, moved by the energy of human muscles, by this date it was instead designed as a kind of glider capable of

Moggy orusa vato oddony vary vseto vys vyy i). Jusish outure in a la sun a sur in la international of the opposite ishising who more pursions - Alun osish linn la mase obblique soite quith sury I Mygy orway vdo July other vyypiliz THE MUTTO & GRUSSING MENDER MANNES GAILS GAILS Makillian alle Cerana lane Dotto printo utlen ellapire (nechigheliste : mollance vonité Li verebne fire, cibotitic notto binto into into into ville allegorius inininal Tidotto Jotring throp control of the John MARISINA

- 1. Note on historical burning of the library at Alexandria; caricatures of heads; ironic verse on Petrarch (1487-1490), Codex Trivulziano (fo. 1v).
- 2. Clockwork mechanism (c. 1495-1499), Codex Madrid I (fo. 27v).
- 3. Clock spring and device for automatic release of loads; set of linked chains (c. 1495-1499), Codex Madrid I (ff. 9v and 10r).
- 4. Drawings for clockwork mechanisms and notes (c. 1495-1499), Codex Madrid I (ff. 13v and 14r).

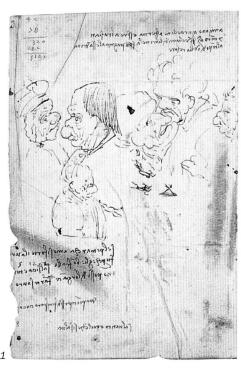

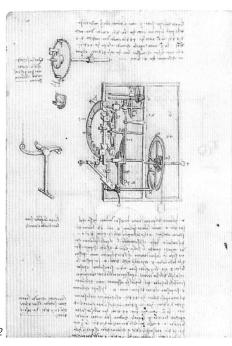

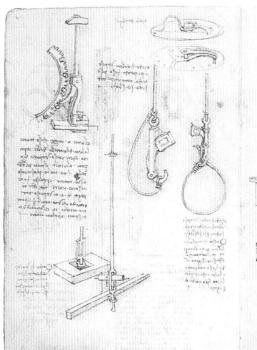

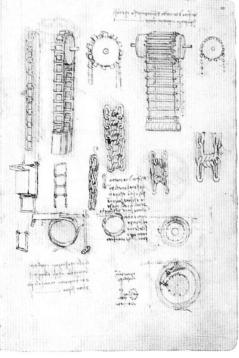

exploiting currents of air. CODEX TRIVULZIANO

This codex, of format approximately 20.5x14 cm (Milan, Biblioteca del Castello Sforzesco Library) - originally consisting of 62 folios, several of which are missing today - was marked by Francesco Melzi with the letter F. Owned by Leoni and then by Arconati, it is described in the act of donation to the Biblioteca Ambrosiana (1637) but must have been taken back by Arconati in exchange for the volume then known as Manuscript D. News of this codex was then lost until it reappeared again in the possession of Gaetano Caccia, who gave it to Prince Trivulzio in 1750. With the Trivulziano collection it entered the Biblioteca del Castello Sforzesco in 1935. Bound with some of the booklets upside-down, its pages have been renumbered in red ink to avoid confusion in the order of the sheets. Among the oldest known manuscripts by Leonardo, it dates from the years 1487-1490.

NOTEBOOKS MADRID

This is the name given to the two volumes found astonishingly – and by chance – in the Biblioteca Nacional of Madrid in 1966 and published in facsimile in 1973. It now seems certain that these are the two books possessed by Don Juan Espina, who probably received them through the Leoni heredity.

At the death of Espina the two volumes seem to have passed to the Spanish Crown and then to the Royal Library where they were catalogued for the first time in the inventory of 1831-1833. But in moving them (1830) along with other manuscripts from the palace to the Royal Library, an error was made in transcribing the designations, which blocked all attempts at finding them again until 1966.

In Codex Madrid II (dating for the

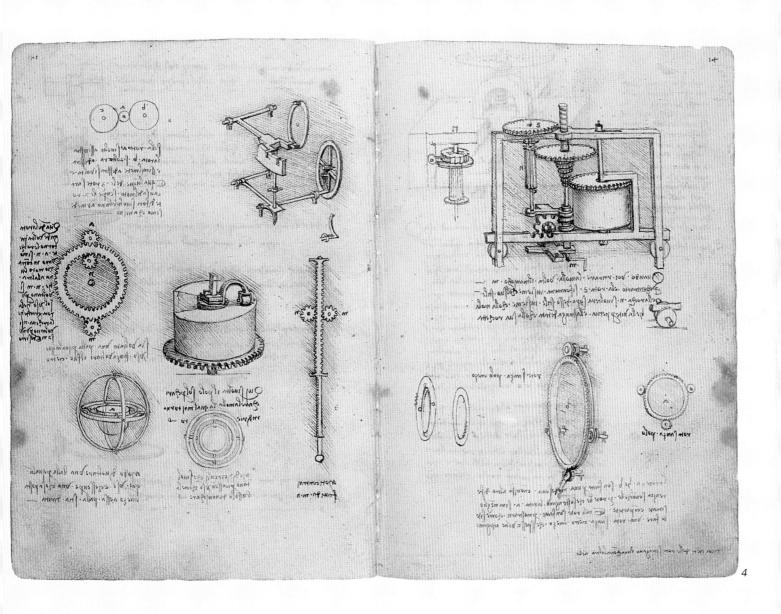

- 1. Study for the casting of the equestrian monument to Francesco Sforza (c. 1493) detail, Codex Madrid II (fo. 149r).
- 2. Antique binding of Codex Hammer (1720-1730).
- 3. Page of notes on the Moon; drawings and notes on lighting of the Sun, the Earth, the Moon (1506-1508),
- Codex Hammer (ff. 36v and 1r).
- 4. Siphons for studies on communicating vessels (c. 1506-1508) detail, Codex Hammer (fo. 34v).
- 5. Studies of "mechanical elements" (levers and springs) (c. 1497) detail, Codex Madrid I (fo. 44v-45r).

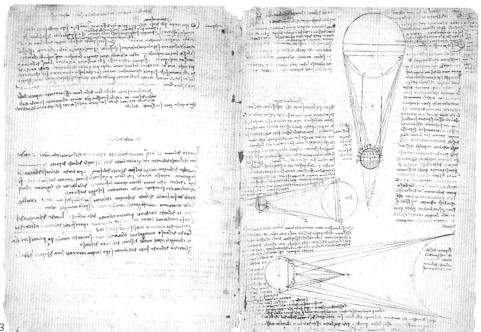

most part from 1503-1505) there are very important notes on the *Battle of Anghiari* and on perspective, which were used by Melzi in compiling the *Libro di pittura*. The manuscript also contains an inventory of books, of fundamental importance for defining "Leonardo's library".

CODEX HAMMER

Now at Seattle, in the Bill Gates collection, this is a group of 18 double sheets (thus 36 folios with recto and versus, having an average size of 29x 22 cm) which Leonardo compiled in pen and ink from 1506 to 1508, with additions made up to 1510, working on one dual sheet a time, each of which was then placed inside the others as in a book, but making of it a kind of mobile repertoire, open to reconsideration and revision. It is probable however that it was Leonardo himself who decided to have the folios sewn together to make a book, so that the manuscript can rightly be called a codex. After having been bought by Armand Hammer (1980), the codex was dismembered and now consists of loose sheets, as when Leonardo compiled it.

In 1994 it was purchased by Bill Gates, and has thus remained in the United States. The predominant theme of this manuscript is that of studies on water, illustrated by fascinating drawings of currents, waterfalls and whirlpools.

he study of Leonardo through his manuscripts has taken on the aspect of international co-operation, ensuring its continuity and effectiveness. The research organisations involved have developed around specialised libraries, such as the Biblioteca Leonardiana of Vinci, which is the oldest (founded in 1898), the Raccolta Vinciana of Milan (1905 wich edit since then the homonymous year-book), the Elmer Belt Library of Vinciana, donated by the founder to the University of California at Los Angeles in 1961 and since then incremented by Carlo Pedretti as professor and researcher. Pedretti has also established at the same university a Chair of Leonardo Studies unique the world over, made possible by the sponsorship of Armand Hammer, also responsible for the institution, in 1985, of the Hammer Center of Vincian Studies at the same university. Directed by Pedretti from the start, the Center carries out a program of academic and editorial activities and exhibitions (also in collaboration with the

Museo Ideale di Vinci, founded and directed by Alessandro Vezzosi) and publishes the yearbook "Achademia Leonardi Vinci" (Giunti). The Italian headquarters of the Hammer Center is lo-

STUDYING LEONARDO

The "villa" of Castel Vitoni, Italian headquarters of the Pedretti Foundation for Leonardo Studies. Below, from left: Elmer Belt, founder of the Elmer Belt Library

cated at the Faculty of Philosophy of the University of Urbino.

Carlo Pedretti has also founded, again at Los Angeles but with a European base in his villa of Castel Vitoni at Lamporecchio above Vinci, the Foundation that carries out on his behalf an ambitious program of collaboration with cultural institutes in Italy and other European nations as well as the Near East, with Israeli universities in particular.

Already in 1977, at Brescia, another Leonardo expert, Nando De Toni, had founded a Center for Leonardian Research with the quarterly publication of a bulletin of bibliographical updating, repertoires and special contributions to the study of Leonardo's manuscripts and drawings,

of Vinciana at Los Angeles; the bulletin of the Brescia Center for Leonardian Research; The Yearbook of the Hammer

Center at Los Angeles.

and to their sources in particular. The activity of the Brescia Institute was then concentrated on the organisation of exhibitions and annual symposiums, also within the context of the programs of the local university, and maintaining contact with scholars all over the world.

Seminars, conferences and other academic activities have been favoured by the generous bequest of André Corbeau, including his vast Vincian library, to the University of Caen in Lower Normandy, France. Similar objectives are pursued by the Leonardo da Vinci Society at London, which has been active for some years under the guidance of Martin Kemp of the University of Oxford, with the periodic publication of a "Newsletter for Leonardisti".

An important Florence-based organisation is the Fondazione Leonardo da Vinci, which supports the activity of the Giunti publishing house as concerns the programs of the National Edition of Manuscripts and Drawings of Leonardo da Vinci, in particular with fellowships managed by the Museum and Institute of History of Science in the same city. The Vinciana Commission for the National Edition of the Works of Leonardo, a ministerial organisation founded in 1902,

has recently assumed the function of research institute as well, promoting special projects aimed at producing working tools such as indexes, glossaries, repertoires and bibliographies.

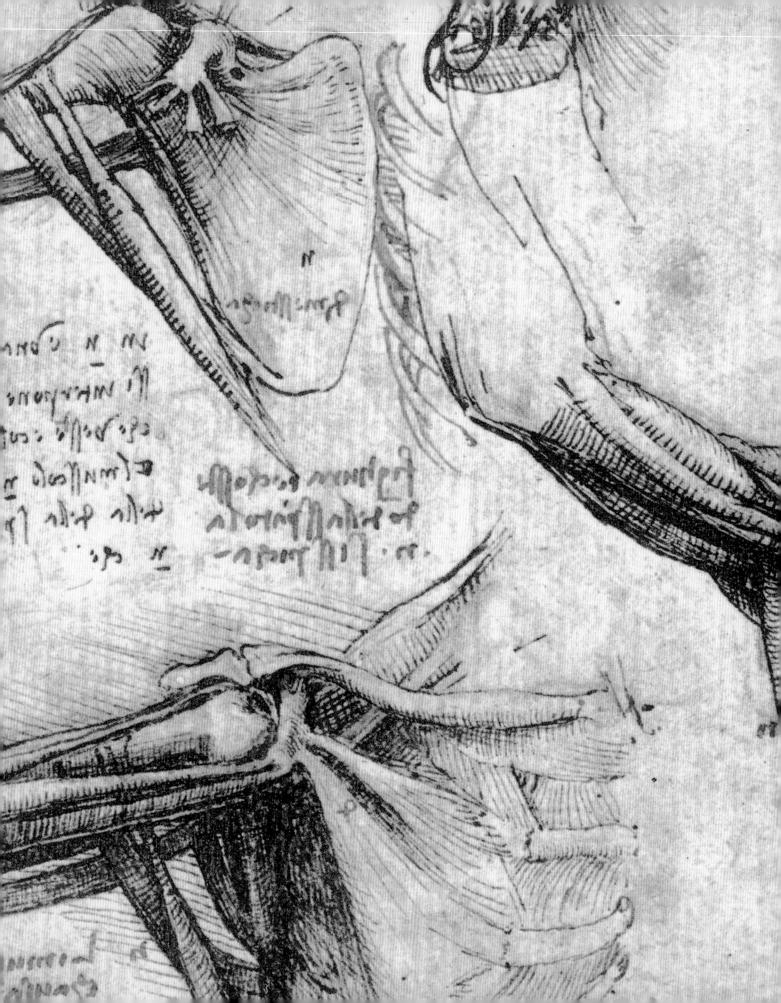

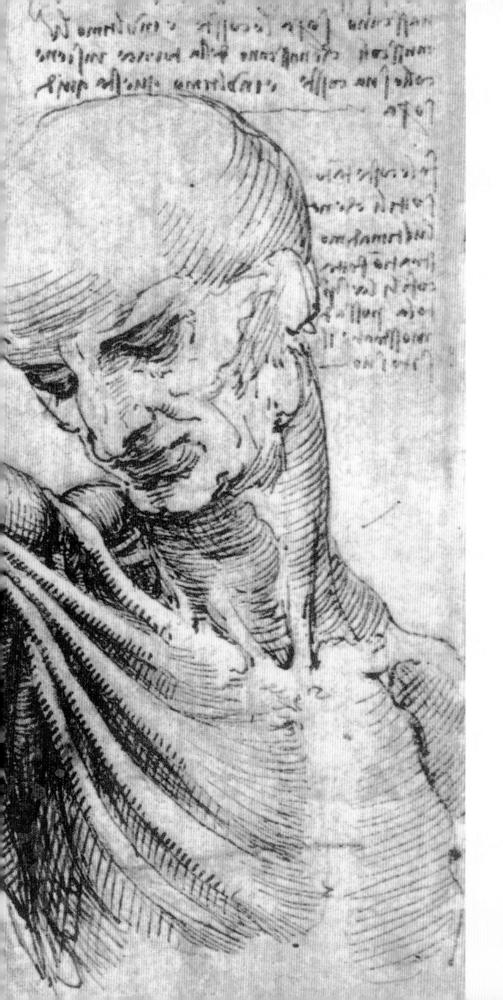

The corpus of Leonardo's anatomical drawings, composed of approximately two hundred folios, is kept in the Royal Library at Windsor. They are fascinating, intensely interesting drawings showing a superb balance between art and science. Leonardo dedicated himself to observation of the human body with a commitment so extraordinary as to arouse the admiration of his contemporaries. This is expressed in the words of Antonio De Beatis who in 1517 accompanied the Cardinal of Aragon on a visit to the studio of the now elderly Leonardo in France: «This gentleman has compiled a treatise on anatomy, with the demonstration in painting [...] in a way that has never yet been done by any other person. All of which we have seen with our eyes and he said that he has already dissected more than thirty bodies, both men and women of all ages».

- Overleaf, on the two preceding pages: Muscles of the shoulder (1509-1510) detail, Windsor, Royal Library.
- Old man with a thin body, probably the centenarian
- dissected by Leonardo in 1507 (c. 1507-1508), Windsor, Royal Library.
- Royal Library.

 2. Muscles
 of the shoulder
 (1509-1510),
 Windsor,
 Royal Library.
- 3. Muscles of the shoulder at three different moments during dissection; bones of the foot (c. 1508-1510) Windsor, Royal Library (RL 19013v; K/P 144v).
- 4. Muscles
 of the shoulder,
 of the neck and
 of the chest in action
 (c. 1508-1510),
 Windsor,
 Royal Library
 (RL 19001v;
 K/P 136 v).

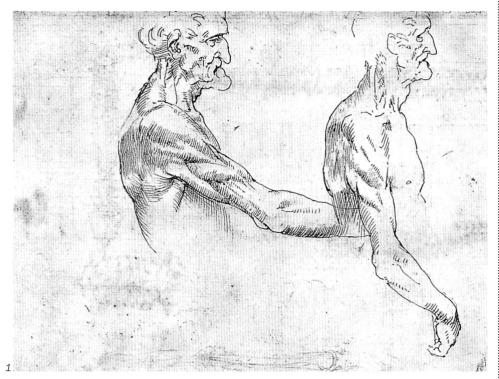

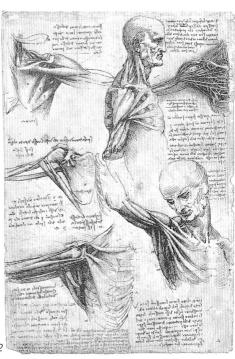

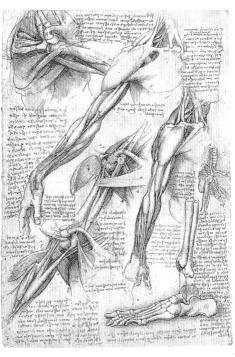

p to the winter of 1507-1508 Leonardo did not practice dissection in any systematic way. At this time he had the opportunity of studying anatomy directly on the corpse of an old man in the hospital of Santa Maria Nuova in Florence, as he recalls in a famous note: «This old man, a few hours before his death, told me he was over a hundred years old, and that he felt no illness in his person apart from a certain weakness, and so sitting on a bed in the Hospital of Santa Maria Nova in Florence, with no other movement or any sign of accident, he passed out of this life. And I practised anatomy on him, to see what was the cause of such a gentle death [...], the which anatomy I performed very diligently and easily, as the old man had no fat or humours in him, which make it difficult to recognise the parts».

This experience, based on the direct observation of a cadaver rather than on acquired medical knowledge, was central to Leonardo's renewed anatomical interest. It was followed by the years of his stay in Lombardy (1510-1511) where he met and exchanged information with Marcantonio della Torre, a young but already renowned physician-anatomist in Pavia. Lastly, it is known that Leonardo conducted anatomical studies in Rome, between 1514 and 1515, in the Hospital of Santo Spirito, studies which were broken off due to an accusation of witchcraft resulting from the denouncement of his German assistant. The results of this decade of studies, while not decisive to the progress of medical science, were extraordinary in the field of anatomical illustration, which had been rough and crude

Leonardo decided to compile an

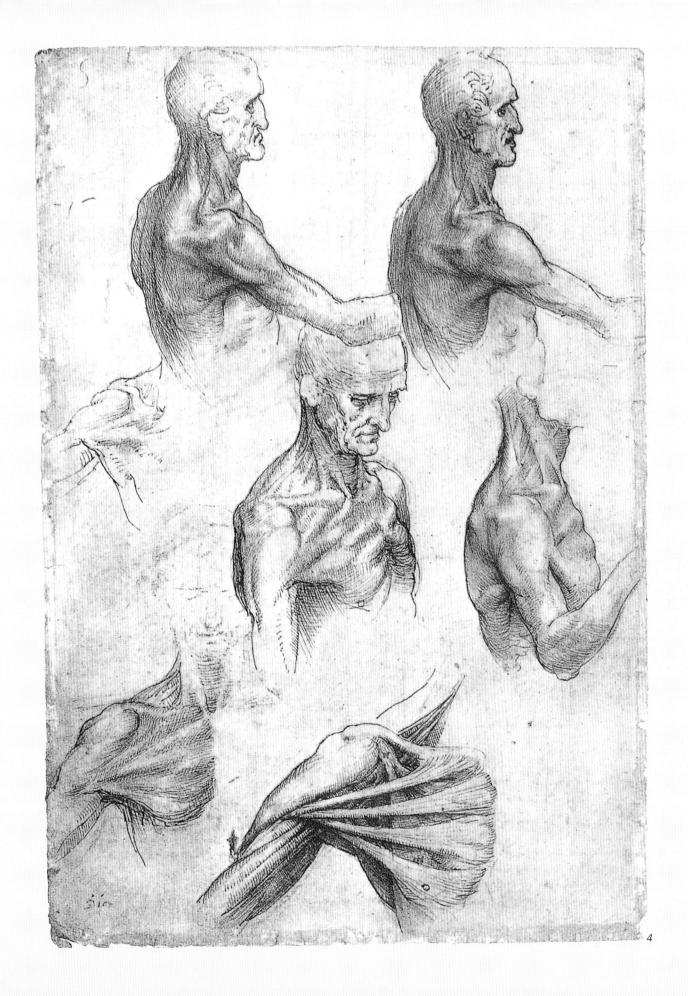

1. Anatomical figure depicting hearts, lungs and main arteries (1490-1500), Windsor, Royal Library (RL 12597r; K/P 36r). organs, bladder and urinary and seminal canal; pig's lung (1508-1509), Windsor, Royal Library (RL 19098v; K/P 106v). 3. Muscles of the arm

in rotation; tongue, throat and uvula (c. 1508-1510), Windsor, Royal Library (RL 19005v; K/P 141v). 4. Superficial veins

detail.

Windsor.

K/P 69r).
5. Female genitals and foetus in the uterus (1510-1512), Windsor, Royal Library (RL 19101r; K/P 197v).

Royal Library

(RL 19027r;

2. Male genital

Description of the state of the

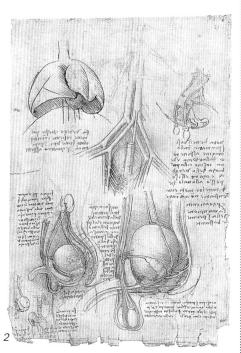

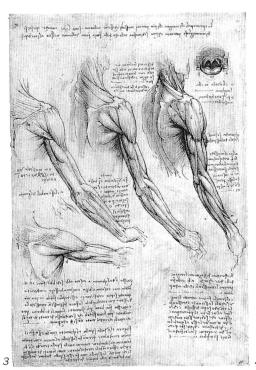

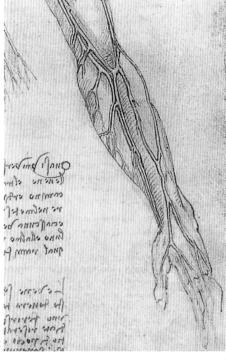

"anatomical atlas", similar to Ptolemy's *Cosmography*, composed of a number of plates illustrating his experience on various cadavers, to furnish a tool even more clear and useful than the direct practice of anatomy.

This is obvious from the following proud claim, an extraordinary example of scientific prose of the highest level as well as an avowal of the difficulties, often revolting, endured by Leonardo in his thirst for knowledge:

«And you who say it is better to see anatomy conducted than to see these drawings, you would be right if it were possible to see in a single figure all of the things that the drawings show; but with all of your ingenuity in this, you will not see and you will have no knowledge of anything but a few veins [...]. And a single body was not enough for the time required so that it was necessary to go on to many bodies in order to have complete knowledge, and I did this twice to see the differences [...]. And if you are attracted to such a thing you will perhaps be prevented by the stomach, and if this does not prevent you, it will be the fear of spending the hours of the night in the company of such bodies, quartered and skinned and unpleasant to see. And if this does not prevent you, perhaps you will have no gift for drawing, which is needed for such illustration; or, if you have a gift for drawing, it will not be accompanied by perspective; and, if it is, you will be lacking in the order of geometric demonstration, or in calculating the forces and power of the muscles, or perhaps you will be lacking in patience, so that you will not be diligent. If all these things have been present in me, the hundred and twenty books

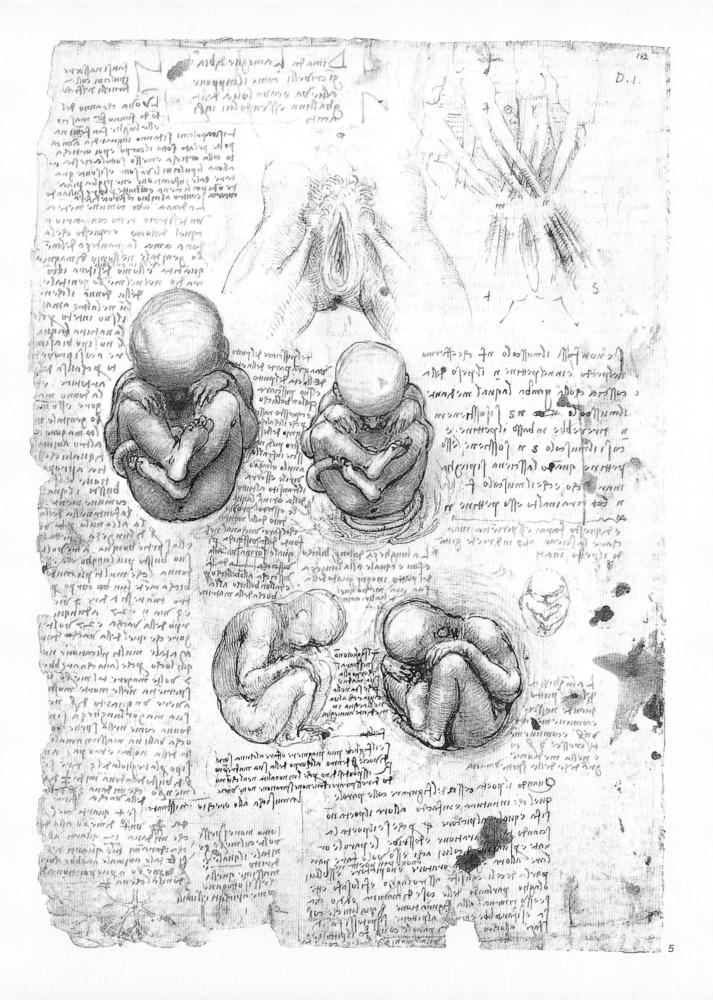

- 1. Observer looking into a glass model of the human eye (1508-1509) detail, Manuscript D (3v).
- 2. Lateral views of the skull (c. 1489), Windsor, Royal Library
- (RL 19057r; K/P 43r).
- 3.Technique for injecting molten wax into the cerebral ventricles to reveal the inner shape of the brain of an ox (c. 1508-1509), Windsor.
- Royal Library (RL 19127r; K/P 104r).
- 4. Section view of a human head (c. 1493-1494), Windsor, Royal Library (RL 12603r; K/P 32r).
- 5. The ventricles, eyeballs with optic nerve and cranial nerves (versus of the so-called Weimar Folio).

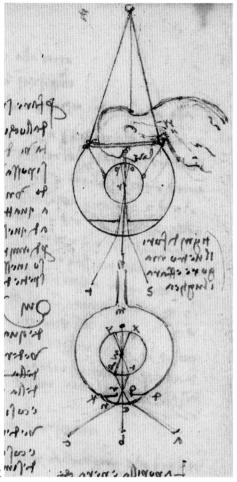

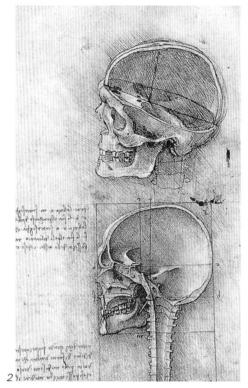

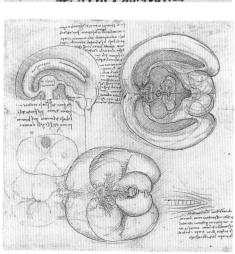

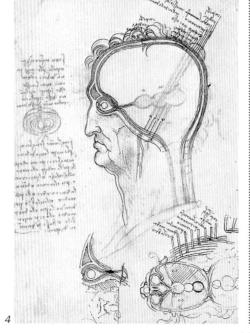

[chapters] composed by me will give judgement, in which I have been impeded neither by avarice nor by negligence, but only by time. Farewell».

THE EYE AND THE BRAIN

Leonardo's first true anatomical studies date from the years 1487-1493, during his stay in Milan. These studies consisted of exploration of the cranium (rendered in the drawings with extraordinary accuracy and perspective) through which Leonardo hoped to find the meeting place of all of the senses, or "common sense", which was also considered the seat of the soul.

The activity of painter and the investigation of nature, based on observation of its phenomena, must have triggered in him interest in the functioning of the eye as the instrument of sight. Already in the early 1490s Leonardo was drawing, following the indications of the ancient authors, eyeballs from which the optic nerves depart for the brain. And in the early 16th century he was still dedicated, but with greater independence, to studying the connections between eye and brain, drawing first the chiasma, or meeting point of the optic nerves.

Leonardo later carried his examination of the ventricles of the brain (not human but bovine) still further by developing an ingenious sculptural technique consisting of injecting melted wax into an organ, allowing it to solidify and then removing it to reveal the shape of that anatomical part.

THE SKELETON AND BONES

Leonardo's interest in osteology (the study of bones) emerged in the years of his maturity, in about 1508-1510, contemporary with other stud-

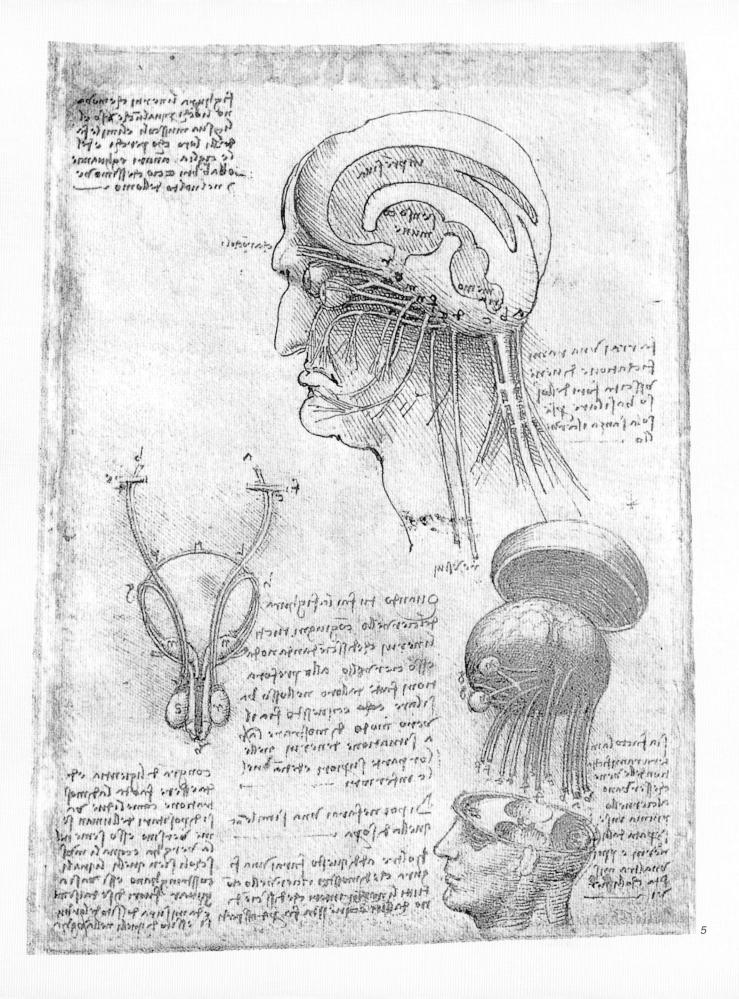

- 1. Bones of the foot and shoulder (1508-1510), Windsor, Royal Library (RL 19011r; K/P 145r).
- 2. The backbone (1508-1509), Windsor,
- Royal Library (RL 19007v; K/P 139v).
- 3. Bones of the legs and knee (c. 1508-1510), Windsor, Royal Library (RL 19008r; K/P 140r).
- 4. Movements of the arm determined by the biceps (c. 1508-1510), Windsor, Royal Library (RL 19000v; K/P 135v).
- 5. The skeleton of the trunk and legs (1509-1510), Windsor, Royal Library (RL 19012r; K/P 142r).

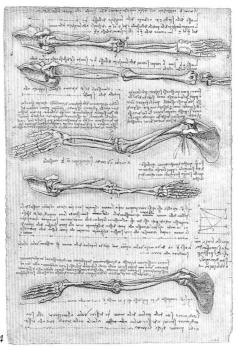

ies conducted directly on the human body, the muscles for example, for the purpose of describing their functioning.

In a note written slightly earlier, a memorandum or "commencement" (one of the many) for a treatise on anatomy, Leonardo begins with a reference to the skeleton and the bones as the bearing elements of the human machine: «This instrumental figure of man will be a demonstration in [24] figures, of which the first three will be the ramifications of the bone structure. i.e., one will show the latitude of the sites and figures of the bones; the second will appear in profile and will show the depth of all of the parts and their site; the third figure will illustrate the rear part of the bones. Then there will be three other figures of similar aspect, with the bones sectioned, in which their size and inner cavity can be seen».

This note is also useful for understanding the technique of illustration that Leonardo intended to use, consisting of representing the skeleton and each of its individual bones from different angles and at different depths. This can be seen by observing the drawings for this section, rightly considered to rank among Leonardo's finest for their realist anatomical detail as well as for their clearness of line.

MUSCLES AND NERVES

Leonardo's study of the muscular apparatus (myology), conducted mainly between 1505 and 1510, found expression in a series of drawings unanimously acclaimed as among the best and most evocative of the entire anatomical corpus.

The study of muscles proceeded contemporaneous with that of bones and the skeleton, although with sci-

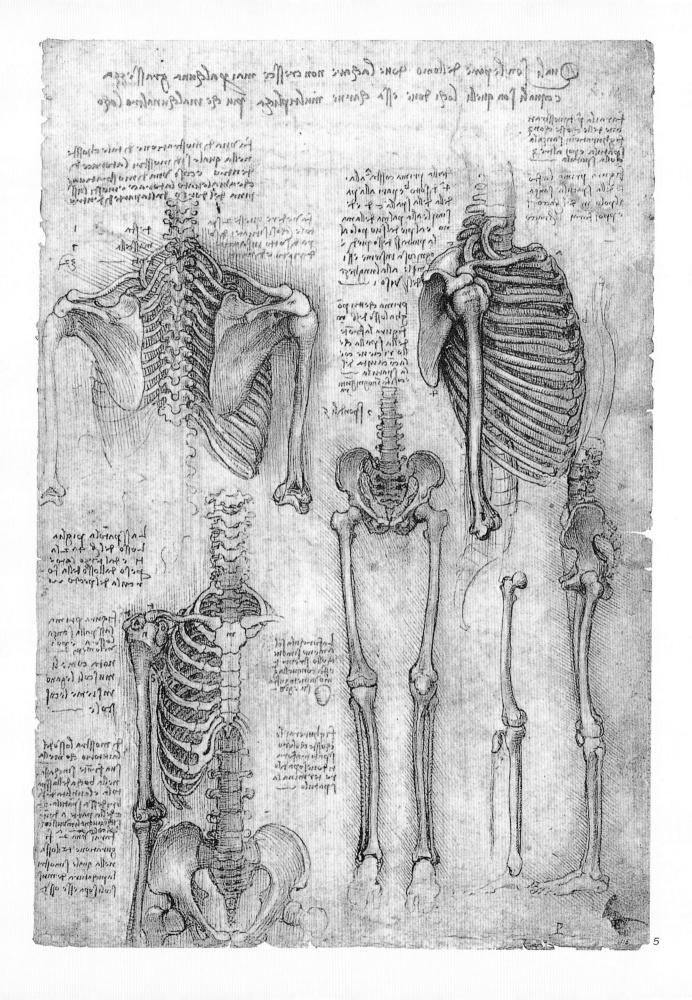

- 1. Heart of an ox, Windsor, Royal Library (RL 19073-19074v; K/P 166v).
- 2. Muscles of the arm, hand, and face (1509-1510), Windsor, Royal Library (RL 19012v; K/P 142v).
- 3. Muscles of the neck (c. 1513), Windsor, Royal Library (RL 19075v; K/P 179v).
- 4. The heart and the lung (c. 1513), Windsor, Royal Library (RL 19071r; K/P 162r).

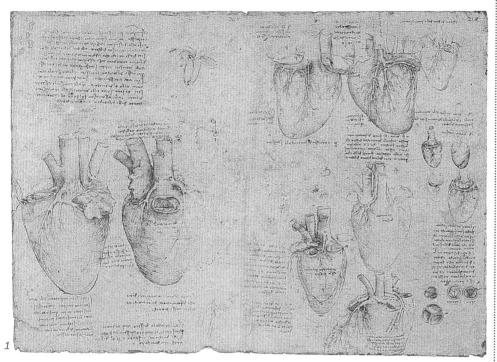

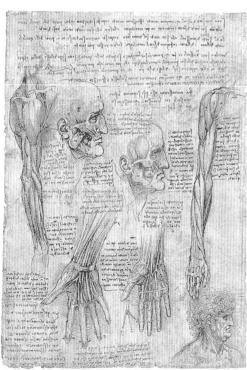

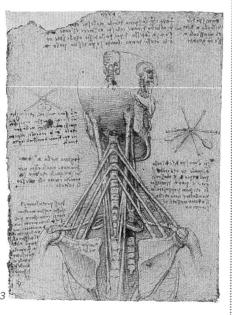

entific results not always on the same level, both for the objectively greater difficulty of investigation and for the pioneer nature of studies in myology at the time.

Correlated to the study of the muscles was that of the nerves. After youthful experiments on frogs and monkeys Leonardo made significant progress in the representation of the human central nervous system, drawing the so-called "tree of nerves" which from the brain and the neck extends along the spine from where it branches off to the arms and legs.

THE HEART AND VEINS

Leonardo studied the cardiovascular system at two different times in his life. Dating from the last decade of the 15th century is a drawing depicting "the tree of the veins", strongly influenced by the theories in vogue at the time, the Classical ones of Galenus and the Medieval ones of Mondino.

It was only in later years, around 1513, that Leonardo began to study the heart more thoroughly, experimenting through dissection, although this was done only on animals (mainly oxen) rather than human organs.

But Leonardo was never able to furnish a new, comprehensive, organic idea of the circulatory system, remaining in this substantially bound to the concepts of the Galenic school.

Leonardo exerted great effort to understand the mechanism of the opening and closure of the valves (the aortic valve in particular) and the flow of blood through the heart. To this end he employed again applications and experiments already developed in his activity as hydraulic engineer, when practice in

Aguni, and gave internal replaces

smoot on your following representing updailthos officiental ougul many of your Manner of the state of the Coffe and or non-flower descere white light inclouding enall, who tridand our thus hond obned 4. (1) Auftion: 4. (1) הואים כ מב בולב לפי המור ולי בי ועול ביו possibility of allings worders are a fancil allumble sent university curting youles ets anothing 10 reason of a duril a boul a in (vaniery the se sector black) "apita poar atoy" was legens contrar infirmalingly deview of its stub it alabily mente mountait exclisionly itamet by אין משתחת למיושו בשהלת ש בולחן Enforts we Buttom: Jelle Deter while of the sales of the state of the sail frothers believes for language to and an infact of Hat and and about Constitution which was a constituted and south of the constitution the afternoon of the party of the salary of Minhiga caper atundant which at about a tour at the specific Levening note Manne inter विवासिक राम के गार्टिक विवास विभाव and the specific continues of princing the specific control of the specific co to the mentiones and the hana fella happanan and action of action File fellowskill and nous he wastered attent pray part signation of the Sughin sulp by Sulping really of need of white pelature continue la justi May Joseph vu בלפה קוותלו למנהי הי למין להיו office antiflated indo an mortunita vo maps affine instead Holly Average wind of he will ment hashe 1: 20/00 andony viddotan illig white his restrictions Lynnah benning Winter Weema william peralle investered of The street with a little and the street and the str Halphan Color constant in him pully adelly print per rue et entetuni fun roma pata tions alogung mater for top aftern The every al pennic विज्ञाम (() will brings when hipping carrens lifurfunkanale いれているというか of the phant of the story a sullandia the statum anterior encoveration of שיון שיירוש אל ביודים בין HOIMANTIN HINT [compfulling single change in by the federal consider System date pl Inppose bette be fiber edenverie colorge edellisheshe William Is short remained following accounts INE SHALL MOHEN went chamed las Mand 150 process suppopulate and from the state many states and a state of the market would are the standing and the stand stands are the stands and said the standing of the The stall enteres force of the stall such and the state of the water to belond to the bushes beaut after chald the treat E finish buche incompequines with courses frame (course to confict to chellerer establinary lekningstocking to the of the full time inminishing in ham the telling we blentlike our betrille ally per multipliana ecompletations billediens chemister ets chantlants eine the reference employer alla prantice quality ever thin we be mund by attending the many peny some one of the continued to the first through the continued to t The pill of minimum of the call of the call over round draft till colle vidente tu had towed to annumber adouble chouse you aluelly eventherms of the discussion event in broke trans the aft (aftifficient to be desimant

- 1. Organs of the chest and abdomen of a pig (1508-1509), Windsor, Royal Library (RL 19054v; K/P 53v).
- 2. Abdominal viscera (1506-1508),Windsor.
- Royal Library (RL 19039v and r: K/P 61v and r).
- 3. Representation of the stomach and intestines (1506-1508),Windsor. Royal Library (RL 19031v:
- K/P 73v).
- 4. The liver and the branches of the hepatic veins, Windsor. Royal Library (RL 19051v; K/P 60v).
- 5. Viscera of the chest and abdomen with

particular attention to the heart, the vascular system and the lungs (1506-1508), Windsor, Royal Library (RL 19104v; K/P 107r).

the construction of channels had led him to study attentively phenomena linked to the flow of water. He even constructed a glass model of the aorta, utilising a waxen mould of the artery of an ox, through which he passed liquid to conduct experiments on the flow of the blood.

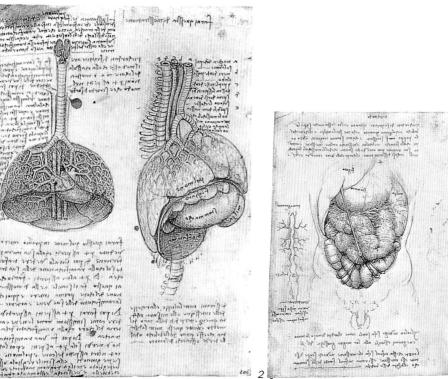

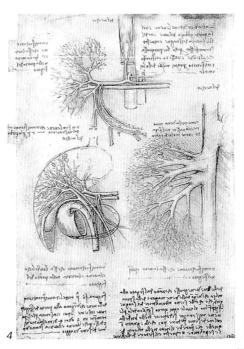

RESPIRATORY, ALIMENTARY AND DIGESTIVE SYSTEMS

Leonardo's observations on the respiratory system are concentrated in the years of his maturity, between 1506 and 1510, and were conducted mainly on animals.

The lungs (of pigs) appear several times in his drawings, represented together with the trachea and the branches of the bronchial tubes and bronchial and pulmonary arteries. Nonetheless, the concept formulated by Leonardo of the respiratory system was not far from that of classical medicine, revived in the Middle Ages, which was limited to declaring the presence of air in the lungs. On the inflow and outflow of this air Leonardo pondered at length, finding no answer.

As regards the alimentary and digestive system, after the rather schematic drawings of his youth Leonardo went on to representing the organs serving these functions with a keen accuracy deriving from his observations on the cadaver of the old man in the winter of 1507-1508.

THE GENITAL ORGANS AND REPRODUCTION

In the case of the genital organs as well, Leonardo went on from a first representation (around 1492-1494) which is quite traditional, although vivacious and expressive, to the extraordinarily accurate one of the years 1510-1512, made famous by a

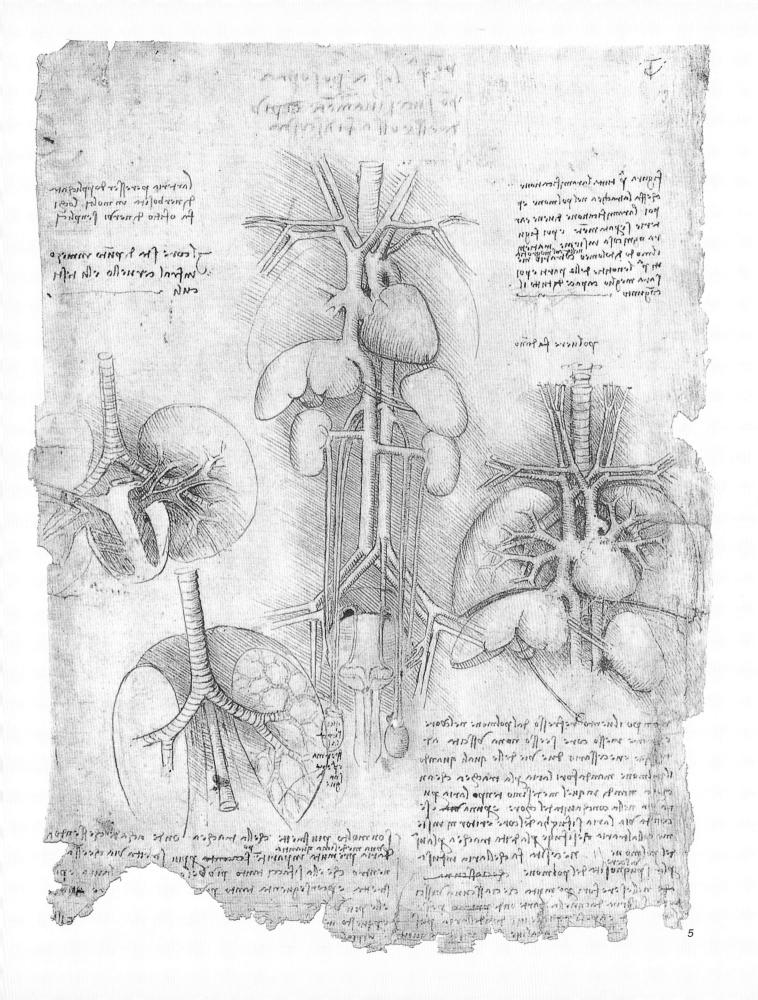

- 1. Studies on copulation (c. 1493) detail, Windsor, Royal Library (RL 19097v; K/P 35r).
- 2. Human uterus with foetus (1510-1512), Windsor, Royal Library (RL 19102r; K/P 198r).
- 3. Uterus of a cow seen from the
- exterior (above) and interior (below) (1506-1508), Windsor, Royal Library (RL 19055r; K/P 52r).
- 4. Female genital and urinary system;
- ejaculatory canal (1508), Weimar, Schloss Museum.
- 5. Foetus in the uterus (1510-1512), Windsor, Royal Library (RL 19101r; K/P 197v).

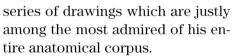

Important, in the case of woman, is his study of the ovaries and the uterus, represented during pregnancy.

To embryology (the study of the embryo) Leonardo applied himself with particularly brilliant results, although he can frequently be caught in the error of transposing to the human case experiments made on cattle.

We know however that Leonardo had had access, through dissection, to a human foetus of approximately seven months. The drawings show it, in fact, from different points of view, huddled inside the uterus with the umbilical cord that Leonardo describes as being «of the length of the child at each age». In addition to the length and positioning of the umbilical cord, Leonardo was attempting to understand, and with significant results, the miraculous phenomenon that governs growth and development of the foetus in its mother's womb up to the birth of the new life.

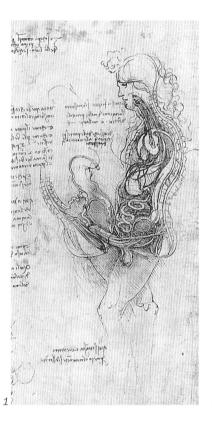

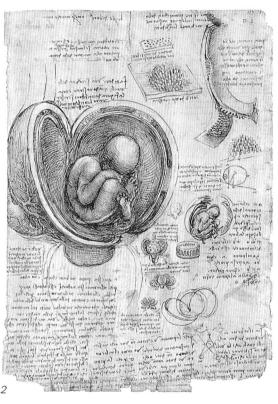

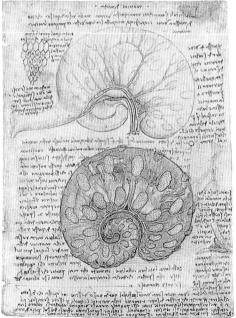

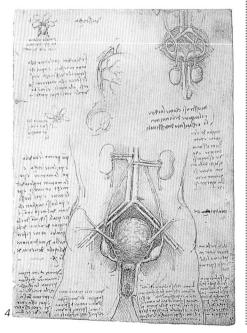

The Painter, to be good at portraying the members in all the attitudes and gestures that can be made by nudes, must know the anatomy of the nerves, bones, muscles, and tendons, know for the different movements and forces which nerve or muscle is the cause of such movement, and depict only those, enlarged and evident». So states Leonardo in the Trattato della pittura, showing that he considered it necessary for the artist to study anatomy from life, through the practice of dissection. Only in this way could a painter be able to represent

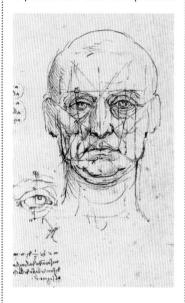

the human figure correctly. While Leonardo's anatomical notebooks are revolutionary for the quality and the intent of the representation as well as for the conception of man as a machine, it is also true that the context in which they were written was mature to welcome such results. The need for a "scientific" portrayal of the human body was perfectly in keeping with the other conquests of Renaissance art. In a space constructed according to scientific rules (arithmetical and perspective), it was only logical and necessary that

THE BODY IN ART AND IN SCIENCE

Above, from left: study on proportions of the face with details of eyes (c. 1490) detail, Turin, Biblioteca Reale (no. 15574); male nude viewed from the back, Windsor, Royal Library (K/P 84r; RL 12596r); studies on muscles of the mouth (c. 1508) detail, Windsor, Royal Library, (RL 19055v). At right: geometric proportions applied to the human figure (c. 1490), Windsor, Royal Library (RL 19136r).

man should be constructed in equally rigorous manner. And it is precisely this integration between anatomy, proportion and perspective at the service of the representation of the human body which was the true innovation of the Renaissance, when science and art found themselves closely linked and the artist became the crucially important illustrator of what anatomical practice was then discovering. This is why the Renaissance nude, presuming studies in both perspective and anatomy, can be considered the synthesis of this new epoch in art.

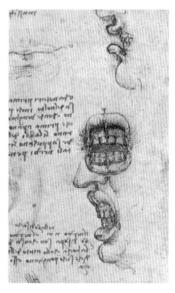

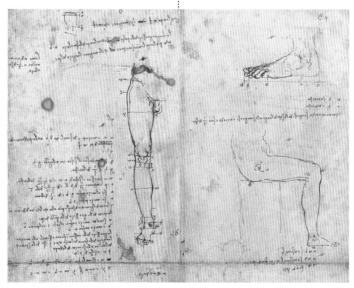

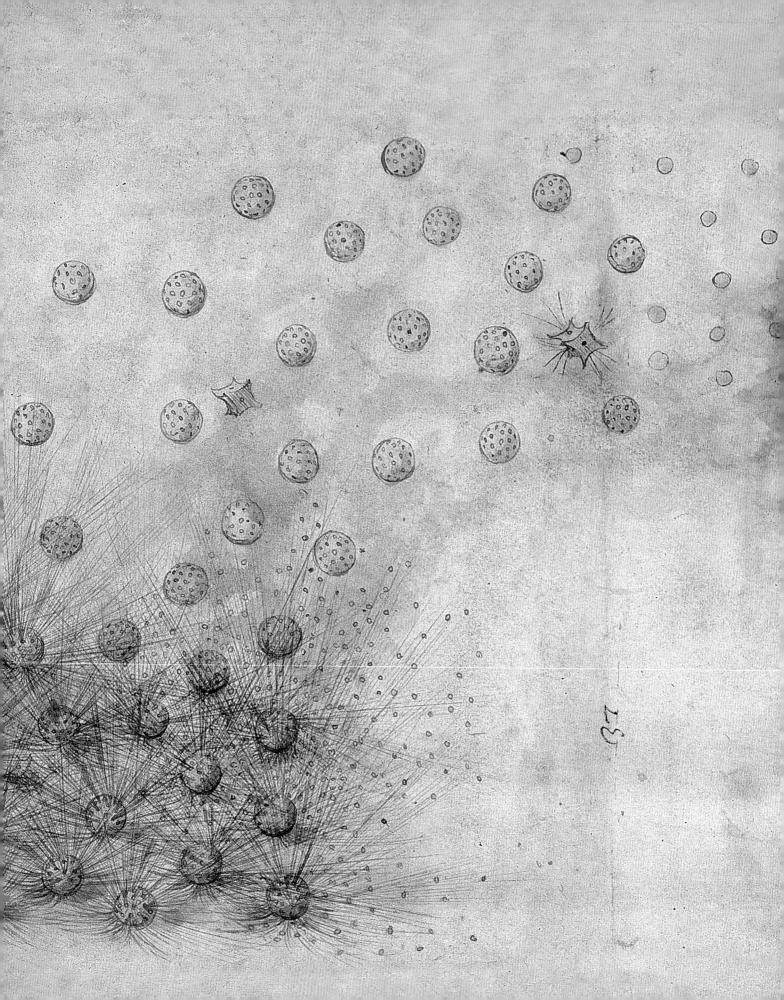

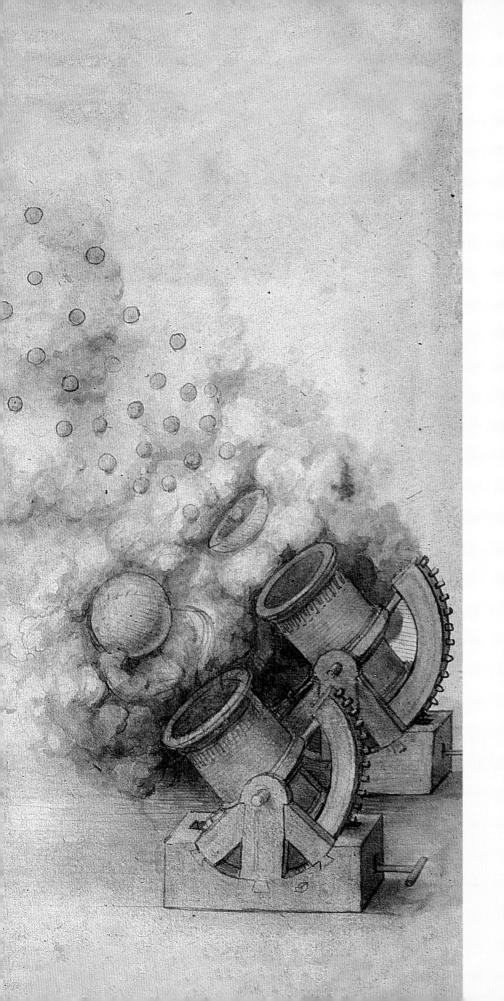

Famed for many decades as the highest manifestation of human genius and invoked as eloquent proof of the freedom from historical limitations of human thought, capable of bounding high above its own time, Leonardo remains today for a vast public a sensational "precursor", a man who surmised centuries in advance the direction that would be taken by science and technology.

This glorified image has been subjected in recent years to progressive revision, still in course, made possible especially by the adoption of stricter criteria for "reading" his work.

Overleaf, on the two preceding pages: mortar with mechanisms for adjusting its range: the cannon-balls, upon hitting the ground, ejected smaller shot,

Codex Atlanticus (fo. 9v-a).

- 1-4. Series of designs for machines, Manuscript 8937, Madrid, Biblioteca Nacional (ff. 7r. 4r. 81r. 68v).
- 5. Spring-driven motor (c. 1495), Manuscript I (fo. 14r).
- 6. Model of springdriven motor, Florence, Museo di storia della scienza.
- 7. Studies on solid geometry with a reminder (at centre, above) «Make lenses to see the moon enlarged» (1513-1514), Codex Atlanticus (fo. 518r).

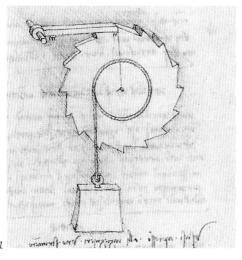

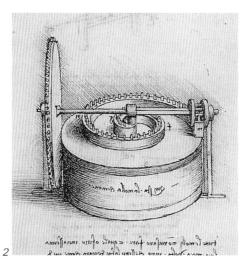

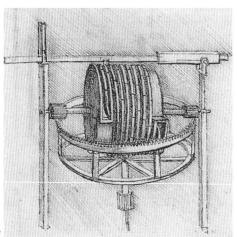

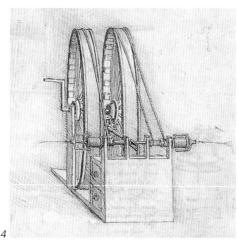

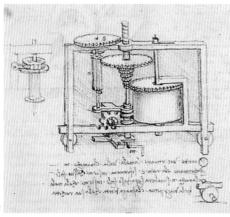

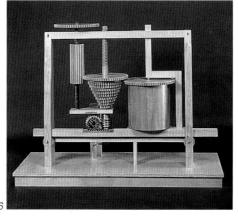

In recent years a strong tendency has emerged to tone down the hard-to-die image of Leonardo as misunderstood genius and to emphasise instead the strong evidence of the attention he systematically dedicated to the most advanced experiments and research in the technology of his time. Contemporaneously, it has been noted that Leonardo's career was marked by a number of abrupt, profound changes.

From his apprenticeship with Brunelleschi in the Florence of the 1470s to the attempt to immerse himself in the great texts of classical and contemporary culture during his stay in Milan, the change was significant. Equally significant were the efforts exerted to learn geometry, in the late 15th century and the first decade of the 16th, under the guidance of his friend Luca Pacioli. These powerful effort exerted in "retraining" also led to a sharp change in the underlying concepts of his technological research, which Leonardo increasingly attempted to derive from general scientific bases.

The science of hydraulic engineering dictated the rules for "repairing" rivers. Fluid mechanics, especially the study of the element "air" with its winds and currents, presided over the engineering of flight. A general reflection on "force", "weight", "motion" and "percussion" inspired the analysis of simple mechanisms and thus the engineering of the machines of which they were composed.

Lastly, the "factory" of the human body was subjected to the same mechanical rules through which Leonardo explained the great phenomena that have marked the face of the earth and have contributed over

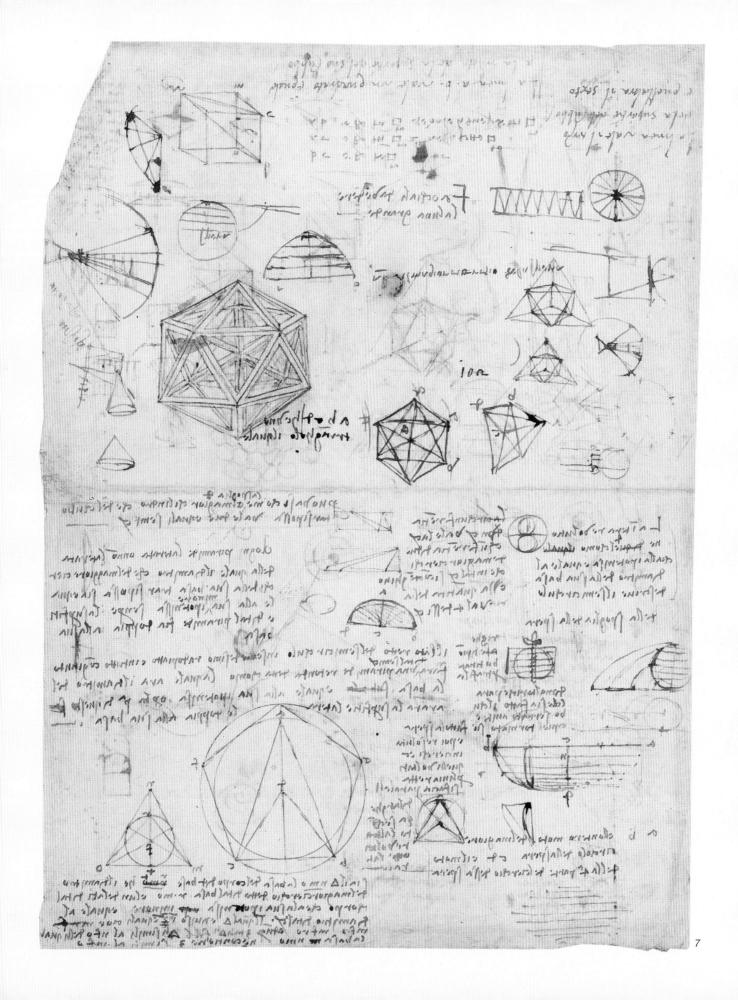

- 1. Study for a flying machine (the socalled "helicopter") (1487-1490) detail, Manuscript B (fo. 83v).
- 2. Study of lifepreserver and fins (1487-1490), Manuscript B (fo. 81v).
- 3. Study of artificial wing (1487-1490), Manuscript B (fo. 74r).
- 4. Method for experimenting the strength of a wing (c. 1487-1490), Manuscript B (fo. 88v).
- 5. Design for ornithopter with pilot in prone position (1487-1490), Manuscript B (fo. 75r).

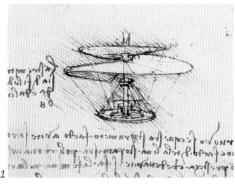

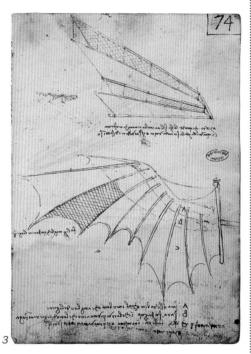

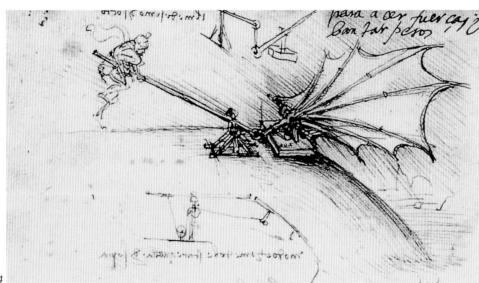

the centuries to determining its present-day aspect (mountains and valleys, floods and earthquakes, oceans, springs, and so on).

The effect of this change in attitude on the production of Leonardo the engineer after 1500 is obvious. Isolated technical projects representing an end in themselves, those which were not the direct consequence of vast, ambitious scientific research, become fewer. Vice versa, there was a proportional increase in the frequency of solemn declarations on his intention of dedicating general treatises to great sections of a universal scientific encyclopedia which was at a certain point to absorb most of his energy. The subjects to be treated were water, first of all, the truly universal element, the principal agent of the natural force whose mechanical laws Leonardo was searching for in order to bend it to the service of man; and then motion and weight, anatomy, geometric "transmutations" and all the rest.

Viewed in a chronological perspective, one which shows the evolution of his career, the question which remains fundamental - of Leonardo's relationship with the other Renaissance engineers takes on a more complex meaning. It now seems that both the traditional sharp contrast between the great inventor and his colleagues and the more recent attempts to confine Leonardo's engineering activity within the limits of practice, procedures and projects already fully developed by contemporary engineers and those of previous generations must be rejected as inadequate.

It has been entirely appropriate to call attention to such great and original engineers as Brunelleschi, Taccola and Francesco di Giorgio Mar-

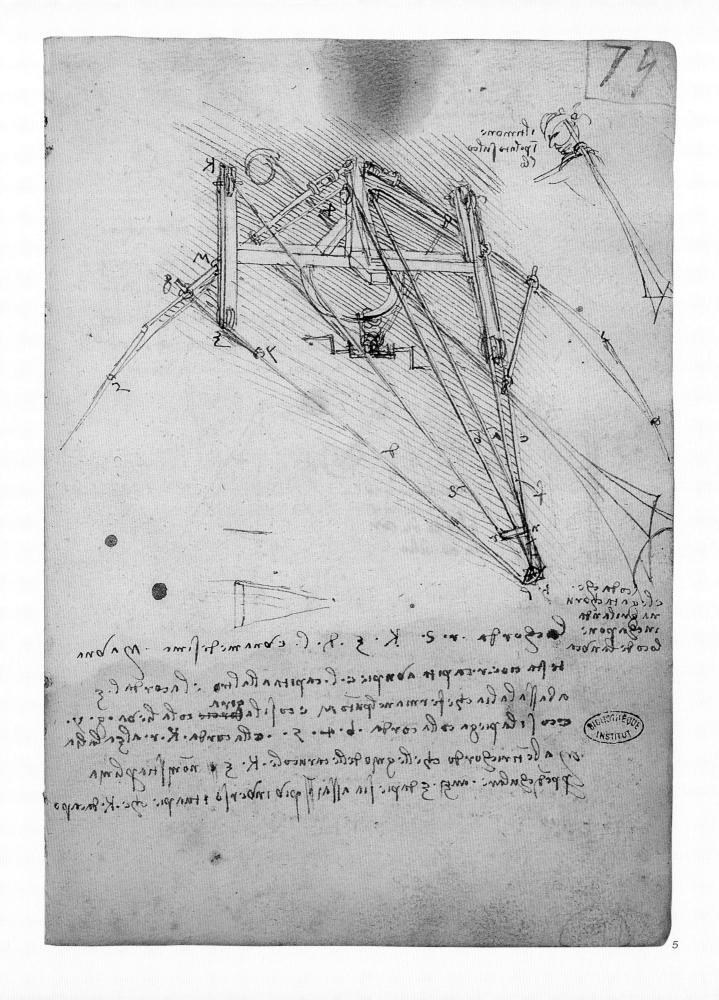

- 1. Vertical ornithopter (1487-1490), Manuscript B (fo. 80r).
- 2. Devices for manufacturing concave mirrors (1478-1480), Codex Atlanticus (fo. 17v).
- 3. Studies for "battiloro" machine (c. 1493-1495), Codex Atlanticus (fo. 29r).
- 4. Drawings of military machines (1487-1490) Windsor, Royal Library.

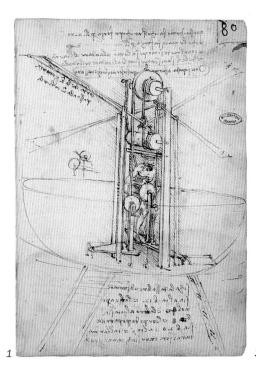

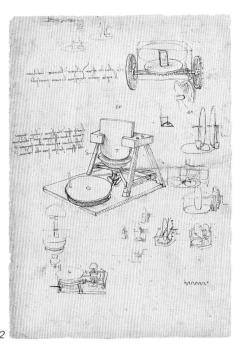

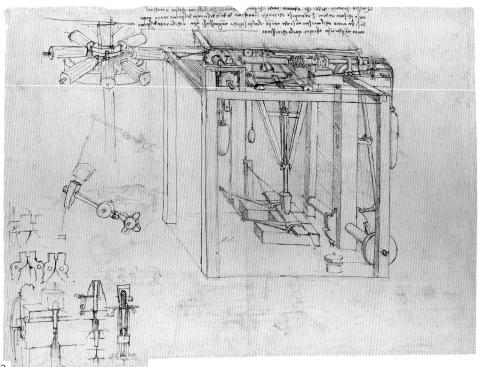

tini, esteemed by Leonardo himself. However, it must not be forgotten that Leonardo, at a certain point, radically changed his own concept of the engineering profession, proposing to replace a culture founded on practice and aimed at resolving individual cases with a set of universal scientific principles on which any particular technical solution must always be strictly based.

Although his dramatic efforts ended substantially in failure, although he never managed to let man really fly or live and work underwater, Leonardo must still be considered an extraordinary innovator.

THE DRAWING AS DESIGN

Leonardo's originality is to be found expressly in his search for the general mechanical principles which govern the operation of any type of machine, rather than in the sensational inventions long presented as fabulous precursors.

And Leonardo was original also in his drawings which, even in their incompleteness, are correctly interpreted as the conceptual equivalent of the "model".

This has been correctly understood as the meaning of the extraordinary attention he dedicated to developing and defining some exceptional techniques of technological drawing, thanks to which he managed to depict not only the machines as a whole and their fundamental mechanisms, but also to diagram their operation.

In this field Leonardo boasts a supremacy which is unrivalled and which places him at the very beginning of modern scientific illustration. Never before had anyone managed to demonstrate a complex technical design so effectively in a drawing.

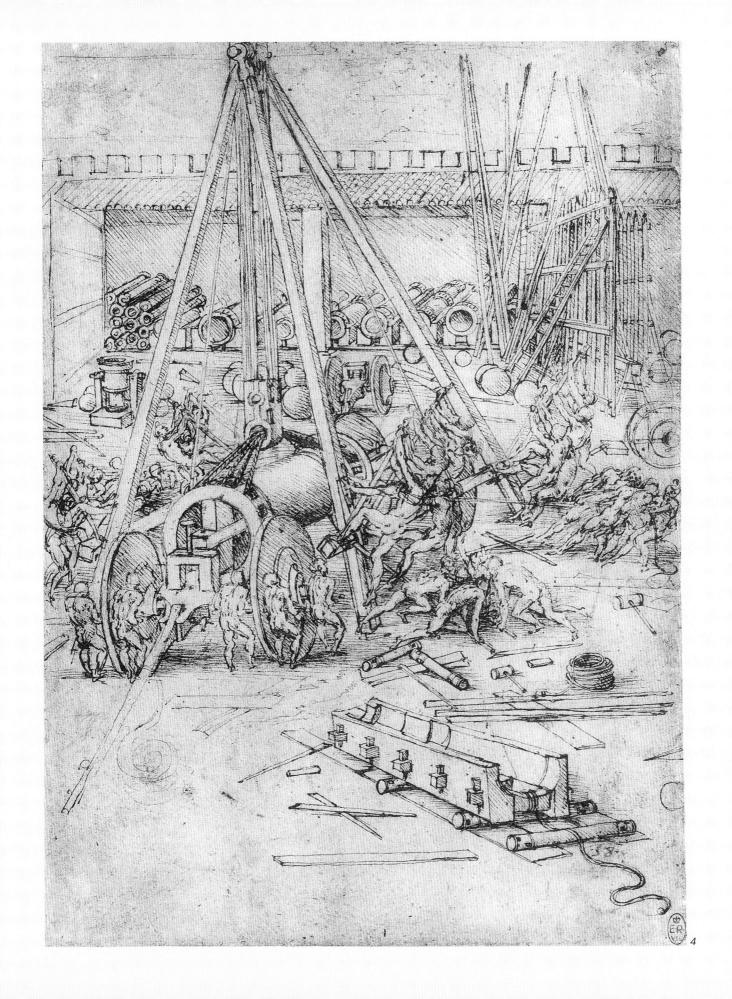

- Wooden model of building reproduced in figure 5, Florence, Museo di storia della scienza.
- 2. Study on thrust of arches for the dome on the Milan Cathedral (c. 1487-1490), Codex Atlanticus (fo. 850r).
- 3. Revolving crane (1478-1480), Codex Atlanticus (fo. 965r).
- 4. Model of revolving crane,
 Florence,
 Museo di storia della scienza.
- 5. Study for church with central plan (1487-1490), Manuscript B (fo. 95r).

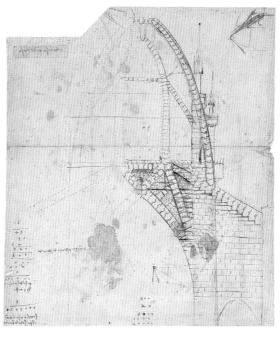

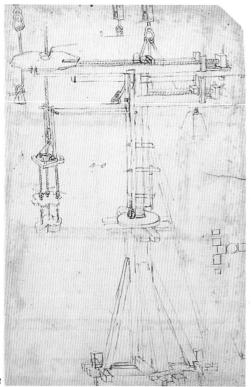

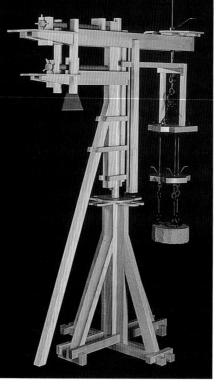

LEONARDO AS ARCHITECT

Leonardo was not and did not claim to be an architect, although he furnished, and above all made drawings of, architectural models. The nature of his work is clear only in a few circumstances, such as in the case of the design for the dome on the Milan Cathedral, in 1488-1490; or that of the villa commissioned him by the Governor of the Duchy of Milan Charles d'Amboise in about 1506-1508; or again in that of 1516-1517 for the castle of Romorantin at the request of the King of France, François I.

But his most prodigious contribution to the development of a new architecture all over Italy cannot be clearly defined. The same difficulty, moreover, was announced by Vasari already in 1550. After having proclaimed the Leonardo's supremacy in the field of painting he continues: «Not one profession alone did he practice but all those involving drawing. And he had an intellect so divine and marvelous that, being an excellent geometer, not only did he work in sculpture and in architecture, but declared painting to be his own profession». He added a significant addition in the edition published in 1568: «But in architecture he still made many drawings, of both plans and other buildings, and was again the first who, as a young man, spoke of the Arno river and of channeling it from Pisa to Florence».

This having been said, the most interesting thing is perhaps to understand the place held by Leonardo in the "architectural culture" of the age, his relations with contemporaries and predecessors.

In alternative to ancient texts translated and commented for him (Bramante and Pacioli were always

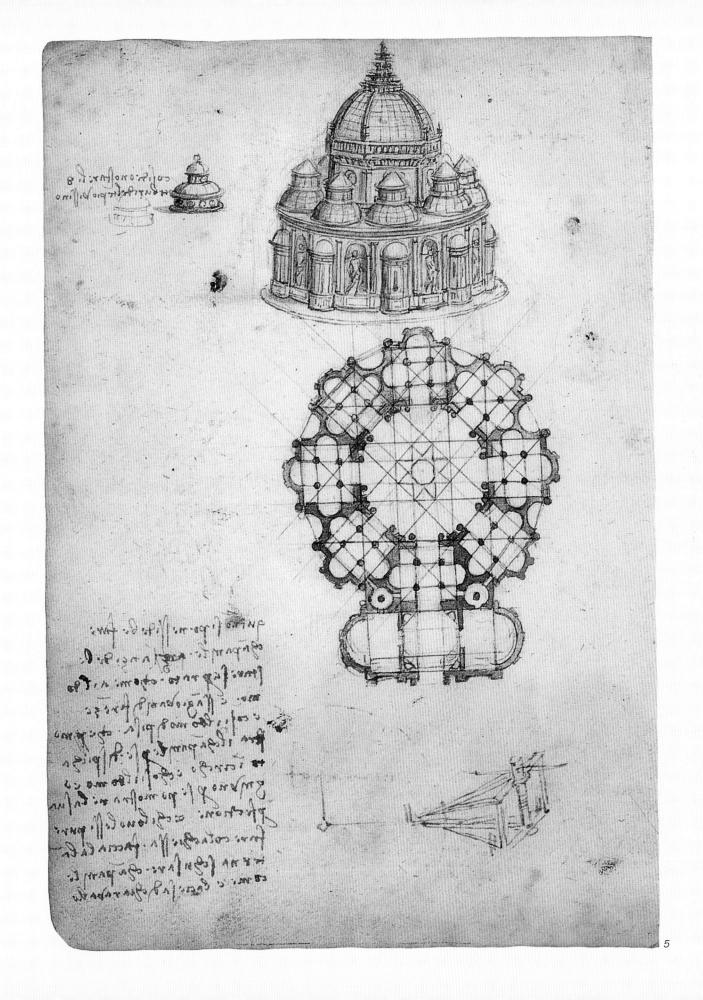

- 1. Imaginary reconstruction of an Etruscan tomb, with view of exterior, plan and subterranean chamber, Louvre (no. 2386).
- 2. Studies of churches with circular plan, of reverberatory furnaces and of a "tool with spheres", i.e., one for manufacturing burning mirrors (1487-1490),
- Manuscript B (fo. 21v). 3. Bird's eye view of a fortress (c. 1504), Manuscript 8936 (fo. 79r), Madrid,

Biblioteca Nacional.

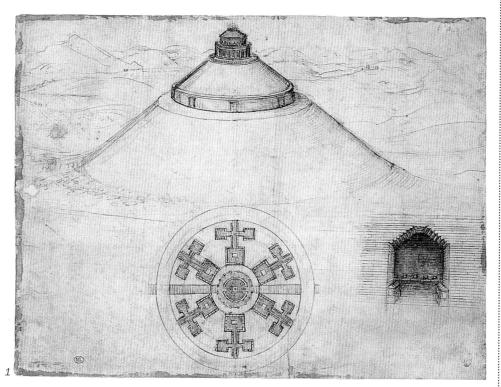

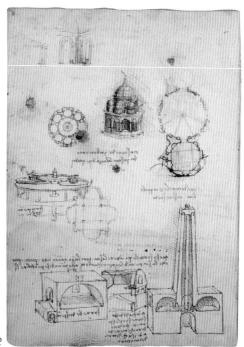

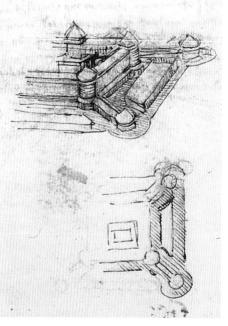

nearby, in Milan), Leonardo turned to the contemporary works of Francesco di Giorgio Martini, a copy of whose *Trattato di architettura civile e militare* he annotated. Codex Madrid II, for example, contains the project for a fortified body with ravelins (fo. 79r) unquestionably derived expressly from Francesco di Giorgio Martini. There are also quotations in the *Trattato* referring to working diagrams.

Nor should the influence of Giuliano da Sangallo, who was also in Milan in 1492 for the matter of the cathedral dome, be underestimated. But it is to Brunelleschi first of all that we must look to understand the formulation of Leonardo's ideas on architecture. The legacy of Brunelleschi had been thoroughly asimilated at the time of Leonardo's "polytechnical" apprenticeship in Verrocchio's workshop. Not only the sublime octagon of the dome on Santa Maria del Fiore and the pure rhythms of the Florentine basilicas, but also the apparatus of machines, winches, lifts, levers and building formulas whose example was under the eyes of all. The entire reflection on the central plan, which was to take shape in about 1490 with the admirable small design of an octagon with radially chapel, is manifestly derived from Brunelleschi's example.

Concerning Leon Battista Alberti instead, a strange silence reigns over the work of Leonardo. It is perhaps inevitable to accept the conviction that he wished to avoid the example of a declared disciple of Vitruvius and of classicism such as Alberti. And it was in fact in Milan, with Bramante and Pacioli, in a new environment, "freer" than that of Florence, that Leonardo was to find his path.

istorical research has now verified that among the ancient texts re-introduced to the western culture of the Humanists in the 15" century, those of Archimedes were decisively important in favouring a true "rebirth" of science, based on strictly geometrical and mathematical principles, destined to produce revolutionary results at the close of the 16th century with Galileo. Already in the late 15th century, however, Archimedes was a mandatory reference point in scientific debate. His works were studied both in the Greek text (which Poliziano had copied at Venice for the Libreria Medicea in a volume that belonged Lorenzo Valla) and in the Latin versions: the Medieval one of Moerbeke and the Renaissance one of lacopo da Cremona.

Like the other great engineers of the Renaissance (Francesco di Giorgio Martini, Alberti and, later, Tartaglia), Leonardo felt the need to return to Archimedes, leaving evidence of intense study of his writings. It is certain that he could consult the *Dimensio Circuli* published by Gaurico in 1504. He was acquainted with the *Equilibrio dei Piani e dei Galleggianti* (transcribed in part in the Codex Atlanticus).

In Leonardo's texts, the Syracusan scientist shows the dual nature conferred on him by tradition: the very concrete aspect of engineer-inventor (burning mirrors to set fire to the Roman ships; «screws» for lifting; the «architronite», a steam cannon the invention of which Leonardo attributes to him; a system for detecting the ruse of the swindler who had sold for gold to Gerone, the tyrant of Syracuse, a crown made instead of gold

AND I CAN SQUARE THE CIRCLE

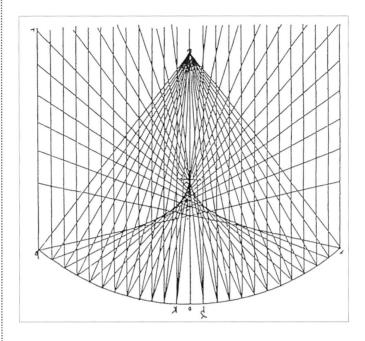

Above: Studies on reflection causistics inspired by Archimedes' burning mirrors (c. 1508), Codex Arundel (fo. 87v).

and silver alloy); and the contrasting aspect of "Platonizer", absent-minded scientist, incapable of abandoning his contemplation of geometric bodies even while the Romans were invading Syracuse, and thus paying with his life

Below: Studies of parabolic mirrors for exploiting solar energy (c. 1513-1515), Codex Atlanticus (fo. 750r).

for his love of truth.

It is probably in relation to the concept of Archimedes as engineer and inventor that Leonardo's name was recorded in the Gaurico edition of Archimedes' writings (where Leonardo is called «famous for

chimedes' writings (where Leonard thus paying with his life and the second of th

his Archimedean genius»).

However, many passages by Leonardo testify to his admiration for the Syracusan scientist's knowledge of geometry. This admiration, although enormous, never took the form of passive imitation.

Leonardo carefully considered Archimedes' solutions to the problems of squaring the circle and to curvilinear figures, pointing out the aspects he found inadequate: Archimedes' squaring of the circle was well stated and badly done». Archimedes had squared not a circle but «a figura laterata», while Leonardo believed he himself had gone further: «And I can square the circle, except for a portion as minimal as the mind can imagine, i.e., the visible point».

Elsewhere Leonardo announces that he has found, on November 30, 1504, the solution to the age-old problem of squaring the circle: «On the night of St. Andrew I found the end of the squaring of the circle at the end of the lamp-light and of the night and of the paper I was writing on; it was concluded at the end of the hour». Unfortunately, no trace of this presumed solution remains.

Leonardo's intense reflections on squaring the circle are not one of the most interesting and original aspects of his scientific activity. But for Leonardo, as for many of his contemporaries, the return to Archimedes represented not merely the chance to find an answer to some of the great problems of geometry, but above all the discovery of a method of geometrical/mechanical investigation of reality that was to bring about a radical transformation in the very way in which scientific knowledge was understood.

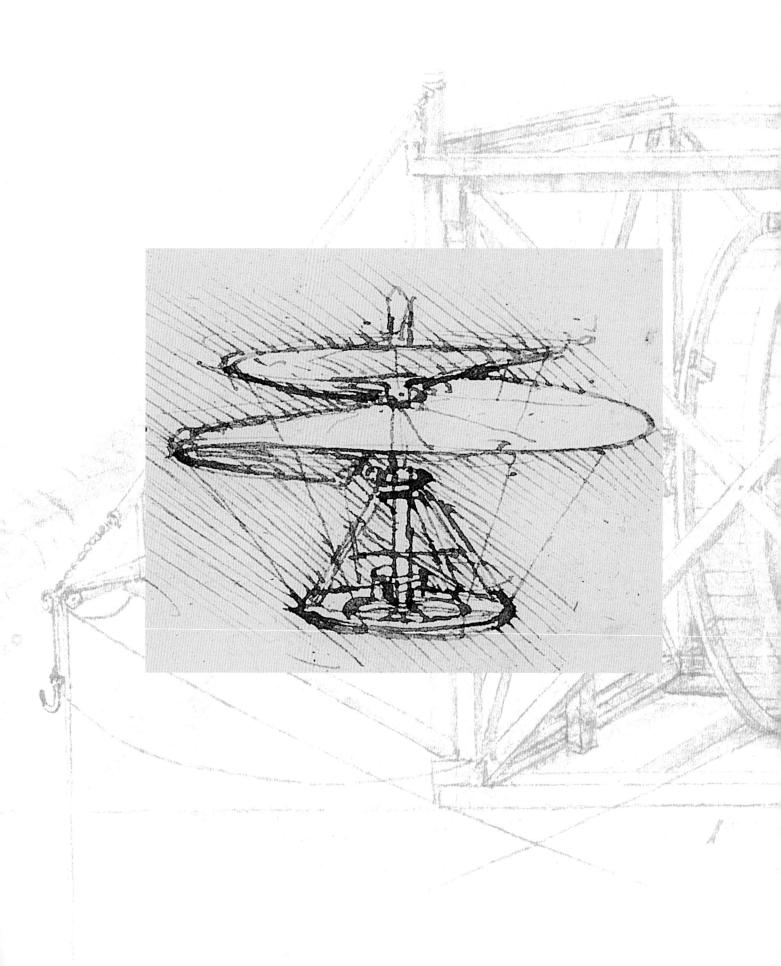

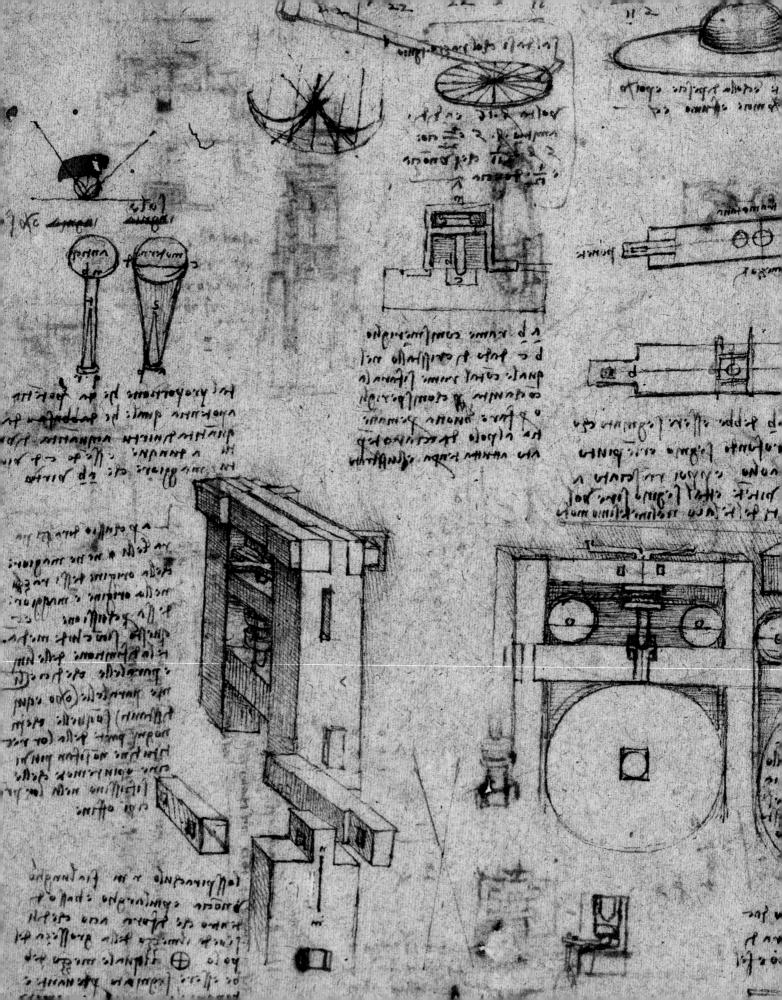

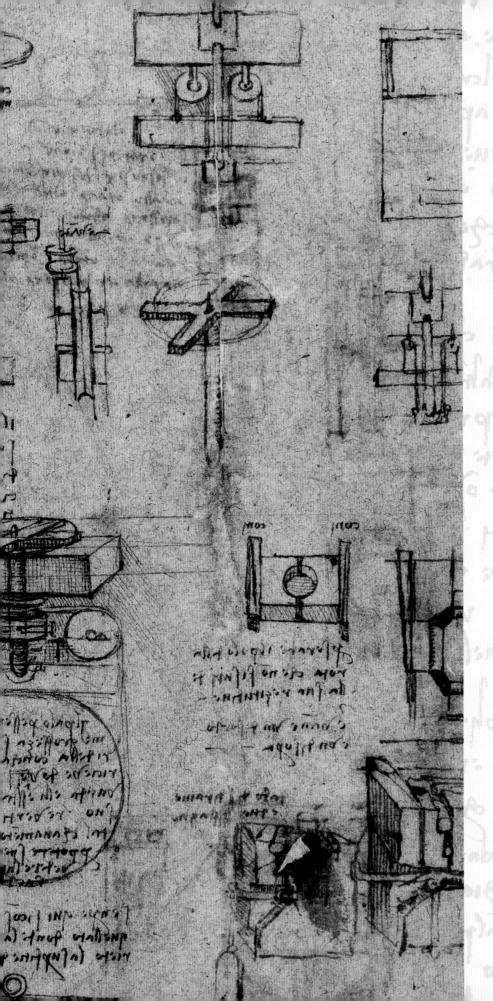

The distinguishing trait of Leonardo the inventor, acknowledged by his contemporaries to be endowed with «archimedean ingenuity», was the strict scientific basis he deemed indispensable to any technological concept. Accordingly, he turned back to the Scholastic tradition to confer on the practical activity of the workshop the professional dignity accorded architects and engineers in antiquity. Throughout his extraordinary career as technologist, the striking example of Archimedes was always before him. With «true science» he conceived of new uses for the burning mirrors invented by the legendary Syracusan, and this to exploit solar energy for industrial purposes and even for astronomical observation.

Overleaf, on the two preceding pages: studies of mechanisms for constructing great parabolic mirrors used for exploiting solar energy CA f. 1036 ii v c. 1513-1515

- 1. Experiments with artificial wing Ms B f. 88 v c. 1487-1490
- 2. Study for flying machine (the so-called "helicopter") Ms B f. 83 v c. 1487-1490

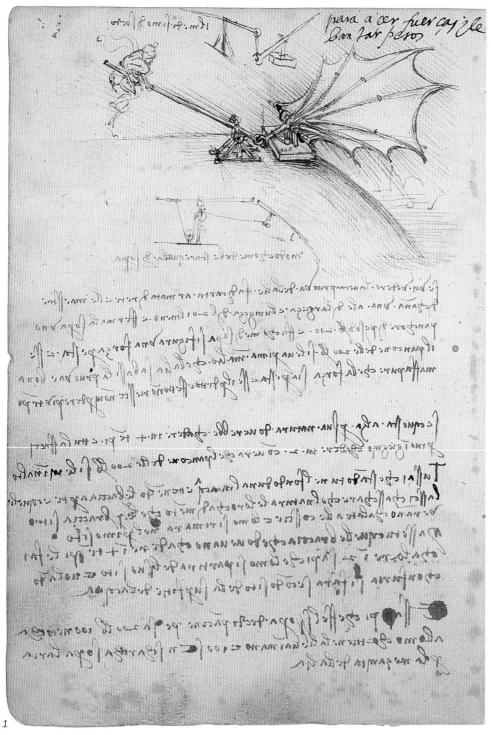

ne day in the years between 1487 and 1490, Leonardo picked up a «thin wide ruler» that he was probably using to draw some geometric figure or machine component, and whirled it violently about in the air. Why we do not know. Perhaps he did it once by chance, and then again to verify a scientific theory that had flashed through his mind. He had suddenly realized that his arm tended to rise, guided by the motion of that blade whirling through the air. This is the basic principle of the helicopter the helicopter of today, where the propeller is merely a double vane, and thus analogous to Leonardo's «thin wide ruler». Spinning that ruler, Leonardo realized that its angle of inclination caused it to rise through the air. And since his own shoulder was the fulcrum for the spinning, a spiral motion was created. In his mind, the whirling ruler became a continuous surface, like the helical thread on a screw: a surface swelling out like a sail which, instead of billowing in the wind, turned like a screw, «spiraling in the air and rising high».

From this to making an experimental model was only a short step. For Leonardo a sketch was sufficient, without entering into details but employing the structural elements of nautical technology: the great screw sail has its shrouds which provide stability, obviously rotating along with the hoops to which they are fixed. The motive force could only be a wound-up spring, like that of a clock, which can in fact be seen in the sketch beneath the axis of the aerial screw.

Although he does not say so, Leonardo was obviously thinking of the so-called "archimedean screw" that draws up water through a similar process. Moreover, water and air were for him similar elements, with the same conditions of cause and effect appearing in

No amora convious of no be found good of the house of you go do be dealthouse The formation for about an desiration of a same formation from La Strong Land Lander De Contraction of the Contrac to the local of the possion of the same we want a more of the possion of the poss and to make before and when a flancaful in the const in las madeurs de la paperes se la Penne lange egraffe bus long bighed fens innut bere site after lan affer to repolition from

- 1. Studies on flight of birds in relation to the wind Ms E f. 42 v c. 1513-1514
- 2. Drawings of device for rotating wing Codex on the Flight of Birds ff. 16 v-17 r c. 1505
- 3. Studies on flight of birds in relation to the wind Ms E f. 43 r c. 1513-1514

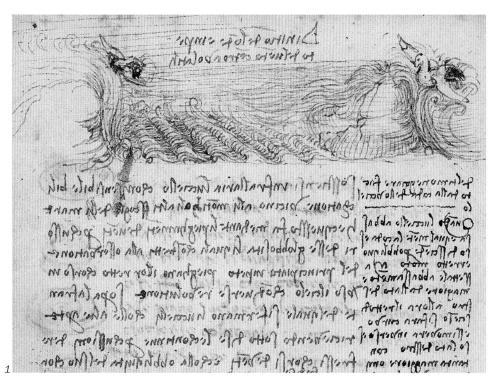

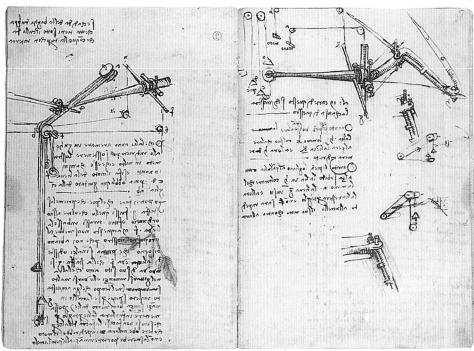

both. And so he studied the motion of fish to understand that of birds, and vice versa.

In 1513-1514 Leonardo, now sixty years old, finally formulated a theory of flight that could qualify as «true science», or «perceivable science», insofar as it could be perceived by the senses and could thus be verified by experiment.

«In order to give the true science of the movement of the birds in the air it is necessary first to give the science of the winds, and this we shall prove by means of the movements of the water. This science is in itself capable of being received by the senses: it will serve as a ladder to arrive at the perception of flying things in the air and the wind».

LEONARDO SCIENTIST?

With his renewed studies on the flight of birds, and in particular gliding flight assisted by the wind, Leonardo became increasingly convinced that man too could fly with the aid of a mechanical device. At that same time and in the same codex he wrote: «Mechanics is the paradise of the mathematical sciences, because by means of it one comes to the fruits of mathematics».

It may be said, paradoxically, that Leonardo arrived at the age of twenty-three without knowing the meaning of the word "science". Incredible as this may seem, it is the only explanation for the fact that, among the words he listed in about 1487 for which an explanation should be sought, as in a dictionary, are the following:

«Science: knowledge of the things that are possible present and past»; «Prescience: knowledge of the things which may come to pass».

This appears in the first manuscript compiled by Leonardo in Milan, the so-called Codex Trivulzianus, written

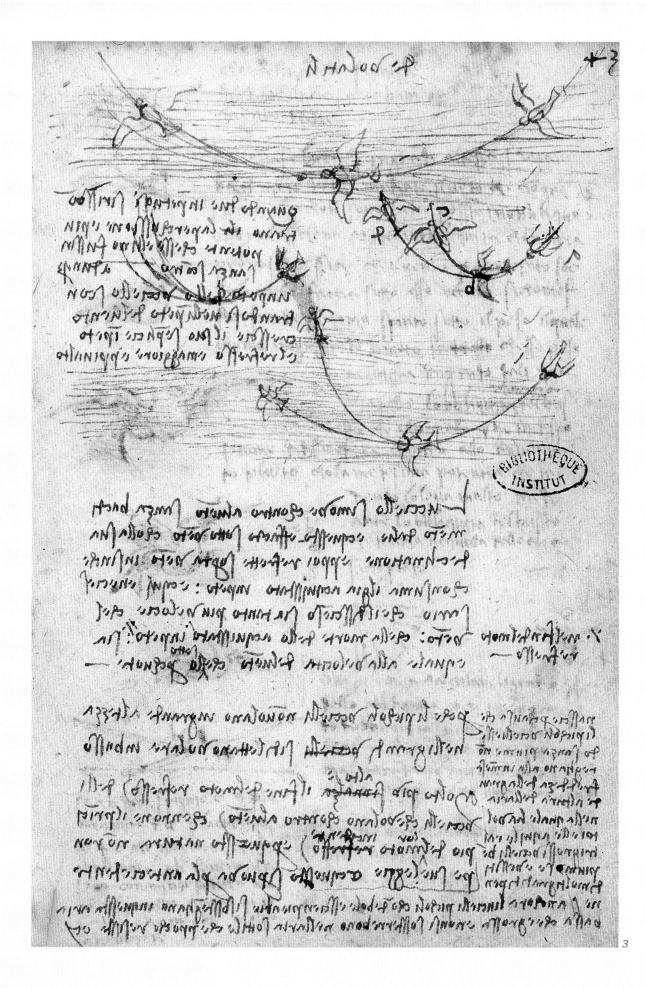

- 1. Studies on flight of birds Codex on the Flight of Birds f. 15 v c. 1505
- 2. Studies on flight
 of birds
 in relation to
 air currents
 Codex on the Flight
 of Birds
 f. 8 r
 c. 1505

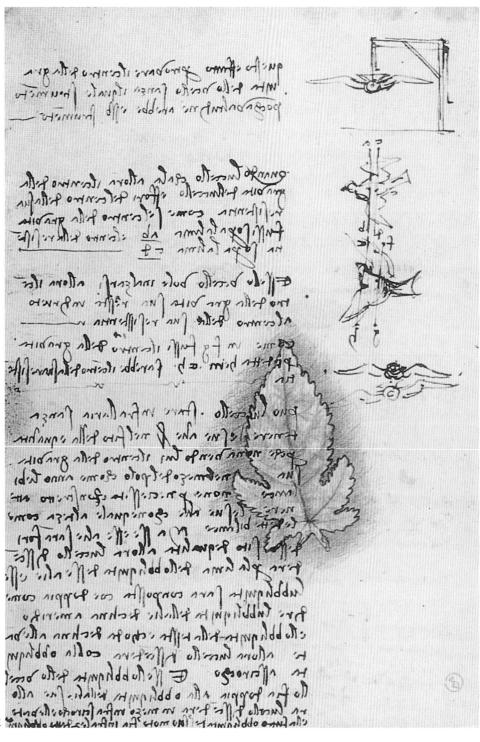

slightly before the French Codex B, the one containing the study on the helicopter. The identification of "science" with "theory" (that is, the opposite of "practice"), according to a still-medieval concept, is confirmed by a note appearing several pages before: «Theoretical: science without practice». Moreover, Leonardo frequently uses the form "scientia" in place of "science", just as it appears in scholastic texts, always with the meaning of "theory"; «Ars sine scientia nihil est»: there can be no art, i.e., "practice", without theory, proclaimed the theoreticians who engineered the Duomo of Milan toward the end of the 14th century.

Accordingly, caution should be used in referring to Leonardo as a scientist, a term which in his days certainly did not have the same meaning as today. Those who studied the natural sciences – anatomy, zoology, botany, geology, meteorology and astronomy – were known as philosophers. As Vasari stated in regard to Leonardo's astronomical studies: «For which he formulated in his soul a concept so heretical that he embraced no religion of any kind, deeming it better to be a philosopher than a Christian».

This also explains the opinion expressed by Francis I, King of France, in 1542 in regard to Leonardo's scientific knowledge. As Cellini reports, «I feel that I must not neglet to repeat the exact words which I heard from the King's own lips about Crim, which he told me in the presence of the Cardinal of Ferrara, the Cardinal of Lorraine, and the King of Navarre. He said that he did not believe that there had ever been another man born into the world who had known as musch as Leonardo, and this not only in matters concerning Sculpture. Painting and Architecture, but because he was a very great Philosopher».

A philosopher was of course a ma-

Mugar ausa vatel oddom very verso vija vyzy i Jusial ochura ingisina oblodo upula minus. The obloque is tall lots pinto of Every daily. sury Wyy aprile [var Coby variate vpyll:]2 idina et ingre Marday junton et jaddo vyujetus Mayor office offolist small office of LUNDER WITHING (VOSO BY LOTTO DINO LINISTAN LA VIII) DE LOSO DINO LINISTAN LA VIII LI UNUBANG Coportico of equal of the burn copy coty logo of a stage of a stage of the logo of the l

- 1. Homo vitruvianus from Cesare Cesariano's edition of Vitruvius (Como 1521)
- 2. Homo vitruvianus as a robot From the dust jacket of the book by Mark E. Rosheim, Robot Wrist Actuators (New York 1989)
- 3. Homo vitruvianus Venice, Accademia Galleries n. 228 c. 1490

thematician as well, more specifically interested in arithmetic, geometry, stereometry, mechanics, statics, dynamics, optics, acoustics, and hydraulics. The geometer was already engaging in practical applications such as land-surveying, and could thus work beside the architect, to whom geometry (like other sciences) was necessary for designing buildings. Then came the cosmographer, who produced nautical and celestial charts.

THEORY AND PRACTICE

Leonardo as a child received the first rudiments of arithmetic and grammar at the "scuola dell'abbaco", or primary school, where he learned to read, write and do sums. After this he entered a workshop to learn art, that is, the practice of painting and sculpture. Within this context, architecture too might be involved. This activity, consisted mainly of producing a wooden model of an architect's project, still remained within the sphere of sculpture. But the step was brief and it was better to be prepared. A more thorough knowledge of geometry was needed, indispensable moreover for studying human proportions and perspective. And the architect himself, as exemplified by Vitruvius, must study proportion and optical techniques. Leonardo's famous drawing of a man inscribed in a circle and a square is actually an illustration - in fact, the first illustration, datable around 1490 – of the theories on proportion postulated by Vitruvius in the 1st century BC as basis for the study of architecture.

Painting and architecture, then, can and must proceed side by side, as Brunelleschi and Masaccio had already understood. And in fact the first renovator of Italian painting, Giotto, was also an architect. Giorgio Vasari tells us that Verrocchio himself, as a youth, had assiduously studied geome-

Virunia - webit-do mich in the fun ope trucher of the miffur tothem for to the marine Allengames and illo une to roos de de de ly betwee a to be per be be to be to be to be de de de בעלורן לה יולים הים יול בינה בלון מופלים וה יו החולים י לבי בד המדומן לה ילים מו בינחו ליותן ליוני לחות להור הל החול אות הליבה בסף וד מדומן ליוני בינחו ליותן ליוני לחות להור הליבה בסף וד מדומן ליוני בינחו ליוני ליותן ליוני ליותן מופלים וד ליותן הליוני בינחו ליוני בינחו ליוני Compreheter to Coppies terinos in frall gabe fra mingolo : quitaris To porto of firmore 48 . Impac truto apo lomo no Langa ajunto co la lua . Eleca John of in mo broken of atten of one Atmine . Therems what in Artun of the foch of mens . alla form My one the one track towns for a few bours of form the one of the one to the man the form form of the most

Ante Jacto Stanoche atmatento Somanato to talund some to Tomo to Jamo de Sollino de Manne atures of all of the flowers broke body chair front our bound born ble flower of or code of the son straits

- 1. Detail of a painting by Biagio di Antonio, Tobias and the Archangels (c. 1470); Florence, Bartolini Salimbeni Collection, showing the lantern of the Florence Cathedral under construction.
- 2. Revolving crane CA f. 965 r c. 1478-1480
- 3. Model of revolving crane (1987) Florence, Museum of History of Science
- 4. Dome of the Florence Cathedral, detail of the lantern

try. It is not surprising, then, that geometric figures already appear on Leonardo's earliest folios, from 1478 on, alongside the first drawings of machines, most of them reproductions of devices invented by Brunelleschi to be used in constructing the dome for the Florence Cathedral, around 1420.

This link with Brunelleschi's technological tradition is also explained by the fact that in 1469 Andrea del Verrocchio had been commissioned to construct a copper ball, two and a half meters in diameter, to be placed on top of the lantern on Brunelleschi's dome. It was to be the final touch to the greatest monument of the Florentine "Quattrocento", a symbol of the relationship between the arts: an abstract sculpture in the most perfect geometric shape, designed to crown a work of architecture. Its practical realization involved the technological problem of raising it to the top of the dome, a feat which was accomplished in the year 1470.

Leonard, who had recently entered Verrocchio's workshop, was able to observe the whole operation, and probably contributed to it as well. This was not merely an undertaking requiring manual skill and technical capability; it was also a project of scientific endeavor. For the first time Leonardo felt the fascination of calculation and geometry, an experience he was never to forget. In 1515, at the age of sixty-three, he was to write: «Remember the solderings which were used to solder the ball of Santa Maria del Fiore».

Forty-five years later; it was the time of his studies on harnessing solar energy through parabolic mirrors. This same system, whose origins date back to antiquity, had already been employed by Leonardo's master Verrocchio to weld together the numerous sections of the copper ball to be placed atop the dome of the Florence

- 1. Studies and calculations on parabolic mirrors with note (f. 84 v) on use of burning mirrors in 1469 to solder the copper ball for the lantern on the Florence
- Cathedral Ms G ff. 84 v-85 r c. 1515
- 2. Machines for manufacturing concave mirrors CA f. 1103 v c. 1503-1505
- 3.-4. Machines for manufacturing concave mirrors Madrid Ms I f. 61 r c. 1495-1497 Ms B f. 13 r c. 1487-1490
- 5. Devices for manufacturing concave mirrors CA f. 17 v c. 1478-1480

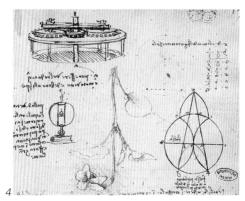

Cathedral. The curvature of the geometrically established sections had been scrupulously calculated in relation to what was to be the center of the ball. This could not be done by eye. Devices for controlling the shape assumed by the copper plates under the blows of the hammer had to be designed. And the shearing of the curvilinear sides had to be precise to the millimeter to achieve the final effect of a continuous surface, smooth and gilded, perfectly reflecting the sun's rays.

OPTICS AND ENERGY

The equipment used for welding had to be perfected too. The oxyhydrogen flame had not yet been invented, and small welds were executed at the forge. For large ones instead greater power was required, and the only source available was the sun. For this purpose catoptrics, the science of mirrors, was necessary. It could be learned from the classical texts of Ptolemy, Euclid and Archimedes, and from Medieval compendiums such as those of Vitellius and Alhazen, to which Lorenzo Ghiberti had also referred for his Commentaries published in 1450.

This explains the insistence with which Leonardo, in his early folios, studied machines that could be used to produce burning mirrors, or «fire mirrors» as he called them. Ranging in diameter from seventy centimeters to one meter, they could be manufactured in a single piece. Their curvature was of course calculated according to the point at which the reflected rays would be concentrated, where smelting was to take place. It was thus a question of determining what scientists today call the "caustic of reflection" or "catacaustic".

Only a few traces of these calculations are found in the young Leonar-

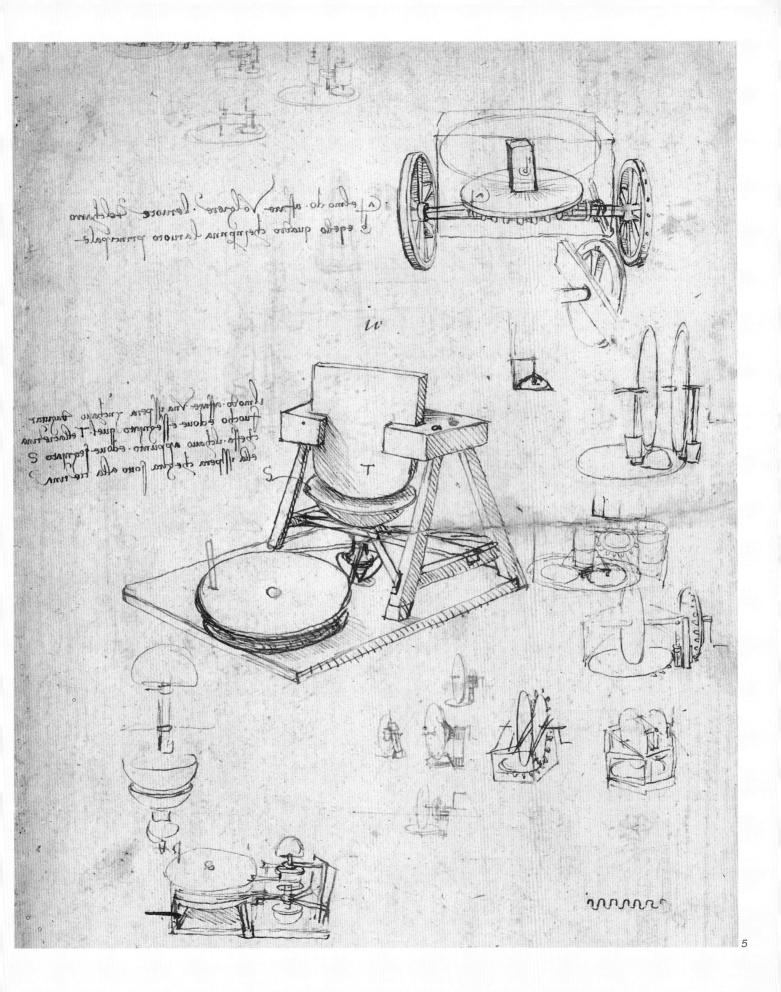

- 1. Studies on reflection caustics and device for manufacturing parabolic mirrors CA f. 823 i r c. 1503-1505
- 2. Studies
 of large
 parabolic
 mirrors
 for exploiting
 solar energy
 CA f. 750 r
 c. 1513-1515
- 3. Studies on reflection caustics and device for manufacturing parabolic mirrors
 Codex Arundel ff. 86 v-87 r c. 1503-1505
- 4. Studies on reflection caustics and device for manufacturing parabolic mirrors
 Codex Arundel ff. 84 v-88r
 c. 1503-1505

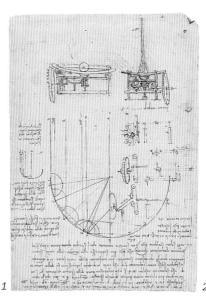

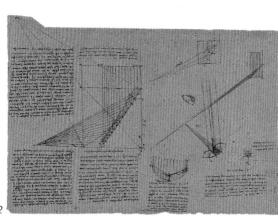

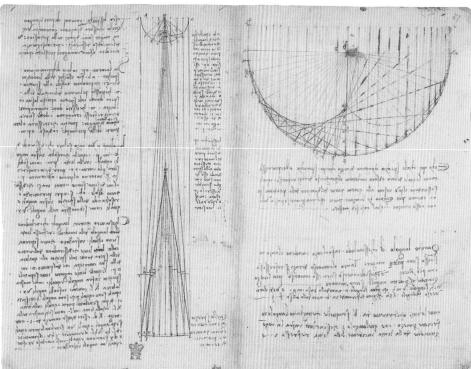

do's papers. Later, after 1500, they are instead abundant, and accompanied by stupendous geometric drawings. We will now try to understand why.

Machines used to produce mirrors, perfected in comparison to those appearing in the early folios, frequently recur in Leonardo's manuscripts from the last years of the 15th century on. The mirrors were mostly of normal diameter. But around 1503-05, the idea of a burning mirror of great size, like those used by Archimedes to set fire to the Roman ships at Syracuse, began to emerge. This could also explain why, in one of the first published mentions of Leonard, in the *De sculptura* by his contemporary theoretician Luca Gaurico in 1504, the artist is cited not only as a pupil of Verrocchio but also as being endowed with «archimedean ingenuity». Producing a concave mirror surface like that of the great antennas of today's space probes was practically impossible in those days. But remembering the great ball that Verrocchio had built in sections, Leonardo realized that the same system could be applied to constructing a parabolic mirror. A very high-precision instrument would however be needed, a "templet" to smooth the various sections to the established curvature.

1513-1516: Leonardo was in Rome, working in the Vatican for Giuliano de' Medici, the Pope's brother. Two German technicians, mirror manufacturers, were his assistants. Project: installing equipment to exploit solar energy for industrial use. It seems that the Medici intended to develop a textile industry in Rome like the one that had brought prosperity to Florence.

Leonardo's studies barely hint at the purpose of the project: «One wonders whether the "pyramid" [the pyramid is the bundle of reflected solar rays] can be condensed to bring so much power to one single point and whether it ac-

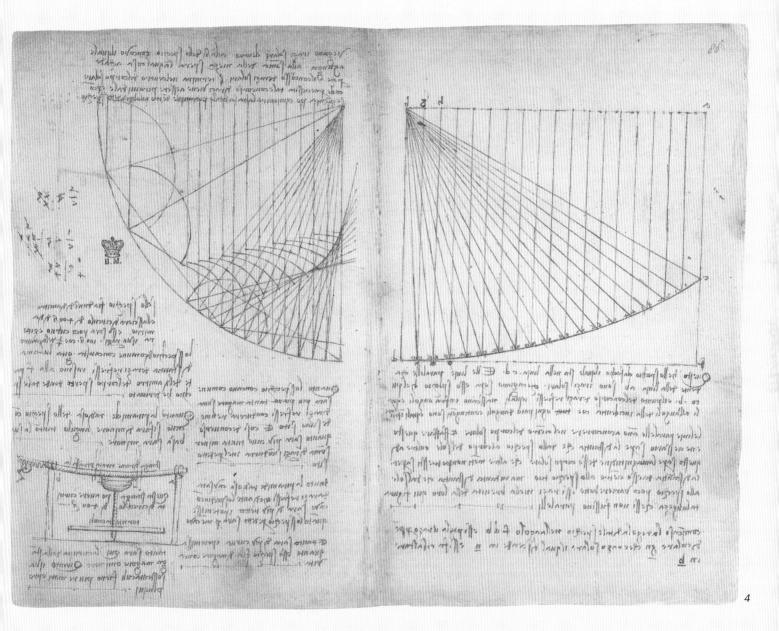

1. Anatomical studies of eyeballs Windsor RL 12602 r c. 1506-1508 2. Studies on proportions of the face with detail of eyes Turin, Biblioteca Reale no. 15574 c. 1490

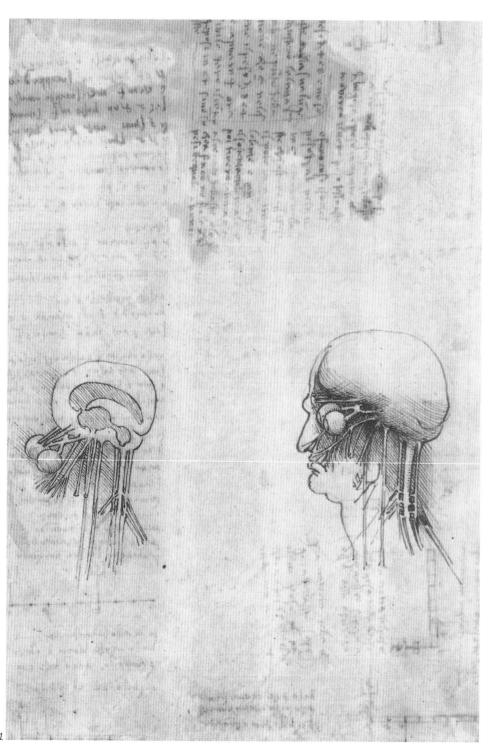

quires more density than the air that sustains it». And then, immediately afterward, the note that reveals what it is all about: «With this one can supply heat for any boiler in a dyeing factory. And with this a pool can be warmed up, because there will be always boiling water». So it was a system of central heating that could also be used to heat swimming pools. But this was not all. The enormous burning mirror constructed in sections is actually a multi-block telescope.

ASTRONOMICAL OBSERVATION

On a page of calculations and diagrams for this project appear the words: «To observe the nature of the planets have an opening made in the roof and show at the base one planet singly: the reflected movement on this base will record the structure of the said planet, but arrange so that this base only reflects one at a time».

Although it is certain that Leonardo was suggesting using the parabolic mirror for astronomical observations, the note merely gives an idea of the procedure without furnishing details. and as such it may appear incomprehensible. Leonardo does say however to open the roof, just as in an astronomical observatory. To show a planet at the «base» means directing the mirror so as to receive the planet in the base of the reflection pyramid. The «reflected motion of said base» is thus the reflection at the focal point, where the «structure ("complessione") of the planet», magnified, can be observed. The «complessione» is the surface, like that of the skin. The «base», concludes Leonardo, should center one planet at a time. This is no less than an allusion to Newton's reflecting telescope, although it is not explained how the enlarged image of the planet will be transmitted to the observer. Perhaps the telescope was only an idea.

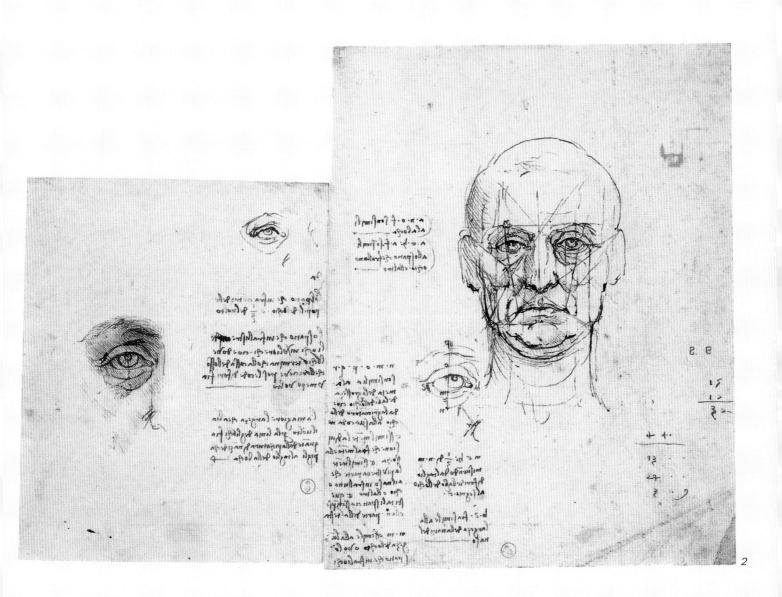

- 1. Demonstration of mechanism of the eye using glass model Ms D f. 3 v c. 1508
- 2. Study of astronomy with explanation of the "earth-shine" of the new moon (one hundred years before Galileo) Codex Hammer f. 2 r c. 1508

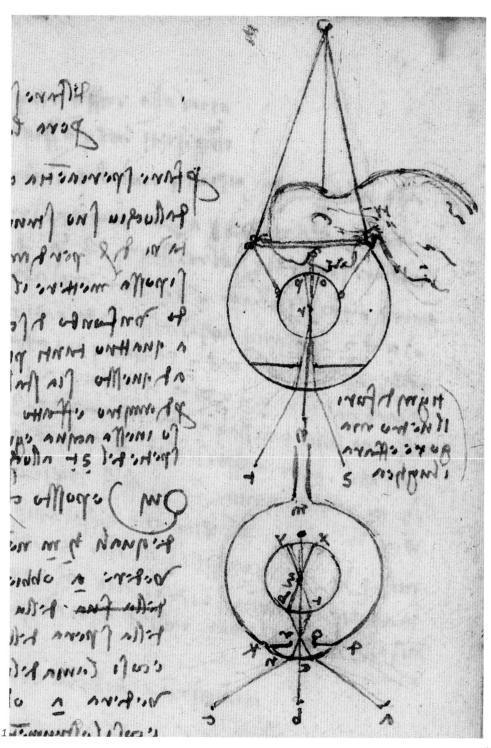

Otherwise Leonardo would have realized that there is no water on the moon, contrary to his belief. And yet, in the experimental stage, he must have constructed some device for astronomical observation, although without achieving the results attained by Galileo a century later. «Make lenses to see the moon large». And still further: «If you keep the details of the spots on the moon under observation you will often find great differences in them, and I have myself proved this by making drawings of them».

The multi-block telescope, like so many other projects, was to end in nothing. «Barely begun, it was drowned: by the circumstances», reads a note on a sheet from that period. Leonardo's German assistants went into business for themselves in the Vatican, manufacturing mirrors to be sold at fairs. Leonardo, deeply perturbed, suffered a first breakdown.

Yet some knowledge of his ideas and scientific projects from that period, entrusted to his notes and even to scale drawings, all now lost, must have become known from his manuscripts after his death. The suspicion arises from this comment made by the philosopher Arrigo Cornelio Agrippa in his *Della vanità delle scienze* (Venice 1552): «And I know how to make mirrors in which all the things illuminated by the shining Sun, and regardless of their distance, whether it is four or five miles, can be seen most clearly».

When Leonardo moved to Milan in 1482 he found greater scope for dedicating himself to scientific studies, since his activity in that city was focused mainly on civil and military engineering and technology. The architectural projects he was involved in from 1487 to 1490, in particular that of the "tiburio", or central tower of the Milan Cathedral, led him to study the principles of statics inherent to the thrust of

- 1. Study of thrust on arches for the lantern of the Milan Cathedral CA f. 850 r c. 1487-1490
- 2.-5. Studies on statics and dynamics of arches Madrid Ms I f. 143 r c. 1495
 Ms A ff. 49
 and 53 r c. 1492
 Madrid Ms I f. 139 r c. 1495
- 6. First ideas for the lantern on the Milan Cathedral on a folio of studies of figures, caricature profiles and studies of hydraulic wheel CA f. 719 r c. 1487

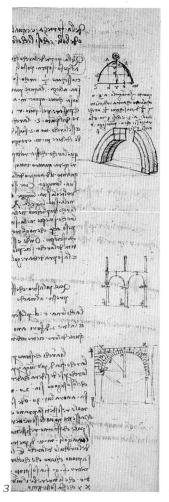

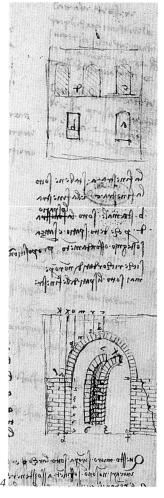

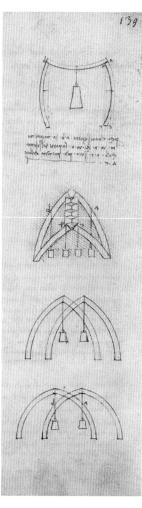

arches. And the projects for weapons are related to studies on mechanics concerning theories of striking, impetus, rebound and inertia, conducted in the early 1490s.

SCIENTIFIC ILLUSTRATION

At the same time Leonardo began his studies on water, which gave rise to his interest in hydraulics and hydrostatics, just as painting had stimulated his interest in optics and anatomy. Soon these active scientific interests were to intermingle in an intense program of interdisciplinary research. Leonardo now had to report the results of his observations in manuscripts to which he could constantly refer, in a continuous process of elaboration and reviewing, all effectively presented through the immediacy of visual language.

Leonardo's enormous contribution to the scientific writings of the Sixteenth Century was, in fact, this: the use of illustration. It can be evaluated in the later treatises on architecture and anatomy such as those of Sebastiano Serlio and Andrea Vesalio, not to mention the books on machines by authors ranging from Giovanni Branca to Agostino Ramelli, or the monumental work of Ulisse Aldrovandi on the natural sciences. Leonardo himself, in his anatomical studies of 1510, acknowledges to drawing the faculty of providing «true information» on the limbs and their functions, «and in this way you will give the true conception of their shapes, which neither ancient nor modern writers have ever been able to give without an infinitely tedious and confused prolixity of writing and of time».

Unfortunately, what has remained of Leonardo's writings is not sufficient to allow objective evaluation of his contribution to the «theoretical». The mathematician Luca Pacioli, a

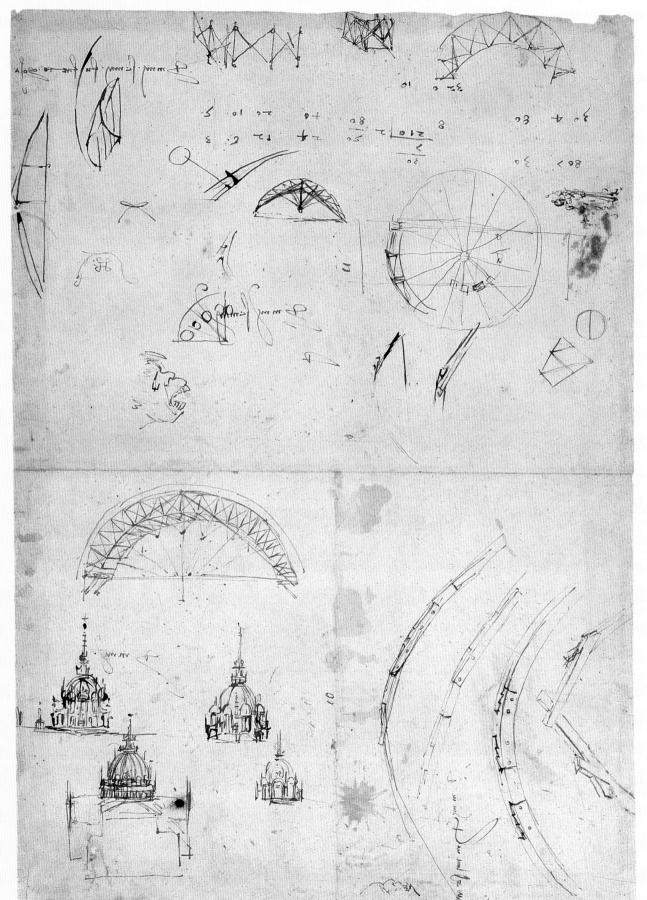

1. 3. Studies for a repertoire of «mechanical elements» Ms I Madrid ff. 8 v, 9 v, 10 r c. 1495-1497 2. Studies for a manually operated elevator device Ms I Madrid f. 9 r c. 1495-1497

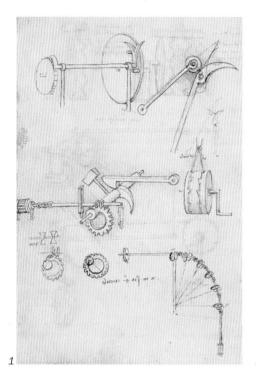

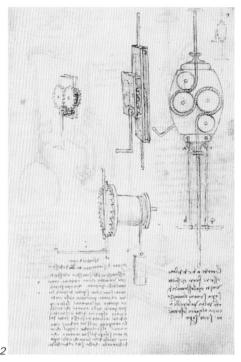

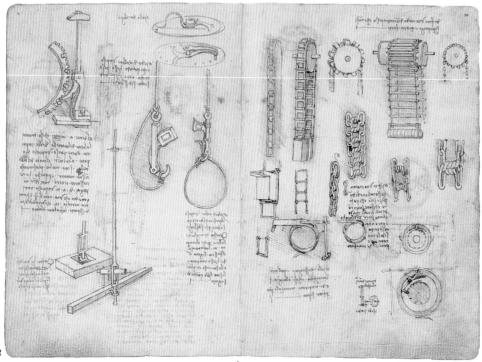

treatise writer by profession, mentions one of Leonardo's treatises, *Del moto locale et de le forze tutte, cioè pesi accidentali*, in a work dated 1498.

It is thus unjust to belittle Leonardo's scientific contribution, which was moreover acknowledged by contemporaries such as the mathematician Pacioli, the physician and historian Paolo Giovio and the philosopher Gerolamo Cardano, on the grounds that he lacked the formal and academic training, and even the temperament, of the treatise writer. Luckily, it can now be stated, instead of knowing Latin as his father did; he knew how to draw.

The Milanese art historian Giovan Paolo Lomazzo expressed a different opinion in 1590, after having seen Leonardo's books still integral at the home of Francesco Melzi, his pupil and heir. After having mentioned those on human and equine anatomy, on proportions and perspective, he notes the existence of «many other books, in which he showed how many movements and aspects can be explained by mathematical principles». And adds, «And he showed the art of pulling weights, and this in books of which the whole of Europe is full, and which the experts keep in highest esteem, judging that nothing more can be done that what he did».

The wide-spread diffusion of Leonardo's scientific ideas implied by Lomazzo, noticeable especially in Germany and Flanders, has been confirmed by recent research, that of the Leonardo scholar Ladislao Reti in particular, responsible among other things for the critical edition of the Madrid manuscripts found in the 1960s, the first of which is a true repertoire of «mechanical elements», i.e., those which carry out a primary function in the structure and operation of each machine.

ince it was presented for the first time by Gilberto Govi in a brief communication to the Academy of Sciences in Paris (Sur une très ancienne application de l'hélice comme organe de propulsion) in 1881. Leonardo's small drawing on f. 83 v of Codex B of the Institut de France has been the subject of repeated interpretations and comments which have led to its reconstruction in models (frequently arbitrary) for Leonardo museums or itinerant exhibitions. Suitable updating, also bibliographic, of the pertinent technological problems discussed in my Studi vinciani of 1957 (pp. 125-129) can be found in the essay by Giovanni P. Galdi, Leonardo's Helicopter and Archimedes Screw: The Principle of Action and Reaction, in

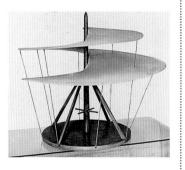

"Achademia Leonardi Vinci", IV, 1991, pp. 193-195. Precedents, even from medieval times, have been found in miniatures showing children playing with toys of a kind still in use in modern times, consisting of a threaded rod along which a rising thrust is imparted to a bladed device that whirls off it into the air. Cf. Ladislao Reti, *Helicopters and Whirligigs*, in "Raccolta Vinciana", XX, 1964, pp. 331-338, with reference to previous publications on the same subject by Charles H. Gibbs-Smith.

However, the best comment on Leonardo's drawing is still his own text which accompanies it: «Let the outer extremity of the screw be of steel wire as thick as a cord, and from the circumference to the cen-

THE HELICOPTER

THE HELICOPTER AND THE HANG GLIDER

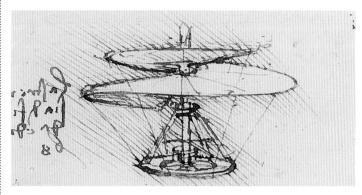

Above, the "helicopter" in Ms B f. 83 v c. 1487-1490 Left, model of Leonardo's helicopter, Milan, Museum of Science and Technology

Below, studies of kites for sailplaning flight Madrid Ms I, f. 64 r c. 1497 Right, model of Leonardo's "hang glider", constructed in Great Britain in 1993

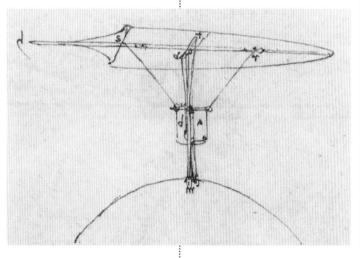

tre let it be "braccia" [approximately 5 meters]. I find that if this instrument made with a screw be well made – that is to say made of linen of which the pores are stopped up with starch – and be turned swiftly, the said will make its spiral in the air and it will rise high. Take the example of a wide and thin ruler whirled very rapidly in the air, and you will see that your arm will be guided by the line of the edge of the said flat surface. The framework of the above-mentioned linen should be of long stout cane. You

may make a small model of pasteboard, of which the axis is formed of fine steel wire, bent by force, and as it is released it will turn the screw.

The vast "corpus" of Leonardo's studies on flight was enriched in the 1960s by the discovery of two of his manuscripts in Madrid. The second of these, written in around 1504, contains notes on the flight of birds, while drawings of flying machines appear on a folio from the first, datable to about 1497. In the manuscripts dating back to the

first decade of Leonardo's stay in Milan, from 1482 to 1490, the idea of an ornithopter, a machine designed to reproduce the beating wings of birds, predominates. Around 1505 Leonardo realized that the best solution would be a machine for gliding flight maneuvered by the pilot who could change its center of gravity by simply shifting the position of the upper part of his body.

This is the principle of the hang glider, at which Leonardo arrived not only through systematic study of the flight of birds but also by observing the behavior of kites, some of the largest of which were capable of lifting a man off the ground. This is explained on f. 64 r of the Madrid Ms I, where such a device is actually designed in a

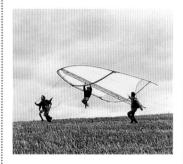

spherical shape to sail on the wind down a mountain slope, while "the man will remain standing" in Cardan's suspension in a spherical cage at its center.

The other device appearing on the same page already shows all of the characteristics of the hang glider. A model of it was constructed for the first time in 1993, and attempts at flight were made in England (see "Achademia Leonardi Vinci", VI, 1993, pp. 222-225), while a version more faithful to Leonardo's drawing has recently been built at Sigillo in Umbria by the local association "Progetto Insieme" with the consultation of Alessandro Vezzosi, within the context of the educational-exhibition activities of the Museo Ideale at Vinci.

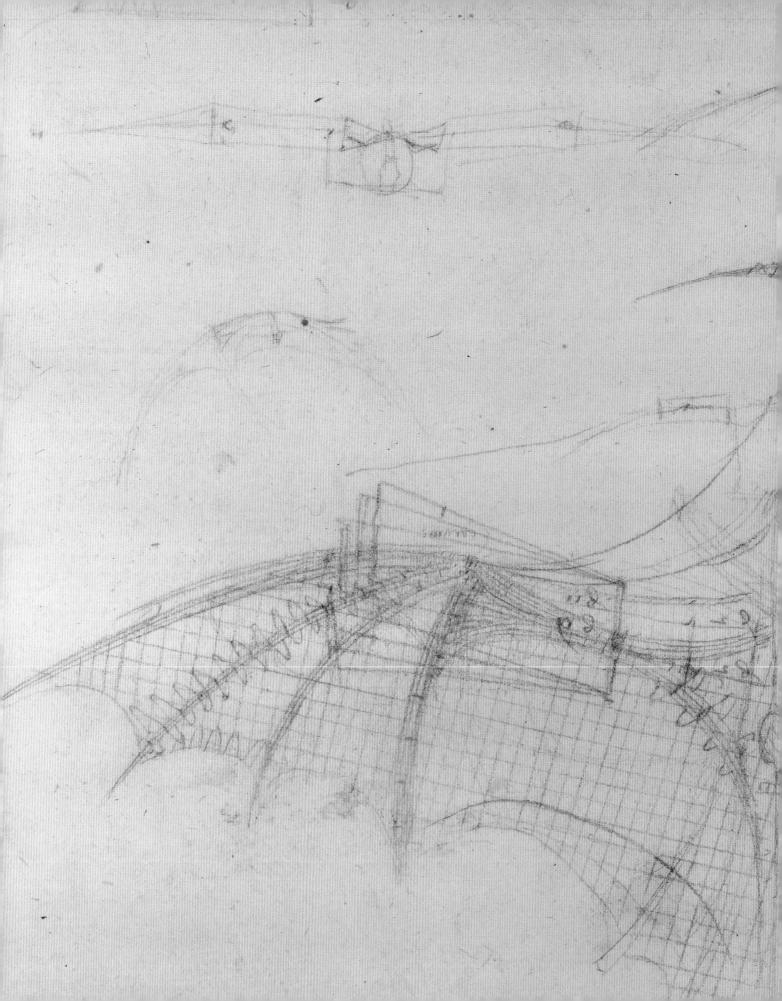

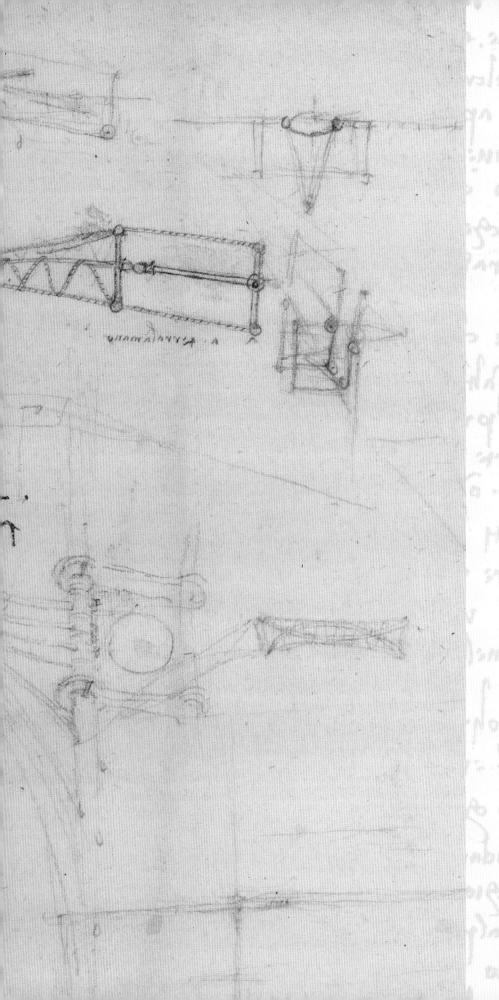

The extraordinary combination of art, science and technology that marked Leonardo's fervent theoretical and practical activity in every field of knowledge can be explained by the historical and cultural context surrounding him in Florence and Milan during the latter half of the Fifteenth Century. His manuscripts bear witness to the serious intent with which he carried out an arduous program of study, referring to traditional sources, ancient and medieval, also through the mediation of contemporary experts such as the mathematician Luca Pacioli. In the early years of the Sixteenth Century Leonardo, by now «most impatient with his brush», was wholly absorbed in the fervor of scientific research.

Overleaf, on the two preceding pages: first studies for sailplaning flight CA f. 70 ii r c. 1493-1495

- 1. Lorenzo de' Medici in a sketch by Leonardo Windsor RL 12442 r (from CA f. 902 ii r) c. 1483-1485
- 2. Ludovico il Moro in a detail from the Pala Sforzesca by
- an anonymous Lombard painter of the late 15th century Milan, Brera
- 3. Architectural studies for the cathedral of Pavia CA f. 362 v-b c. 1487-1490
- 4. Studies of churches with circular plan, of reverberatory furnaces and of a «tool with spheres» used in manufacturing burning mirrors Ms B f. 21 v c. 1487-1490

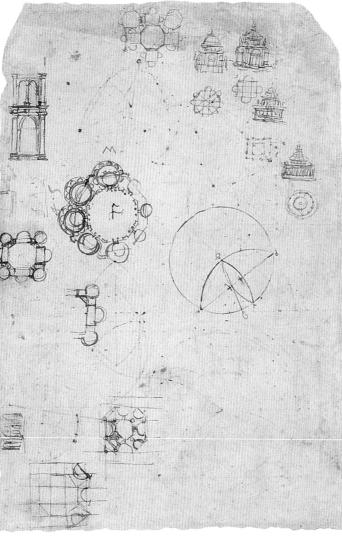

3

he culture linked to the universities in the great cities of Northern Italy, from Milan to Pavia, and Padua in particular, was different from that of Lorenzo de' Medici's Florence. Leonardo realized this as soon as he arrived in Milan in 1482. Although unable to evaluate the underlying reasons, he could not fail to realize that in his homeland, Florence, the emphasis was placed on those aspects of moral philosophy which concur to define the civic stature of man.

The philosopher Marsilio Ficino had in fact established, at the desire of Lorenzo himself, the Neo-Platonic Academy which in studying and interpreting the works of Plato sought to define a social order based on man's dignity and spiritual uplifting.

SCIENCE AND CULTURE IN MILAN

Milan was instead more pragmatic, as could be seen at a glance in the vast plains crisscrossed by a great network of canals planned by Francesco Sforza to stimulate industry as well as agriculture and commerce. University teaching was focused on study of the physical world, of nature. It was the teaching of Aristotle's natural philosophy that had been renewed in the famous schools of Oxford and Paris and that had spread over Northern Italy already in Medieval times. In Milan, Leonardo soon came into contact with the eminent personages of scientific culture. The occasion was offered him by Ludovico Sforza, who encouraged the arts and even organized meetings and scientific debates among the learned, including professors from the Pavia; and for once Leonardo too was included.

Scientific education in Milan and Pavia was often a family profession, as in the case of the Marliani. The distinguished writings, both published and unpublished, of the recently deceased

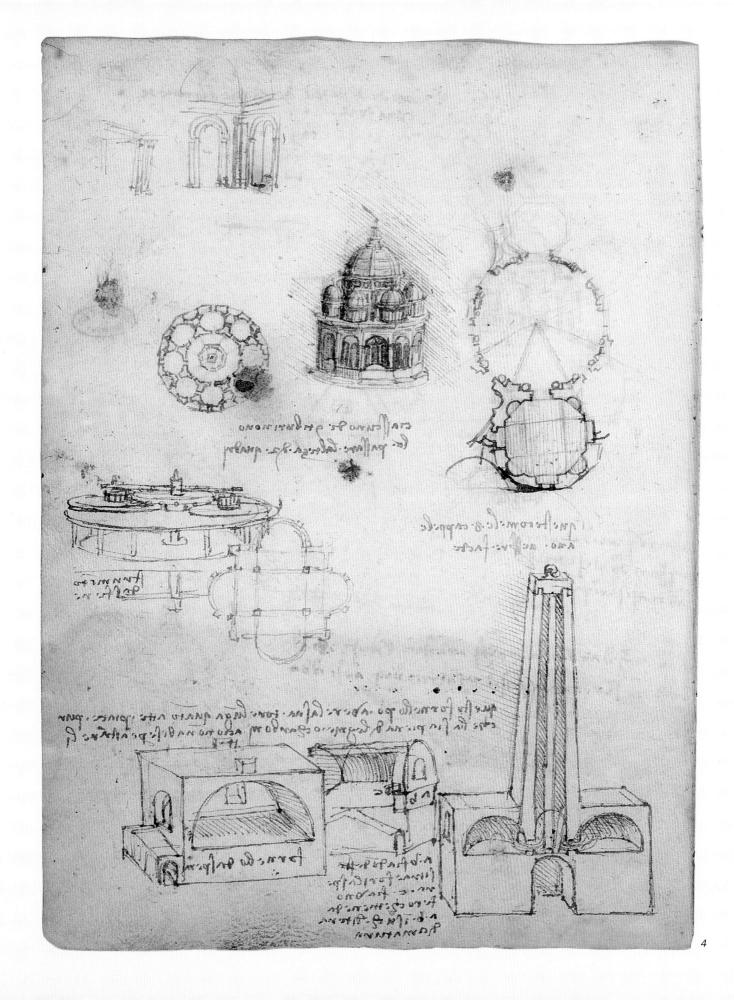

- 1. Study of church with circular plan Ms B f. 95 r (Ashburnham Ms f. 5 r) c. 1487-1490
- 2. Wooden model of building shown in the preceding figure Florence, Museum of History of Science 1987

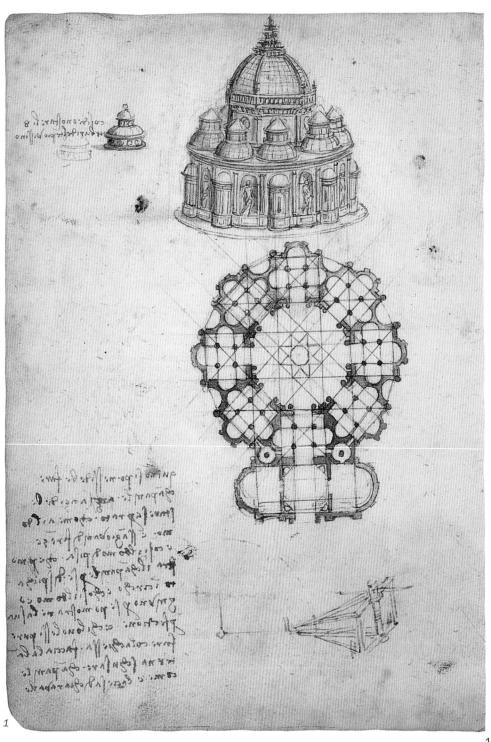

physician and mathematician Giovanni Marliani induced Leonardo to meet his sons, Gerolamo and Pier Antonio, who were also learned in the mathematical science: «Algebra, which the Marliani have, made by their father». In particular, Leonardo was interested in Marliani's observations on the relationship between light and shadow, a problem with which he himself was intensely concerned in about 1490. Although Marliani's works were all in Latin, Leonardo was able to understand them, perhaps with the help of a friend who translated or explained them. He could thus discuss them, at least with himself: «How can one have certain dense bodies that do not cast any shadow on their juxtaposed object. The Marliani science [i.e., theory] is therefore false».

In approaching the texts of ancient and Medieval knowledge, Leonardo recurred to experimental verification and contributed to the renewal of science by establishing mathematical justification as criterion for rationality. He could thus state: «There is no certainty where one can neither apply any of the mathematical sciences nor any of those which are based upon mathematical sciences». Observation and experience were thus the prerequisites for the formulation of physical laws: «It is my intention first to cite experience, then to show by reasoning why this experience is constrained to act in this manner. And this is the rule according to which speculators as to natural effects have to proceed».

From this came a break with tradition and his definition of «true science», that which goes beyond conceptual analysis: «No human investigation can be termed true science if it is not capable of mathematical demonstration. If you say that the sciences which begin and end in the mind are true, this is not conceded, but is de-

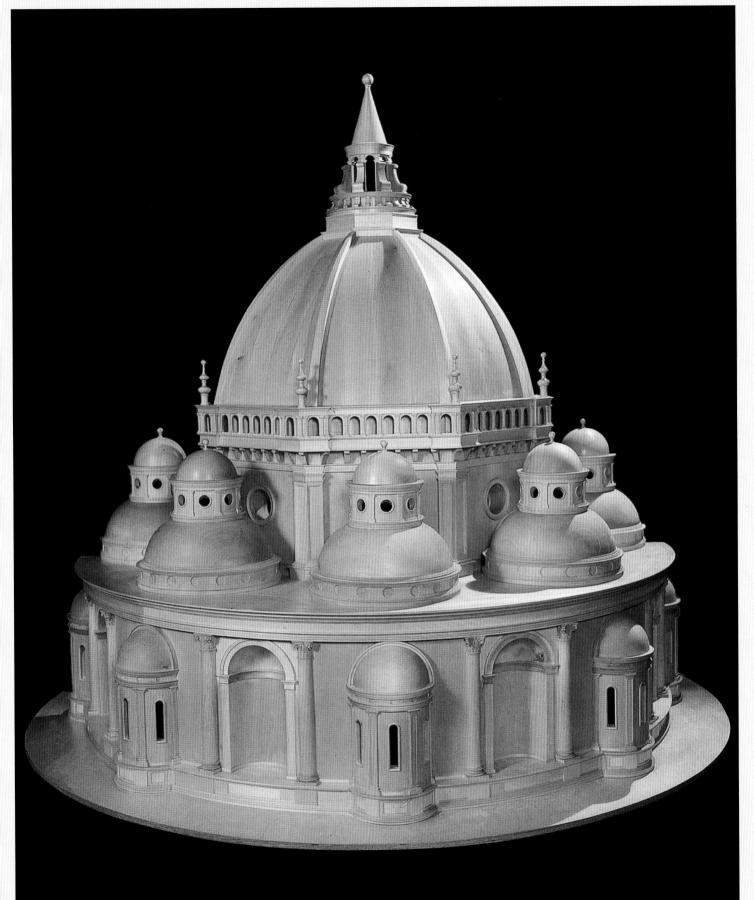

1-4. Principles
of proportion and
center of gravity
in studies of skull
dated by Leonardo
himself
«2 April 1489»
Windsor RL
19057 r, 19057 v,
19058 r, 19058 v

5. «Body born of the perspective of Leonardo da Vinci, disciple of experience» CA f. 520 r c. 1490

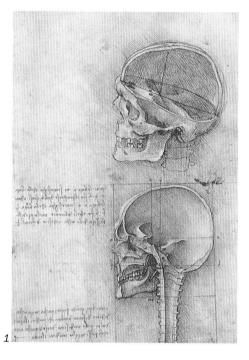

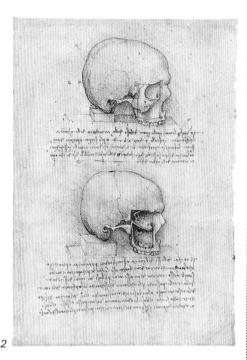

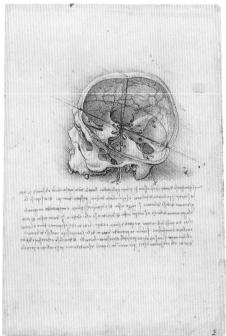

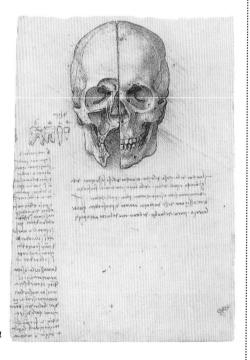

nied for many reasons, and foremost among these is the fact that the test of experience is absent from these exercises of the mind, and without these there is no assurance of certainty».

This is a text known only through a copy in the first chapter of the *Libro di pittura* (compiled after Leonardo's death), in which he proposes to demonstrate that painting is science. In a manuscript from 1515 he repeats the same concepts: «There is no certainty where one can neither apply any of the mathematical sciences nor any of those which are based upon the mathematical sciences».

THE BASIS OF KNOWLEDGE

All this began in the early days of Leonardo's stay in Milan. The meetings and confrontations were not always serene and cordial. «They will say that because of my lack of book-learning. I cannot properly express what I desire to treat of». This explains that geometric drawing of a body executed at the very time this statement was made, around 1490, under which appear the words: «Body born of the perspective of Leonardo Vinci, disciple of experience». This is followed by an explanation of what is involved: «Let this body be made without any relation to anybody, but out of simple lines only».

Perspective, proportion and mechanics. These are the cornerstones of the scientific basis of the study of art, and to them Leonardo turned from the very beginning of his stay in Milan. The Classical and Medieval texts he studied were subjected to the verification of experience through mathematical calculation. In the Medieval *Treatise of Proportions* by the Arab Al-Kindi, a work particularly well-known in the Milan of the 15th century, Leonardo could find a note of agreement, since the author had proclaimed that «it is impossible to understand philosophy

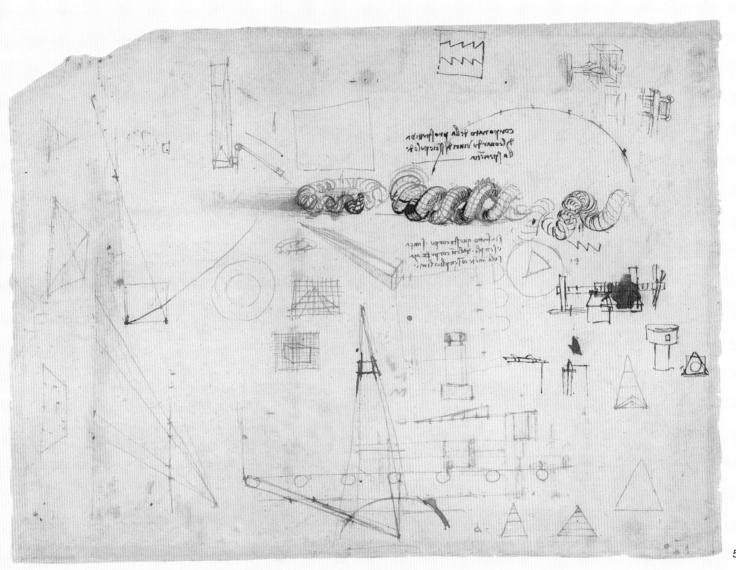

- 1. Illustration for
 De divina
 proportione
 by Luca Pacioli
 (1498):
 panel with the
 "Duodecedron
 elevatus vacuus"
- 2.-3. Solid geometry and polyhedrons Ms E f. 56 r c. 1513-1514 Forster Ms I f. 5 r 1505
- 4. Detail
 of sketch of a
 dodecahedron
 on a folio of studies
 of fortifications
 CA f. 942 v
 c. 1503-1504
- 5. Illustration of the geometric principles of proportions applied to architecture on a folio of anatomical studies Windsor RL 12608 r c. 1485-1487

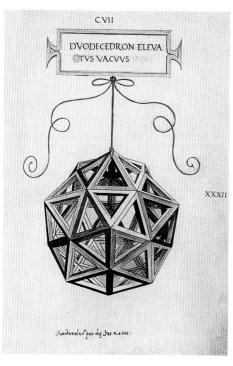

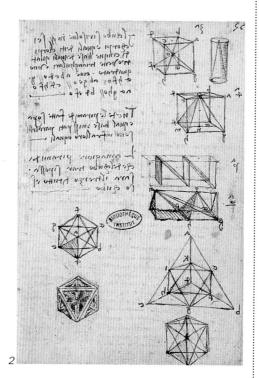

without a knowledge of mathematics». Leonardo was acquainted with this work through the version with comments by Giovanni Marliani given him by the physician Fazio Cardano, father of the great philosopher Gerolamo: «Alchendi's proportions as explained by Marliani: Messer Fazio has it». Fazio Cardano had, among other things, published the Prospettiva communis by the philosopher Giovanni Peckham, from which Leonardo was to take the famous eulogy to light translated into Italian. For Leonardo, what was proportion? He tells us in a note from 1505: «Proportion is found not only in numbers and measurements but also in sounds, weights, time, positions, and in whatsoever power there may be».

This explains Leonard's anthropometric interests in about 1490, which ranged from graphic interpretation of Vitruvius' principles to minute measurements performed on the human body through an analytic-comparative method, correlating for example the height of the head to that of the foot and other limbs.

THE STUDY OF GEOMETRY

Leonardo's first anatomical studies were, in fact, based on proportional schemes used to determine the factors of weight and balance in the human body. The famous Windsor drawings of skulls, dated 1489 by Leonardo himself, illustrate how these schemes were used to identify the center of gravity in a cross-section view of the skull, as in a geometric body.

Leonardo, as we know, had studied geometry already as a young man in Florence. In Milan he resumed these studies immediately, along with those of painting, anatomy, optics, mechanics and hydraulics. Geometry was for him the foundation stone of all aspects of scientific research and interpreta-

- 1.-2. Solid geometry and polyhedrons Forster Ms I ff. 13 r, 13 v 1505
- 3. lacopo de' Barbari Portrait of Luca Pacioli dated 1494 Naples, Capodimonte
- 4. Studies on solid geometry with the note (at center, above) «Make lenses to see the moon large» CA f. 518 r c. 1513-1514

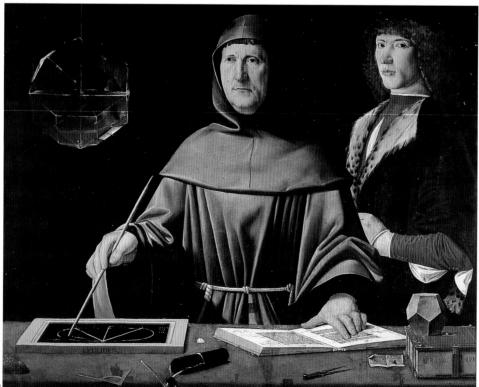

tion of natural phenomena. As such, it had to be studied in depth. The occasion for doing so arose with the arrival in Milan, in 1496, of Luca Pacioli, teacher of mathematics, disciple of Piero della Francesca, and author of a voluminous *Summa di aritmetica* published in Venice in 1494 and immediately purchased by Leonardo, who also noted the price paid, 119 "soldi" (for a book worth about a hundred million lire today).

With the aid of Pacioli, Leonardo advanced, with some difficulty perhaps. through the complexity of Euclid's theorems. Here he had to go beyond those first three books of elementary concepts on which the teaching of geometry was based. With an almost Evangelical sense of humility he resolved one problem after another, proceeding step by step, like a diligent scholar. Already nearly forty-five, he had just finished the Last Supper, the work in which he seems to demonstrate an awareness of the need to consider space in geometric, harmonious scanning. After this he was ready to surpass himself in the virtuosity of the geometric and plant motifs for the decoration of the Sala delle Asse in 1498.

Luca Pacioli was finishing the work that was to make him famous, De divina proportione (completed in Milan in 1498 and published in Venice in 1509), to which Leonardo contributed with the illustrations: geometric bodies represented in perspective, from the simplest, purest shape (the sphere) to the most complex polyhedron. The models of the bodies were made of glass to show their structure at a glance; an example can be seen in a well-known portrait of Luca Pacioli painted by Iacopo de' Barbari in 1494. For each body Leonardo provides a solid version and a "pierced" one, portrayed in lattice-work to indicate its structure. Subsequently he was to em-

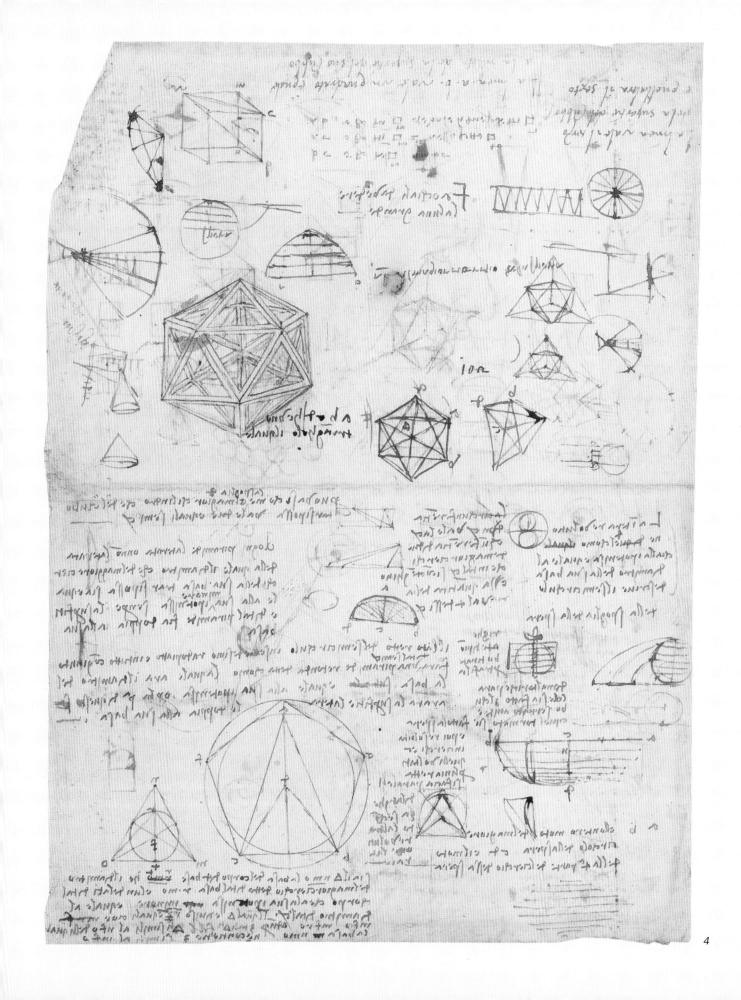

1.-2. Geometric proportions applied to the human figure Windsor RL 19132 r Windsor RL 19136 r c. 1490 3. Studies of proportions of the head and human figure Windsor RL 12001 r c. 1490

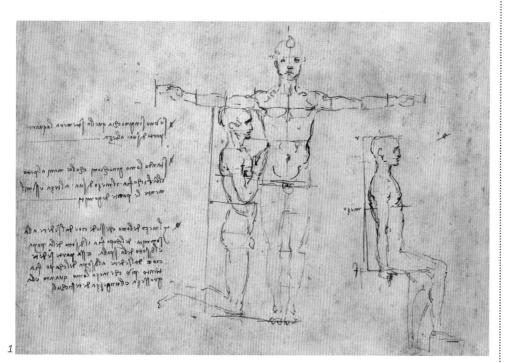

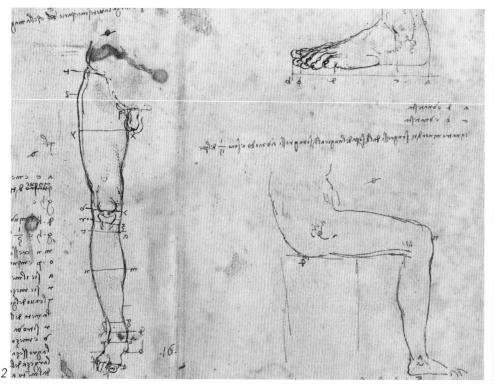

ploy a similar method in the schematic representation of muscles, reduced to chords indicating the lines of force.

In these illustrations for Luca Pacioli's De divina proportione converged all of the intellectual currents of the 15th century, from the experiments of Paolo Uccello to those of Piero della Francesca, from the concepts on proportions expounded in the texts of the Scholastic authors to the Platonic-theological symbology underlying Marsilio Ficino's philosophy. For Leonardo it was not only an exercise in graphic abstraction, but a way of reconsidering the question of the modular principles of architectural shapes, which form the basis for processes of geometric manipulation of space. It is not merely by chance that Bramante was at the same time completing the apse of Santa Maria delle Grazie, in the refectory of which Leonardo had painted the Last Supper. And Pacioli speaks expressly of that work as example of the «new architecture». He also relates a highly revealing episode, that of the stone-cutter in Rome who boasted of being able to carve capitals with unsurpassed skill, but was incapable of sculpting one of the simple forms of a geometric polyhedron.

The recent studies of Augusto Marinoni on Leonardo's relations with Pacioli have contributed significantly to our knowledge of Leonardo's scientific work, in all of its intensity and its limitations. The development of Leonardo's mathematical studies, as regards geometry in particular, can now be traced more clearly. And we can more easily understand the determination and serious intent with which, after his return to Florence, Leonardo dedicated himself to the systematic study of geometry, «most impatient with his brush», as reported by a contemporary. It was a program of study followed by Leonardo under the con-

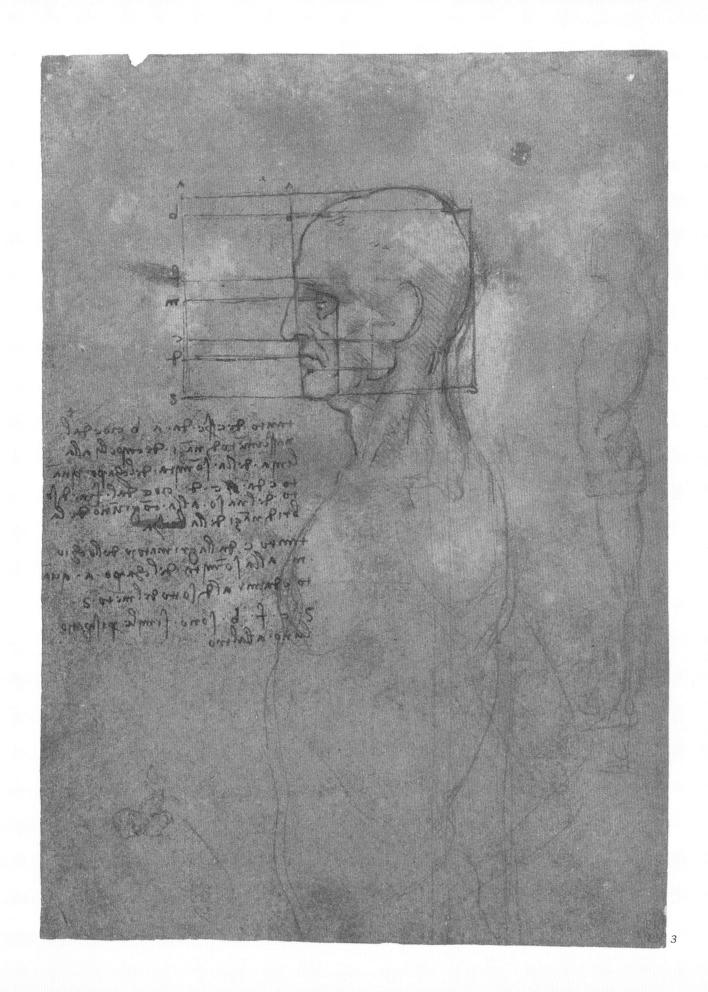

- 1. Geometric proportions applied to the study of traction: the force of the oxen is inversely proportional to the diameter of the wheel to be pulled CA f. 561 r c. 1487-1490
- 2. Parabolic compass CA f. 1093 r c. 1513-1514
- 3. Studies of «lunulae» CA f. 455 r c. 1515

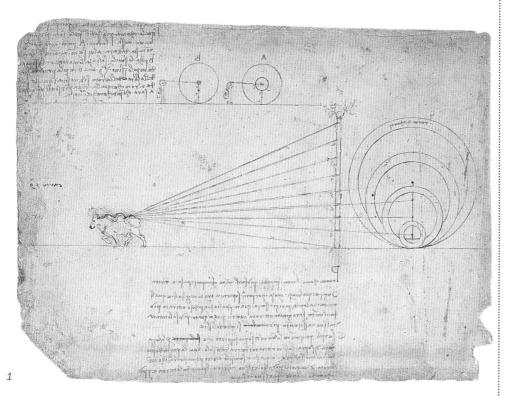

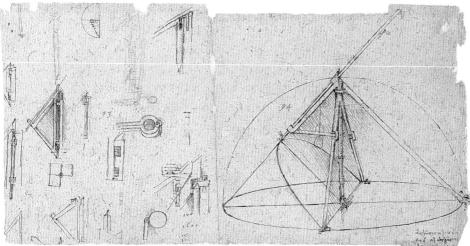

stant stimulus of Pacioli, who had returned with him to Florence. Together they worked on a new edition of Euclid which Pacioli was to publish in Venice in 1509, with an acknowledgment to Leonardo for the substantial help he had given in those years.

In the meantime, Leonardo was finding other stimuli in Florence: the scientific encyclopedia by Giorgio Valla published in 1501, utilized by him for to study Hippocrates' «lunulae» and the problem of the «proportional means»; and then the 1503 edition of Archimedes' brief treatise on the squaring of the circle. During this time Leonardo also visited the famous libraries of San Marco and Santo Spirito to consult texts on optics and mathematics, such as those of the Polish Vitellius (Erazm Ciolek) and the Arab Alhazen (Ibn al Haitam). At the time of the Battle of Anghiari (1503-1505), traces of exercises on Euclid's theorems can still be found in his manuscripts. But Leonardo was now ready to confront the field of stereometry and the transformation of surfaces, and thus of the «lunulae», a field he was practically never to abandon again until his death in France.

THE THEORY OF FLIGHT

«A bird is an instrument working according to mathematical law, which instrument it is within the capacity of man to reproduce with all its movements, but not with a corresponding degree of strength».

After the lengthy but unsuccessful studies on artificial flight conducted in Milan, Leonardo dedicated himself to studying the flight of birds, starting immediately after his return to Florence in 1500. In 1505 he compiled comprehensive observations on the behavior of birds in relation to the wind, many of which he collected in a small codex that also contains notes on me-

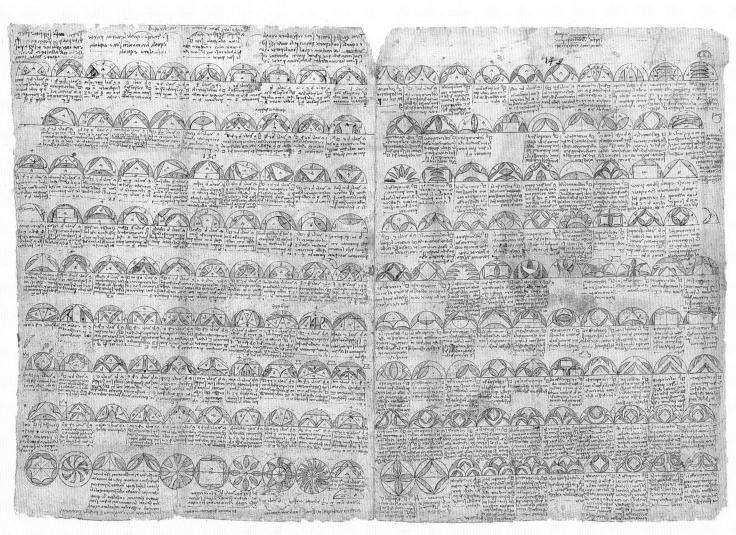

- 1.-2. Studies
 of wing
 for glider
 Codex on the Flight
 of Birds
 ff. 16 v-17 r
 c. 1505
- 3. Studies on balancing of pilot in glider Codex on the Flight of Birds f. 5 r c. 1505
- 4. Anatomy of bird wing Windsor RL 12656 c. 1513-1514
- 5. Ornithopter with pilot in prone position Ms B f. 79 r c. 1487-1490

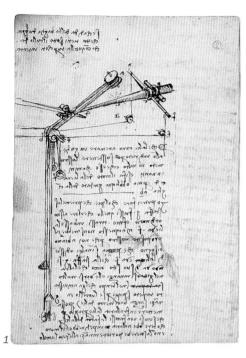

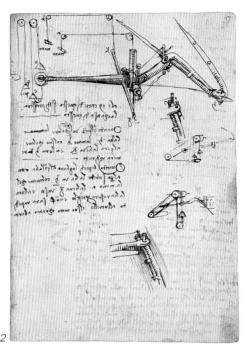

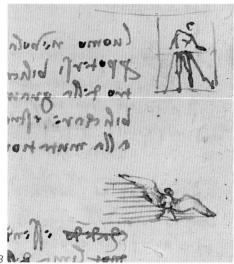

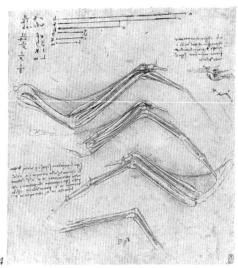

chanics, hydraulics and architecture. The analytical mind of the scientist proceeds by analogy: «That bird will rise up to a height which by means of a circular movement in the shape of a screw makes its reflex movement against the coming of the wind...» Or, in alternating soaring and descent: «They flock together and spiral upward with many turns, and then repeat again their first movement, in a line slanting gently downward; then they flock together again, and rise wheeling through the air».

This is the spiral flight in which Leonardo recognized the vitality of nature. He saw it in whirlpools of water, in the flow of the blood and in wavy hair, as well as in the arrangement of the branches of plants, discovering the law of phyllotaxy which in modern botany bears his name. It was this same vital force that Leonardo expressed, just at that time, in the serpentine lines of *Leda and the Swan*, and in the impetuous whirling of the horses in the *Battle of Anghiari*.

The idea of a glider, a flying machine to be launched in flight from the top of Monte Ceceri, at Fiesole near Florence, also dates from this time, around 1505. In 1550 Gerolamo Cardano was to recall Leonardo's experiments with flight: «He tried to fly but in vain. He was an excellent painter».

The study of flight continued, resumed at intervals, and increasingly based on scientific criteria and a comparative approach: the anatomy of birds as compared to that of man; the motion of the wind as compared to that of water.

From 1510 on, Leonardo conducted further research. «I will show the anatomy of the bird's wings, along with the chest muscles that drive these wings. And I will do the same of man, to show how he can be supported in the air by the beating of wings».

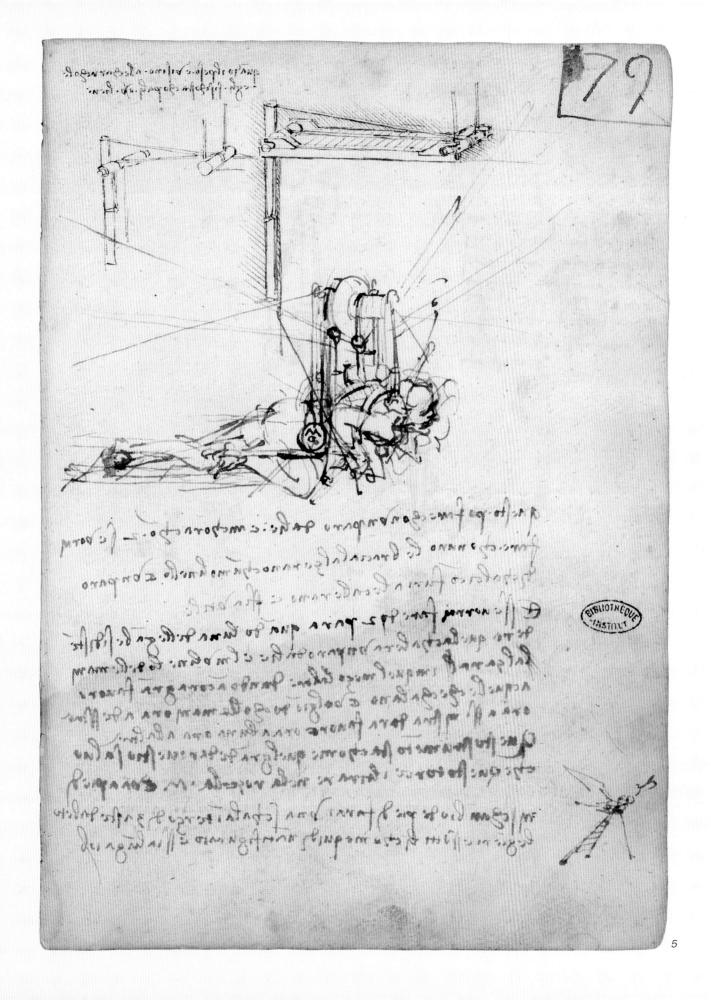

- 1. Systems of locks for river navigation CA f. 90 v c. 1480-1482
- 2. System of locks for river navigation CA f. 28 r c. 1485
- 3. Studies on the behavior of water in currents conditioned by the presence of obstacles Windsor RL 12660 v c. 1508-1510
- 4. From the "Deluges" series, collapse of rocky barrage on the waters of a lake Windsor RL 12380 c. 1515-1516

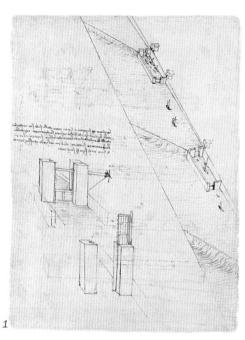

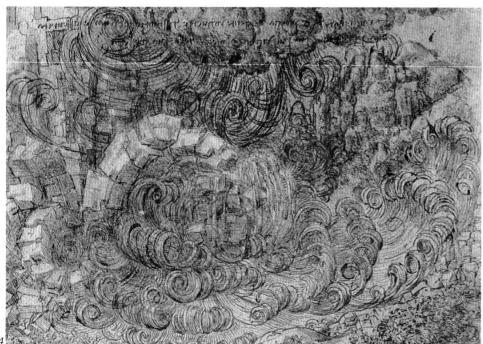

These studies, now at Windsor, are datable to 1513. At that time, surprisingly, Leonardo had returned to the conviction that an aircraft could be lifted by man's muscular strength alone. Only recently a pilot in Pasadena, California, Allen Bryan, has proved that Leonardo was right. In the same late period, around 1513-1514, Leonardo continued to study air currents, and expounded the concept of «true science», i.e., of theory formulated on the basis of observation and experience, according to which the motion of air could be likened to that of water. This is expressed in the famous text cited at the beginning (p. 10), which is a first formulation of the science of fluids.

To the study of water, «Nature's carrier», Leonardo had dedicated himself intensely since the early years of his stay in Lombardy. Already at that time he had touched on almost all of its aspects, but still without the impetus that would make him dream of compiling a treatise on water, in fifteen books, on which he was still working as an old man.

From 1508 on, his studies of water currents and whirlpools were marked by increasingly exuberant vitality. But the strict accuracy of their geometric schemes is unable to restrain them within the bounds of mere illustrations to a text. Soon they overflow in a majestic vision of terrifying floods, leaving no space for a written text. They are transmuted into images of pure energy encompassing all of the elements, a manifestation of destruction that is a part of the natural process of change. Everything is overwhelmed in a well-orchestrated fury: plants, men, animals. The beings of the perceivable world, minutely and lovingly studied in the past, are hurled into the oblivion where nature claims supreme sovereignty.

t is known that Leonardo invented various instruments to facilitate the work of artists. These instruments, which were used even by Albrecht Dürer, are in fact mentioned in his will.

The perspectograph, already mentioned by Leon Battista Alberti and represented an early sheet of the Codex Atlanticus is a forerunner of the camera insofar as it provides the artist with an exact reproduction of reality. As such it is often taken as symbol of scientific research, and it has been suggested that the figure of the young observer in the drawing is the artist himself.

The ellipsograph was known to Arab mathematicians. Leonardo conceived it as a mechanical device capable of presenting the geometric process of conic sections in graphic form. He drew it in several versions, one of which, now lost, was widely diffused and copied a number of times by his contemporaries, among them Dürer.

The instrument, a model of which was created for the Bologna Exhibition of 1953,

THE PERSPECTOGRAPH AND THE ELLIPSOGRAPH

Above, Dürer's perspectograph 1525 Lower left, perspectograph, CA f. 5 r c. 1480-1482 Below, adjustable-opening compasses
Ms H f. 108 v, c. 1494
At left and below, models of adjustable-opening compasses and of the ellipsograph (Bologna Exhibition of 1953)

consists of three legs forming a triangle and a styluscarrier rod used to inscribe perfect ellipses. It was designed to be used for precision mechanisms such as the ovalshaped wheels in planetary clocks, some examples of which can be seen on f. 24 r of the Madrid Ms I.

In a codex by Benvenuto di Lorenzo della Golpaja now in Venice – a collection of drawings of inventions by his father and numerous other contemporaries, among them Leonardo – appears, with the name of its inventor, the adjustable-opening compass drawn by Leonardo in about 1494 on f. 108 v of the Paris Ms H.

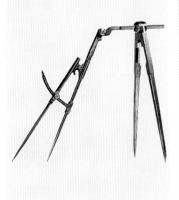

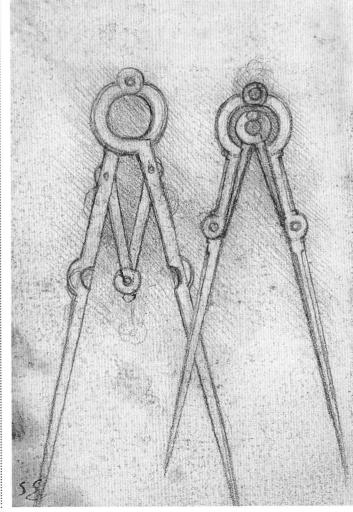

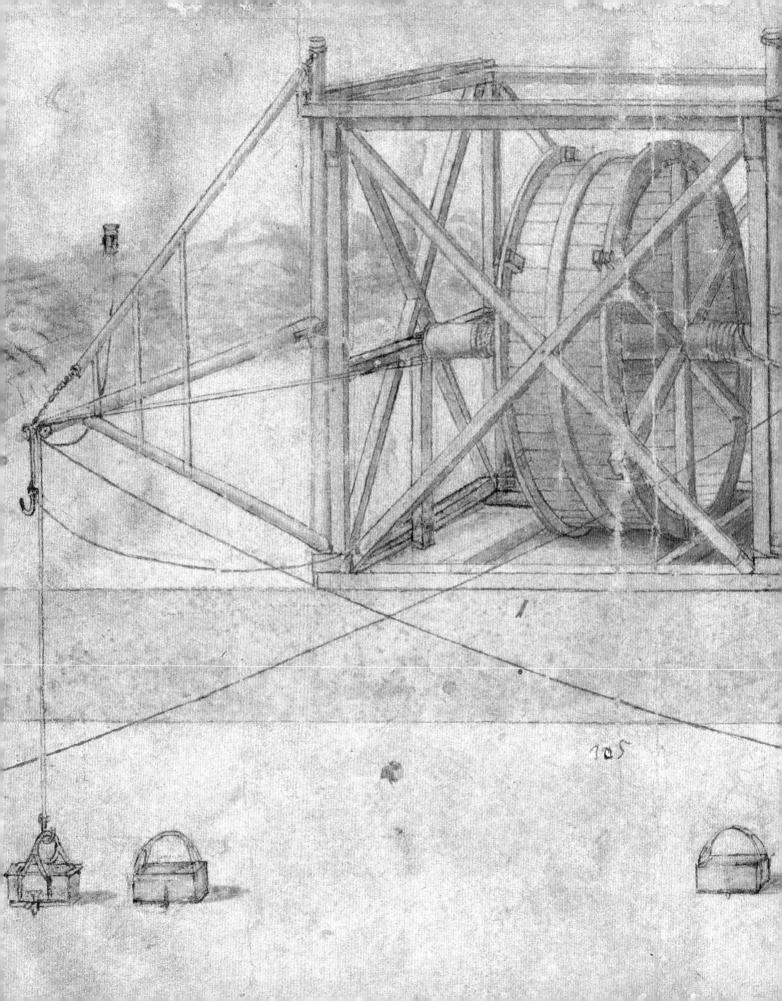

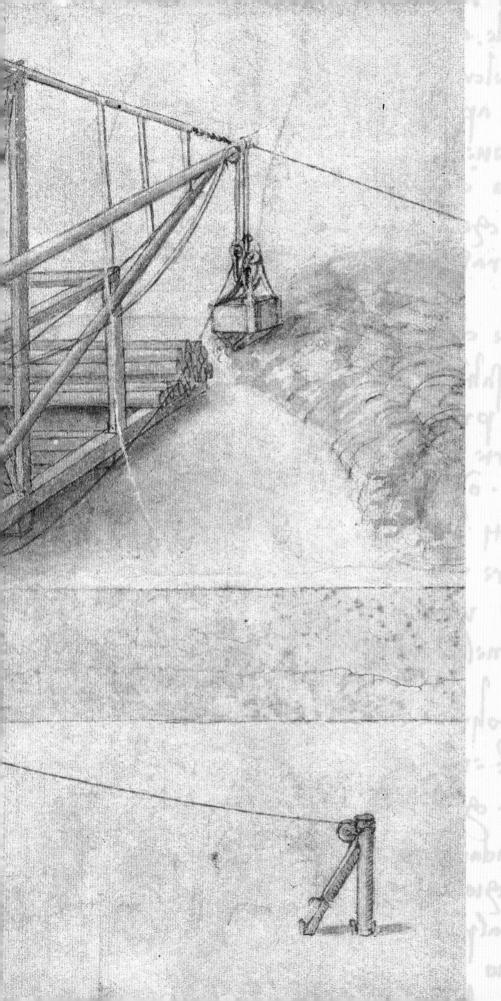

Every one of Leonardo's technological concepts is inspired by the examples of nature. In each of them man, as a living machine, is recognized as the insuperable model of inventive genius which can only in part be simulated by a robot. This is an aspect of Leonardo's technology that has only recently emerged, predominating over the still fascinating subject of his inventions in the military and civil sphere - inventions that range from the armored tank to the helicopter, from the submarine to the automobile all the way to the spectacular excavating machines. Within this context the close relationship seen by Leonardo between anatomy and technology, which led him to apply the same principles of drawing to both, becomes strikingly evident.

Overleaf, on the two preceding pages: detail of excavating machine CA f. 3 r c. 1503

- 1.-2. Studies on mechanics of the human body Windsor RL 19040 r-v c. 1508
- 3. Diagram of wing mechanism for glider CA f. 934 r c. 1506-1508
- 4. Studies for an anatomical model of leg with muscles indicated by copper wires Windsor RL 12619 c. 1508
- 5. Studies of muscles of the mouth Windsor RL 19055 v c. 1508

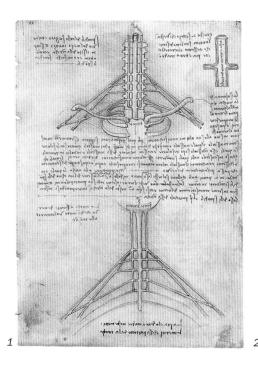

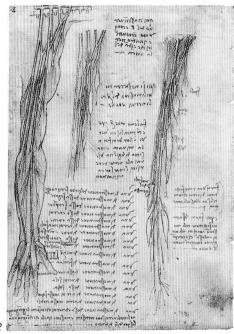

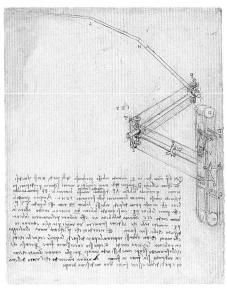

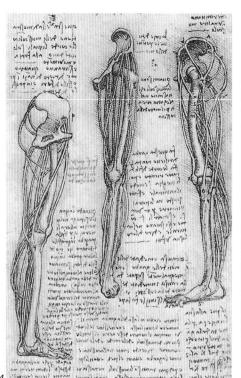

he Mona Lisa, the Last Supper and the letter to Ludovico Sforza in 1482 can be taken as a summary of Leonardo's fame the world over: the artistic-scientist and inventor. To understand his art we must follow his thought through its systematic, passionate exploration of nature and its laws, as expressed in his manuscripts and drawings. It then becomes clear that art was for him a form of creative knowledge which went beyond science. It was a higher means of expressing human feelings - of «mental motions», - the essence of which was to be found in the smile.

The smile is, in fact, produced by complex imperceptible movements of the facial muscles that no machine can ever replicate. Leonardo was aware of this. It was the motions of the twenty-four muscles of the mouth that he proposed to describe and portray, «testing these motions with my mathematical principles». The same method was applied in his anatomical studies from 1508 to 1510, where he began to consider the relationship between the human machine and the one invented by man.

From this emerges a portrait of himself as inventor: «Although human ingenuity makes various inventions, responding with different instruments to a single objective, never will it find an invention more beautiful, more facile, nor more direct than those of nature, because in her inventions nothing is lacking and nothing is superfluous».

THE MECHANICAL LION

The invention of Leonardo that made the most striking impression on his contemporaries is the one of which no trace has remained, not even a note in his manuscripts: the mechanical lion. Only recently has it been learned that the automaton was

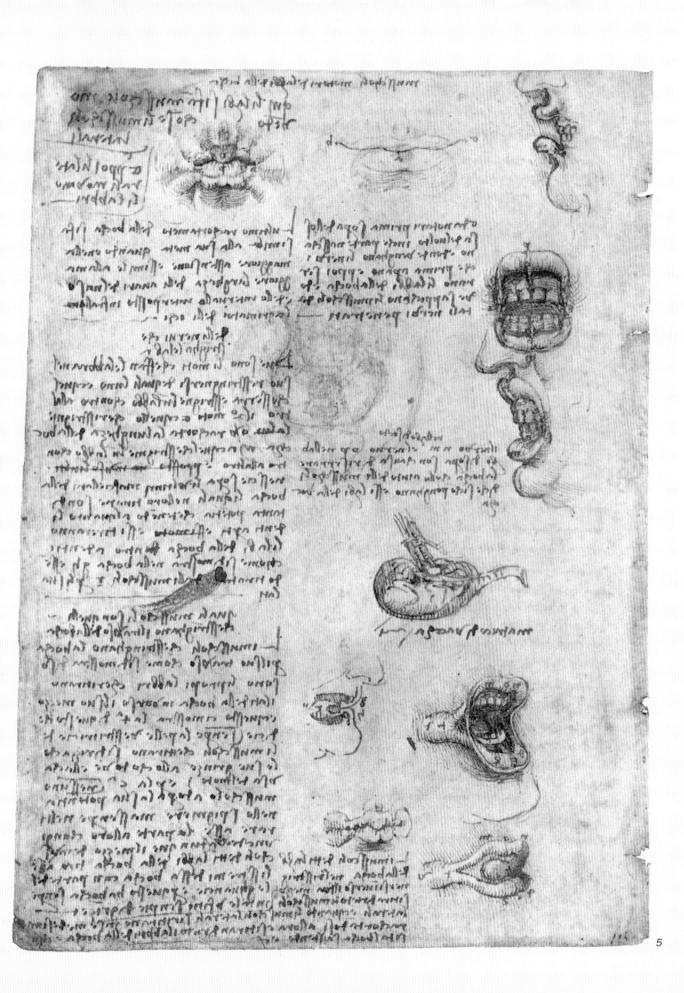

1.-2. Studies of lion's heads Windsor RL 12586, RL 12587 c. 1500-1503

3. Study of parade helmet in the jaws of a lion Windsor RL 12329 c. 1517-1518

4. Study of fantastic animal, probably idea for an automaton Windsor RL 12369 c. 1515-1516

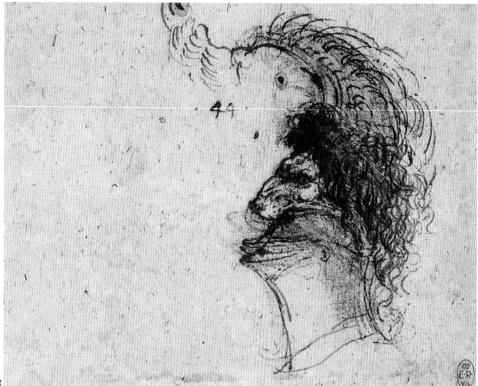

constructed at Florence in 1515 and sent to Lyon to greet Francis I, the new King of France, upon his triumphal entry into that city.

The festivities were organized by the Florentine colony, which explains the choice of a lion as reference to their adoptive homeland. There was however a double meaning. The symbolic homage was addressed to the powerful monarch with whom the Medici Pope, Leo X, was anxious to ally himself. He did in fact manage to arrange a marriage between the king's aunt, Filiberta di Savoia, and his brother Giuliano de' Medici, Leonardo's protector. So Leonardo had to invent another political allegory, this time recurring to technology. The governor of Florence who commissioned this work of him was the Pope's nephew, Lorenzo di Piero de' Medici, for whom Leonardo also designed a splendid palace that was to have been built beside the old Palazzo Medici.

The lion was the symbol of Florence, like Donatello's *Marzocco* (and had a double meaning: lion-Leo X). The idea was to have the automaton walk toward the king, halt in front of him, rise on its rear legs and open its chest with its front paws to show that in place of a heart it bore the lilies of France, the same lilies that Louis XI had granted to the Florentine republic in the 15th century. This symbolic act was to sanction the renewed friendship between the two nations.

In 1584 Giovan Paolo Lomazzo spoke of this automaton as an «admirable artifice», noting on another occasion that Leonardo could teach the way «to have lions walk by way of wheels». It is probable that the structural details of the mechanism were described and illustrated by Leonardo in manuscripts now lost. A replica

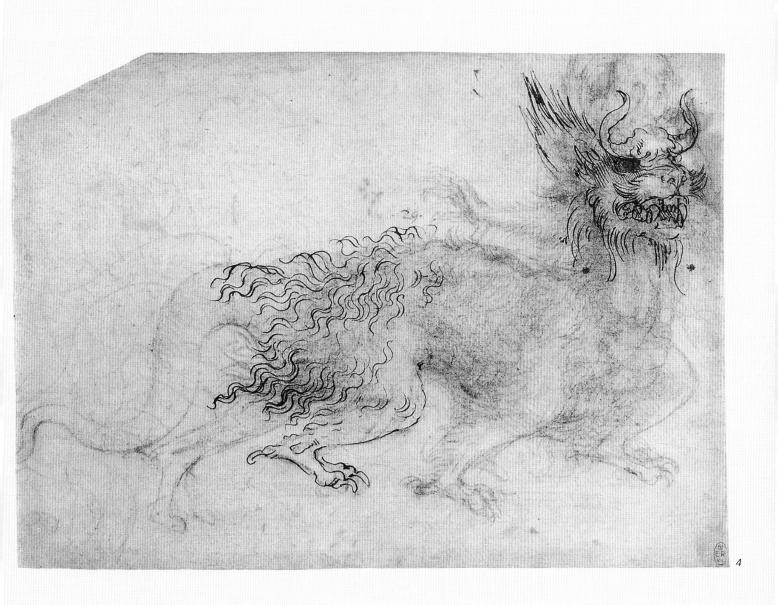

- 1. Benvenuto di Lorenzo della Golpaja, water meter designed by Leonardo for Bernardo Rucellai Codex Marciano 5363 f. 7 v c. 1510
- 2. Sketch of Rucellai machine CA f. 229 r c. 1510
- 3. Scale working drawing of Rucellai machine according to the measurements specified by Golpaja (from C. Pedretti in "Raccolta Vinciana" Sect. XVII, 1954, pp. 212-213)
- 4. C. Pedretti: draft model for the Rucellai machine (1953)
- 5. Studies for Bernardo Rucellai's water meter Ms G f. 93 v c. 1510-1511

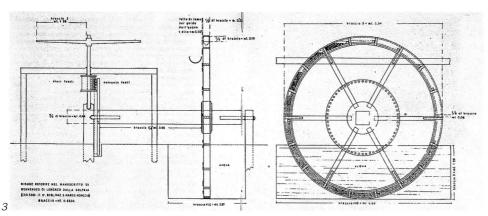

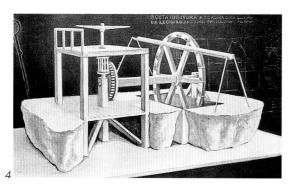

of that lion was in fact used in the festivities for the wedding of Maria de' Medici and Henri IV, King of France, in 1600. In the published report of that event Leonardo's previous invention is mentioned with an explanation of the circumstances. This is still further proof of the diffusion of Leonardo's technological ideas after his death, a point which should be emphasized.

CONCRETE ACHIEVEMENTS

Fifty years have now passed since I discovered the only document proving that a machine invented by Leonardo had been constructed by him. This was a water meter which he had built by a Domodossola artisan in about 1510 and sent to the merchant and humanist Bernardo Rucellai in Florence, probably to be used on his Quaracchi estate. The instrument is described by one of Leonardo's contemporaries, on the basis of the working drawings it seems, since the measurements are given for each component.

The document which I published in 1952 is a codex by one of Leonardo's contemporaries, Benvenuto di Lorenzo della Golpaja, now in the San Marco National Library at Venice. Two other inventions by Leonardo are described and illustrated: the adjustable-opening compass, which appears drawn by Leonardo himself in one of his notebooks from 1493-1494 now in Paris, and an ingenious compass used «to make an oval», i.e., an ellipsograph probably designed for use in manufacturing oval wheels for planetary clocks. The idea was taken up by Albrecht Dürer and was then diffused in Germany, as proven by a drawing of his at Dresden (see insert on p. 49, above).

The museums of Leonardo's machines which have sprung up all over

- 1. Studies of naval artillery Windsor RL 12632 r c. 1487-1490
- 2. Drawings of military machines Windsor RL 12647 c. 1487-1490

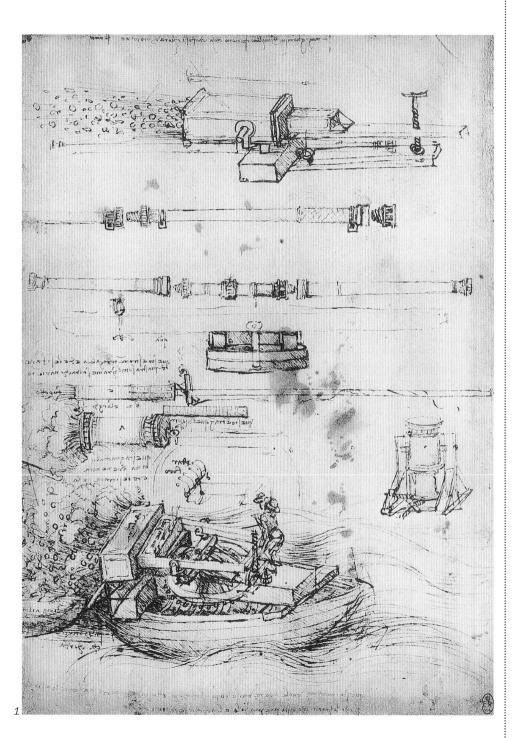

the world in recent years – from Italy to France, from America to Japan – insist on presenting models based on drawings by Leonardo which are directly related to the various inventions of military nature listed in the famous letter to Ludovico Sforza.

In addition, there are models of flying machines (mostly of the ornithoptic type, with beating wings, rather than the gliding type), nautical devices such as diving suits and special equipment for underwater connections, machines for excavating channels, hydraulic machines, and so on; in general, all of the most spectacular items that can be taken from his manuscripts, classified by subject rather than chronologically. The extraordinary development of Leonardo's technological activity would instead be shown more clearly in a chronological arrangement.

MACHINES AND DEVICES

The discovery of the Madrid manuscripts in 1967 has contributed still further to incrementing Leonardo's technological repertoire, especially in the sector of textile machines and clocks, as well as devices belonging to the category of «mechanical elements», those which carried out a primary function, such as levers, wheels, gears, etc.

The first of these codexes is the one that contains the most eloquent examples of Leonardo's inventiveness in this sector, the best demonstration of how to present a technological idea through visual language.

These drawings date from about 1497-1500, during the period following that of the *Last Supper* and the studies for the equestrian monument to Duke Sforza. Now famous among them is the full-page drawing illustrating the principle of transmission of motion from a spring for clocks,

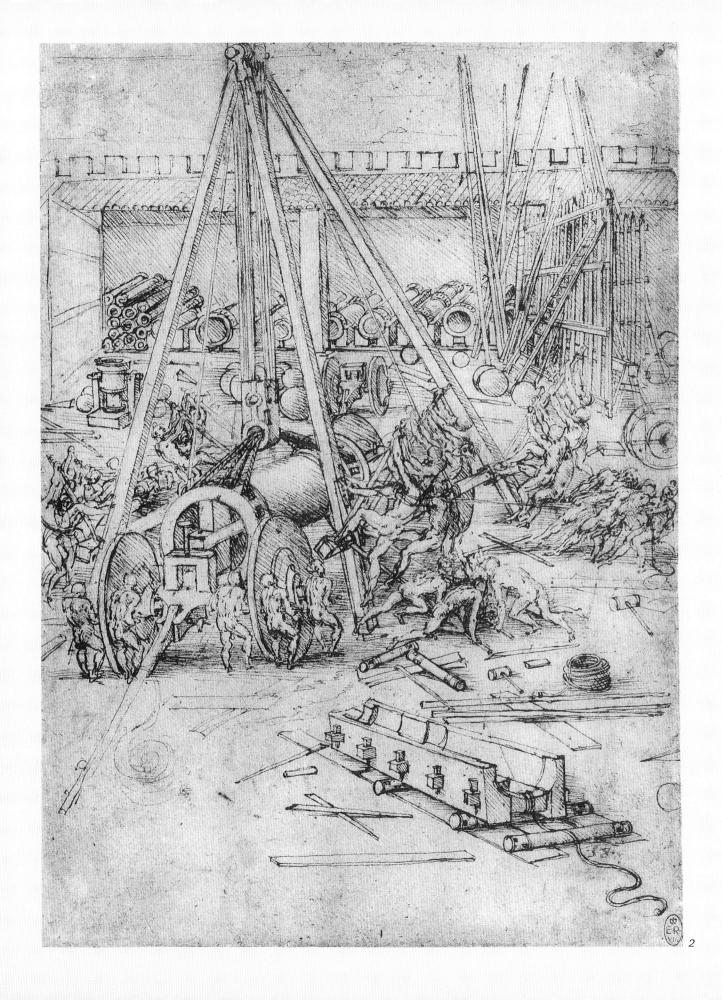

- 1. Reverse screw and steering device for cart Madrid Ms I f. 58 r c. 1495
- 2. Spring-driven motor Madrid Ms I f. 14 r c. 1495
- 3. Circular worm screw Madrid Ms I f. 70 r c. 1495
- 4. Model of spring-driven motor Florence, Museum of History of Science 1987
- 5.-6. Worm screw engaging a toothed wheel Madrid Ms I f. 17 v and functioning model Florence, Museum of History of Science 1987
- 7. Studies of
 «mechanical
 elements»
 (levers
 and springs)
 Madrid Ms I
 ff. 44 v-45 r
 c. 1497

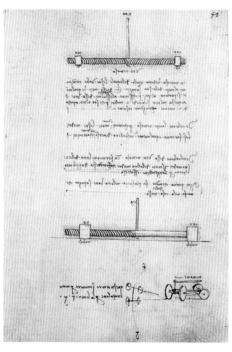

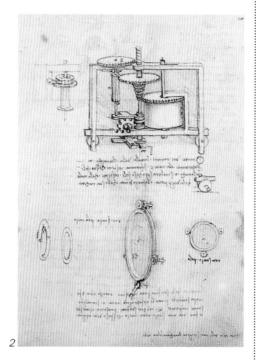

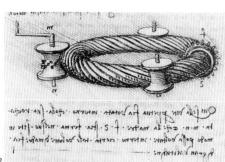

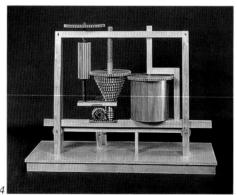

and at the same time as imposing as that of an architectural monument. Similar architectural characteristics appear in the drawing of the device shown on the following page. It is hard to imagine what this device could be used for, although its horizontal section and elevation views are clearly drawn. A number of vertical rods are arranged in a circle around a central opening in a circular platform. Each of them is hinged so that it can move outwards along a radius starting from the center of the platform. Problem: how to open the rods simultaneously as if they were the poles of an enormous umbrellalike tent. Solution: a system consisting of a continuous rope passing through a double array of pulleys, the outer ones fixed to the platform, the inner ones mobile but fixed to the base of a pole. As the ends of the rope

wound and enclosed in a drum. Here

Leonardo demonstrated how motion

could be transmitted through a vo-

lute spring to compensate for the de-

creasing force of the spring as it un-

winds. The note is limited to infor-

mation on its construction. The ex-

planation of its functioning is instead

entrusted to the drawing, so appropriate in its vigorous, precise lines

The brief note accompanying the drawing merely observes that «the wheels toward the center are movable, while those near the greater circle are stable», so that «a circular motion results from turning the crank because the inner rollers draw nearer to the outer rollers and pull anything attached to them».

are wound up on a crank, a uniform

pressure is exerted on the inner array of pulleys, controlling the poles as

they open out simultaneously.

A glance at the illustration shows that this explanation is superfluous. The drawing is self-explanatory. The

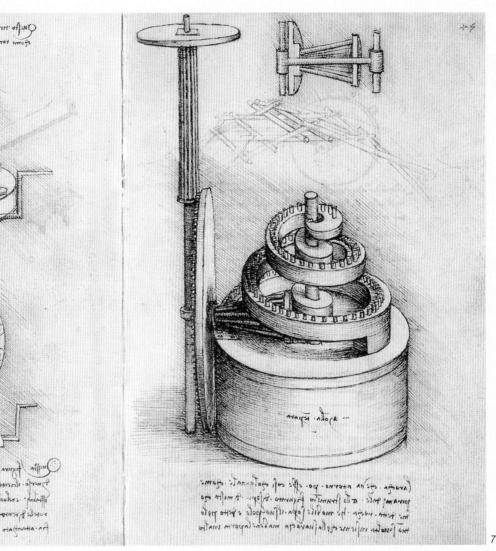

Sundand Sty of other labouts style swely

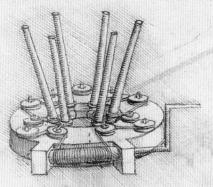

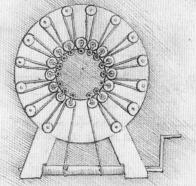

and the state of a solution of the solution of

- 1. James E. McCabe, The operation of Curius' theater as interpreted by Leonardo 1969
- 2.-4. Operation of Curius' theater in Leonardo's interpretation of Pliny's text (model built by James E. McCabe according to his interpretive drawings)
- 5. Curius' theatre Madrid Ms I f. 110 r c. 1495

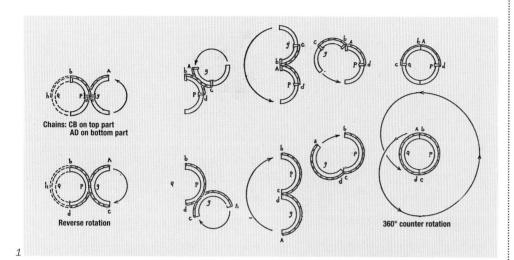

same can be said of other examples taken from the same manuscript, like those presented as illustration of the relevant models reconstructed for Leonardo exhibitions and museums all over the world.

CONFRONTATION WITH ANTIQUITY

One little-known aspect of Leonardo's technology is his interpretation of a technological reference in a classical text. In this case the theme of «mechanical element» comes from a literary source, Pliny's Naturalis Historia. Pliny's text merely reports that the wealthy Roman building contractor Curius constructed a grandiose wooden mobile theatre made of two rotating halves that could be turned back-to-back, providing two amphitheatres for the simultaneous performance of two plays. The two halves of the theatre could be rotated without disturbing the audience in any way. Pliny reports only this, with no other details. Leonardo took this information and presented it as a problem: «I find among the great Roman works two amphitheatres which were placed back-toback and then, with all of the audience, were rotated to close together in the form of a theatre».

The following explanation is only a description of the motion of the two amphitheaters diagrammed in horizontal section: back-to-back, aligned and, in the largest format, viewed back-to-back as well as closed to form a circle. In the main drawing Leonardo has traced a perspective view of the entire system in the closed position.

It seems impossible, but Leonardo had succeeded where others, some of the most famous architects and engineers of the 16th century, were to fail; and these were interpreters of

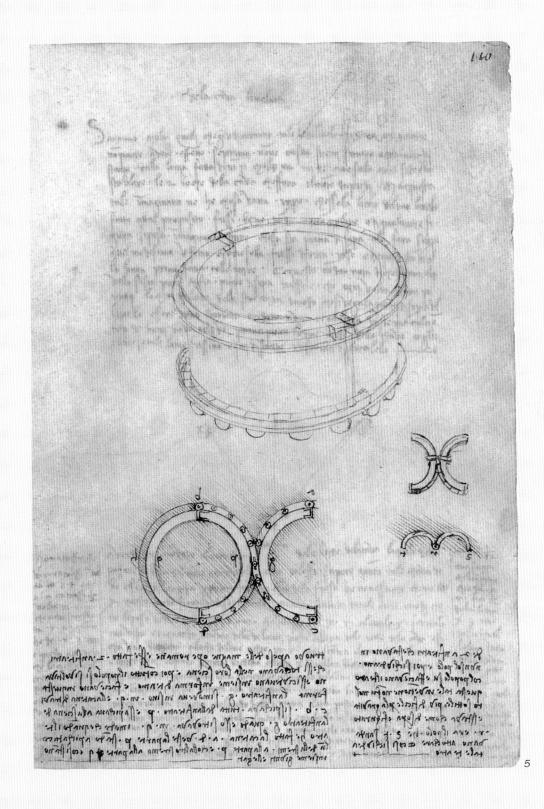

- 1. Bernardino Luini,
 Child Playing
 with panels held
 together
 according
 to the principle
 of Curius' theater
 as interpreted
 by Leonardo.
 Location unknown
- 2. Model of ball bearing Florence, Museum of History of Science, 1987
- 3. Ball bearings Madrid Ms I f. 101 v c. 1495-1497
- 4. Model of ball bearing, Florence, Museum of History of Science 1987
- 5. Ball bearings Madrid Ms I f. 20 v c. 1495-1497

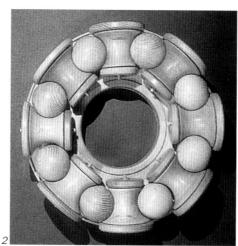

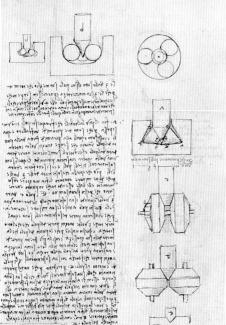

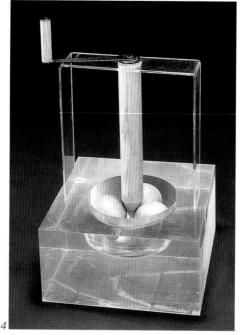

Pliny and Vitruvius such as Daniele Barbaro, Francesco Marcolini da Forlì, Andrea Palladio and Gerolamo Cardano. Leonardo demonstrated that imagination and fantasy are as vitally important to the technologist as to the painter. The mechanical principle in fact - the «mechanical element» to be sought for in the classical text – is the same applied in the ancient toy consisting of two panels held together by three ribbons and opening alternatively so that a slender object like a straw or a piece of paper is always held down by one or two ribbons. Although the procedure is difficult to describe it may be recalled that this device was used in the past as a portfolio. Undoubtedly, Leonardo knew of it. In a well-known painting by Bernardino Luini it appears in the hand of a laughing child.

The two amphitheatres were joined in the same way by chains made of wooden blocks, jointed like those of a bicycle and placed one at the base, the other at the top of the amphitheatres, but in alternation. Here an explanation is not only superfluous but may even be confusing.

The American engineer James E. McCabe, accustomed to working with missiles in the Apollo project, managed to understand Leonardo's drawing without reading the caption, and has made a functioning schematic model of it. The reader may find it interesting to resolve the problem himself, on the basis of the visual data offered by Leonardo's drawing, and then check his own solution against McCabe's explanatory diagrams.

Leonardo's schematic demonstration is purposely limited to the problem posed by Pliny's text. Accordingly, no explanation is given of the motive force employed. It can be easily imagined that the great machine

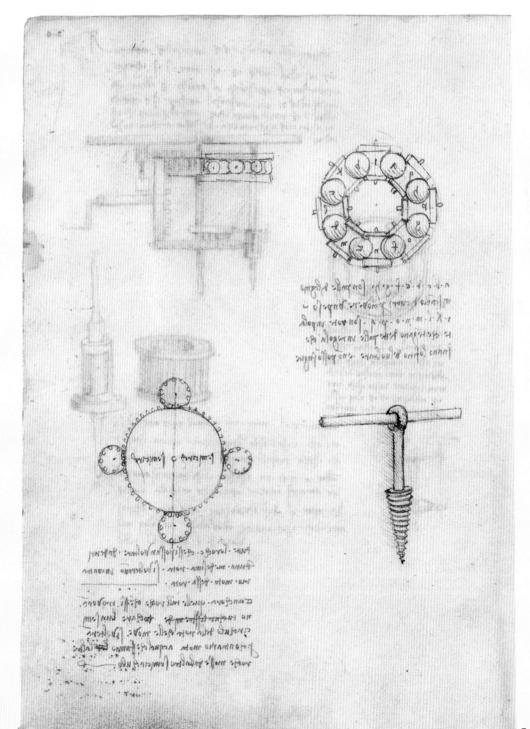

- 1. Design for canal excavating machine of conventional type CA f. 3 r c. 1503
- 2. System of counterweights applied to arms of a crane Madrid Ms I f. 96 r c. 1497
- 3. Studies of excavating machines CA f. 994 r c. 1503

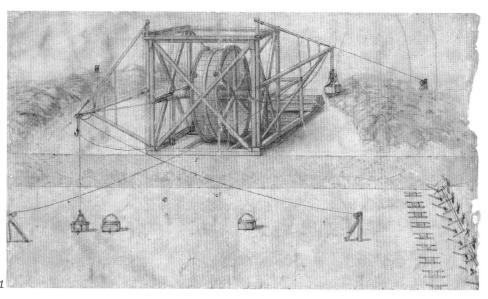

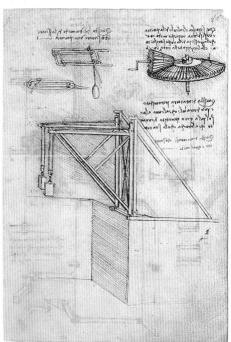

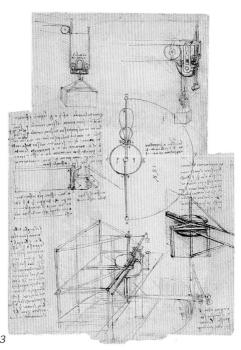

was placed on rollers and rotated through cranks drawn by animals. The use of rollers to facilitate motion was known to Roman technology, as demonstrated by the rotating platforms found in sunken ships in Lake Nemi. It is known that Leonardo himself had worked on the problem of friction, and in fact, in the same Madrid manuscript that contains the interpretation of Curius' theater the solution of the modern ball bearing is indicated.

EARTH LOADING AND UNLOADING

Not many machines of large size were conceived and perhaps built by Leonardo, certainly none that could rival the grandiosity of the «great Roman works». Among the few exceptions are the machines for excavating channels, especially those drawn on two sheets appearing at the beginning of the Codex Atlanticus which originally formed a single folio.

A date around the first years of the 16th century is suggested by the style of the large recomposed drawing, so similar, also in the type of heavy paper, to the famous map of Imola of 1502. It is more likely, however, that these two excavating machines relate to the drafts of extensive description or technical reports on the canalization of the Arno River in manuscripts from 1503-1505.

These are drawings which have been damaged by the unfortunate "restoration" of the Codex in the 1960s, Consequently, the notes written by Leonardo as well as the consecutive numbers of the original collector (the ones re-done by the "restorer" are no longer consecutive) have almost entirely disappeared. In my *Leonardo architetto* published in 1978, I reproduced the sheets from old photographs showing them still

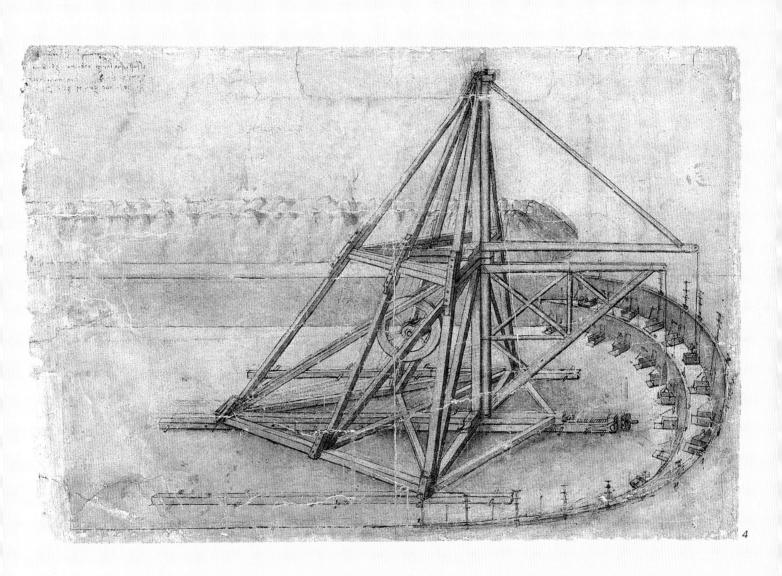

1. The «architronito», Archimedes' steam cannon Ms B f. 33 r c. 1487-1490

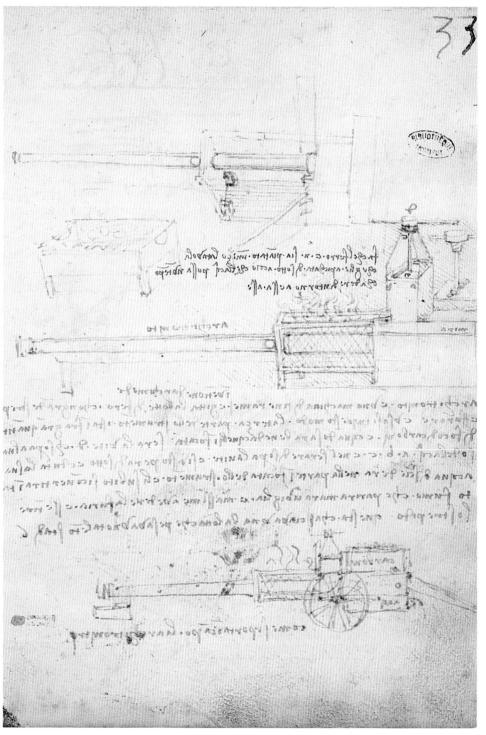

intact, allowing them to viewed together as originally drawn by Leonardo. Proof of this is provided not only by the paper and the style but also by the representation of the channel, which is a single drawing running from one sheet to another.

To the left Leonardo depicts the traditional excavator near one of the banks of the channel. It is a system derived from Vitruvius' treatise on architecture, consisting of a drum put in motion by workers who walk inside it to drive the arms of the crane that transports loads of earth piled up by diggers in the ditch.

Obviously, once a certain sector has been excavated the work must come to a halt while the machine is being moved to the next position. Using the technique of "contextual" drawing Leonardo demonstrates the superiority of his own machine in direct confrontation, shown in action on the same canal, to the right. Leonardo's machine advances progressively on tracks inside the canal as the soil is dug by the workers, standing in a semi-circle on two levels of the bank (only their digging tools hoes and spades – are indicated at the places assigned them). The arms of the crane turn along the same axis to unload the excavated material laterally, onto the banks of the ditch. The small wheel shown at the center of the frame winds up the continuous cable passing from one crane to another. Leonardo devised a highly genial application of the dumbwaiter, as can be verified by notes and drawings found elsewhere in his manuscripts. One box filled with soil rises while the other, emptied, is thrust down by the weight of a worker who jumps into it. The operation is orchestrated to proceed alternatively, and as the excavation goes on, sections of rail are progressively added.

eonardo had read in Petrarch or some other still unknown source (perhaps the historian and humanist Guglielmo di Pastrengo) that Archimedes built a steam cannon, the «architronito». Leonardo's drawing is almost certainly an example of interpretation of a classical or medieval text.

A similar steam cannon was constructed and used during the American Civil War (see Ladislao Reti, *II mistero dell'«architronito»*, in "Raccolta Vinciana", XIX, 1962, pp. 171-184).

The industrial application of steam dates back to the early 19th century, starting with the river boat designed by the American Robert Fulton, also famous as the inventor of the submarine.

THE STEAM CANNON

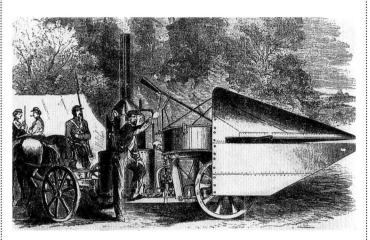

Above, Winan's steam cannon Below, roasting-jack driven by hot air CA f. 21 r, c. 1480 Lower right, Codex Hammer, f. 10 r c. 1508

Below, "moor's head" (steam-driven bellows), CA f. 1112 v Right, anonymous, steam-driven bellows (model, Florence, Museum of History of Science, 1995)

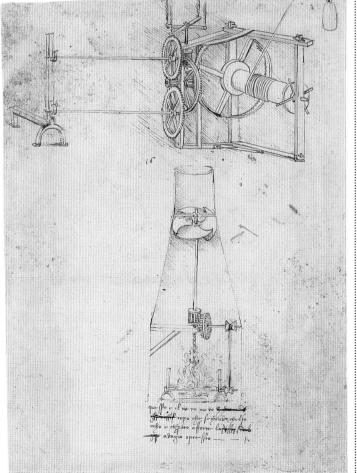

Moreover, the properties of steam had undoubtedly been known since antiquity, as exemplified by the "heliocell" of Erone Alessandrino, the steam windmill mentioned also by Vitruvius, which was undoubtedly the embryonic form of the reaction turbines of the future.

Leonardo had studied various aspects of thermal energy, to the point of formulating the principles of the steam-driven machine and even of the internal combustion engine.

But the application of steam to practical purposes was already known in his time.

The famous drawing from his youth of a roasting spit driven by a hot-air turbine already appears in 15th century treatises,

from Mariano Taccola to Giuliano da Sangallo.

Even the device mentioned in the Codex Hammer ("The water, which spurts out through the little opening of the vessel in which it is boiling, blows with fury, and is all converted into wind; with this, the roast may be turned") is merely a derivative of Erone's "heliocell", similar to the "moor's head" proposed by Filarete to stir up the fire in a fireplace.

ous to the majors offer of isonandal one copones of the computer of copones of the computer of the copones of the computer of the copones of the computer of the copones of m. Julico . of no more . fix . dup. malo . v de gra inter mily man . no make . com he to Sirven & pr. bo . This wife another the verse delivered .

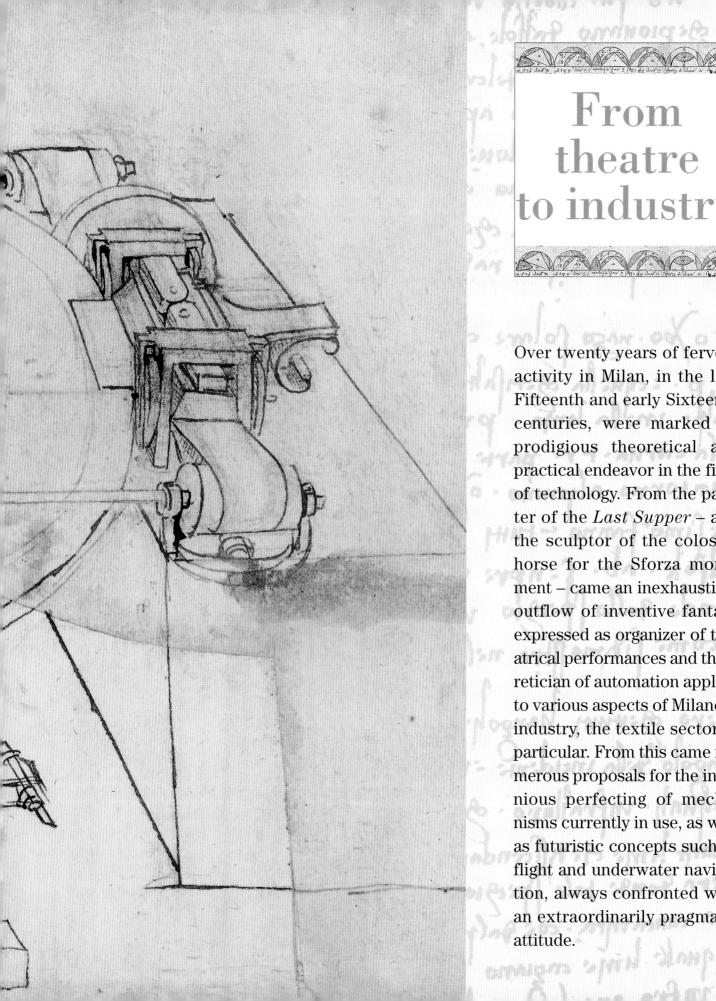

Over twenty years of fervent activity in Milan, in the late Fifteenth and early Sixteenth centuries, were marked by prodigious theoretical and practical endeavor in the field of technology. From the painter of the Last Supper - and the sculptor of the colossal horse for the Sforza monument – came an inexhaustible outflow of inventive fantasy expressed as organizer of theatrical performances and theoretician of automation applied to various aspects of Milanese industry, the textile sector in particular. From this came numerous proposals for the ingenious perfecting of mechanisms currently in use, as well as futuristic concepts such as flight and underwater navigation, always confronted with an extraordinarily pragmatic attitude.

Overleaf, on the two preceding pages: machine for sharpening needles CA f. 86 r c. 1495

 Studies for staging of Poliziano's Orpheus Codex Arundel ff. 231 v-224 r c. 1506-1508

2. Folio of studies for theatrical machine for Poliziano's Orpheus (formerly CA f. 50) 3.-4. Model built in 1964

5. «Ocel della comedia» automaton for theatrical performance CA f. 629 ii v c. 1506-1508 6. Copies of Leonardo's technological drawings, in part lost, first half of the 16th century, Florence, The Uffizi, Gabinetto dei Disegni e delle Stampe, no. 4085 A. c. 1530

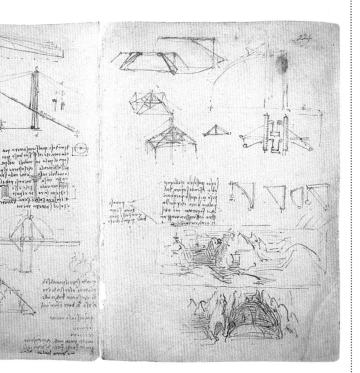

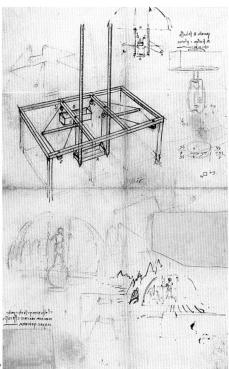

he application of the principle of counterweights is suggested in some of Leonardo's other technological drawings (and appears also in the series of «mechanical elements» in the Madrid manuscript). Leonardo himself alludes to it in the famous text previously quoted (p. 52, above), when he says that the superiority of nature in its operations is shown by the fact that it «does not work by counterweights» but has infused a «soul» into the limbs designed to move. The same principle of counterweights was applied by Leonardo to create the rotating stage for the performance of Angelo Poliziano's Orpheus in Milan in around 1506-1508. This was a "coup de théâtre" in which a mountain was shown opening while Pluto emerged from the Underworld through an opening in its center. A functioning model of this stage was created in 1964 by the laboratory of the Theatre Department of the University of California at Los Angeles for a symposium on Renaissance theatre organized in that year by the Paris Sorbonne. This model does not yet appear in any of the world's numerous Leonardo museums.

Due importance has instead been acknowledged to a large folio by an anonymous 16th century artist now in the Uffizi drawings collection at Florence, and published by myself for the first time in 1975. It contains nothing less than copies of Leonardo's technological drawings, for the most part lost. Of special importance are the copies of the Munich fragments which had never before been published until I did so in 1957. In these copies the drawings are reproduced before having undergone mutilation.

The stupendous Florence folio, which has shows of the characteristics of a Leonardo original, is important above all as further proof of the dif-

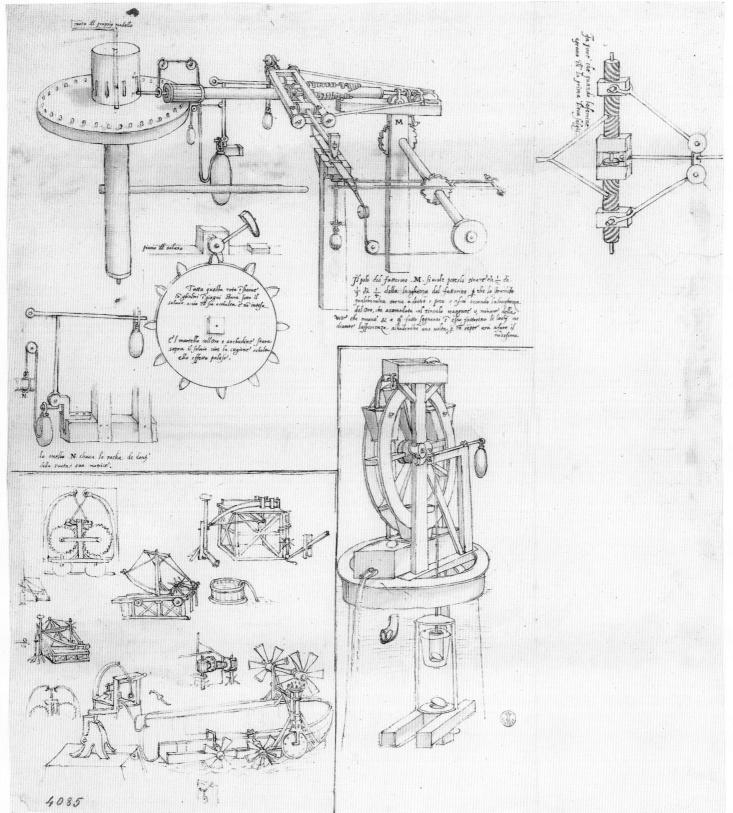

- 1. Studies of punches for the production of "bisantini" (sequins for evening dresses) CA f. 1091 r c. 1495
- 2. Studies
 of textile machines
 for spinning
 with tab spindle
 CA f. 1090 v
 c. 1495-1497
- 3. Textile machine for winding reels Madrid Ms I f. 65 v c. 1495
- 4. Large mechanical shearing machine CA f. 1105 r c. 1495
- 5. Machine for twining cord CA f. 13 r c. 1513-1515
- 6. Studies for «battiloro» machine CA f. 29 r c. 1493-1495

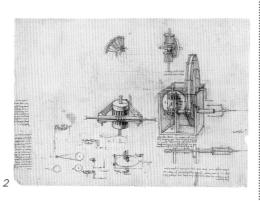

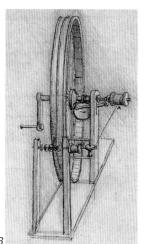

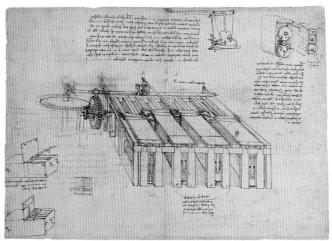

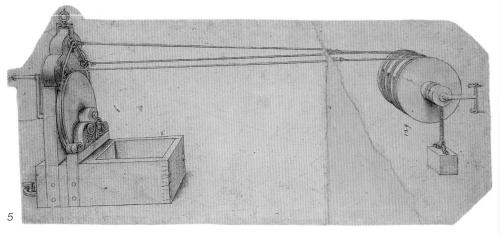

fusion of Leonardo's technological concepts after his death. The drawing at the top, which reproduces the largest Munich fragment prior to its mutilation, refers to a series of studies made by Leonardo for a «goldblater», a machine for the industrial production of «bisantini», or metal sequins to decorate ladies' evening dresses. The series is datable to about 1495 and suggests Leonardo's participation in the development of the textile industry in Lombardy. The extensive studies on textile machines, automatic reeling devices, teaseling machines, etc., in the sheets of the Codex Atlanticus, fall within the same chronological period. These machines are frequently seen transposed into models, entirely removed from that historical, economic and social context within which they could usefully viewed, at least for educational purposes.

TECHNOLOGICAL DRAWINGS

In the Florence copy (insert at lower left) are some drawings whose source has been lost but which reveal, by reflection, the youthful character of Leonardo's technological drawings. They trace back, in fact, to a drawing dated 1478 with studies of shepherds for a Nativity (see on p. 77) and sketches of mechanical devices on both sides of the sheet. These in turn lead back to other youthful folios in the Codex Atlanticus and elsewhere, including the study of a self-propelled cart still today termed – for the presence of the differential if nothing else -Leonardo's "automobile". (see insert on p. 81, below).

Lastly, the Florence sheet includes a strange kind of boat propelled by wind vanes, which suggested to me a possible reference to Brunelleschi's "Badalone", the legendary river boat invented and even patented by the famous Florentine architect that was to be

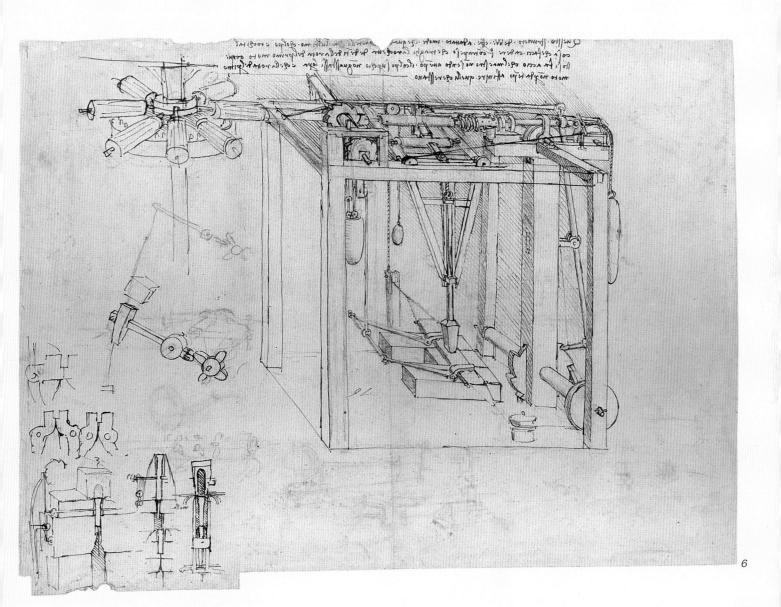

1. Boat driven by wind vanes, copy of lost drawing by Leonardo which probably reproduces Brunelleschi's legendary "Badalone" Florence,

The Uffizi, Gabinetto dei Disegni e delle Stampe no. 4085 c. 1530

2. System for transmitting motion to the axle of a cart (principle of the differential)
CA f. 17 v
c. 1478-1480

3. Studies of shepherds for a Nativity and of mechanism for a self-propelled cart Florence, The Uffizi, Gabinetto dei Disegni e delle Stampe no. 446 E dated «December 1478»

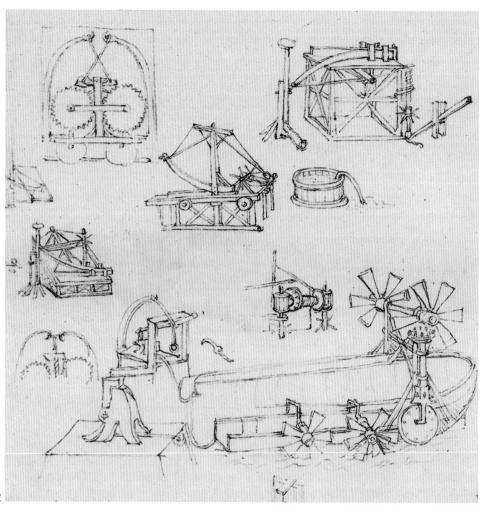

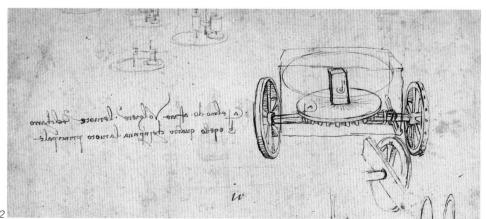

used for transporting marble from Pisa to Florence to build the Cathedral dome. It was a failure. The chronicles of the time report that the strange boat ran aground in the basin formed by the Arno River at Empoli, and was abandoned there. Perhaps it still existed in the time of Leonardo, and as a boy he may have gone to see it from the nearby town of Vinci. Although this is only a hypothesis, it may be used to seek in Leonardo's youth for the roots of his great fascination with technology. Soon afterward, as has been seen (p. 16), he was to find in Verrocchio's workshop another contact with Brunelleschian tradition in the construction of the copper ball to crown the cathedral dome.

CONTEMPORARY TECHNOLOGY

Every aspect of Leonardo's technology, from the first to the last machine designs, can be related in some way to the technology of his time. A study of the context to which a design belongs in no way diminishes its importance. On the contrary, it reveals its originality, by revealing the techniques devised by Leonardo to improve existing devices. There is only one field into which he ventured alone: the study and perhaps the testing of flying machines. It is true that the problem of flight had been mentioned already in the 13th century by the learned Roger Bacon (whose works Leonardo knew), while the Paduan architect Giovanni Fontana seems to have studied it in about 1430. And it is also true that attempts at flight seem to have been made toward the end of the 15th century at Perugia, but the news was reported only in the 17th century. No document has yet confirmed that the architect Giovan Battista Danti of Perugia tested a flying machine of his own invention over Lake Trasimeno. Moreover, Leonardo himself suggested that

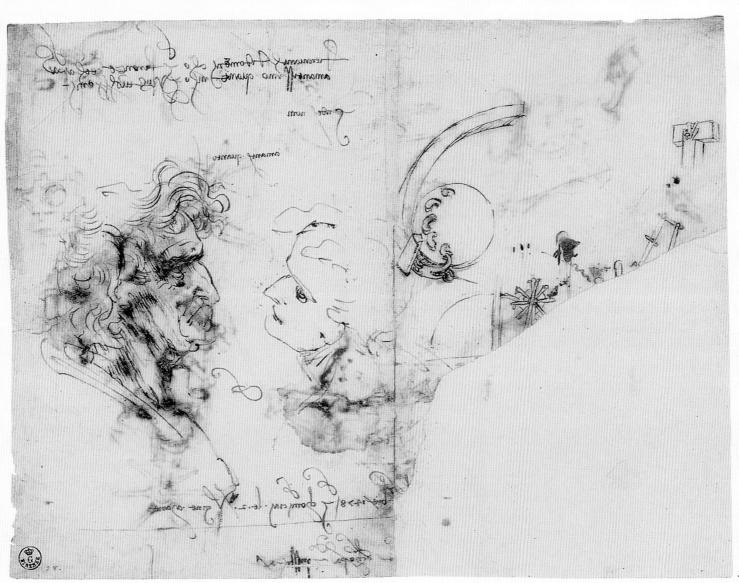

- 1. Study of artificial wing Ms B f. 74 r c. 1487-1490
- 2. Design of ornithopter with pilot in prone position Ms B f. 75 r c. 1487-1490
- 3. Vertical ornithopter Ms B f. 80 r c. 1487-1490
- 4. Studies of flying machines Florence, The Uffizi, Gabinetto dei Disegni e delle Stampe, no. 447 E r c. 1480
- 5. Study of flying machine

- CA f. 860 r c. 1480
- 6. Folio of studies on artificial flight; upper right, sketch of parachute CA f. 1058 v c. 1480

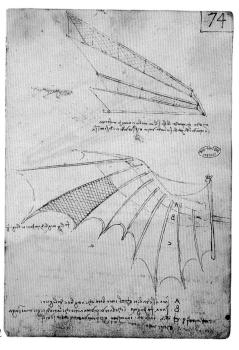

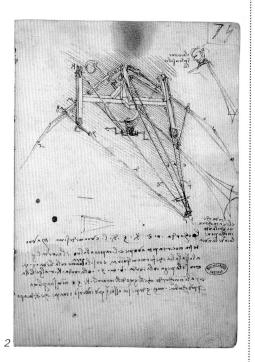

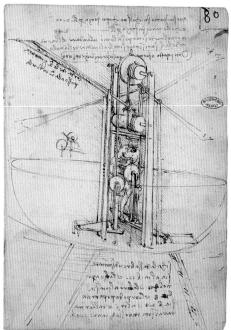

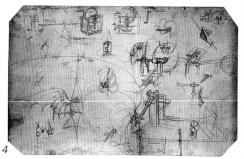

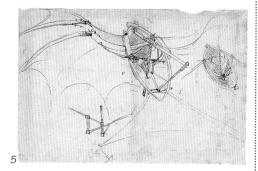

his machine should be tested over a lake to avoid the danger of a possible fall. It is interesting to note that flight was already being thought of in relation to military architecture. The parachute designed by Leonardo was indicated by him as suitable for leaping down from a great height, such as a tower or the bastions of a fortress. Moreover, Leonardo's known studies on flight, including the helicopter, are found in a Paris manuscript of 1487-1490, the so-called Codex B, largely dedicated to fortifications and weapons. It is also certain that at the time of Leonardo kites were used for reconnaissance purposes, based on models that may have been imported from China, allowing a man to be lifted to a considerable height. Leonardo himself has left us a graphic memorial of this in the first of the Madrid manuscripts (see insert on p. 29, above).

BETWEEN SKY AND SEA

Leonardo began his studies on flight much earlier than has been commonly believed, as early as the time of the Adoration of the Magi, in 1481, and thus before going to Milan. This is demonstrated by a drawing in Florence, at the Uffizi, where beside a study of drapery for one of the figures in the Adoration appear sketches of mechanisms and a diagram of the gliding flight of birds, as explained in a note: «This is the way birds descend». It is therefore unsurprising that the back of the sheet is entirely dedicated to studies for a flying machine in which the characteristic shape of artificial wings inspired by those of the bat already appears. Although I published these drawings already forty years ago, it is only now that they have received due attention in the contributions of Domenico Laurenza to the chronology of Leonardo's studies on flight. And the submarine? Leonardo must be reco-

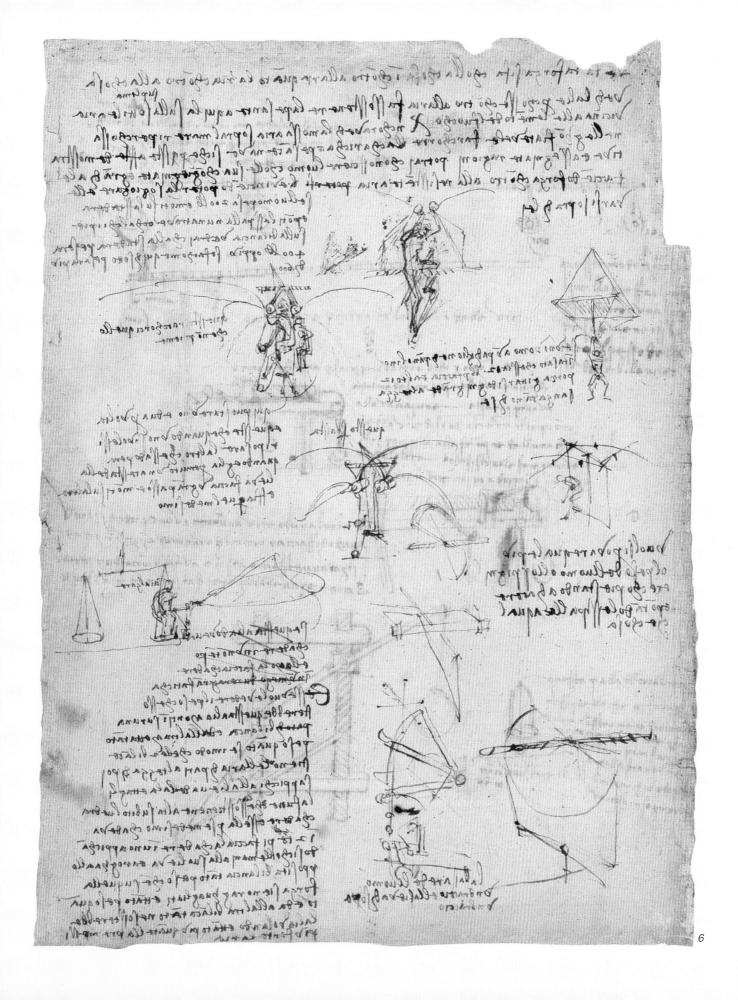

1. Studies for submarine CA f. 881 r c. 1485-1487

2. «Boat to be used to sink ships» Ms B f. 11 r c. 1487-1490 3. «Breathing apparatus for diver» Codex Arundel f. 24 v 1508

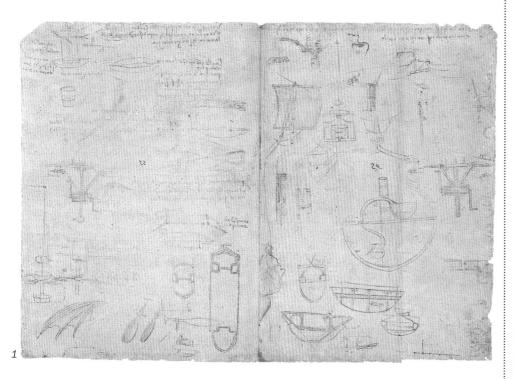

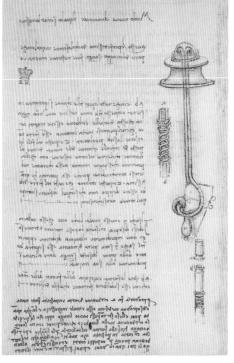

gnized as the father of this invention, as he himself claimed: «How many stay with an instrument for a long time under water. How and why I do not describe my method of staying underwater as long as I can stay without eating, and this I do not publish and divulge due to the evil nature of men, who would use it to murder at the bottom of the sea, breaking ships at the bottom and sinking them along with the men who are on them. And although I teach other methods, they are not dangerous because the mouth of the reed used for breathing, coming from the wineskins or cork, can be seen above the water». This now famous declaration, in a manuscript datable to about 1506-1508, is often cited as proof of Leonardo's moral stature. It may be considered that Leonardo really invented (and then tested) a submarine, but only to realize the treacherous use to which it could be put. From his studies on the compressibility of air seems to have sprung the idea of a pressurizing system that would allow prolonged immersion. In a folio dating from the first years in Milan he sketches a sort of submergible boat, just large enough to hold a man lying down, who seems to drive the craft through a system of pedals. Another manuscript from the same period contains a sketch of a similar boat, and the accompanying note seems to hint at a method of pressurizing. On the other hand, it might allude to a mention by Cesare Cesariano, a contemporary of Leonardo's, of a craft used to navigate under water from the moats of the Castello Sforzesco in Milan to the Castello di Musso on Lake Como. Cesariano, a pupil of Bramante and author of the 1521 edition of Vitruvius, was in Milan around 1508, at the time when Leonardo was engaged in hydraulic studies and when he declared to himself that he would not divulge his invention of the submarine.

he first indication that the sketches on f. 296 v of the Codex Atlanticus are studies for a self-propelled vehicle appeared in an article by Guido Semenza published in 1929. This served as basis for the model built by Giovanni Canestrini for the 1939 Leonardo exhibition in Milan, and for replicas which are still being produced today.

The object in question is a three-wheeled cart with a steering device, in which the great leaf springs have been erroneously interpreted as the source of motive power. The latter is instead furnished by springs wound around the fulcrum of each of the two horizontal wheels, coupled at the center; springs probably placed under those wheels, since they are barely visible in the horizontal section view. Through a complex system the unwinding of the leaf springs could be controlled, keeping efficiency constant and allowing them to be re-loaded alternatively.

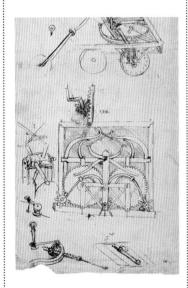

All this has recently been explained by the American Mark Elling Rosheim, a young inventor specialized in robot technology who works for the NASA.

Rosheim has managed to decipher a few brief notes made by Leonardo in 1497, interpreting

THE AUTOMOBILE AND THE LIFE PRESERVER

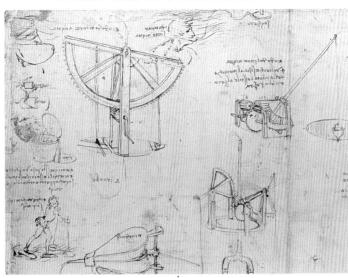

Above, technological studies with system for breathing underwater and a «way of walking on the water», CA f. 26 r, c. 1480-1482 Left, studies of self-propelled cart, CA f. 812 r, c. 1478 Below, study of life-preserver,

them as studies for the construction of a real robot: a mechanical man that walks, moves its arms, sits and opens its mouth to speak. This is reported in "Achademia Leonardi Vinci", IX, 1996, pp. 99-100.

Leonardo's "automobile" was a vehicle designed for short runs, perhaps from one end of a public square to the other. This can be seen in details on the horizontal section view in the Florence copy as well (p. 76, above).

It is probable, as Rosheim suggests, that this is a cart for festivals or the mechanism of an automaton like the mechanical lion Ms B f. 81 v, c. 1487-1490 Below, study of diving suit, CA f. 909 v, c. 1485-1487 Right, device for air rescue, with wineskins used according to the "air-bag" principle. Codex on the Flight of Birds, f. 16 r, 1505.

created by Leonardo almost forty years earlier.

Leonardo da Vinci's secret method for staying underwater revealed by his manuscripts. Under this title Nando De Toni, in 1939, published the correct interpretation of some enigmatic drawings by Leonardo on two folios in the Codex Arundel dated 1508.

This is not however the submarine Leonardo refers to in the famous text in the Codex Hammer where he states that he will not divulge his invention «due to the evil nature of men».

It is instead a diver's apparatus. A system of valves for air intake is illustrated and it is specified that the device, equipped with a floater that always reveals its presence, is useful for "calafatare" (to caulk), that is, for performing maintenance and repairing the hulls of ships without having to put them in dry dock.

This is a perfecting, although a highly ingenious one, of devices in use even before Leonardo's time, and already considered by him in his earliest manuscripts, such as Codex B in Paris dated 1487-1490 and in early folios in the Codex Atlanticus.

In the folios of that time Leonardo also showed interest in swimming and maritime rescue, as can be seen in drawings of fins and life-preservers.

There is also a curious system for walking on water.

It is not surprising then that

Leonardo also considered the problem of rescue in case of attempted flight over water. From this came the idea of using inflated wine-skins to protect the body in a fall not only in water but also on land.

One of his notes in the Codex on the Flight of Birds, dating from 1505, is illustrated by a small drawing (f. 16 r) which has only recently been interpreted by Alessandro Vezzosi.

It is the schematic figure of a standing man wrapped in a system of "wine-skins tied together like rosary beads", the principle of the "air bag".

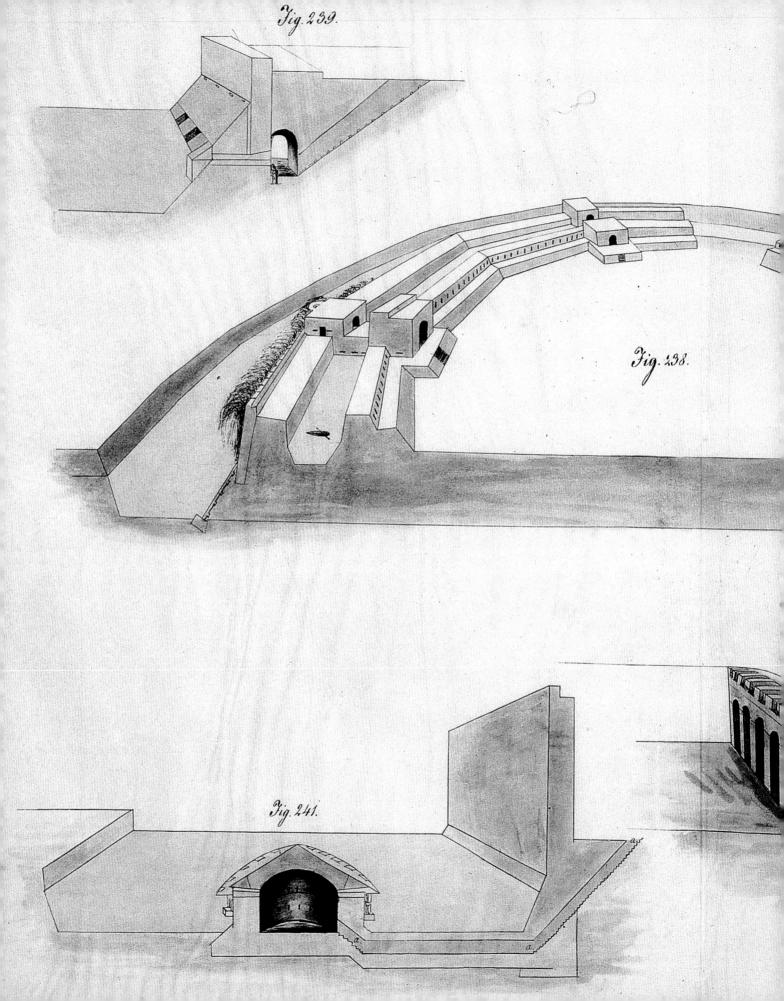

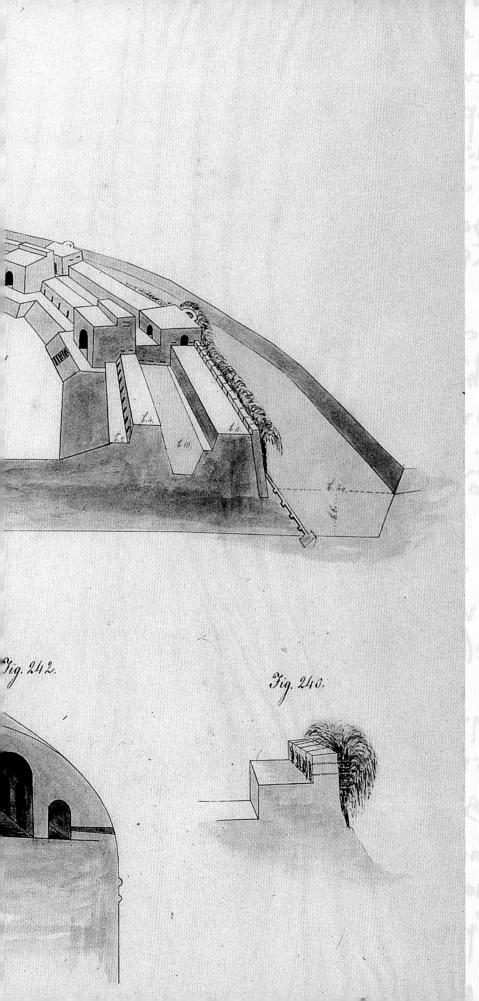

The birth of Leonardo coincided with that of the printing press. Fascinated by typographical presses from the very beginning, around 1480, he studied them already with the innovative idea of an automatic page-feeder, a concept which was to reappear near the end of the Fifteenth Century. With his renewed interest in anatomy in the early years of the Sixteenth Century and with the systematic arrangement of his writings in preparation for compiling numerous treatises, Leonardo become increasingly aware of the need to divulge his inventions through printing. With this in mind he devised a method to be used for the simultaneous reproduction of texts and drawings, three centuries in advance of William Blake.

Overleaf on preceding pages, drawings of military architecture from the Codex Atlanticus copied by G. François and L. Ferrario plate XLI (Milan 1841)

- 1. Study of typographical press with automatic page-feeder and sketch of kneeling Virgin CA f. 995 r c. 1480-1482
- 2. Fragmentary sketch
- of typographical press CA f. 991 v c. 1480-1482
- 3. Studies for a textile machine CA f. 985 r, c. 1495
- 4. Details of automatic page-feeder for

typographical press on a folio reconstructed from two in the Codex Atlanticus and a Windsor fragment with study of a figure (RL 12722) CA ff. 35 r and 1038 r, c. 1497

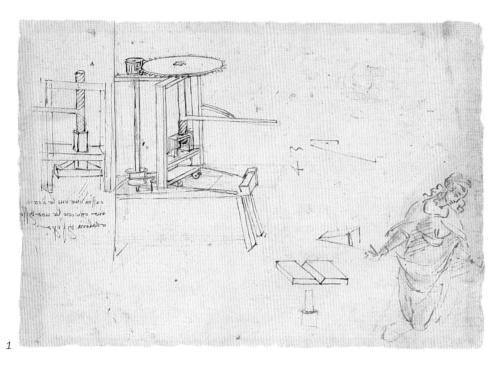

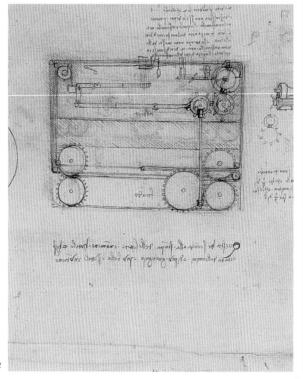

I will not publicize nor divulge». This statement may be taken, upon reflection, as proof of the fact that Leonardo was accustomed to publicizing and divulging his inventions. Of this we can be certain (and we now have the proof), although the means of communicating information, in his day, were certainly not those of our own mass-media. The printing press made its first appearance in the mid-15th century, just at the time when Leonardo was born. Nothing of his was published while he was still alive.

One of Leonardo's statements in the *Libro di pittura* has been taken as indication of why he did not print his works. It is where he speaks of painting as an art superior to all others, insofar as it cannot be reproduced in copies: «This does not make numberless sons as printed books do».

And yet, in the scientific and technological field, Leonardo had certainly come to recognize the need to find a means of disclosing his ideas and discoveries. A drawing of a typographic press with automatic feeder appears in one of the earliest folios in the Codex Atlanticus, beside the sketch of a kneeling Virgin, probably a study for a *Nativity* or *Annunciation*, datable around 1480-1482. Devices for printing are also mentioned in folios from the last decade of the 15th century.

And there is a real tribute to printing, albeit an indirect one, in a text where Leonardo explains the importance of one of his inventions in the field of textile technology. This appears on a sheet of the Codex Atlanticus datable at around 1495: «This is second to the letterpress machine and no less useful, and as practiced by men it is of more profit and is a more useful and subtle invention».

Later, in about 1505, Leonardo even conceived of a rudimentary system for the simultaneous reproduction of text

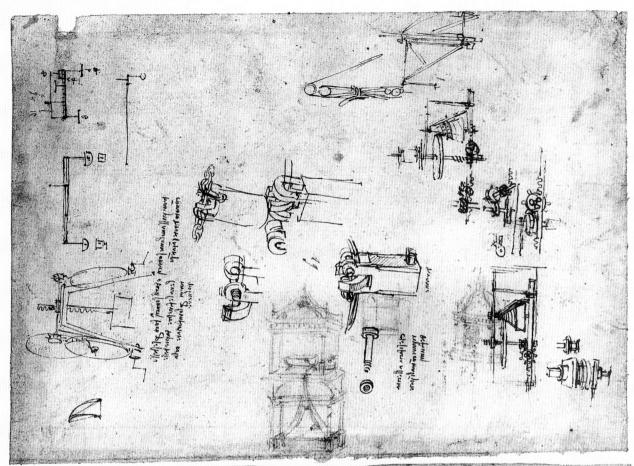

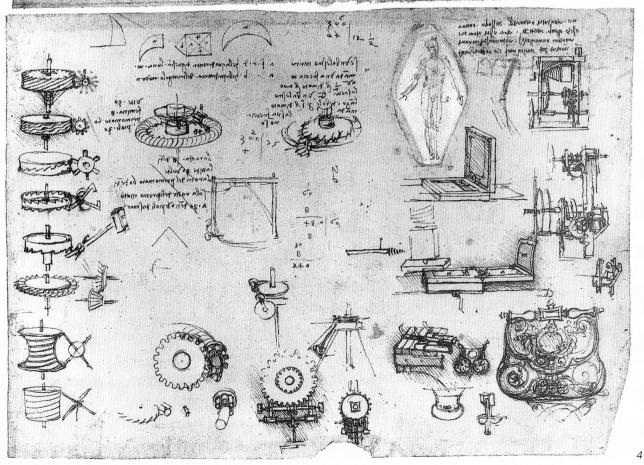

- 1. Clock mechanism: example of drawing "paginated" for printing Madrid Ms I f. 27 v c. 1495-1497
- 2. Anatomical drawings "paginated" for printing; in the lower righthand corner, is a note addressed to posterity Windsor RL 19007 v 1510

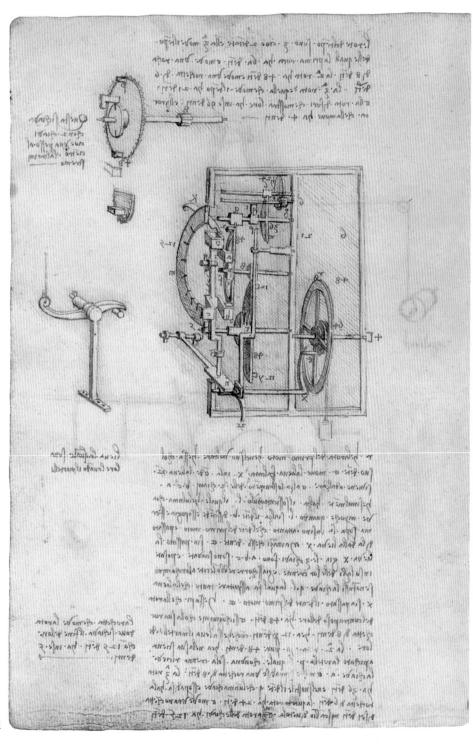

and illustrations, the method that William Blake was to adopt two centuries later (see insert on p. 91, below).

And even later, in about 1515, Leonardo notes his intention of having some of his own works printed, and calculates the number of characters required to compose a book of 160 "carte" (about 320 pages) of 52 lines each, with 50 characters to a page.

PRINTING METHODS

A little earlier, in a sheet from the splendid series of anatomical studies dated 1510 now at Windsor, there is a comment on the need to reproduce those studies through an extremely expensive procedure such as that of engraving on copper. Superb examples of this technique existed but the costs were enormous, as in the documented case of the great and famous «Prevedari print» by Bramante.

Leonardo wrote: «You should make the bones of the neck from three aspects united and from three separated; and so you will afterwards make them from two other aspects, namely seen from below and from above, and in this way you will give the true conception of their shapes, which neither ancient nor modern writers have ever been able to give without an infinitely tedious and confused prolixity of writing and of time. But by this very rapid method of representing from different aspects a complete and accurate conception will result, and as regards this benefit which I give to posterity I teach the method of reprinting it in order, and I beseech you who come after me, not to let avarice constrain you to make the prints in [...]».

The last word is missing because the margin of the paper has been damaged, but it can only be «wood», referring to the xylographic procedure, which is effective as graphic illustration but unable to render the complex

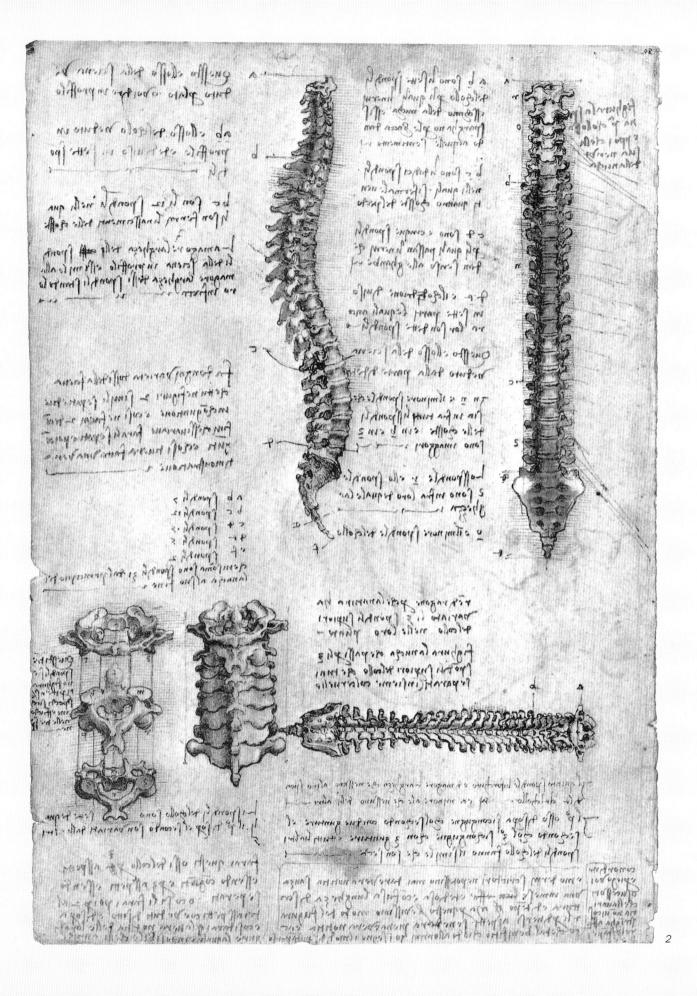

1.-5. Drawings
of mechanisms
"paginated"
for printing
Madrid Ms I
f. 2 r, f. 30 r, f. 43 r,
f. 50 r, f. 99 r
c. 1495-1497

6. Drawing of hammer winches "paginated" for printing Madrid Ms I f. 92 v c. 1495-1497

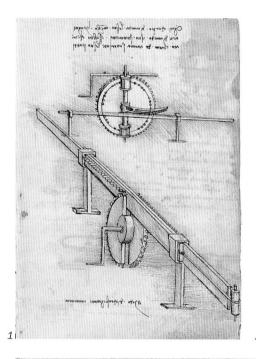

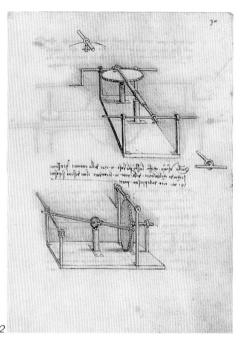

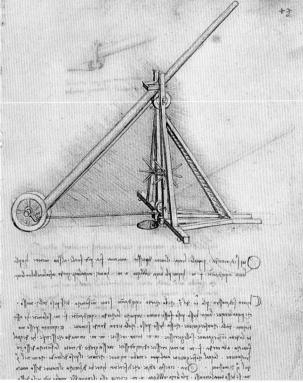

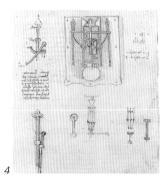

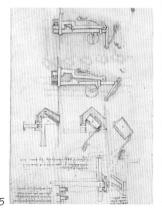

details of an anatomical drawing. This is why in the draft printing of the *Libro di pittura*, carried forward by his pupils after his death, the illustrations planned by Leonardo himself are limited to diagrams and small schematic figures easily reproducible by xylography, and, moreover, at low cost.

And the machines? These too, if not designed to be built or offered to possible customers, could be drawn with the idea of publicizing them through printing. Some hints of this can be found in Leonardo's manuscripts, as when he insists that a machine should be represented in its basic elements. without its shell, so that its operation can be immediately understood. In the first of the Madrid manuscripts he states, in about 1497: «All such instruments will generally be presented without their armatures or other structures that might hinder the view of those who will study them».

Machines that are to be studied, then. All of the text on that page seems in fact to foreshadow the technological repertoires of the great French encyclopedias, from Belidor's hydraulic encyclopedia to Diderot's universal one. It is thus unsurprising that he concludes by describing how extremely heavy objects can be salvaged from the seabed through a method which has been applied with spectacular results in the nautical technology of our own times:

«We shall describe how air can be forced under water to lift very heavy weights, that is, how to fill skins with air once they are secured to weights at the bottom of the water».

And it is even less surprising that in books printed in France and Germany, but also in Italy, from the late 16th century on, Leonardo's machines appear again and again, at times with such identical details as to leave no doubt of their origin.

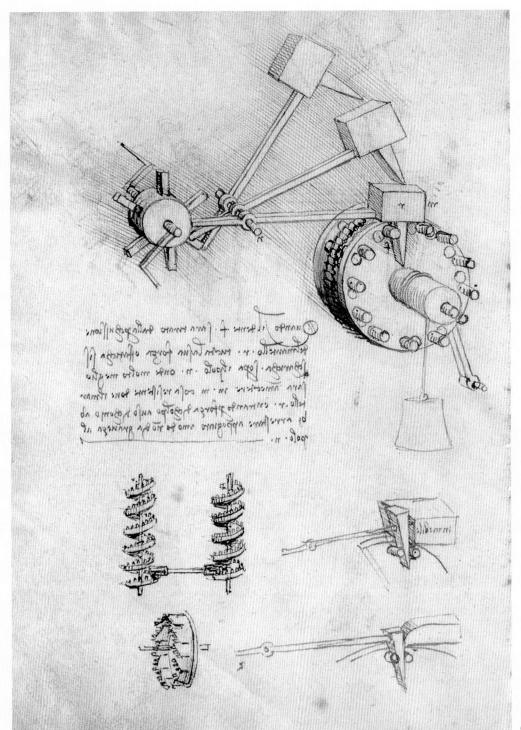

1.-5. Drawings
of weapons,
war machines
and military
architecture from
the Codex
Atlanticus copied
by F. François
and L. Ferrario
(Milan 1841)

frontispiece, plates X, XII, XIV, XXXV: first example of systematic reproduction of a "corpus" of technological drawings by Leonardo

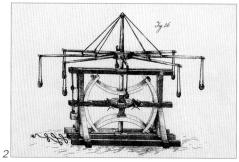

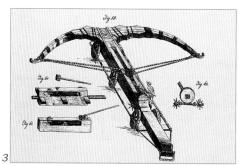

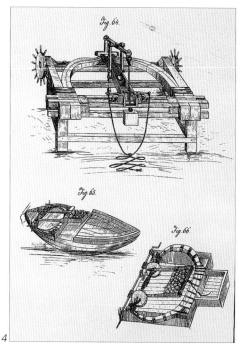

CREATION AND BENEFITS

Leonardo spent the last three years of his life in France, as the guest of King Francis I in the Castle of Clos-Lucé near Amboise, where in 1517, two years before his death, he was visited by Cardinal Louis d'Aragon.

To the illustrious prelate and his entourage Leonardo showed paintings, drawings, and above all manuscripts: «an infinite number of volumes», wrote the Cardinal's secretary in his *Diary*, «and all in the vulgar tongue, which would be most profitable and enjoyable should they ever come to light». Perhaps Leonardo himself had spoken to his guests of these writings as works he intended to publish, although realizing that this was now to be a task for posterity.

The work of compiling had become for him, more than ever, a daily habit, no longer a burden. Nothing could interfere with the laborious process of transcribing, elaborating, reviewing his own notes with patience, determination and even humility, vigilant in the awareness that his work could bring benefits that must not be lost: «Look over all these cases tomorrow and copy them, and then cross the original through and leave them in Florence, so that, if you should lose those that you take along, the invention will not be lost». These words were written in about 1508, at the time when the Codex Hammer was compiled.

In the end, then, he was again a man absorbed by the fervor and anxiety of works that must be completed even when physical strength was ebbing, even when he could have rested on his laurels.

Leonardo, already an old man, left Italy. It was not to find refuge in the welcoming protection of a King of France, but to contribute to the creation of a future that for him had already begun. n an article on Leonardo's graphic arts published in London in 1971, Ladislao Reti pointed out an invention of Leonardo's that was an extraordinary forerunner of the printing method introduced by William Blake in the late 18th century for the simultaneous reproduction of texts and drawings. The invention of the printing press with movable characters dates back to the mid-15th century, just at the time of Leonardo's birth.

But in the second of the manuscripts found in Madrid, he himself proposes a printing method which, at substantially lower cost, would facilitate the immediate diffusion of his writings and drawings.

This was a new kind of relief etching on metal which is described on f. 119 r of the Madrid Manuscript II as follows:

«Of casting this work in print. Coat the iron plate with white lead and eggs and then write on it left-handed, scratching the ground. This done, you shall cover everything with a coat of varnish, that is, a varnish containing giallolino or minium. Once dry, leave the plate to soak, and the ground of the letters, written on the white lead and eggs, will be removed together with the minium. As the minium is frangible, it will break away leaving the letters adhering to the copper plate.

RELIEF ETCHING

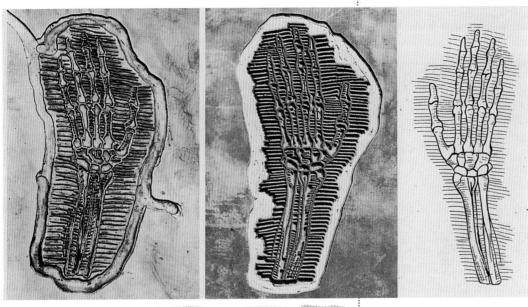

After this, hollow out the ground in your own way and the letters will stay in relief on a low ground. You may also blend minium with hard

resin and apply it warm, as mentioned before, and it will be more frangible. In order to see the letters more clearly, stain the plate with fumes of sulphur which will incorporate itself with the copper».

Following these instructions, an artist of our own times, Attilio Rossi, has reproduced the detail of a hand from a folio of anatomical studies drawn by Leonardo in 1510, now at Windsor, no. 19009 v. It would be interesting to repeat the experiment including Leonardo's writing as well which, according to his instructions, would appear normally, no longer in mirror image.

Above, Attilio Rossi, print of anatomical drawing by Leonardo executed by the method described in Madrid Ms II, f. 119 r, c. 1504 Near left, system of physiotypic printing, CA f. 197 v, c. 1508-1510 Far left, William Blake, illustration for America: A Prophecy, 1793, plate 10 («Orc in the fires of energy»)

CHRONOLOGY

1452

Leonardo is born at Vinci on April 15, the natural son of the notary Ser Piero di Antonio da Vinci.

At Arezzo, in the Church of San Francesco, Piero della Francesca begins the cycle of frescoes known as the *Legend of the True Cross*.

1454

The Peace of Lodi inaugurates a period of political stability in Italy.

1469

Leonardo presumably enters Verrocchio's workshop in this year.

1472

He is enrolled in the painters' association, the Compagnia di San Luca. His first works start from this date: costumes and sets for festivals and jousts, a cartoon for a tapestry (lost) and the paintings of uncertain dating.

1473

He dates (August 5) the drawing of the *Landscape of the Val d'Arno* (Florence, The Uffizi).

1476

Accused of sodomy along with other persons, he is acquitted.

In Milan Galeazzo Maria Sforza is assassinated in a plot. His son Gian Galeazzo succeeds him; the city is governed by Simonetta.

1478

Leonardo is commissioned to paint the altarpiece for the Chapel of San Bernardo in Palazzo della Signoria. In this same year he states that he has completed two paintings of the Virgin, one of which is now identified as the *Madonna Benois*.

The Pazzi Conspiracy, fomented by Pope Sixtus IV, fails. Giuliano de' Medici dies, but

the authority of his brother Lorenzo the Magnificent is reinforced.

According to the "Anonimo Gaddiano", Leonardo works for Lorenzo de' Medici.

Ludovico Sforza kills Simonetta, imprisons his nephew and illicitly becomes the lord of Milan.

1481

Contract for the Adoration of the Kings.

1482

Leonardo moves to Milan leaving the *Adoration of the Kings* unfinished.

1483

In Milan Leonardo stipulates the contract for the *Virgin of the Rocks* in collaboration with Evangelista and Ambrogio De Predis.

Raphael is born in Urbino.

1487

Payment for projects for the lantern on the Milan Cathedral.

1488

Verrocchio dies in Venice, where he was completing the equestrian monument to Colleoni. Bramante is in Pavia as consultant for designing the Cathedral.

1489

Leonardo designs sets for the festivities celebrating the wedding of Gian Galeazzo Sforza and Isabella d'Aragon. In this same year he begins preparations for the colossal equestrian statue in honor of Francesco Sforza.

1491

Giangiacomo Caprotti da Oreno, known as "Salai", enters Leonardo's service. The nickname "Salai", which means "devil", derives from the boy's unruly character.

1492

For the wedding of Ludovico il Moro and Beatrice d'Este, Leonardo designs the costumes for the parade of Scythians and Tartars.

In Florence Lorenzo de' Medici dies. The system of alliances sanctioned by the Peace of Lodi begins to break up.

1494

Land reclamation work on one of the Duke's estates near Vigevano.

The King of France Charles VIII, allying himself with Ludovico il Moro, invades Italy to claim his right to the Kingdom of Naples.

1495

Leonardo begins the *Last Supper* and the decoration of rooms in the Castello Sforzesco. The artist's name is mentioned as Ducal Engineer.

1497

The Duke of Milan urges the artist to finish the *Last Supper*, which is probably completed by the end of the year.

1498

Leonardo completes the decoration of the Sala delle Asse in the Castello Sforzesco.

Pollaiolo dies in Rome, where he has designed the tombs of Sixtus IV and Innocent VIII. Michelangelo is commissioned to sculpt the *Pietà* in St. Peter's. In Florence Savonarola is burned at the stake.

1499

Leonardo leaves Milan in the company of Luca Pacioli. Stops first at Vaprio to visit the Melzi family, then leaves for Venice passing through Mantua, where he draws two portraits of Isabella d'Este.

Luca Signorelli begins the frescoes in the Chapel of San Brizio in the Orvieto Cathedral. Milan is occupied by the King of France, Louis XII.

Leonardo arrives in Venice in March. Returns to Florence where he resides in the Monastery of the Servite Brothers in the Santissima Annunziata.

In Florence, Piero di Cosimo paints the Stories of Primitive Humanity.

1502

Leonardo enters the service of Cesare Borgia as architect and general engineer, following him on his military campaigns through Romagna.

In Rome, Bramante begins the Tempietto di San Pietro in Montorio and the Belvedere Courtyard.

1503

Leonardo returns to Florence where, according to Vasari, he paints the *Mona Lisa*. Devises projects for deviating the course of the Arno River during the siege of Pisa. Commissioned by the Signoria to paint the *Battle of Anghiari*.

1504

Continues to work on the *Battle of Anghiari*. Is called upon to participate in the commission that will decide where to place Michelangelo's *David*. First studies for the *Leda and the Swan*.

Michelangelo completes the *David* commissioned from him three years before by the Republic of Florence. Raphael paints the *Marriage of the Virgin*; then moves to Florence, where he is profoundly influenced by Leonardo's work.

1506

Leonardo leaves Florence for Milan, planning to return within three months. The stay in Milan extends beyond this time.

1508

Leonardo is in Florence, then returns to Milan.

In Rome, Michelangelo commits himself to frescoing the ceiling of the Sistine Chapel. In Venice, Giorgione and Titian fresco the Fondaco dei Tedeschi.

1509

Geological studies on the valleys of Lombardy.

Raphael is in Rome, where he begins decorating the *Stanze*.

1510

Studies on anatomy with Marcantonio della Torre at the University of Pavia.

1512

Michelangelo completes the frescoes on the ceiling of the Sistine Chapel. The Sforza return to Milan.

1513

Leonardo leaves Milan for Rome, where he lives in the Vatican Belvedere under the protection of Giuliano de' Medici. Remains in this city for three years, engaged in mathematical and scientific studies.

Pope Julius II dies. He is succeeded by Giovanni de' Medici under the name of Leo X. In Florence, Andrea del Sarto begins the cycle of frescoes *Stories of the Virgin*. In Milan, Cesare da Sesto with his *Baptism of Christ* achieves a synthesis of the style of Leonardo and that of Raphael.

1514

Projects for draining the Pontine swamps and for the port of Civitavecchia.

In Rome Bramante dies. Raphael succeeds him as architect of the Fabric of St. Peter's.

1515

Francis I becomes King of France. With the victory of Marignano he reconquers Milan.

Raphael works on the cartoons for the tapestries in the Sistine Chapel.

1516

Charles of Hapsburg becomes King of Spain.

1517

Leonardo moves to Amboise, to the court of Francis I, King of France. In mid-January he visits Romorantin with the King to plan a new royal residence and a system of canals in the region of Sologne.

In Rome, Raphael and his assistants paint the "Logge" in the Vatican and the Loggia of Psyche in the Villa Farnesina.

1518

Leonardo participates in the festivities for the baptism of the Dauphin and for the wedding of Lorenzo de' Medici to the King's niece.

1519

On April 23 Leonardo writes his will. The executor is his friend the painter Francesco Melzi. He dies on May 2. In the burial certificate, dated August 12, he is described as a «noble Milanese, first painter and engineer and architect to the King, State Mechanical Engineer».

Charles V of Hapsburg is elected Emperor of the Holy Roman Empire. Open conflict breaks out between France and the Empire. In Parma, Correggio paints the Badessa's Chamber in the Convent of San Paolo.

INDEX

A

Accademia Galleries, Venice, 14. 22, 24, 44, 54, 80, 82, 148 Accademia Gallery, Florence, 66, 72 Alberti, L.B., 54, 76, 136, 137. 183 Aldrovandi, U., 160 Alexandrine artist, 203 Alhazen (Ibn al Haitam), 152 Al-Kindi, 170 Amboise, Charles d', 24, 34 Andrea del Castagno, 44, 48 Andrea del Verrocchio, 148, 150, 152, 154, 210 Annunciation (1475-1480), 4-5, 30-33, 82 Anonimo Gaddiano, 18 Antonello da Messina, 62 Antonio da Vinci, 12 Apelle, 84 Archimedes, 137 Arconati, G., 92, 106 Aristides, 52 Aristotle, 166 Arrigo Cornelio Agrippa, 158 Arundel, Lord, 92, 98, 100 Ashburnham, Lord, 94, 102

В

Bacon, R., 210

Bandello, M., 44 Barbaro, D., 196 Bargello National Museum, Florence, 12, 62 Bazzi, G., known as "Sodoma". 60 Belidor, 222 Bellincioni, poet, 64 Belt. E., 109 Benci, G., 16 Biagio di Antonio, 150 Biblioteca Ambrosiana, Milan, 4, 36, 50, 62, 76, 89, 100 Biblioteca Apostolica Vaticana. Rome, 12, 72 Biblioteca Leonardiana of Vinci. 109 Biblioteca Nacional, Madrid, 92, 128, 136 Biblioteca Reale, Turin, 16, 36, 72, 74, 86, 104, 125, 156 Binding (Antique) of Codex Hammer, 108 Binding (Original) of Manuscript C, 92 Binding (Original) of Windsor Collection, 98

Boltraffio, G.A., 36, 42, 62, 89
Bonaparte, N., 94, 100
Borgia, C., 22
Bossi, G., 88
Bramante, Donato di Pascuccio d'Antonio known as, 136, 176, 214, 220
Branca, G., 141,160
British Museum, London, 18, 74, 89
Brunelleschi, F., 132 136, 148, 150, 208
Bryan, A., 182

Blake, W., 220, 225

C

Caccia, G., 106

Canestrini, G., 215
Caravaggio, 40
Cardano, F., 172
Cardano, G., 172, 180
Castellani, R., 29
Castello Sforzesco, Milan, 20
Caterina da Vinci, 12
Cellini, B., 24, 146
Cesariano, C., 80, 148, 214
Christ Church College, Oxford, 20, 66
Clark, K., 70

Clouet, J., 26 Codex Arundel, British Library, London, 8, 92, 100, 137, 154, 206, 214, 215 Codex Ashburnham, 102 Codex Atlanticus (CA), Milan, 26, 28, 60, 70, 74, 78, 84, 92, 94, 96, 128, 137, 166, 170, 172, 178, 182, 183, 186, 190, 200, 203, 206, 208, 210, 212, 214, 215, 218, 225 Codex Forster I, London, 102, 104, 172, 174 Codex Forster II, London, 42, 102, 104 Codex Hammer, Seattle, 108, 158, 215, 224, Codex Leicester, Seattle, Washington, 4, 94 Codex Marciano, 190 Codex on the Flight of Birds, Turin, 94, 104, 144, 146, 180 Codex Trivulzianus, Milan, 106, 144 Codex Vaticano Urbinate, 72, 127 Colleoni, B., 16 Corbeau, A., 109 Costa, L., 68

Crivelli, L., 66

Czartoryski Muzeum, Cracovia, 64

Dal Pozzo, C., 72
Danti, G. B., 212
De Beatis, A., 50, 68, 72, 111
De Predis, Ambrogio, 20, 36, 89
De Predis, Evangelista, 20, 36, 89
De Toni, N., 109, 215
Della Porta, G., 94
Della Torre, M., 11, 112
Diderot, D., 222
Donatello, Donato de' Bardi known as, 32, 188
Dutertre, A., 46

E

Elmer Belt Library of Vinciana, Los Angeles, 109 Emblem of the Achademia Leonardi Vinci (engraving), 89 Espina, J., 106 Este, Beatrice d', 66 Este, Isabella d', 22, 36, 66, 68 Euclid, 102, 152, 178

F

Ferrario, L., 218, 224 Ficino, M., 89, 166, 176 Fitzwilliam Museum, Cambridge, 34.64 Florentia, map known as "della Catena", 12 Fondazione Leonardo da Vinci, Florence, 109 Fontana, G., 210 Forster, J., 94, 104 Fra Angelico, 32, 48 Fra Giocondo, 82 Francesco I, 11, 20, 139, 144, 188, 224 François I, 218, 224 Freud, S., 8, 74 Fulton, R., 203

G

Gabinetto dei disegni e delle stampe, Uffizi Gallery, Florence, 14, 16, 18, 22, 32, 34, 40, 54, 88, 89, 96 Gaddi, T., 48 Galdi, G. P., 163 Galenus, C., 120 Galilei, G., 137, 158 Gallerani, C., 20, 29, 62, 64, 66, 68, 80 Galleria Borghese, Rome, 60, 66 Galleria Doria Pamphili, Rome, 68 Galleria Nazionale, Parma, 70 Galleria Palatina, Florence, 66, 72 Gallerie dell'Accademia, Venice, 22, 24, 44, 54, 80, 82 Gates B., 96, 108 Gaurico, L., 154 Gazzera, R., 44 Ghezzi, G., 94 Ghiberti, L., 152 Ghirlandaio, D., 14, 48 Gibbs-Smith, C. H., 163 Giotto, 148 Govi, G., 163 Graphische Sammlung Albertina, Vienna, 58

H

Hammer, A., 96, 108, 109
Hippocrates, 176
Holkam Hall, 22
Homo vitruvianus [as a robot], 148

Institut de France, Paris, 102 Integration of the emblem of Ginevra Benci, 62

K

Kemp, M., 109 Kunstmuseum, Basle, 82

Last Supper, 20, 22, 29, 31, 40,

42, 43, 44, 46, 48, Last Supper, 44, 48 Last Supper, 48 Last Supper, 48 Last Supper, detail before and after restoration, 58 Last Supper, detail of Christ, 46. 47 Last Supper, detail of Judas, Peter and John, 48, 49 Last Supper, detail of Matthew, 56, 57 Last Supper, detail of Philip, 52, 53 Last Supper, detail with Thomas, James the Elder

Last Supper, Santa Maria delle Grazie, 40, 42, 52, 58 Leoni, P., 92, 96, 98, 100, 104, 106 Leroy, P., 29 Libri, G., 94, 102, 104 Lippi, F., 34 Lomazzo, G.P., 42, 162, 188 Ludovico il Moro, 18, 20, 29, 40, 62, 64, 66 Luini, B., 198 Luis of Aragón, 68, 224 Lytton, Count of, 104

M

Madrid I Manuscript, 128
Malermi, N., 50
Manuscript A, Institut de France,
Paris, 52, 92, 102, 160
Manuscript B, Institut de France,
Paris, 92, 102, 104, 130, 132,
134, 36, 142, 152, 163, 166,
168, 180, 202, 212, 214, 215
Manuscript C, Institut de France,
Paris, 92, 102
Manuscript D, Institut de France,
Paris, 92, 116, 158
Manuscript E, Institut de France,
Paris, 92, 94, 102, 144, 172

Paris, 84, 92, 94, 102 Manuscript G, Institut de France, Paris, 92, 102, 152, 190 Manuscript H, Institut de France, Paris, 92, 183 Manuscript I, Institut de France, Paris, 92, 102, 128 Manuscript K, Institut de France, Paris, 92, 102 Manuscript L, Institut de France, Paris, 92, 102 Manuscript M, Institut de France, Paris, 92, 102 Manzoni di Lugo, G., 104 Marliani, Ger., 168 Marliani, Giov., 168, 172 Marliani, P., 168 Martini, S., 32 Marzocco, 188 Masaccio, 148 Maximilian, Emperor, 20 McCabe, J., 196, 198 Medici, Giovanni de', 14, 26 Medici, Giuliano de', 14, 26, 68, 158, 188 Medici, Lorenzo de', know as the Magnificent, 7, 14, 18, 89, 166 Medici, Piero de', 14, 188

Melzi, F., 92, 94, 106, 108, 162

Manuscript F. Institut de France,

Metropolitan Museum, New York, 78 Moerbeke, medieval writer, 137 Mona Lisa, 52 Mondino dei Liuzzi, 120 Morgan Library, New York, 76 Musée Bonnat, Bayonne, 29, 60, 76 Museum of History of Science, Florence, 128, 134, 150, 168, 194, 198, 203 Museo Ideale di Vinci, 109, 163 Museo Leonardiano, Vinci, 60 Museo Vinciano, Castello Guidi, Vinci, 12 Museum of Science and Technology, Milan, 163

N

Napolitano, F., 89 National Gallery, London, 36, 38 National Gallery, Washington, 16, 62 Newton, I., 158

0

Ost, H., 88

Pacioli, L., 40, 46, 128, 136, 162, 174, 176, 178 Palazzi Vaticani, Stanza della Segnatura, Vatican City, 86 Palladio, A., 196 Pater, W., 28 Payne, R., 88 Peckham, 178 Pedretti Foundation for Leonardo Studies, 109 Pedretti, C., 42, 52, 98, 109 Petrarca, F., 203 Pierpont Morgan Library, New York, 32 Pinacoteca Ambrosiana, Milan, 72 Pinacoteca Civica, Forlì, 68 Pinacoteca Vaticana, Rome, 16, 18.34 Plato, 166 Poliziano, A., 14, 100, 137, 206 Pollaiolo, Antonio del, 32 Portrait of a maiden (La Scapiliata), 71 Portrait of a woman, 36 Portrait of a woman, 36, 89 Portrait of a Young woman (The

Lady of the Jasmine), 68

P

Portrait of a young woman, 64
Portrait of Gerolamo Casio, 89
Portrait of Isabella d'Este, 66,
86
Portrait of Leo X, 26
Portrait of Leonardo, 88
Portrait of Lorenzo de' Medici,
26
Portrait of Luca Pacioli, 40
Portrait of the Musician, 62, 68,
72, 73, 89
Portrait painted with the
perspectograph, 78

R

Raffaelli, G., 44
Ramelli, A., 160
Raphael, 12, 26, 34, 66, 70, 76, 86
Reti, L., 162, 163, 225
Rosheim, M. E., 80, 215
Rossi, A., 225
Rucellai, B., 190

S

Sabachnikoff, T., 104
Salai and Leonardo, 68
Sangallo, Aristotele da, 22
Sangallo, Giuliano da, 136, 203

Semenza, G., 215 Serlio, S., 160 Sforza, Francesco, 166 Signorini, T., 28

Taccola, engineer, 132
Tartaglia, N., 137
The Last Supper on the
Silverware Cupboard, 46, 48
The Last Supper, 44, 46
The Passion Flower, 44
The School of Athens, 86
The three Ages of Man, 72
The three archangels, 89
The Uffizi, Florence, 72, 76, 78
Trivulzio, G. G. 24, 98, 106

Uffizi Gallery, Florence, 4, 6, 14, 16, 18, 26, 32, 34, 40

V

Valla, G., 178
Valla, L., 137
Van Dyck, A., 72
Vasari, G., 7, 16, 18, 24, 29, 72, 74, 76, 134, 146, 148

Venturi, A., 78
Venturi, G. B., 100
Verrocchio and Leonardo, 16, 52
Verrocchio, Andrea di Cione
known as, 7, 11, 14, 16, 31,
32, 60, 62, 74, 136
Verrocchio, workshop of, 14
Vesalio, A., 160
Vezzosi, A., 109, 163, 215
Vitruvius, 13, 80, 82, 148, 196,
202, 203, 214

W

Wallarf-Richartz Museum, Cologne, 76 Warhol, A., 44 Windsor Royal Library, (Windsor RL), 156, 166, 170, 172, 176, 180, 180, 182, 186, 188, 218, 220